ADOBE MASTER CLASS
ADVANCED COMPOSITING IN
ADOBE PHOTOSHOP CC
SECOND EDITION

BRINGING THE IMPOSSIBLE TO REALITY—WITH **BRET MALLEY**

ADOBE MASTER CLASS
Advanced Compositing in Adobe Photoshop CC, Second Edition

Bret Malley

Copyright © 2018 by Bret Malley

Adobe Press is an imprint of Pearson Education, Inc. For the latest on Adobe Press books, go to www.adobepress.com. To report errors, please send a note to errata@peachpit.com. For information regarding permissions, request forms and the appropriate contacts within the Pearson Education Global Rights & Permissions department, please visit www.pearsoned.com/permissions.

Adobe Press Editor: Nancy Davis
Senior Production Editor: Tracey Croom
Developmental Editor: Victor Gavenda
Technical Editor: Scott Valentine
Copyeditor: Linda Laflamme
Proofreader: Kim Wimpsett
Composition: Kim Scott/Bumpy Design
Indexer: Valerie Haynes Perry
Cover Design: Charlene Charles-Will
Interior Design: Charlene Charles-Will and Kim Scott/Bumpy Design
Cover Images: Bret Malley

Notice of Liability
The information in this book is distributed on an "As Is" basis, without warranty. While every precaution has been taken in the preparation of the book, neither the author nor Pearson Education, Inc. shall have any liability to any person or entity with respect to any loss or damage caused or alleged to be caused directly or indirectly by the instructions contained in this book or by the computer software and hardware products described in it. Any views or opinions presented in the interviews in this book are solely those of the author and interviewee and do not necessarily represent those of the companies included in this book.

Trademarks
Adobe, the Adobe logo, Creative Cloud, the Creative Cloud logo, Illustrator, InDesign, and Photoshop are either registered trademarks or trademarks of Adobe Systems Incorporated in the United States and/or other countries. Adobe product screenshots reprinted with permission from Adobe Systems Incorporated. Apple, Mac OS, macOS, and Macintosh are trademarks of Apple, registered in the U.S. and other countries. Microsoft and Windows are either registered trademarks or trademarks of Microsoft Corporation in the U.S. and/or other countries. Unless otherwise indicated herein, any third-party trademarks that may appear in this work are the property of their respective owners and any references to third-party trademarks, logos, or other trade dress are for demonstrative or descriptive purposes only. Such references are not intended to imply any sponsorship, endorsement, authorization, or promotion of Pearson Education, Inc. products by the owners of such marks, or any relationship between the owner and Pearson Education, Inc. or its affiliates, authors, licensees, or distributors.

ISBN-13: 978-0-134-78010-8
ISBN-10: 0-13-478010-8

1 17

Printed and bound in the United States of America

To Kellen, you will always be my ultimate partner in adventure—
I am so proud and excited to see where you take us next!
And terrified! But mostly excited!

To Erin, you have imparted a whole new meaning to the words
patience, love, and support. I can only hope to do the same in return.

You both are my will, my life, my love.
I am grateful and yours.

CONTENTS

ACKNOWLEDGMENTS

Thank you first of all to Victor Gavenda for your brilliance, banter, and frequent benevolence as an editor! It was truly a pleasure working with you at every stage of this book, even when the edits and comments felt relentless. Victor somehow made the intense time commitment (understatement) of writing feel more like an epic adventure/action movie—complete with a witty and encouraging sidekick. I may have been the sidekick, the more I think about it, and him the lead! Victor also began this entire process by being my first contact with Peachpit during the first edition; I am so grateful for that encounter!

Thank you, Scott Valentine, for pointing out things that should have been obvious as well as some things I never knew about in Photoshop—it's great to always be learning at every stage, so thank you, Scott, for being part of that! Thank you, Linda Laflamme, for your keen editing mind, for your spot-on advice, and for nearly co-authoring (or so it felt) the first edition of this book with all your strategic edits and forethought—you are brilliant as ever! Thanks to both of you, Tracey Croom and Kim Scott, for bringing your awesome layout and production skills and knowledge to this book! Thank you to Kim Wimpsett for a final editing pass catching what the rest of us somehow missed regardless of how many times we read it all! Thank you, Nancy Davis, for assembling this team and getting the ball rolling on this second edition project to begin with! I know it was an uphill push, but like any Photoshop master knows—gravity is meant to be defied! And thank you to the rest of the Adobe Press team who worked behind the curtain to make the magic happen again on this book, I wish I knew you all better! All I know is that you *rock* and that I am so grateful for your dedication and care.

To my colleagues and students at Chemeketa Community College, thank you for your patience and understanding of my relapse into a (fast-talking) zombie, with my consistently dazed look, and my incoherent sentences from many sleepless months of working on this book! You have all been encouraging, supportive, and inspiring—so thank you!

Special thanks to the Winder Family for sharing your powers with the rest of the world in Chapter 10. Thanks to lighting Jedi Jayesunn Krump at www.JKrump.com and model Miranda Jaynes for your contributions and support in the first edition. Thank you to the featured artists, Josh Rossi, Erik Johansson, Christian Hecker, Holly Andres, Mario Sánchez Nevado, and Andrée Wallin. You are all *so* talented and inspiring, and I hope readers will follow you and keep a close eye on all your future work like I do! To the rest of my family, thank you (with copious amounts of love!) for your support over the months, your patience, and just being there through it all! And again, thank you Kellen for the wonderful dream and Erin for making it possible. And thank you, Mom, for telepathically crossing the finish line with me (again!). Your unconditional support and love is felt in every action and accomplishment I do (and survive). This is no exception!

Bret Malley is an educator, professional photographer, author, and Photoshop expert specializing in imaginative, surreal, epic, and often magic-enhanced image creation. He is a full-time college professor in visual communications and teaches a range of classes and topics, including photography, design, motion graphics, and Adobe Photoshop. With an MFA in computer art from Syracuse University, Bret is a regular guest expert on Photobacks TV and also speaks at national events and teaches online classes (through CreativeLive.com and Craftsy.com). Whenever he is not teaching, leading international photography tours, creating personal works, or out adventuring around Oregon with his wife Erin and son Kellen, Bret is also squeezing in commercial work across the United States. See more of Bret's work at www.BretMalley.com.

Bret is also an Irish bodhran drummer, hiker, juggler, snowboarder, filmmaker, traveler, didgeridoo player, and cat lover. Bret sometimes wonders why people always mention their pets in these kinds of third-person descriptions. He also likes to abide by some conventions from time to time.

Adobe Photoshop is the ideal hub for nearly limitless creativity. With it you can composite disparate images together to create a new reality—or a real mess. The goal of *Adobe Master Class: Advanced Compositing in Adobe Photoshop CC Second Edition* is to excite your imagination and inspire you to do the first, while giving you the tools, techniques, and instruction to avoid the second. This second edition is not only an updated version with the latest features but is also a substantial expansion and rewrite with two new chapters that are well worth your time. Whether you are endowing children with superpowers, envisioning endless vistas, bringing strange new creatures to life, or populating beautifully rendered dreamscapes, let this book be your guide and master class for nearly any style of Photoshop compositing so that by its end you are able to not only composite your own highly imaginative works but craft them like a pro.

Adobe Master Class: Advanced Compositing in Adobe Photoshop CC Second Edition will lead your exploration into many fascinating aspects of Photoshop and the nature of compositing. After revealing some nifty techniques and features hidden behind the basic tools, layers, and adjustments, I will then move on into a whole world of editing methods for intermediate to advanced image manipulation and compositing. Whether you are a quick-study Photoshop initiate or a seasoned wiz, there is always something more to learn about this brilliant application, and this book is going to help you master it!

What's in This Book?

Adobe Master Class: Advanced Compositing in Adobe Photoshop CC Second Edition is composed of three sections:

- **Section I** provides a lively orientation to the repertoire of tools and concepts you'll need for the later tutorials and then outlines some photography basics and strategies for compositing. This first section of the book is especially good for those of you still picking up a few things or feeling fairly rusty with your Photoshop chops. For the compositors up to speed on these features, it's the next two sections that are bound to catch your interest.

- **Section II** is filled with four hands-on tutorials where you finally get to play with fire. (Think I'm kidding? Read Chapter 8.) In this section, theory turns into step-by-step instruction and practice—not to mention pure digital fun as you get to jump into several of my worlds and build your own versions from the ground up with the resources provided. By the end of this section, you are enveloped in a new world of complexity as Smart Objects are compounded, raw images are embedded and mastered, and even your editing machine is put to the test.

- **Section III** switches gears as it presents a wide range of inspirational project demonstrations, explaining how I created different styles of composites—specifically incorporating the "why" behind each technique step,

strategy, and tip. This final section is geared to get your own creative juices flowing, as well as provide some insights and helpful lessons I learned along the way. Many of these projects also draw from the hands-on topics covered earlier in Section II—this way you can see all those practiced maneuvers in action!

Nested between the Section III chapters are some additional gems: the "**Master Voices**" interviews with master digital artists who are brimming with creativity and genius knowledge of Photoshop and compositing. It is my hope that you will be as inspired as I am by these folks and will take their words of wisdom and personal insights to heart—and then create something brilliant of your own!

Downloading Tutorial Resources

This next part is incredibly important! To work along with me through the tutorials in Section II, you'll need each chapter's accompanying resource files. To download them, log in or set up an account at **peachpit.com**. Enter the book's ISBN, 9780134780108, or go directly to the book's product page to register.

Once on the book's page, click the **Register Your Product** link. The book will show up in your list of registered products along with a link to the book's resource content. Click the link to access the resource files for each chapter. For example, all the files you need for Chapter 8 are contained within *Chapter8_Resources*. The files

are waiting for you. Download them when you're ready to work, or log on and start downloading now so you can be ready to go once you get to Section II—just make sure you remember where you put them.

Is This Book for You?

So, the book description sounds nice and all, but how do you know for sure if the book is for you? Try this out. If you recognize yourself in the following list, then you'll benefit from the chapters to come:

- You want to learn about Photoshop and seamless editing, especially compositing.

- You like fantasy and sci-fi effects and imagery and want to try creating some yourself.

- You want to learn about blending modes and clever uses for getting stunning results.

- You want to make the most out of even the basic tools and discover their lesser-known features.

- You want to learn how to paint with textures and other images from a custom photo palette.

- You want to master masking, Smart Objects, and other nondestructive workflow techniques and features.

- You are looking to learn how to shoot your own imagery and build a photo archive for any number of projects.

- You are interested in composition strategy and finishing effects for color, lighting, and other adjustments.

- You love Photoshop, but you fall asleep every time you crack open a technical book or manual about it.

In summary, this book should be for you, whoever you are and whatever your compositing goals. I sincerely hope you find it of good and entertaining use!

Dig into Photoshop

Mastering Photoshop is very much like mastering a language: Frequent repetition is the key. Practice every day if you can, but *at least* twice a week. Teaching Photoshop-intensive courses has shown me that only once-a-week practice is simply not enough for most of us.

While you practice, don't neglect the keyboard. My students often ask if keyboard shortcuts are really that useful. This is art, they say, not programming. Yes, the shortcuts are truly *that* useful. For the majority of people who want to use Photoshop with increased regularity and at a professional level, shortcuts help tremendously with efficiency. For a select few, though, keyboard shortcuts are truly just too much. If that group includes you, that's fine. I, myself, am dyslexic and understand when things just don't

sense make. You can still accomplish just about everything without shortcuts, but definitely try to pick up a few as you go.

No matter what, get hands-on as often as possible. Repetition is critical. Repetition enables you to take short-term "that's neato!" memory and store it in the doing-without-thinking part of your brain. So, pick something fun to work on each week, and just do it! Repeatedly. You will be glad you did; eventually you'll work by using your Photoshop instincts alone. Masterful things may come of it! *Will* come of it!

I began my own computer art career as a little dude sitting on my dad's lap some 28 years ago, and I haven't really stopped using these machines to make art ever since. While my love for this medium has never changed, the creative tools available definitely have come a long-long way—and, boy, am I glad. Even now with two degrees in the digital arts, I am still continually acquiring more tools for my craft.

Tools and techniques are nothing, however, without the passion and vision to create that we each bring to our work. My hope is that something—a tip, an idea, an image—within this book will ignite your imagination and help you bring it to life with Photoshop. As I tell all my students, anything is possible in Photoshop—now it's time to enjoy and learn how!

SECTION I
BASICS

CHAPTER 1

Get Oriented

▶ IMPOSSIBLE (2013)

COVERED IN THIS CHAPTER

- Tool locations
- Keyboard shortcuts
- File types
- Workspace customizing
- Workflow and organization

Adobe Photoshop has so much packed into it, navigating can be a bit challenging at times, especially if you are new to it or your skills are on the rusty side. The best way to approach it is as you would a city: Get to know some of the main streets so you can get to the useful spots and then learn the rest as you go with a guide—like this book! The key is to be brave. Photoshop is huge, but do not be afraid to click something, try a new thing, or act on impulsive curiosity. You can always undo or go back a few steps in your history (unlike in real life; believe me, I've tried that one). So have courage, digital-courage!

If you already happen to have a solid understanding of the tools and other features of Photoshop and are comfortable with the program's current interface, you can race ahead to later chapters. At the same time, Photoshop is an ever-changing city, and the engineers love to change the road names! It's all for the better of course but makes navigating with an older map or outdated memory a challenge. Later chapters will explore plenty of tools in the context of projects, while this chapter concentrates on the principal features and ensures we're all oriented to the same layout of Photoshop. It will also delve a bit into finding some of those older but still favored features.

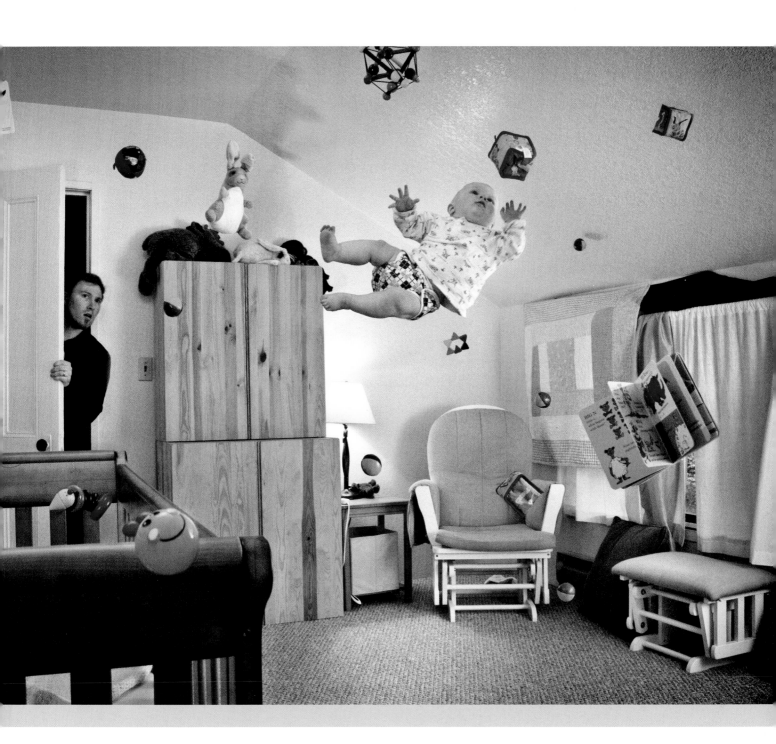

Navigating the Workspace

In this book, I will mainly use the 2018 release of Adobe Photoshop CC but will occasionally compare it with versions that preceded the Creative Cloud subscription model. Don't worry; whatever version you have, many things have stayed the same (although not everything, thankfully). Assuming that you have your settings fairly consistent with the program defaults, your screen should look similar to **FIGURE 1.1**.

On the left is still the familiar toolbar. Chapter 2 will go over some hidden features of these tools. Remember, a tool of some kind is always selected as you work on your image. If you're squeamish about an accidental editing mess, switch to something harmless like the Hand tool (H) for safely moving your cursor around for benign clicking between operations.

On the right side you will still find your panels for layers, color selection options, adjustments, brushes, and other

TOOLBAR MENU BAR OPTIONS BAR PANELS

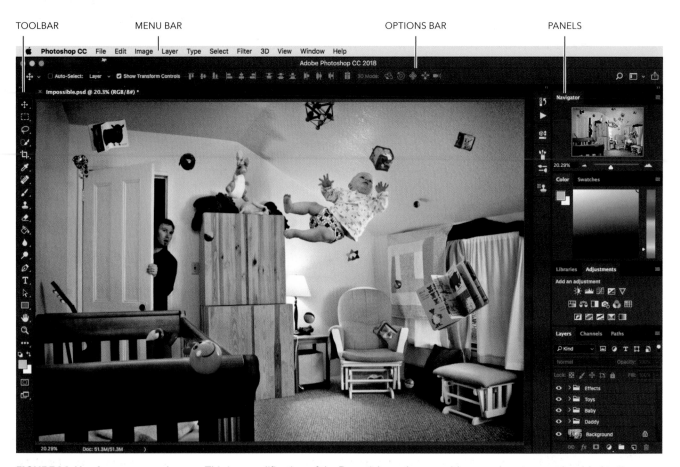

FIGURE 1.1 Here's my own workspace. This is a modification of the Essentials workspace with a couple extra panels added to it.

nifty items. Don't neglect the panel menus that open when you click their controls; these are always located in the upper-right corner of a panel (**FIGURE 1.2**). Take note of some of the new layout and panel shortcuts. If you're unsure of a control, just hover over it to see a pop-up reminder of its name after a second and a half.

If your workspace is missing any of the tools or panels shown in Figure 1.1, you may need to reset your workspace by choosing Window > Workspace > Reset Current Workspace. (A great thing about Photoshop is the ability to reset things when they get wonky.) Or, you can choose a new workspace from the workspace switcher in the top-right corner (**FIGURE 1.3**). If you're unsure which workspace you're in, this menu will tell you. The defaults (depending

on your Photoshop version) are Essentials, 3D, Graphic and Web, Motion (for animation/video), Painting, and Photography. You may have noticed in Figure 1.3 an additional workspace I created titled I Heart Compositing. We will discuss customizing and organizing workspaces later in this chapter; for now, just remember that this is where to choose and switch workspaces to optimize your work. In general, each workspace selection brings up an arrangement of various tools and panels optimized for getting you started with a specific kind of editing. Essentials is a good one to begin with as it has a relatively small number of panels good for a little bit of each kind of editing (**FIGURE 1.4**).

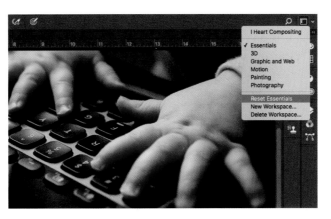

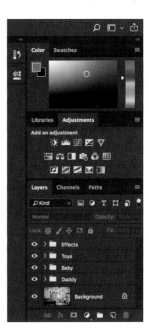

FIGURE 1.2 The default panel stack, showing the Color panel menu. The panels may look different than in earlier versions, but they're still located on the right in Photoshop by default.

FIGURE 1.3 It's a good idea to reset your workspace in case someone was on the computer before you.

FIGURE 1.4 The panels in the Essentials workspace offer a little bit of everything.

Common to all of the workspaces is the main menu bar at the top of the screen (with the options bar just below; **FIGURE 1.5**). These menus contain the commands you'll use while you work in Photoshop. You can also use keyboard shortcuts to access those commands to increase your efficiency, productivity, and general awesomeness as a Photoshop master. Take a good look at the menu shortcuts, and try to memorize a new operation or three each time you open up Photoshop. You'll be an expert in no time!

Here's a rundown of the menus and what they're used for:

- **File** contains all the usual suspects for opening and saving, as well as provides access to Adobe Bridge (**FIGURE 1.6**). If you have version CS5 or earlier, don't forget to save your work insanely often with the Ctrl+S/Cmd+S shortcut. Newer versions have frequent auto-saving enabled as a default. This background saving is a multitasking genius as Photoshop saves all those stunning layers and edits of yours while you continue working.

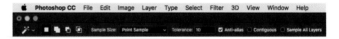

FIGURE 1.5 No version of Photoshop is complete without the menu bar and options bar.

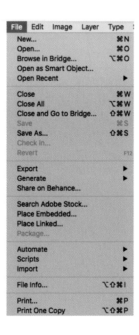

FIGURE 1.6 The File menu's Open Recent command enables you to pull up everything you were working on from the previous session, which I find very useful.

- **Edit** is the place for executing and reversing procedural edits (**FIGURE 1.7**): Copy, Paste, Paste in Place (use this when exact position matching matters), and Undo. Step Backwards enables you to undo multiple steps. Quite often just one undo is not enough, and sometimes opening the History panel for your edit history can get in the way. Step Backwards is perfect for following those breadcrumbs back a few quick steps! Puppet Warp is somewhat out of place in this menu but amazing. Like the other transform features, it lets you warp a selection of pixels but by placing your own puppet string pins throughout the image (hence the name). We'll dig more into this kind of warping in later tutorials.

- **Image** allows you to adjust a layer's individual color balance, curves, orientation, color replacement, and a slew of other destructive edits—once you do them and move on, that's how they stay (**FIGURE 1.8**). We will go over how to do most of these things nondestructively in subsequent chapters, but these are still fun to try. I use Image Size and Canvas Size frequently in my own work, and knowing the shortcuts is helpful.

- **Layer** allows you to alter, add, and organize your layers. Functions such as grouping, flattening, merging, renaming, and much more are all packed into the menu. This is only an introduction to the larger discussion of layers and what you can do with them; Chapter 3 discusses layers in more depth, including shortcuts and other improved ways to work.

- **Type** has some nifty options for working with text. We won't use this menu very much in this book, but apply some digital courage and play around with it when you have a chance!

- **Select** is another menu that you will quickly learn how to shortcut right out of use—for the most part. (See the sidebar "Keyboard Shortcut Cheat Sheet.") With the exception of two powerful selection commands found here, Color Range and Focus Area, the commands listed on this menu generally require that you manually modify your selections or remove selections.

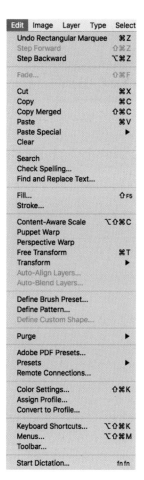

FIGURE 1.7 The Edit menu shows common shortcut goodies plus some great transform features such as Puppet Warp.

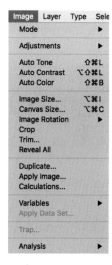

FIGURE 1.8 The Image menu gives you access to various image adjustments, most of which I'll go over how to accomplish nondestructively.

- **Filter** can alter layers with a mind-blowing array of effects (**FIGURE 1.9**). From blurs to noise reduction, this menu is invaluable for advanced editing and masterful composites. You'll use this menu in the tutorials. For now, take note of a few effects that may sound interesting and plan to return!

> **NOTE** Each version of Photoshop has a different arrangement and selection of filters; be sure to learn what's in your own version.

- **3D** is great for adding in 3D content in addition to 2D images. I rarely use it for my own composites, but your mileage may vary if you're a 3D modeler or work with one. (If you have an older version of Photoshop, by the way, you may not even have this menu.)

- **View** contains the usual Photoshop controls for toggling visual elements such as rulers, guides, snap-to features, and other layout tools.

- **Window** is your life-saving go-to menu for bringing up the full range of Photoshop features with all those beautiful panels (**FIGURE 1.10**). So whether you just don't have the panels you need (or you accidentally turned some off), you can toggle their display from here. One selection I find useful for tracking (and sometimes reversing) my work is History, the equivalent to aspirin for headaches. The Brushes panel is handy to have open as well. Figure 1.1 shows you where I like to dock them under their minimized icon .

- **Help** gives you quick access to Adobe's extensive and exceedingly helpful application documentation. If you need more background on a tool than this book provides, I definitely recommend you consult the Help menu, as well as the large library of online help from Adobe.

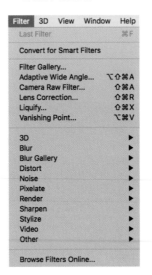

FIGURE 1.9 Filter is a standard go-to menu for tasks like adding blur and even lens correction.

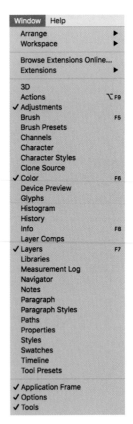

FIGURE 1.10 The Window menu allows you to toggle the visibility of key panels (like Adjustments, Color, and Layers), which is useful if they disappear on you!

KEYBOARD SHORTCUT CHEAT SHEET

Shortcuts can save you time and help you work efficiently, but they aren't always obvious. Here are some common shortcuts used throughout the book, arranged mainly by menu. Learn them! Your workflow will be glad you did.

File:
- Save: Ctrl+S/Cmd+S
- Save As: Ctrl+Shift+S/Cmd+Shift+S
- New: Ctrl+N/Cmd+N
- Open: Ctrl+O/Cmd+O
- Close: Ctrl+W/Cmd+W
- Exit/Quit Photoshop: Ctrl+Q/Cmd+Q

Edit:
- Copy: Ctrl+C/Cmd+C
- Copy Merged: Ctrl+Shift+C/Cmd+Shift+C
- Stamp Visible (Hidden feature and shortcut): Ctrl+Alt+Shift+E/Cmd+Opt+Shift+E
- Paste: Ctrl+V/Cmd+V
- Paste in Place: Ctrl+Shift+V/Cmd+Shift+V
- Undo: Ctrl+Z/Cmd+Z
- Step Backward: Ctrl+Alt+Z/Cmd+Opt+Z
- Step Forward: Ctrl+Shift+Z/Cmd+Shift+Z
- Fill: Shift+F5

Image:
- Invert: Ctrl+I/Cmd+I
- Curves: Ctrl+M/Cmd+M
- Image Size: Ctrl+Alt+I/Cmd+Opt+I
- Canvas Size: Ctrl+Alt+C/Cmd+Opt+C

Layer:
- Group: Ctrl+G/Cmd+G
- New Layer via Copy: Ctrl+J/Cmd+J
- New Layer: Ctrl+Shift+N/Cmd+Shift+N
- Clipping Mask: Ctrl+Alt+G/Cmd+Opt+G
- Merge Down: Ctrl+E/Cmd+E

Select:
- Deselect: Ctrl+D/Cmd+D
- Reselect: Ctrl+Shift+D/Cmd+Shift+D
- Select Inverse: Ctrl+Shift+I/Cmd+Shift+I

Filter:
- Apply Last Filter: Ctrl+F/Cmd+F

View:
- Zoom in: Ctrl++/Cmd++ [plus key]
- Zoom out: Ctrl+-/Cmd+- [minus key]
- Fit on Screen: Ctrl+0/Cmd+0 [zero]
- Cycle through full-screen modes: F
- Rulers: Ctrl+R/Cmd+R
- Snap: Ctrl+Shift+;/Cmd+Shift+;

Window:
- Brush: F5
- Color: F6
- Layers: F7
- Hide/Reveal panels: Shift+Tab
- Hide/Reveal toolbar, options bar, menu bar, and panels: Tab

Help:
- Online Help: F1

File Format Advantages

Let's talk about shoes and file formats. Believe it or not, file formats are like shoes: The best one is the one that suits the road or project you're on. The shoes I need for heavy-duty work aren't the same as those most comfortable for hiking or the ones that shine and impress on a job interview. From JPEG to raw to PSD and PSB to TIFF, file formats each fit best to different purposes, as well (**FIGURE 1.11**). Here's the skinny on each of the formats I most commonly use for compositing (or see **TABLE 1.1** for the abridged edition):

- **JPEG:** Lightweight but comfortable. JPEG (.jpg, .jpeg, .jpe) is the most common file format supported by digital cameras, phones, and tablets. These compressed files sacrifice image data in the name of space saving. When working with JPEG files, do not compress them for compositing work; always save them at the maximum quality level (12) in Photoshop. Anything less will continue to compress your image, simplifying the data in subtle yet damaging ways that add up to big and bad changes over time and repetition. Saving at quality 12 will keep the file size from getting any smaller, even with frequent saves. In addition, JPEG files are flattened, meaning they cannot save your individual Photoshop layers for later editing—as if the laces become glued onto your shoes after you tie them. I don't typically work with a JPEG file except at the very beginning and ending of a project. If I am editing nondestructively with layers, the composite will need to be saved as a different file in the interim even if it was originally a JPEG.

FIGURE 1.11 Photoshop can work with a long list of image file formats, but for most compositing work you'll only need a few of them.

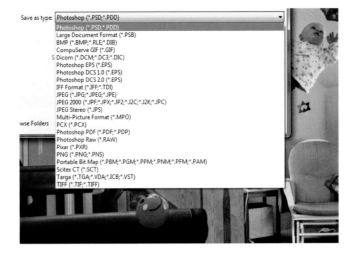

TABLE 1.1 The Tradeoffs of File Formats

	JPEG	Raw	PSD	PSB	TIFF
Pros	Small file size Easy to transfer and view on any machine Perfect for source imagery photographs Quick saving Can upload anywhere	Contains far more information than JPEG as it is an unprocessed file (no white balance, sharpening, or compression added) Not compressed; lossless file data Nondestructive editing Beautiful and flexible image files	Made for Photoshop specifically Can save layers, adjustments, styles, and more Contains images brought into it as layers; saves as a single file Can be brought into other Adobe applications	More heavyduty file size capability than PSD with same advantages Can save files larger than 2GB	Versatile file format for many applications Can save uncompressed data up to 4GB Can save layers, adjustments, masks, and more Can easily save as a high-quality flattened file
Cons	Compressed file; data loss Cannot save with multiple layers Can lose clearly noticeable quality if saved lower than 12 No nondestructive flexibility within the image	Larger file sizes than JPEG (roughly by a factor of 5+) Can require special and up-to-date software to view latest raw formats Not viewable on machines without raw readers Not all cameras can shoot in raw	Massive size, not easy for transferring Can take longer to save In most cases, not viewable without Photoshop or a similar editor Not fully backwards compatible	Same as for PSD Massive file, requires much storage and memory space Often slow to save	Does not save everything a PSD or PSB file does Layers may appear flattened when outside of Photoshop

- **Raw:** Versatile shoes that look good and are exceptionally functional. "Raw" is an umbrella term for a range of file formats that contain an awesome amount of data. You'll often come across the term spelled in all caps (RAW), but this is misleading, as it's neither an acronym nor a proper name for a specific file format. For example, Nikon uses the extension .nef, while Canon saves its raw files as .cr2. Sony apparently has dyslexic spelling like I do and calls them .arw files.

Each manufacturer of high-end cameras has a proprietary version of this advanced file format that saves far more information than can fit into a skimpy compressed JPEG file. DNG is an increasingly common raw format, used in many mirrorless cameras and phones.

More data saved means more options for your composite. For those who enjoy computer-speak and are comfortable with binary numbers, raw images can

FIGURE 1.12 This image was shot in both "Large" JPEG (a 14.19MB file size) and the camera's raw format (a whopping 82.34MB).

often be saved with 12 or 14 bits of data per channel (but are treated as 16-bit files in Photoshop), allowing many more combinations of 1 and 0s than an 8-bit JPEG (this means more distinct levels of representation per channel).

Whenever possible, shoot in either your camera's raw format or raw + JPEG (which saves a processed file alongside the raw data), assuming you have the memory space. Shooting in both raw and JPEG together allows for flexible editing with JPEG backups that will always be usable for editing and display. Plus you can always archive your smaller JPEG files, but raw images may not all fit on your hard drive due to their size.

Although working with raw files can be very powerful, size is the one major drawback to raw files. So much awesomeness can't be contained in a small package. **FIGURE 1.12** shows an image shot on my Sony A7RII at 42.4 megapixels; the AWR (raw) file is 82.34MB, while as a JPEG file it consumed only 14.19MB. Fortunately though, memory is continually getting cheaper, and what you'll gain in image quality with a raw file is worth spending a little more money on larger hard drives and memory cards for your camera!

- **PSD:** The Photoshop equivalent of happy hiking shoes. Simply called Photoshop format on the Mac, PSD (.psd for PhotoShop Document) is the native file type for Photoshop and is well designed for saving your big composite files. Because Adobe designed this proprietary file type for working specifically in Photoshop, PSD format can save layers, adjustments, masks, and more for later editing. The drawbacks include not being laterally compatible with other applications. Even backwards compatibility can be an issue if the saved file includes some fancy new effects.

- **PSB:** Big outdoor boots. When your heavy-duty composites grow too large to fit into a mere PSD wrapper (larger than 2GB), Adobe has your extra-large, super-size file covered. Just save it as a PSB (.psb for PhotoShop Big), and you are good to go, girth and all. This format has the same drawbacks as a PSD, and files will often take much longer to save if they are larger than 2GB.

- **TIFF:** Generic-brand shoe that is great for a wide range of uses; equally at home working or well shined—and they fit nicely in a shoebox for long-term storage! Technically, TIFF format (.tif, .tiff) can save much of the same information as the PSD format, including layers, masks, and adjustments, but it is generally more accessible for other applications. Just be sure to look into the TIFF saving options that appear in the prompt window after you choose to save; each option is for a specific purpose and file advantage. If you no longer need to edit your layers, you can flatten them into a high-quality TIFF file, which is great for an impressive delivery compared to a JPEG file. TIFF files don't discard data when compressed in the same way that JPEG images do. This is called lossless compression versus JPEG's lossy compression. Make sure, though, to check whether you are saving with layers intact (default for files with layers and masks) or as a flattened TIFF. Flattening will throw out those editable layers but is helpful when you need a single-layer delivery format. The ability to save layers and masks makes TIFF very alluring for a working and editing format that can save smaller files than PSD. In general, TIFF is a favored delivery format for a variety of graphic fields. When I am working just in Photoshop and Adobe Bridge, I don't often need to venture beyond PSD or PSB formats as I make sure to have loads of hard drive space. Still, it is always great to have TIFF files as a nearly equally robust but more accessible option when collaborating.

TIP Simply changing a file's name and extension will not change its format and may prevent you from opening the file by confusing your system. Only change the file format by choosing File > Save As and choosing a different format from the menu.

Organized, Clean, Efficient

Stay organized! What a supremely helpful statement, huh? Really though, when your composites begin to get more and more complicated, finding the right layer, mask, or panel becomes incredibly important for time and sanity's sake. You want to get lost in the creativity, not frustration!

One of the best tactics is to create an efficient workspace free of superfluous panels. Sometimes a lot of panels are needed, but sometimes they really just get in the way; so be sure to organize and arrange them in a way that is helpful, efficient, and clean. As discussed earlier, you can always use the workspace switcher to reset or switch a workspace, or you can enable or disable individual panels using the Window menu. Once you get a configuration of panels and tool arrangements you find useful and efficient for a specific kind of work (retouching, compositing, etc.), save it by choosing New Workspace from the workspace switcher (**FIGURE 1.13**). Name it something memorable; for example, mine is currently called I Heart Compositing—obviously optimized for compositing work.

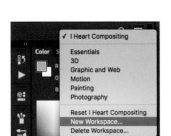

FIGURE 1.13 Use the workspace switcher to save your workspace once you get a panel configuration that you enjoy.

> **TIP** If your panels are taking up too much room, click the double-arrow icon ▶▶ to collapse them to their minimized state.

Here are a few other quick tips for saving your life (or at least hours of it):

- Label your layers! In the course of Chapter 3 and the later tutorials, you'll learn why this is so useful. For now, just do it. Really. Double-click the layer name to rename it something useful.

- Group your layers. If you have a section of several layers all adjusting lighting, for example, group them into a folder named Lighting (Ctrl+G/Cmd+G).

- Color code your layers. Seems a little anal-retentive, and that's because it is. But it's really helpful too. Again, see Chapter 3 for more details.

- Save all your materials and files in one folder if you can, and use names that are helpful. Saving your file as Master_Blaster_Final.psd is all fine and good—except when it's probably not your final version. If you work in versions or on different machines, number versions sequentially and stick to it.

- Evaluate and discard truly unneeded layers. This one is extremely hard for me to do. I confess, I am a digital hoarder: well organized, but chronic at saving everything. Photoshop files are terribly wonderful for feeding my layer-saving addiction (I'm often working with 200+ layers), but there can be a definite downside. Photoshop files save and work so much better without the extra unused layers, so it's worth the effort to force yourself to discard things every once in a while! I know, it's just so painful! On the flipside, though, if you think you really will need it, don't toss it—or perhaps consider placing it in a new file!

Workflow Inspiration

Ever been completely in the groove? Not just with Photoshop, but with anything; things just work the way you want them to—smooth, fun, and ever addicting? Workflow is a lot like getting into a good groove of complete creativity. Less romantically, however, workflow is also a term used for a style or ordering of operations and certain procedures. Usually it is used in terms of generating efficient, accurate, and controlled results.

Good workflow is all about optimizing and making things easier for you, and every Photoshop master has his or her own workflow. With that said, I will give you the methods and secrets to my own workflow in the making of some of the images that might have convinced you to purchase this book.

Workflow is also ever evolving with each new version or application update. Consider some of the later tutorials, for example. My workflow has evolved (and continues to evolve!) since the images were first created. In most cases, I will point out and even critique previous workflow styles and give tangible examples for learning from my former caveman habits.

So follow my lead, but always be on the lookout for your own groove! There are ten ways to do any one thing in Photoshop, so find the ones that either make it easier for you or just make you happy and in control!

Hidden Basics

Making masterful Photoshop composites is largely about knowing and using your tools well. That, and knowing how to be clever with them. Very clever. MacGyver clever—or Tony Stark, if you prefer. In either nerdy case, once you learn and understand the hidden features of each tool, you can combine them to enhance your projects in endlessly creative ways.

This chapter takes a look at the main tools and clever techniques that I personally find useful. Think of it as a tool reference guide for the upcoming tutorials, which are based on my own composite creations and workflow.

For you pros already confident with your tools, feel free to jump ahead to the more hands-on lessons in later chapters. But remember, too, what MacGyver could do with the humble paper clip. Take another look at these basics, and you may find a few unexpected uses of your own.

▶ SERENE DANGER (2014)

Inside My Toolbox

All artists have their own set of favorite, go-to tools for projects. For example, the Photoshop tools and their short-cuts I use for the vast majority of my workflow are these:

- Move tool (V) ⊕
- Selection tools: Marquee (M) ▣, Lasso (L) ◯, Magnetic Lasso (L) ⧉, Magic Wand (W) ⟋, Quick Selection (W) ◔
- Brush (B) ✎
- Bucket (G) ◔
- Eyedropper (I) ✐
- Healing tools: Healing (J) ✐, Spot Healing (J) ✐, Content-Aware Move (J) ✄
- Clone Stamp (S) ⬙

Don't let the brevity or simplicity of the list fool you: These commonly used tools hide quite a bit of power and can combine to create complex projects. Take a closer look at each to see how they can team up with your own favorites to enhance your workflow.

All About the Move Tool

The Move tool (V) can do so much more than simply relocate objects: Scaling, skewing, rotating, flipping, warping, layer selection, and even duplicating are all packed into this Swiss Army knife of a tool. Like several other tools, combining various modifier keys with the Move tool really packs it with extra power.

Before you begin pulling out the tool's hidden surprises though, be sure to select Show Transform Controls ☑ Show Transform Controls on the options bar (right below the main menu bar)—small box, big differences! Your layer's image will sprout handles, which are the keys to manipulating the Move tool's hidden features (**FIGURE 2.1**).

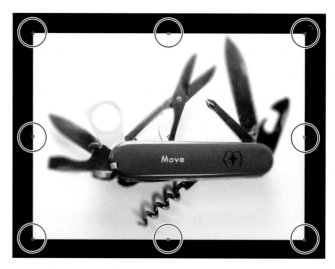

FIGURE 2.1 The Move tool's transform controls are the little square handles at the edges of the image.

> **NOTE** The Move tool cannot move a locked layer, such as the Background layer. If you want to move the locked Background layer, either make a duplicate of it (Ctrl+J/Cmd+J) or double-click the layer's thumbnail in the Layers panel; then press Enter/Return when the New Layer dialog box opens. Enter/Return will quickly close the window and unlock the layer. A third alternative is to click the layer's lock icon, but that almost seems too easy. (Chapter 3 will discuss layers more fully). On the flip side, it's possible to move a selected layer that has visibility switched off—so watch out for what you can't always see!

The nearby Auto Select checkbox may look tempting, but think twice before you toggle it on. Auto Select enables you to use the Move tool as a tool for selecting layers by clicking their pixels (again, Chapter 3 will more adequately dig into layers). This can save time in certain

circumstances such as when layers are separated well and you have a clear line of sight to the layer you want. It can also be quite annoying as it will select only the topmost layer you click within the image—whether that's the desired layer or not. This is especially true anytime you have low opacity content or a nearly masked out (non-destructively erased) layer. I find more control in manually selecting each layer I want to transform by clicking it in the Layers panel.

> **TIP** Select a different layer you want to move that is below another by right-clicking within the composite on an image using the Move tool. A context menu will give you the option of switching to another layer or group by choosing its name from a list! This can definitely come in handy when trying to move the correct object below another without making an accidental mess.

Transforming with the Move Tool

So, you toggled on Show Transform Controls; the transform handles and bounding box are visible around the image. Now what? Double-check what you are actually transforming! Transforms are dependent on both your selection within the image and your layer selection in the Layers panel, so always double- and triple-check which layer you are working on. Remember, a highlight means the layer is selected. Likewise, if you switched from a selection tool with a selection still active (it's surrounded by marching ants), that selection will be transformed instead.

As for the nifty transform handles, take it slow; the hot spots for different transformations can be slippery to pinpoint at first. In short, though, once you see the symbol for what you would like to do as a transformation, drag accordingly. Hover near a handle to see icons representing the actions available from that point.

FIGURE 2.2 shows all of the possibilities available (visible all at once for reference only). The icon varies based on where your cursor is relative to the corner point. The four possibilities are

- **Move:** Indispensible for compositing work, this is the basic Move tool function. Click within the transform bounding box and drag in the desired direction. (We'll do more with this in a bit.)

- **Scale:** This symbol appears directly over the corners and means you can resize and scale the selection. It also lets you stretch or squish the image (often by accident), so unless you want your image to lose or gain a bit of weight, hold down Shift as you drag to constrain the horizontal and vertical ratios. Shift-dragging the control point scales the image while keeping the height and width proportional. Make sure to let go of Shift after you stop dragging, otherwise you may still end up with a squashed image. A good way to remember keeping it in proportion is to hold down Shift first and last and you'll always be distortion free.

> **NOTE** Transform control hotspots are touchy, so go slow if you're having trouble.

- **Rotate:** This symbol enables you to rotate your selection. For full control, just drag. Hold Shift while you drag to snap your rotation to 15-degree increments. Shift-dragging is helpful for getting things rotated perpendicular and still level-ish, while free rotating is perfect for eye-balling just the right angle of an image.

FIGURE 2.2 Hovering the mouse pointer around a transform corner handle reveals a slew of options. Although displayed here in a group for illustration purposes, the options actually appear individually.

- **Stretch:** 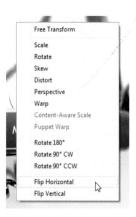 This transform handle (accessible from hovering over any edge along the bounding box) stretches your selection in the indicated direction of the cursor arrows (it's fixed to the direction of just the one side you clicked). Be very careful with Stretch, because it typically makes the selection pretty distorted—not usually what you want, unless you're designing a fantastically cheesy B-movie poster.

After scaling, rotating, or stretching you must commit to (accept) or cancel the results. To accept the transform modifications, either press Enter/Return or click the Commit button in the options bar below the main menu bar ✓. Cancel your transformation by pressing Escape or clicking the Cancel button ⊘.

Hidden Transforms

Beyond the basic transforms, the Move tool offers some additional options that are quite amazing (assuming you still have Show Transform Controls toggled on). To begin the transforming magic, left-click any transform handle; Photoshop must think that you are initiating a transform of some kind before it will allow you to see the hidden goods. Now right-click the image and behold a slew of awesome things you can now do to the layer (**FIGURE 2.3**).

FIGURE 2.3 Reveal hidden transform options with a left-click on a transform handle; then a right-click anywhere on the image.

TIP You can also press Ctrl+T/Cmd+T from any tool to begin to transform a selected layer. It's good to have alternatives like this, but I find the Move tool much more efficient for transforming. Having a tool dedicated to an action that I use all the time fits in nicely with my own workflow, but for others, the Transform shortcut works just fine!

- **Flip:** Flipping a layer selection is invaluable for a number of reasons. Using the Move tool to flip you can see exactly what is being flipped while retaining the ability to do the other transformations as well. From the context menu you can choose to flip the image horizontally or vertically, specifying the direction (left or right, up or down) when asked. (You can do the same from the Layer menu, but it's slower.)

- **Warp:** Warping is another useful process available from the context menu. Selecting Warp enables you to stretch the image with a rule-of-thirds grid; simply drag the grid in the desired direction (**FIGURE 2.4**). Sometimes images don't fit quite right as you piece your layers together, and subtle warping can be just the trick for this. Ever wish you could jam a jigsaw piece into place when you wanted to? Warp it! (For even more amazing warping and puzzle piece jamming, try Puppet Warp in the Edit menu.)

TIP For more warping options, initiate a transform (click a handle) and then click the Free Transform/Warp Mode button in the options bar 🎛 to change to Warp mode. The Warp menu that appears on the left side of the options bar lists a variety of warping features and options that can be quite handy. Each option in this list creates a different warping grid and interaction, so play with these to get familiar with their differences.

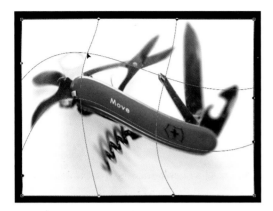

FIGURE 2.4 Warping is endless fun and great for getting that perfect fit.

- **Perspective:** Matching a layer to fit a composite's perspective can come in handy for those composites with obvious vanishing points that are easy to match up. For example, Perspective can help you match a texture to the side of a building that is shot at an angle. Drag a corner transform handle to alter the amount of vanishing and scaling occurring (it will adjust two corners simultaneously to make the vanishing perspective effect). The middle side handles allow you to slide the selected edge further along the direction of the edge.

TIP Along the lines of perspective transforming, you can use a modifier key while conducting a standard transform and create a fully customized perspective that would otherwise be tricky with the perspective transform command. You can eyeball your own perspective by freely transforming a shape: Ctrl/Cmd-drag a single handle to enter a fantastic pseudo-perspective editing mode (**FIGURE 2.5**). This can help you fit images together properly, especially if your images are flat and need to fit, say, on a side of a building. Moving these handle points individually lets you capture just the right transforming perspective.

One-Click Copy

You can easily duplicate any layer to its own new layer with the Move tool by holding down Alt/Opt and dragging the selection to a new location, just like you are moving it around (**FIGURE 2.6**). Slick and easy. Consult Chapter 3 for more options for duplicating entire layers in a similar way.

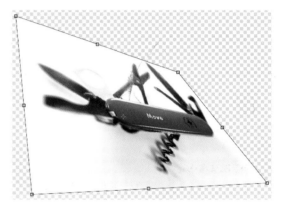

FIGURE 2.5 Holding down Ctrl/Cmd allows you to grab just one corner handle.

FIGURE 2.6 It's easy to get carried away with duplicating using the Move tool, because it's so simple. (Yes, I made some scaling and blending mode changes for this image, as well. You'll learn more about these in later chapters.)

Selection Tools and Tips

Selection tools are great for doing exactly what they sound like, but they can do more. There are three main uses for selections: to grab (copy and paste) or delete pixels, to paint or apply an effect to a specific area (whatever the selection is), and to create a mask to nondestructively hide an element of a layer or group of layers. More than anything, making good selections for composites often means creating seamless masks, an idea which we have not yet really discussed. Generally speaking, a "mask" is a nondestructive method of hiding parts of a layer's visible pixels (often created from a refined selection), which is a *huge* deal for compositing multiple images together seamlessly (literally getting rid of those obvious seams between images). So here's the rundown on my favorite selection tools and their various uses for all three purposes.

FIGURE 2.7 Marquee has two basic shapes as presets; this is the rectangular Marquee selection.

The ordinary Marquee tool (M) is my go-to tool for basic selection of a portion of a layer for copying (Ctrl+C/Cmd+C) and pasting (Ctrl+V/Cmd+V), as well as moving (hold down Ctrl/Cmd for moving on the fly) or limiting an effect (by creating a mask from a selection) to a certain area (**FIGURE 2.7**). One life-saving operation of the Marquee tool is copying and merging multiple layers within the marquee selection. To make a merged copy of all layers, including adjustments, masks, and so on, select the top-most layer and press Ctrl+Shift+C/Cmd+Shift+C to copy and merge your composite nondestructively. Pasting the copied content back into the composite or a new file with the top layer selected gives you a fully rendered flattened image while still keeping your individual layers intact and is thus nondestructive. From here, you can always give yourself a fresh look from a new perspective by flipping the flattened layer horizontally using the Move tool. Going back and forth between two seemingly simple tools can render a wide range of options with very little effort, but with worthwhile results. This layer is used mostly as a temporary and reference-only copy as any work done directly to this layer will not be nondestructive in the true sense—but it still does not touch the rest of your layers, thankfully!

> **NOTE** Whenever selecting, copying, or anything else, always check which layer you are working on!

> **TIP** There's a hidden shortcut for creating a flattened copy of your layers if that's your intent—but it's one heck of a hand cramp afterward! Press Ctrl+Alt+Shift+E/Cmd+Opt+Shift+E and watch as a new layer is created from a flattened version of all visible layers!

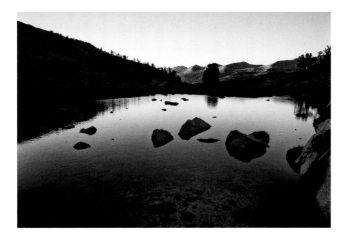

FIGURE 2.8 To clear the way for my compositing plans, I want to remove the rocks from the water.

An increasingly awesome feature of Photoshop and a great partner for the Marquee and other selection tools is the Content-Aware Fill option (not to be confused with the Content-Aware Move tool). It's always mind blowing how this feature works, even when it goes wrong (such as putting a building or tree in the sky)! When you need to remove something from a shot, such as a rock or an ogling tourist, and want to flow the background into the resulting space, Content-Aware Fill is just the ticket. The best way to explain how the Content-Aware Fill feature works is with an example: **FIGURE 2.8** is a nice enough scene, but it could use some improvement and cleaning up before I build a composite on top of it. Specifically, I want to remove some rocks because they'll be in the way of what I plan to composite.

TIP Sometimes there's just not enough background in a base image. In this case, you can expand the edges of your single-layer background image with Content-Aware selected in the options bar when

using the Crop tool. Expand the crop area beyond the original image size and Photoshop will do its best to expand upon the visible content based on what it sees.

NOTE If you want to try out this Content-Aware Fill technique for yourself, you can download a copy of the image shown in Figure 2.8 (Lake.jpg) along with the other resources provided for this book. See the introduction for instructions.

Because this will be a destructive edit (meaning it makes changes I can't undo later), I first duplicated the layer so I'd have a backup. After selecting the rock loosely with the Lasso tool (L) (you can use any selection tool you prefer), I right-clicked the selection and chose Fill from the context menu (alternatively you can press Shift+Backspace/ Shift+Delete) (**FIGURE 2.9**). In the resulting Fill dialog box, I made sure that the Content-Aware option was

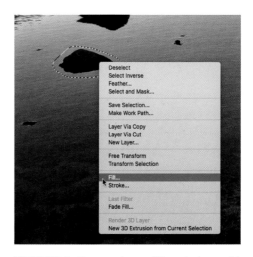

FIGURE 2.9 Content-Aware Fill works best with smaller selections like this rock. It starts to get a little too creative with larger selections as it samples from a larger area.

chosen from the Contents menu and then clicked OK (**FIGURE 2.10**). Finally, I simply watched Photoshop calculate a new background from other parts of the image. Using this technique I was able to remove all the rocks and produce **FIGURE 2.11** in under a minute. For a full-scale project, I typically would add some additional fine-tuning to this base image with clone stamping and healing.

> **TIP** Keep your selections tight. The larger the selection area you use for Content-Aware Fill, the larger the sampling area Photoshop will use, which increases the potential for undesired fill results.

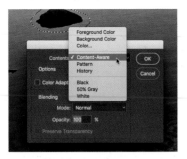

FIGURE 2.10 In the Fill dialog box, choose Content-Aware from the Use menu.

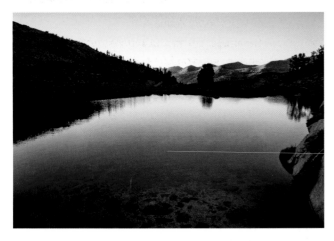

FIGURE 2.11 Removing rocks is easy with the help of Photoshop. Compare these results with where I started in Figure 2.8.

A Pair of Lassos

The Lasso tool (L) adds the ability to draw your selection organically (although I find drawing with a mouse rather like drawing with a potato and much prefer using a Wacom tablet). As with the Marquee tool, you can copy and paste with the Lasso tool, but you're not restricted to selecting only a single blocky shape. From the Lasso tool, you can even switch over to the Move (V) tool to relocate or transform your selection.

> **TIP** The Lasso tool's ability to select custom shapes pairs wonderfully with the Content-Aware Move tool (J). See the "Healing and Cloning Tools" section for more information.

The Lasso tool's sibling, the Magnetic Lasso (L) seeks out contrasting pixel edges of the content you are lassoing and pulls the selection boundary to cling to the edges at points, much like a magnet. It works pretty well for situations that require a little finessing or control but that still have clear edges (**FIGURE 2.12**). By clicking once, you initiate the magnet selection process; then the tool will try to find those edges wherever you move the mouse.

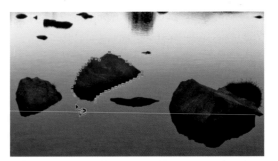

FIGURE 2.12 The Magnetic Lasso automatically clings to the contrasting edges around the rocks. By clicking, I can add additional points to the selection around areas that may need more attention.

Click as you move your cursor around the edges of your desired selection to add custom points to your selection and include fine details that the Magnetic Lasso might skip on its own. To finish you can double-click, press Enter/Return, or complete the selection by clicking the point where you started. Increasing the Frequency setting in the options bar will increase the accuracy by adding more points to the selection as you move the cursor around. Increase the Contrast value in the options bar to make the tool more or less sensitive to contrasting edges. The Anti-Alias default keeps the selection relatively smooth, so keep that one on.

> **TIP** If your mouse goes astray and a Magnetic Lasso selection begins to deviate from your intent, you can back up through the selection points by repeatedly pressing the Backspace/Delete key.

A Quick Selection

The Quick Selection tool (W) is fantastic, especially when you're in a hurry or need to make masks of people or objects (we'll get into this in later chapters). Like the Magnetic Lasso tool, this one will look for the nearest edges based on contrast within the intended image selection. With this tool, however, you can paint your selection with a resizable brush and be a little more discerning. If you want the selection to be an even more refined and accurate edge, you can shrink your brush size with the Left Bracket key ([) and continue to go over the same material. To remove an area from your selection, press and hold the Alt/Opt key as you paint. A minus sign will appear inside the brush to indicate you are now subtracting from rather than adding to the selection. Repeatedly alternating between adding an area to a selection and subtracting that same area will make Photoshop more discriminating about what it adds with each pass.

> **TIP** If your Quick Selection brush is too small for you to see the plus or minus inside of it, take a look at the far left end of the options bar. A plus sign next to the Quick Selection symbol indicates you're adding, while a minus indicates you're subtracting from the selection.

The Magic Wand Tool

The Magic Wand tool (W) is helpful for making a selection of similar pixels, such as a blue sky, a fairly uniform background, and other easy gradients. With a few additional steps, you can even use it to select a complex object: First, select the more uniform background with the Magic Wand; then right-click and choose Select Inverse (Ctrl+Shift+I/Cmd+Shift+I) for a very clean and inclusive selection of the complex object against a plain background. Or, you could do the opposite if you want to discard, say, a plain red ball and keep a complex background. When the other selection tools are having a tricky time, the Magic Wand can often do the job. Later in the book, you'll see this tool in action to create some magical scenarios.

The options bar presents some additional settings for the Magic Wand to help you fine-tune the results. The two that I use frequently are the Tolerance level and the Contiguous checkbox (**FIGURE 2.13**), which can make brilliant differences that completely alter the kind of selection you will get.

FIGURE 2.13 The Tolerance setting and Contiguous checkbox help you refine the Magic Wand tool's results.

Tolerance refers to the range of similar pixels nearest to the selected likeness of the spot being clicked (set on a scale of 0 to 255); changing tolerance changes what is allowed for inclusion in the selection. A lower value, such as 10, means that only pixels very similar in color to the pixel you clicked are included, while a higher value, such as 255 (the maximum), includes pixels in a wider range of colors into the selection.

Consider the common blue sky in **FIGURE 2.14** and all the shades of blue it contains. When I set a low tolerance of 10 and then sample a few spots of sky by clicking, the Magic Wand selects only a narrow band of nearly that exact same blue. A Tolerance setting of 100, on the other hand, selects anything slightly related to the blue family sample (**FIGURE 2.15**). It's up to you to decide which is best: an extended family get-together or a small private gathering. You can also change the tolerance after each selection addition or subtraction—great if you need some last-minute invites or you realize someone needs to be uninvited ASAP!

The Contiguous checkbox indicates whether pixels of a common color need to be touching or not to be included in the selection (**FIGURE 2.16**). When Contiguous is selected, only neighboring, touching pixels will be included. When it's deselected, any pixels within the selected color range will be included. In Figure 2.16, Contiguous is off, so all the pools are selected. With the toggle on, only the large pool in the foreground would qualify. Either way, the Magic Wand tool rocks!

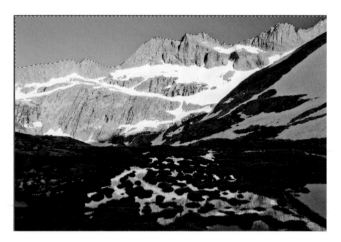

FIGURE 2.15 Increase the range of colors being selected by increasing the Tolerance value.

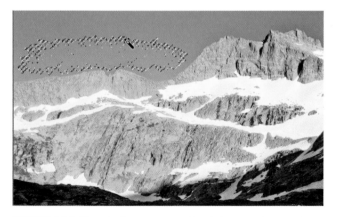

FIGURE 2.14 Blue sky is a common visual element that needs to be masked out for a number of reasons; the Magic Wand tool can work wonders for this.

FIGURE 2.16 Turning off the Contiguous toggle let me select all the separate pools of gold reflection even if they weren't touching.

Select And Mask

Refining your selection can be a huge timesaver if you don't want to painstakingly paint in a mask for what wasn't selected or was selected poorly (hair is a frequent offender). That's where the Select And Mask workspace comes in. Once called Refine Edge, this updated feature essentially works the same way (only better) and is always improving with each release and interface update. To get to this workspace either press the Select And Mask button **Select and Mask...** in the options bar or go to the Select menu and choose Select And Mask from there (Ctrl+Alt+R/Cmd+Opt+R).

Here's how it works: After making a selection, click Select And Mask to open a selection interface chock-full of powerful adjustment sliders and tools that will help you shift and soften your selections and edges to perfection (**FIGURE 2.17**).

The interface for this workspace has three main components: On the left is the Toolbar (not unlike other Photoshop toolbars). Across the top you'll find the options bar—no surprise there. Its content changes depending on the tool currently selected. On the right is the Properties panel, where the good stuff lives: the controls for tweaking and enhancing your selection.

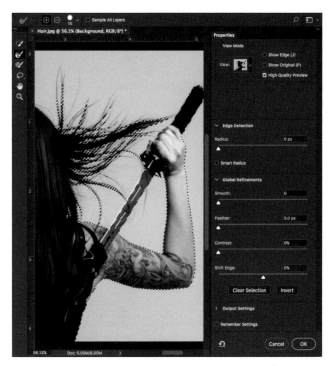

FIGURE 2.17 The tools and controls in the Select And Mask workspace are just the thing for getting a perfect selection.

The Properties panel is divided into four main sections: View Mode, Edge Detection, Global Refinements, and Output Settings. In the View Mode section use the View menu to change the visible background to better see and select areas that may have been missed or not selected tightly enough (**FIGURE 2.18**). Eliminating any selection halos and leftover pixels is intrinsic to good compositing practice, and the ability to use various views is a huge help. I like to switch back and forth between a few of these backgrounds to make sure everything is selected properly:

- Onion Skin (O) casts a translucent veil over the unselected parts of your image, with a nifty slider that allows you to adjust the transparency. This way you can better determine how the selection would look if you turned it into a mask (100% transparency on this slider equates, confusingly, to a 100% mask density) or where you still need to refine your current selection with the tools in the toolbar on the left side.

- On Black (A) is good for finding those leftover light halos that tend to hang on for dear life.

- On White (T) is excellent for spotting leftover, unwanted pixels—especially the dark variety.

FIGURE 2.18 When refining the selection edge, you can look at the selection against a few different background options.

Edge Detection can be helpful in a pinch if you have a fairly uniform selection that was pretty accurate to begin with. This feature looks at a pixel radius area around the selection edges and does its best to include areas similar to those already selected. This works especially well with plain backgrounds. Be careful: the larger the radius setting, the larger the search area, and the higher the potential to include something else by mistake. If you keep the radius under 10px, you'll be fine in most cases.

The Global Refinements section contains four sliders:

- **Smooth:** Making your selections a little rounded and smoothed out can really help with rough edges. This slider drastically helps pat down some of those wrinkles in the selection edge.

- **Feather:** Feathering softens and blurs a selection's clean but abrupt edges. The Feather slider tells Photoshop how many pixels in which to transition from full opacity to zero opacity, in other words, how much blur there is. The larger the pixel range, the softer the feathering (**FIGURE 2.19**).

TIP When selecting hair and other hard-to-find portions not in the original selection, try leaving a small amount of the surrounding image visible. This will help you better search out and select those remaining pieces. When Onion Skin view mode is selected, I go with 80% Transparency on the slider beneath the view mode property. For the other view modes, such as On Black or On White, the slider switches to Opacity. Again, I choose 80% here. It's the best of both worlds in these situations!

FIGURE 2.19 Feathering is great for matching the blurriness of the selection to that of the original image. Anything too sharp will look fake. The same goes for anything too soft. Find that "just right" sweet spot.

FIGURE 2.20 After making something a little soft with feathering, you often need to tighten the edge to bite a little bit more into the selection to avoid giving the image a slight halo.

- **Contrast:** Increasing the contrast tells the selection to be more discerning about edges within the selection and to sharpen them. This is just about the exact opposite feature from Feather.

- **Shift Edge:** Shift Edge contracts or expands the selection's edge by the specified amount. After feathering my selection, I frequently use this helpful slider to bite into the selection to get rid of any funny-looking halo glow (**FIGURE 2.20**).

> **NOTE** Do not forget to deselect (Ctrl+D/Cmd+D) when you are finished editing or using a selection! This can be an annoying "gotcha" that's hard to get out of—especially if your selection is so small it's nearly invisible.

The final section of Properties panel is Output Settings—and very much worth mentioning! Here you get the option to tell Photoshop what it should do with your amazing selection by the time you pull the trigger and click OK. The options on the Output To menu allow you to do a number of things with the current selection, but most often you'll choose to create a new mask (the Layer Mask option) for the currently selected layer or to keep it as a selection (the Selection option). Unless otherwise stated, I almost always leave my output set to Selection; I may have other plans for the selection—and making a mask is as easy as clicking the Add Layer Mask button ⬛ in the Layers panel.

Refine Edge Brush

Ever wonder how to select pesky hair without just chopping it all off? Whether you're working with a fluffy cat or a conditioned model, the Refine Edge Brush tool (R) is engineered for just this hairy quandary. It's the second tool from the top in the toolbar on the left side of the Select And Mask workspace—the one that looks like a brush comet, or perhaps a hairball being painted 🖌. The rest of the tools work much like their cousins in the main Photoshop interface: Quick Selection at the top, then Brush, Lasso, Hand, and Zoom. Use them all to refine and reshape your selections.

In any case, getting to a good base selection as seen in **FIGURE 2.21** will allow for optimal hair selection once you do use the Refine Edge Brush tool on those extremities. Within the Select And Mask interface, Quick Selection is a good tool to make sure you have the main body of hair. Just don't try for those wisps yet with this one; that's the purpose of multiple tools! Once you have a good base selection, you are ready to switch over to the Refine Edge Brush tool (R) 🖌.

> **TIP** Sometimes you will need to paint with the Refine Edge Brush tool well beyond the main body of hair for better refinement, and other times you can simply paint just the body of hair and get incredible results; this changes a little with each circumstance and hair situation.

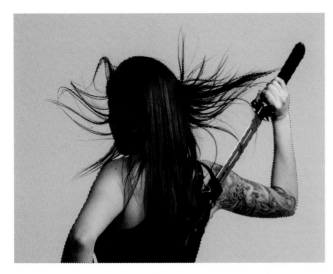

FIGURE 2.21 Here's a very quick (and yet half decent) selection of the hair before using the Refine Edge Brush tool. Grabbing the main bulk of hair and body helps the Refine Edge Brush algorithm to find those lingering wisps of hair.

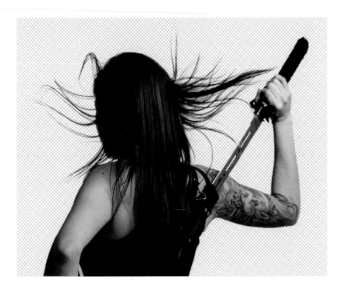

FIGURE 2.22 The Refine Edge Brush tool definitely refines your selection as advertised. Here you can clearly see the hairs in the On White view mode.

NOTE For painting with the Refine Edge Brush tool, be sure to select High Quality Preview in the View Mode section of the Properties panel for a more accurate display of hair selection as you paint. Likewise, selecting Show Edge can help you spot those sections you may have missed as you paint.

Now here's where you truly master hair: With the Refine Edge Brush tool selected, paint over all remaining parts of the hair, even those wispy pieces flying around and anything that shows the bland background through it. Focus on the boundary between the hair and background, including the edge of the head. Painting over these areas will systematically tell Photoshop to find small strings of contrast (such as hair) and include them as part of the selection while leaving out the more solid background chunks. After you paint over all of the hair with the Refine Edge Brush tool, you can sit back and watch as Photoshop does its magic and produces an incomprehensibly amazing selection of the hair (**FIGURE 2.22**). It won't always be absolutely perfect—what haircut ever is—but it will be darn good, especially compared to using the clipper shears or having to manually paint in the hair selection with a clunky tool. After using the Refine Edge Brush tool, click OK to apply the selection; then click the small mask icon ◙ to convert the selection to a mask. Once the layer has its (well groomed) mask, you can then easily put just about any new background behind that hair (**FIGURE 2.23**) and be ready for the masking tips in Chapter 4; as you can see, I quickly placed this selected figure into the scene I removed rocks from earlier.

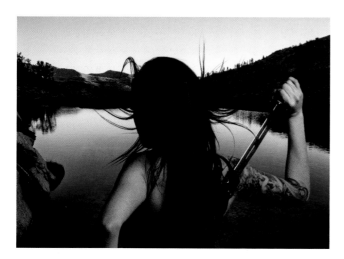

FIGURE 2.23 Now you can put in any kind of background you want without chopping off a majority of those flowing follicles! With a couple other adjustment layers added to the mix, just about any refined selection can fit right in.

TIP When refining edges for both body and hair, it's best to do this in two rounds of Select And Mask. After using the sliders in the Properties panel to get skin and other main body selections looking good, apply the Select And Mask adjustments by clicking OK. Yes, this will take you out of Select And Mask before you have touched the hair, but until there is an Apply button or other alternative added within the Select And Mask workspace, clicking OK is the way to go. Immediately jump back into Select And Mask and use the Refine Edge brush to get those strands of hair—but leave the sliders alone as they will now affect the hairdo. Don't mess with the 'do!

NOTE For hair in front of busy backgrounds (as opposed to solids or gradients), this tool may not know which parts are hair and which parts are the background. If you have a hard time discerning, so may this tool. Avoid this issue whenever possible and shoot in front of something more uniform. If you can't avoid it, you may need to manually paint some hair!

Other neat advantages from this feature don't stop there, however. Each new version of Photoshop includes new fantastic features for a range of selection needs. Have digital courage and explore them as you go! Things to check out include

- The Output Settings menu allows you to go straight to creating a mask from the current selection.

- Use the Invert button to invert your current selection for those times when you first had to select the background as the starting selection. That's more common than you might expect.

- Sample All Layers in the options bar is an exciting newer feature ripe with potential uses. Say you are actually making a selection for a skyline made from several pictures. Sample All Layers will let you select based on the composite of what you see. You definitely have to think a bit outside the selection with this one.

- Remember Settings is another great addition that saves your settings for the next selection session—how handy-dandy is that?

- The rest of the tools on the toolbar help adjust your selection while keeping your workflow within this interface. No longer do you have to jump back and forth in and out of Select And Mask just to grab a bit more of an arm or hair—or even arm hair!

Even the most mundane, familiar Photoshop tools can have unexpected uses. Here are a few of my favorites:

- **Smudge tool:** Beyond simply using various brush shapes and sizes to smudge pixels, this tool can be very useful for pushing pixels around on masks, offering especially refined control to get things just right. Rather than painting back and forth with black and white on a mask, smudge the edge of the mask into place.

- **Eyedropper** (I): The Eyedropper color picker is simple yet very effective in assisting some seamless edits. Need an exact color? Grab a sample to paint from with the Eyedropper. If you need a color average from a certain area, try choosing a Sample Size from the options bar. I tend to keep it tight for most work with a grid size of 3px by 3px or even the exact Point Sample option (this is the default with a size of 1 by 1).

- **Crop tool** (C): This tool is useful for early prepping of images for composites, but I especially like the Crop tool's built-in horizon straightener for prepping landscapes. Click the level-like Straighten button Straighten within the options bar and then drag across a canted horizon to crop a much straighter version of the image. (For more severe angle alterations, look into using the Adaptive Wide Angle filter demonstrated in Chapter 8.)

Healing and Cloning Tools

Many times images require a lot of repair and alterations, but with the healing and cloning tools you can remake anything anew. Clustered behind the bandage icon in the toolbar, the Healing tools (J) and the Clone Stamp tool (S) a few icons below are especially handy for prepping an image or background for seamless compositing. Sometimes a layer contains a small irregularity or something unwanted that mars the shot; rather than throw away the entire layer because of one little eyesore, reach for the healing and cloning tools: Spot Healing, Healing, and Clone Stamp!

> **TIP** This is a big one, especially as we are talking about more advanced and optimized workflows: Each of the healing and cloning tools can be applied non-destructively when used on a blank new layer above the content being healed or cloned; just make sure Sample in the options bar is set to Current & Below! All painting with these tools will be done on the new layer while sampling from the ones below it. In fact, unless you are very sure about your edit, cloning and healing on new layers is really the only way to go.

Spot Healing Brush Tool

Ever had a zit appear at a shockingly bad moment? You know, the day before a big date or on the morning you have to step in front of a camera? The Spot Healing Brush tool is perfect for zapping it and many other blemishes in your image with just a single click. This highly sophisticated tool is able to analyze and blend pixels around the area you click, deleting an element of high contrast and replacing it with the textures, tones, and color of what surrounds that area. Retouchers obviously use this for skin, but it works on cleaning up any number

of things: walls with marks, dust spots from a dirty lens, garbage and sticks from sand, the list goes on. Anything that Photoshop can identify as a visual anomaly from its surrounding area, this tool can replace with a smooth continuity.

This tool is also continually improving with each new release and can now heal near edges of prominent contrast (such as taking out rocks that were too close to the edge of the lake in Figure 2.8). Photoshop's latest algorithm will do its best interpretation of replacing the content with something more believable than a dark smudge as it once did. For instance, it will take the rock out while filling in the edge of the lake! Photoshop simply gets smarter with each release, and it's kind of mind blowing, if not mind reading.

Healing Brush Tool

The Healing Brush tool (J) ![icon] serves the same purpose as the Spot Healing Brush tool but accomplishes it differently and is best for situations requiring more manual control. Rather than automatically using the area surrounding the healing brush radius, the tool relies on you to indicate the area it should sample and heal from (known as the sample point) as well as the area it should analyze and replace (indicated by the brush circumference and location). This is a two-step process. To first give Photoshop the sample point from which it should begin blending texture and tone, press and hold Alt/Opt to turn your cursor into a crosshair sample point selector ⊕; then click a location to sample from for clear blending (**FIGURE 2.24**). (Hint: Pick a location that is clear of other blemishes and spots you intend to take out!) Release the Alt/Opt key, and when you begin brushing in a new location, the Healing Brush tool will analyze pixels from the sample point (**FIGURE 2.25**).

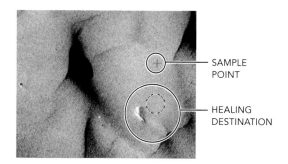

FIGURE 2.24 Select the sample point before healing a different area of the image.

BEFORE HEALING

AFTER HEALING

FIGURE 2.25 Compare the original beach (top) to the result of cleaning up with the Healing Brush tool (bottom).

Keep in mind that the sample point moves with your healing brushstrokes. When Aligned is selected in the options bar, Photoshop establishes the distance between the sample point and where you begin healing and then keeps that distance and orientation locked as you paint. This can be helpful if you need the source sample point to continue moving with subsequent brushstrokes. If Aligned is not selected, Photoshop will return the sample point to your original selection after every brush stroke. In either case, a healing stroke in a line going to the left will move the sample point in a line to the left. Healing downward moves the sample point downward. It's like leashing a robot to match your actions. Just because you can run the robot through a wall as you safely go through the doorway does not make doing so the best idea. So watch where your robotic sample point is headed before you analyze an area that could get you in trouble and make a mess!

Clone Stamp Tool

Similar in many respects to the healing tools, the Clone Stamp tool (S) also takes content from an area you specify but does not blend it in the same way. As the name implies, it clones! This tool is great for more precise cover-ups when you want something replaced rather than just blended and smoothed over. The same rules apply as with the Healing Brush tool: It needs an Alt/Opt click to select a sample point, but Clone Stamp will completely replace the content you paint over, so be mindful of where you are taking from. Even slight differences in value from the sample point and brushing area will show up dramatically in a new location, often requiring more work or a different sample point. This tool will also track your spatial relationship even after the first stroke if you check Aligned in the options bar.

Content-Aware Move

First available in Photoshop CS6, the Content-Aware Move tool (J) is great for making swift alterations. With it, you can move and simultaneously blend selected material into a new location of your choosing. With Content-Aware Move active, simply make a selection and then move it to your desired location; Photoshop will automatically apply Content-Aware Fill to the selection's original location, filling it with the surrounding material like the selected pixels were never there. If you can easily select and separate an object from its original scene, it's a good candidate for the Content-Aware Move tool. The tool is not perfect for every situation, however, as selections and other layer content

(A)

(B)

FIGURES 2.26A and **B** After selecting the golden eagle (A), I moved it down and to the left in the composition (B).

can change how it fills and blends the content (**FIGURES 2.26A** and **B**). For best results, try these quick tips:

- Subtlety is key! The tool is best suited for nudging elements into place and adjusting things that weren't quite right when originally shot, rather than radical relocations.

- Move the selected content to new locations that have a similar background, such as horizon lines, background colors, and other contrasting elements. When you place a selection in a drastically different scenario, the chances of it not looking quite right increase.

- In places with very different backgrounds (say, a background of grass versus a background of sky), keep selections fairly close to the edges of the object, but be sure to expand the selection a pixel or two (Shift Edge slider moved to the right) and add a 0.5 Feather with Select And Mask. Depending on

your selections and refinement, the blending will vary. Tighter selections mean less wiggle room for Photoshop to have creative license with blending. Looser selections can work better in times of very similar backgrounds, which generally have a greater chance for success.

- Use this tool for setting up a clean background scene image by moving things into more optimized positions. This is like re-arranging the furniture in your living room to fit that new couch you'll be putting in.

Finally, be warned that this is also very much a destructive edit if done without changing a couple settings in the options bar, so it's a good practice for this and other healing and altering to use a duplicated layer (Ctrl+J/Cmd+J) just in case.

The options bar has some other slick features to use with the Content-Aware Move tool including Mode, Structure, Color, and the nondestructive feature of this tool: the Sample All Layers checkbox. Here's a quick breakdown of what these can do:

- **Sample All Layers:** When toggled, the Sample All Layers option is truly incredible and is the solution for using the Content-Aware Move tool nondestructively. When a selection is made, create a blank new layer and move the selection with this new layer still active in the Layers panel. Sample All Layers will enable Photoshop to take everything within the selection from all layers, blend the selected content into the new location it has been moved to, and fill with Content-Aware—but all onto this new layer. Aside from analysis, it doesn't even touch the other layers (**FIGURE 2.27**)!

- **Mode:** The two choices for this setting are Extend and Move. Move is ideal for times that you need to relocate the selected object elsewhere, whereas you would use Extend to take a portion of the image that contains

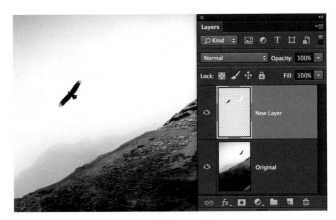

FIGURE 2.27 If you've created a new layer, you can use Content-Aware Move to move selected content onto the empty layer, keeping your workflow nondestructive.

a clear pattern and extend that pattern into a larger area. For example, adding floors to a building.

- **Structure:** Once you move pixels, you can have Photoshop reinterpret the moved selection on a scale of very strict (level 10) to very loose (level 1). Very strict keeps closely to the selected area and doesn't get as inventive around the selection edges or with the main content, unlike the other extreme. Very loose gives a long lead of the leash in regards to making something blend along the edges (even distorting parts of the selection to fit better). In general, though, tighter selections will need higher structure, and looser selections need looser structure.

- **Color:** Similar to Structure, this scale lets Photoshop make some decisions in regards to how closely to match and blend the content's color with the new destination. Level 1 means leave the moved content alone, whereas level 10 is asking for Photoshop to do its best guess. This is helpful if you are moving something from a significantly different-looking part of the image; it will help blend the colors to seem more believable.

As you know, you can accomplish any one task in Photoshop in nearly ten ways—some efficient and some more laborious. Here are a few alternatives to using some standard tools that have dramatically increased my efficiency, accuracy, and nondestructive composite flexibility:

- **Hand tool:** Instead of clicking in the toolbar, press and hold the Spacebar to turn the cursor into the Hand tool for as long as you hold the key.

- **Eyedropper tool:** Switch temporarily to the Eyedropper tool when painting with the Brush tool by holding down Alt/Opt.

- **Magnifying:** Never mind the toolbar or the keyboard shortcuts. My favorite way of magnifying is holding Alt/Opt while scrolling with a mouse wheel or trackpad—no clicking involved. Hold down the Alt/Opt key to hover temporarily over a spot you want to magnify; then scroll upwards with your mouse to zoom in. Zoom out by holding Alt/Opt and scrolling in the opposite direction. This method is touchy the first few times you try it, but, wow, does it save some time in the long run!

Brush Your Textures

The Brush tool (B) is perhaps my most common go-to tool and is especially great for painting on masks and many, many other uses I'll get into later on. It's always a good idea to get familiar with how to change some of the brush properties as this is another versatile life-saving ability. Seriously, I'm sure Tony Stark could find a million uses for this feature—the possibilities are nearly endless! Here are some common suggestions to start off:

- Change your brush size step by step with Right and Left bracket keys (] and [). For lightning-fast size and hardness switching, try holding down Alt+right-click/Opt+Control while dragging the cursor up and down to change brush hardness or left and right movements to change brush size. Alternatively, you can always manually select the size by either right-clicking with the brush or opening the Brush Preset picker from the options bar and adjusting the Size and Hardness sliders (**FIGURE 2.28**).

FIGURE 2.28 Watch your brush size and keep your hardness down low whenever you need a soft transition.

- Change your brush type by pulling up your Brush panel (F5). Alternatively, you can right-click in the image for a more limited but quicker option.

- In general, keep your brush hardness as close to zero as possible when blending (available on default round brushes) as this enables you to more seamlessly edit mask edge transitions and other painting without an obvious and sharp edge to every brush stroke—unless that is exactly what you are going for! Just be sure to bring hardness back down as it's easy to forget about (until you zoom in on the details and cringe).

And here are a few more uncommon brush parameters to try out as well (these can be found in the Brush panel, in the Brush Tip Shape section):

- Dual Brush can help generate better brush texture variations for just about anything imaginable (from brushing clouds to concrete and even rust). The primary brush is the main body source for each stroke, while the secondary brush type adds variation by subtracting from the main brush. Like biting out small pieces of the main brush, both brushes can be modified in nearly endless combinations. To set one up, select the Dual Brush checkbox and then click the words "Dual Brush" to make sure the item is selected. The parameters you select will define the secondary brush.

- Transfer is a wonderful option to use with pen pressure if you have a tablet as it will mimic real-life drawing pressure physics: The harder you press, the higher the stroke opacity.

- Scattering can be a good option for bringing in even more randomness and variation to a brush. The biggest problem with default brush strokes is how easily they are identifiable, and in seamless compositing it's important to hide these seams whenever possible. Scattering takes a fan to the brush shape and generates many variations that can help make things more believable.

FIGURE 2.29 This speed painting was looking okay but was missing some gritty texturing. Loading new brush sets can go a long way toward getting just the right look.

For each option there are countless combinations and variations with sliders and options to choose from, but in case you still don't have enough brush options, try appending even more kinds of brushes to the list by clicking the Brush Presets button in the Brush panel and choosing another variety of brushes from the panel menu, such as Natural Brushes 2. There are also countless amazing brushes you can download from third-party folks, so if you are a brush fanatic, go wild! I personally stick with modifying the basics and enjoy what I can do just from there, but everyone has their own preferences (literally). To load new downloaded brush sets into Photoshop, open the Brush Presets panel and from the panel menu ☰ choose Load Brushes (**FIGURE 2.29**).

FIGURE 2.30 Brushes can be a lot of fun and are always useful for a huge range of actions, from masking to texturing. Learn this panel!

The only way to get an idea of a brush is to try a few of them out and take note of where the default soft, fuzzy, and round brush is; Mr. Soft-and-Fuzzy is our friend in most painting situations (**FIGURE 2.30**)! From blending edges of masks to brushing in various details, this helps keep your image from looking like a cutout collage or having very obvious brush strokes.

> **TIP** Feel free to completely create your own brush tip from an image by making a selection and then choosing Edit > Define Brush Preset. Be sure to provide a descriptive name. Your selection will then show up as a brush preset you can paint with using a variety of brushing tools. It's typically best to make sure no edges are dark, however, as whatever is light within your original selection becomes transparent and whatever is dark will apply the paint or tool selected (think of dark values becoming the bristles of the brush soaking up the paint before a stroke).

Conclusion

Tools can be tricky, and not only because they tend to change a little with each new version. Tools are tricky because of when and how they are used. Knowing the theory of how a tool works is only a small part of knowing the tools, the rest is in the hands-on practice and tackling of a broad range of scenarios. The more challenges you use them on; the more you begin to really understand their potential—the more you begin to get clever, creative, and inventive. Eventually, the tools and their various hidden features just become an extension of you and your work.

Layers and Photoshop Muscle

COVERED IN THIS CHAPTER

- Nondestructive layer properties
- Layer organization, groups, and links
- Masking techniques and strategies
- Clipping masks
- Blending modes
- Smart Object layers and layer styles

Photoshop is all about layers. Blending modes, style effects, clipping, masking, grouping, copying, adjusting—the list of layer features that adds to your creative potential just keeps going. Perhaps the most powerful feature of layers is the ability to add masks to layers, not to mention the clever ways you can use layer masks. The better you understand how layers behave and combine in a composite, the more effectively you can put them to work. As tempting as it may be to dive into the projects of later chapters, take a moment to not only review why layers are the true strength to composite creation but also how to harness that strength.

Nondestructive Super Power

Layers may take time to master, but the payoff is epic (**FIGURE 3.1**). And, unlike playing with fire, layer-based edits help keep your workflow nondestructive, meaning you do not destroy or irreparably edit the original content or layer. (Believe me, when a project suddenly goes horribly, terribly wrong, not having permanently edited the original content is a great thing.) You are free to edit one layer, work on another, and then come back and re-adjust the first edit. Because the edits are separate, a project can have many separate layers, each with its own purpose in the composite. They can be copied, moved, altered, deleted, grouped, and so much more, while remaining nondestructive to the overall composite. Of course, every edit to a layer does change that individual layer, but keeping your edits separated as layers opens up awesome potential.

▶ ELDERS (2008)

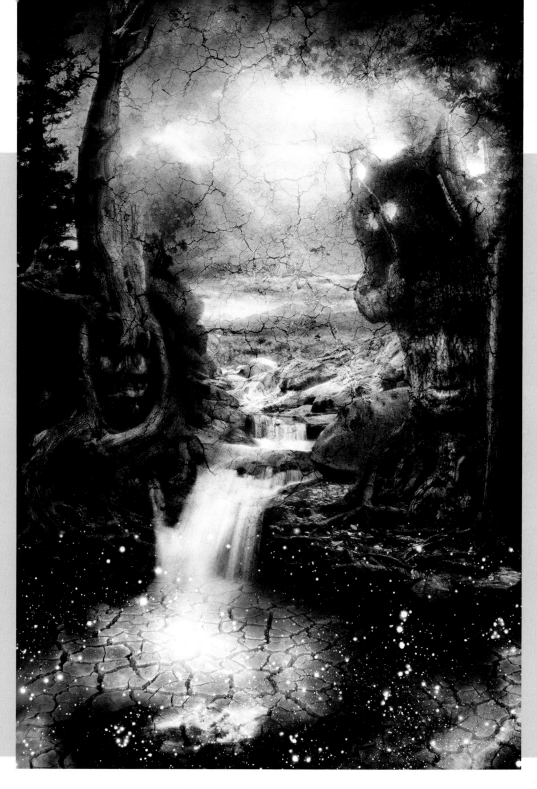

The concept of nondestructive editing is having the ability for unlimited undo options, even after saving and closing the document.

To keep things as nondestructive as possible in my own editing, I am always making duplicate copies of layers, just in case I may want to go back to a different stage of the layer or piece together different sections of it with alternative masking. Even without the compulsion of being a digital hoarder, duplicating is a great idea in many cases. The best way to duplicate, however, depends on what you are doing.

- To duplicate just one layer, you can drag it onto the New Layer icon 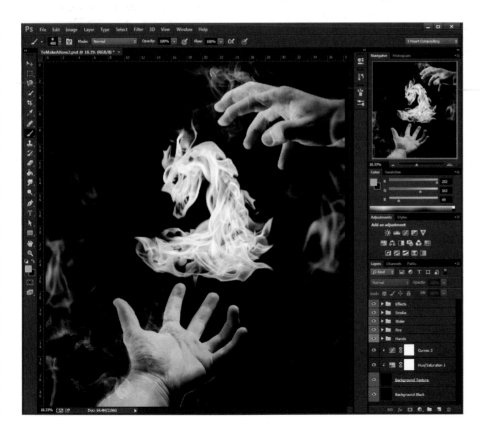 at the bottom of the Layer panel;

Photoshop will make a new layer using the content of the layer you are dragging to the icon. You could alternatively select the layer and press Ctrl+J/Cmd+J.

- I prefer to Alt/Opt-drag the layer up or down one level. This method will make a clone of most layer elements, including masks, selected pixels, folders, effects, and other layers. You can use this same method of duplicating a layer directly on the content; hold down Alt/Opt while dragging with the Move tool to copy the content to the place you drop it—and as a new layer! Alt/Opt-drag to duplicate is one of those features that can be used for just about everything (like duct tape) and is worth remembering.

FIGURE 3.1 Layers can give you super powers, as the edits you make with them can be done nondestructively (as the tutorial in Chapter 8 demonstrates).

FIGURE 3.2 Drag a layer to move it in the stack. A faint double-lined bar will appear between two layers indicating where the layer will be placed when you release it.

Layer Organization

Imagine putting your underwear on outside of your pants. It might create some issues in that order or, at the very least, be uncomfortable—for everyone. Layer order is equally important in composite work. The main thing to understand is that a top layer will affect the visibility of all layers below it in the stack in the Layers panel. Just as in real life, we see whatever is on top first and more clearly than anything else. If you want one layer to be shown above another, make sure to drag it to the proper place in the layer stack—put your pants over your underpants. Thanks.

If you do need to reorder your layers, simply drag each layer within the stack in the Layers panel. As you move up or down in the stack, a thick line will follow the Hand tool, indicating the layer's new position when released (**FIGURE 3.2**). This thankfully also works for group folders and other layers such as adjustment layers and Smart Objects.

FIGURE 3.3 Keep your layers labeled, color coded, and in the right hierarchy as you work.

Names and Colors

A key part of keeping layers organized in the proper order is to give layers easy to identify names and even colors (**FIGURE 3.3**). Whether you're working with 10 or 100 layers, the importance of naming cannot be overstated. If the Socks layer must be beneath the one containing shoes, you need to know which is which in the stack. Image thumbnails can be hard to track down (just like real socks), so use descriptive names and name layers as you add them. Trying to organize and rename once deep into a project is never as easy as it sounds.

To make your layer icons larger or smaller, right-click in an empty gray spot below the last layer and then choose a size from the context menu. (If there is no room below the layers for clicking, you can access the same thumbnail size options by opening the Layers panel menu 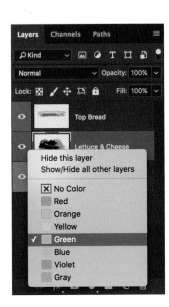 and choosing Panel Options.) Changing the size can be helpful to see which puzzle piece is which as sometimes even descriptive naming is just not enough.

To rename a layer, double-click the letters of its default name. If your clicking is off by one pixel, Photoshop will want to annoyingly do something else such as add layer styles (press Escape if that happens and try again).

Similarly, color coding your layers can make them easier to spot for any kind of searching. To choose a layer color, right-click near the Visibility icon. This brings up a context menu from which you can choose a color for that layer (**FIGURE 3.4**). You will see this used repeatedly in

the later tutorials—and I highly suggest you practice this for better efficiency and organization within your own composites! Just like sandwiches, everyone has their own preference here, so think about a consistent method for your own workflow (and taste). Are blue layers always for painting on and green for certain adjustment layers? It's up to you, but I generally go with some variation of rainbow or analogous ordering based on depth for my larger composites, just so I know where I am at all times.

The latest versions of Photoshop CC enables you to search (filter) for and display specific types of layers, so you can concentrate on only specific kinds of layers at once. Name your layers as you create them, and you can then easily search by those names using the Filter Type option. Be wary of the Layer Filtering toggle, because it may not show all the layers you are expecting to see if you accidentally activate it. Red means it's activated and actively filtering; when in doubt, you can turn it off and go find your layer the old-fashioned way. One interesting use for filtering layers is that you can separate by a type of layer (such as adjustment layers) and then use the group command (Ctrl+G/Cmd+G) to group selected layers together. Once out of the filtering feature, these layers will be contained within one group, but be warned: doing so will take them out of their original order.

Group Folders

Even color-coded, clearly named layer stacks can become unwieldy. Stacking multiple layers together into a single group you can easily handle is perhaps the single most important organizational ability within Photoshop. Think of the layers as sandwich ingredients held within the bread—er, group name. Grouping enables you to have delicious, complex composites without the mess of eating it all separately (**FIGURE 3.5**).

FIGURE 3.4 Right-click to the left of the layer thumbnail for a quick way to color code your layer.

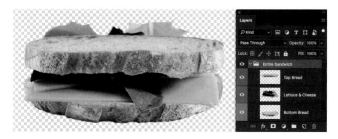

FIGURE 3.5 All three layers of this meager meal are now placed in a Group folder and can be moved, masked, and transformed altogether.

FIGURE 3.6 Collapsing group folders helps keep your layers from getting mixed up. Always keep the Layers panel neat and efficient whenever possible.

Even though they work like stacks of ingredients and bread in a sandwich, visually groups look like folders in the Layers panel. When you need to see the contents of a group, you can expand it to reveal all layers inside, or you can minimize them to show just the folder name, color, and mask if the group has one (**FIGURE 3.6**).

To create a group folder for layers, click the folder icon at the bottom of the Layers panel. Alternatively, you can select multiple layers that you want to be grouped together and press Ctrl+G/Cmd+G to create a new folder and fill it in one move. Groups can be especially helpful for clustering together large numbers of similar layers. Be sure to rename your group from the default and keep it organized as you go. Don't confuse a BLT with a Veggie-Deluxe—name as you go!

TIP Be careful when moving layers near groups. As you drag the layer, you can place it in the group folder inadvertently, rather than just above or below the group. It's easier in these cases to move the entire group folder out of the way rather than moving the individual layer and risk it being swallowed.

Link Layers

One last small feature with a big impact is the ability to link a selection of multiple layers. This can be handy when you need to move or transform blocks of related layers that are scattered throughout the Layers panel because of the composite's depth hierarchy rather than neatly collected in one group. Select multiple layers by Ctrl/Cmd-clicking their names to piece together a medley of layers and then click the small Link Layers icon on the far left at the base of the Layers panel. Once you link the layers, what you do to one will affect them all. For example, move one with the Move tool to move them all together. Transforming in all its varieties can also be done to multiple layers simultaneously if they are linked. To unlink the layers, again select their names in the Layers panel and click the Link Layers icon. Take note that this icon is not visible if one of the linked layers is not selected.

TIP Temporarily unlink a layer by Shift-clicking the Link Layers icon to the right of the layer thumbnail in the Layers panel. This way you can disable the links, make an individual edit, then re-link immediately afterward.

Create, Delete, or Lock Layers

In case you're rusty on some of the very basics, here's a quick reminder. To create a blank new layer, simply click the Add New Layer button on the bottom of the Layers panel [icon] or press Ctrl+Shift+N/Cmd+Shift+N and click OK after giving the layer a meaningful name in the New Layer dialog box that pops up. We will be creating many such new layers throughout the book, so keep this shortcut handy in your brain. Fortunately, deleting layers is just as easy. Select the layer you want to trash and click the Delete Layer button (marked by a trashcan icon) in the lower-right corner of the Layers panel [icon]. Pressing Backspace/Delete on the keyboard or dragging the layer to the Delete Layer button will also delete the selected layer. If you don't want a layer to be accidentally deleted or edited, click its Lock icon [icon] in the Layers panel. Sometimes layers get caught up in a selection or moved by accident and not discovered until later; locking can be a great way to ensure this doesn't happen.

Masking

As briefly mentioned in Chapter 2, masking is the power behind seamless edits, localized adjustments, and the ability to piece anything together at will. What do you do when you want to hide your sandwich from a hungry friend? Throw a napkin over it so they can't see it. Masks are like that napkin: They render what's below them invisible. If you were Harry Potter, you might have a magical cloak that would work better, but in any case, you leave a corner of BLT sticking out and your friend will spy (and maybe swipe) your bacon. Leave a corner of a layer unmasked, and it will be visible in your composite, potentially with equally unpleasant consequences.

Just as your sandwich is safe under that napkin for you to eat later, masking is like nondestructive erasing. To mask a layer, select it, click the Add Layer Mask button [icon] at the bottom of the Layers panel, and then grab a brush (B). A white rectangle, representing the mask, appears next to the layer's thumbnail. You should also see a slight frame around the corners of the mask's thumbnail (this is how you know the mask is currently selected for that layer) (**FIGURE 3.7**). Next, grab a brush, choose a black or white color, and start painting over in your workspace. If the mask was indeed selected and you are painting with black on a white mask, you should see the layer disappear where you paint. As you work, remember the catchy rhyme: Black conceals and white reveals!

As you paint, the layer mask thumbnail will update to show the painted area as seen in Figure 3.7. If you mask a portion of a layer that you shouldn't have or that you later need visible, you can easily retrieve the parts you need

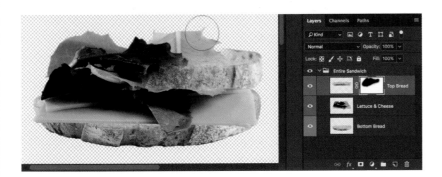

FIGURE 3.7 Within the Entire Sandwich group folder the Top Bread is being masked out with black. Everything under the white part of the mask is visible; everything under the area of the mask painted black is invisible.

by painting white on the layer's mask. Pressing X on the keyboard enables you to swap black and white as you paint. This simple yet handy ability to conceal and reveal becomes exceedingly versatile as your artistic ideas continue to get more ambitious.

TIP Remember, when you paint on a mask, you have no color options, just values: blacks and whites, darks and lights, 256 shades of gray for an 8-bit image to be exact. You can, however, control the opacity of the black or white as you paint, which in turn determines the opacity of the mask. Changing the opacity or value of your Brush tool will change the opacity of the mask you paint (50% gray is equal to 50% opacity).

TIP Although you can use grays to paint on a mask, I find it significantly easier and quicker to paint with black and simply change the opacity of the brush—or if you have a tablet with pen pressure, change your opacity/flow settings so they're adjusted by your drawing pressure (found in the Brush panel under the Transfer settings). In either case, pressing number keys 1 through 9 jumps the opacity a level from 10 through 90%, respectively. Pressing 0 jumps the opacity to 100%.

Just like any other pixels, black and white mask pixels can be selected (with selection tools), transformed (with the Move tool), moved, copied, adjusted, smudged, and so on, giving you endless control over nondestructive erasing. In addition, you can separate the link between the mask and its thumbnail by hitting the small chain link between them. This will allow the layer and mask to be moved and transformed independently from one another, a very useful tool from time to time, especially when you want to mask to stay put but not the layer content.

In my composites, I use masks not only to blend multiple images into one but also to apply adjustment layers, such as Curves (see Chapter 4 for more on adjustment layers), to just one area of the image. So in short, masks are not limited to just image layers but can also be applied to adjustments. For example, in **FIGURE 3.8** I combined a picture of Bell Meadow and a Yosemite mountain with a city scene I shot in Montreal.

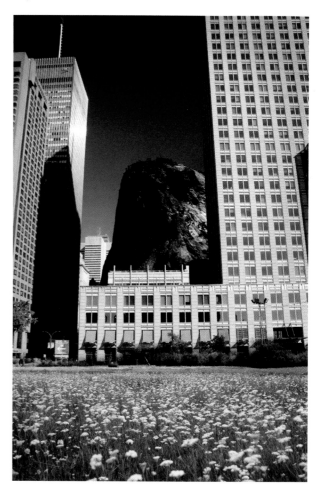

FIGURE 3.8 Three well-placed layers with good masking can completely alter a scene.

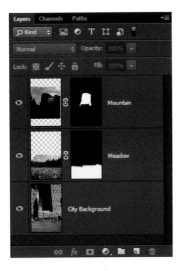

FIGURE 3.9 I painted masks onto the Meadow and Mountain layers of the composite in Figure 3.10.

Finding three shots that matched in lighting and perspective, all I needed to do was mask out what didn't fit the scene. **FIGURE 3.9** shows each layer and its mask; notice how the background city shot didn't need a mask because other layers were placed above it. (In Chapter 9 you can try your hand at re-creating this image to practice your masking skills.) In **FIGURE 3.10** I selectively applied adjustments to certain areas of a composite. Specifically, I used a Curves adjustment layer (as a global edit to alter the entire scene) and its mask to lighten only the center of the entire composite—a simple yet powerful technique. This will come up repeatedly in the tutorials and inspirational projects, so get ready to call on these features.

Masking Tips and Tricks

Perfecting your masks takes some practice to get right, but there are some great hidden features and techniques that can help:

- Refine your selections perfectly (see "Select And Mask" in Chapter 2) and then click the Add Layer Mask icon to mask out everything that was outside of that beautiful selection of yours. Take note that selections, even ones being refined, stay as selections until you click the Add Layer Mask icon.

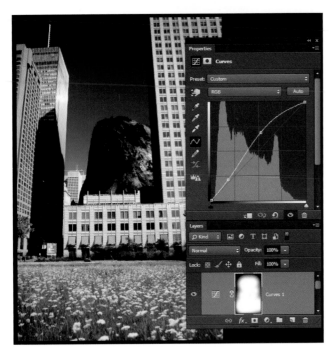

FIGURE 3.10 This Curves adjustment layer affects only the middle section as the black of the mask erases the lightening effect.

- Press the X key to switch between your foreground and background color selections (black and white by default when a layer mask is selected). Just be sure that your color defaults are true black and white (next tip). Switching between painting with black and white by pressing X as you go allows you to conceal and reveal until the mask is perfect!

 Reset the foreground and background colors to their defaults (black and white) by pressing D or clicking the small black-and-white icon at the bottom of the toolbar ⬛. This also saves you from painting with nearly white or nearly black paint (both of which do not fully reveal or conceal, they leave digital grease)! So even if your foreground and background look black and white-ish, press D to leave no room for wondering.

- Alt/Opt-click the Add Layer Mask button to create a new layer mask that is already filled with black. This lets you paint in what you want to see of the layer using white. It can be helpful at times to start with that layer is invisible if there are only small parts that you actually do want visible—paint these small pieces in with white. This also helps to reduce digital grease: If you tried to paint larger areas completely black (leaving small areas white), you'd be likely to miss a spot or two.

- Press the Backslash (\) key to display the masked-out area in an obnoxious red overlay (**FIGURE 3.11**); this is good when checking for leftover, accidentally non-masked pixels you thought were gone. Make sure to always keep your masking clean and intentional. All those accidental faint pixels are like grease that can add up by the end and make for a grimy composite.

- Alt/Opt-click the layer mask thumbnail to edit the black-and-white mask in the workspace. This isolates the mask as you will no longer see the composite or the layer it is masking, just a grayscale image representing the mask. You can use this view for some fancier techniques such as pasting in copied content as a grayscale mask, doing a curves adjustment (Ctrl+M/Cmd+M), or performing any number of edits directly to the mask itself! Just don't forget to exit by once again Alt/Opt-clicking the mask thumbnail in the layer's panel.

TIP You can change the mask's overlay from the default bright red to a color you prefer. When a mask is selected, Open the Properties panel, and click the Masks button at the top of the panel. Then, from the panel menu, choose Mask Options to open the Layer Mask Display Options dialog box. Select a new color and set its opacity.

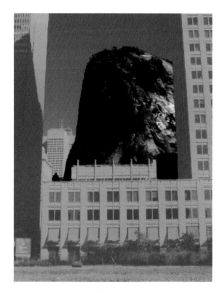

FIGURE 3.11 The Backslash key helps you find those pesky places that need going over on your mask by showing everything masked in bright red.

- Clicking a layer's Visibility icon off and on repeatedly while looking at the composite will reveal what's been completely masked out successfully and will instantly show areas that you may have missed or that still need work. With the layers disappearing and reappearing, it becomes easier to see the flaws of a mask.

 You can also enable and disable just the mask itself by Shift-clicking the thumbnail of the mask (notice the small red X over the thumbnail when disabled). And because there are just never enough ways to do any one thing in Photoshop, you can disable the mask by going to the mask properties in the Properties panel. The Visibility icon in this case disables the mask.

- Color Range is a phenomenal feature for complex masking (**FIGURE 3.12**). As you might guess, it lets you select a range of color to then add to or subtract from a mask. Found in the Mask Properties panel (double-click the layer's mask over in the Layers panel and choose View Properties if a dialog box happens to pop up), this feature enables you to select colors to add to the mask (make sure Invert is checked in the dialog box) or subtract from it (toggle off Invert). To begin choosing a color range, click either in the included thumbnail image within this panel or on the image itself in the main workspace. Although you may not be able to paint with colors onto a mask, that doesn't mean you cannot select a range of colors from the layer that you want masked out and invisible (say blue sky surrounding a red balloon). Using Color Range you can click the blue sky and have it instantly disappear from the view. Part of this feature is a slider called Fuzziness that increases or decreases the variation tolerance—do you want that exact blue masked or all things that are bluish? The fuzzier, the more general the range.

FIGURE 3.12 Clicking the Color Range button in the Mask Properties panel enables you to specify a color to use for custom masking.

TIP In the Color Range dialog box, click the Add to Sample button to select multiple sample colors for the Color Range effect. Alternatively, simply hold down the Shift key and it will also allow you to add more sample colors. This works well when you need to mask out multiple color ranges, such as all the blues and all the greens from an image.

- Just above the Color Range button, the Select And Mask button opens a nifty tool especially for improving the border edges of your mask. Just as you used it on selections in Chapter 2, you can use Select And Mask to adjust the edges of the mask.

- When masking subjects or other objects in a composite, be sure to paint with a brush softness that is equivalent to the edge blurriness or sharpness of the image. If you are masking a crisp image, make your brush small and crisp; if masking something with soft focus, use a matching soft brush.

DIGITAL GREASE AND MASKING

Scrub off "digital grease" as you mask. By this I mean clean up all the hard-to-find pixels that gunk up a composite from careless mask painting (**FIGURE 3.13**). Digital grease clings to those hard-to-find leftover places that didn't get masked out at full opacity as expected—like the greasy residue that clings to the corners of a roasting dish. Always do what you can to remove digital grease as you go. There's nothing worse than going layer by layer late in a composite looking for what causes some unnatural sharp edge or greasy smudge. Here are a couple techniques to help you clean things up for a spotless composite:

- Place a white or black layer (or another color that contrasts well with the content you are masking out) directly below the layer you are masking. This acts like a traditional light table and will reveal smudges and other elements that can really dirty up an image. Invert this contrast layer (select the layer and press Ctrl+I/Cmd+I) to check it against the opposite color, just in case you missed something.

- Check the settings for your brush or whichever tool you're using to refine your masks and make sure they are effective at fully concealing and revealing. Watered-down settings leave you with watered-down results. If you are using a tablet sensitive to pen pressure, temporarily disable Transfer to ensure you are masking at full opacity with every stroke. Along those same lines, ensure the effectiveness of your default foreground and background colors (D for pure black and pure white), as well as brush opacity (press 0 on the keyboard for jumping to 100% opacity). Sometimes blending modes also get changed either on purpose or by accident, so while the Brush tool is selected, check the Mode menu on the options bar and make sure Normal is selected.

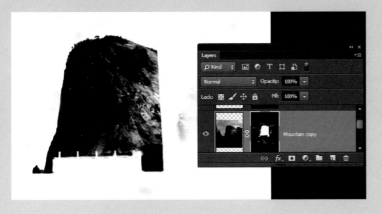

FIGURE 3.13 "Digital grease" like these smudges may seem obvious against a white background, but with complex composites, it simply makes the composite look grimy and can be hard to track down.

Clipping Masks

A clipping mask is a mask that is attached to and used by other layers, which sounds complicated but is easy to understand if you think in physical terms. Imagine several pieces of paper stapled together (the attached layers). On one layer (the bottom layer in this case) you draw an outline (the shape of your mask); then you cut the entire stapled packet along that outline (the effect of your mask). Adjustment layers (covered in Chapter 4) have a built-in clipping option (enabled by clicking the 🔲 button at the bottom of the Properties panel) to attach themselves to the visible parts of layer below them, but you can clip any regular layer with pixel content to another's mask (and still retain the first layer's own mask as well).

A layer that is "clipped to another layer" or "using a clipping mask," means the layer interacts with and affects only the layer directly below it (**FIGURE 3.14**). So if you wanted to make a Curves or Color Balance adjustment layer affect only a certain layer and keep the effect nondestructive, a clipping mask is the tool for the job. Plus, if you previously made a mask for the layer being clipped, it

will stay within those boundaries as well (essentially being double masked). You can even have a stack of multiple clipped layers all affecting only the bottom of the stack. I can't imagine working without clipping masks, and you'll try them out in Section II's tutorial projects.

To use the clipping mask feature, select the layer you want to clip and press Ctrl+Alt+G/Cmd+Opt+G to affix the clipping mask to only that layer directly below it. Alternatively (and sometimes easier as a workflow), Alt/Opt-click between the two layers to clip the top layer to the bottom. Adjustment layers come with a shortcut button 🔲 in the Adjustment Properties panel, which can be another handy alternative. Just be sure to have the clipping layer above whatever you want it to affect!

> **TIP** In the latest versions of Photoshop CC, you can even use a clipping mask applied to a group folder and all of its contents. This profound improvement in efficiency instantly shifts many roundabout workflows into obsolescence.

FIGURE 3.14 These two adjustment layers are clipped to just the Lettuce & Cheese layer, affecting the sandwich contents only, and not the bread below.

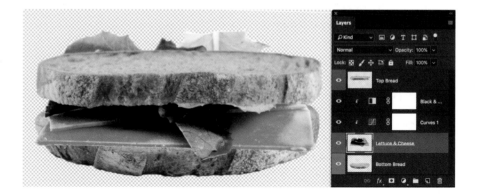

Blending Modes

Whether you want to burn and dodge, change colors, or make a layer's dark pixels invisible, reach for a blending mode to turn your cleverness and creativity into a truly amazing, seamless, or stunning image. Blending modes instruct Photoshop to interpret a layer's pixels differently than simply levels of color and opacity—this gives you immense control (**FIGURE 3.15**).

A blending mode generally requires at least two layers, because in order to see the effects the layers must be interacting with each other in some way. For example, a layer set to Lighten blending mode tells Photoshop to interpret it as something that only adds lighter pixels to what is visible beneath it, ignoring all darker pixels. Apply the Color blending mode to a layer, and Photoshop will ignore light and dark values of that layer, applying only the layer's color to the composite and replacing all other colors from layers below.

To apply a blending mode, simply select a layer and choose a mode from the Blending Mode menu that resides at the top of the Layers panel. By default, it's set at Normal, the boring blending mode that performs standard pixel interpretation. Normal mode is like vanilla ice cream: tasty in most situations, but definitely not for every combination. The blending modes I most commonly use are Overlay, Color, Hue, Multiply, Screen, Lighten, and Darken. In the sections that follow, take a closer look at their strengths and how to use them.

For all blending modes, the Opacity setting can be a lifesaver for lessening the visibility of a selected layer by a percentage. Let's say you want a Color blending mode layer (more on this in a moment) to alter the color of the composite, but it ends up looking just a bit like Technicolor overkill. Changing the opacity of the entire color blending mode layer can help you find just the right balance for blending the new and old together.

In the case of **FIGURE 3.16**, the bread in our sandwich needed to be warmed up, as it was not quite as appetizing with a cooler coloring. I created a new blank layer (which I named Color Layer) and placed it above a group folder (Entire Sandwich) containing the three sandwich layers. I changed the blending mode of the new layer to Color so that anything I painted would alter the colors of the composite to those of this layer. To change the color in just the right spots, I picked a nice warm color and painted on the Color Layer in just

FIGURE 3.15 With so many blending modes to choose from, the possible combinations are nearly endless.

the places I wished the image to look a little warmer—in this case, just where those bread pieces were visible. **FIGURE 3.16A** shows the painted orange blobs and the dramatic effect they had before I brought down in opacity for the more appropriate look seen in **FIGURE 3.16B**.

If you decide to play with some extreme layer blending options, go ahead. You can always scale them back in opacity if you find the results too extreme. Remember, the results are deliciously nondestructive. For deeper details and uses for blending modes beyond what I dig into here, I absolutely recommend one of Scott Valentine's books, *The Hidden Power of Blend Modes in Adobe Photoshop*. Your mind will be blown by blending modes and all you can do with them.

(A)

(B)

FIGURES 3.16A and **B** I first set the opacity of the Color layer (in Color blending mode) to 100% (A) but then reduced the opacity to 22% (B). At 100% it was quite painful to look at, but scaling back the opacity helped make it look a little more believable as well as tastier.

Overlay Is Versatile

Overlay is the go-to blending mode that I use most often, outside of the default of Normal. From dodging and burning to color filtering, this one allows for ultimate control and versatility of your composite, especially in regards to lighting effects. With a mathematical complexity that I'm not going to get into, this blending mode uses a layer's pixel values (lights and darks) to accentuate the composite's shadows or highlights. Anything neutral such as middle gray is completely ignored.

Dodge and Burn Nondestructively with Overlay

When used with black and white, Overlay mode provides a nondestructive alternative to the Dodge and Burn tools. Editing with the Dodge and Burn tools directly on an original layer is a destructive process; however, you can alter or remove Overlay mode's edits because they are on a separate layer that does not permanently affect the rest of the composite.

To dodge and burn with Overlay, first make sure your foreground and background paint colors are set to black and white (D). Create a new layer, set it to Overlay mode, and then simply paint with your brush set to a lowered opacity (start with about 10%) on the new layer with white to lighten (or dodge) overly shadowed areas or with black to darken (burn) areas that are too bright (**FIGURE 3.17**). Because the changes are on a separate layer, you can easily remove them if you change your mind (select the layer and press Backspace/Delete or cash in your one allowed use of the Eraser tool). I'll use this blending mode throughout the book as it is a standard lighting control effect.

Use Overlay as a Color Photo Filter

Using Overlay blending mode with a layer filled with color has an entirely different effect: It blends the fill color with the colors already present in the composite to add both hue and vividness without muddying the overall look of the composite (**FIGURE 3.18**). I often use this flavor of Overlay to make a vibrant and dynamic image with strong color continuity.

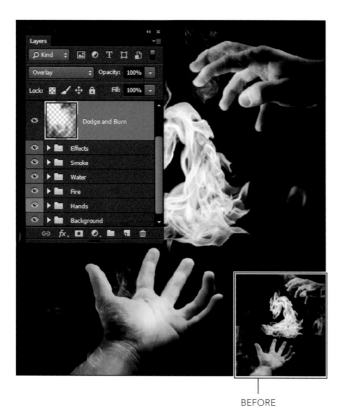

BEFORE

FIGURE 3.17 Change a new layer's blending mode to Overlay to dodge and burn nondestructively by painting with black and white.

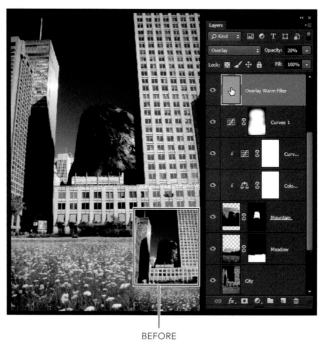

BEFORE

FIGURE 3.18 Overlay blending mode at an opacity of 20% or less makes for a great photo filter with your color of choice, giving you complete control over the composite continuity.

For a number of reasons, I have never liked the built-in Photo Filter adjustment layer effects that come with Photoshop. Instead, I commonly use Overlay as a color Photo Filter. Using the blending mode set to Overlay has allowed for greater control with better results. Here's what I do:

1. Add a blank new layer to the composite, and drag it to the top of the stack.

2. Apply a medium to light, vibrant orangish-yellow color with the paint bucket (G).

3. Change the blending mode to Overlay.

4. Lower the layer's opacity to between 10% and 20%.

Chapter 7 and subsequent tutorials will give you more opportunities to try this technique.

Color and Hue

Good composites are all about controlling your overall image look and feel, as well as the individual layers. A big part of this is controlling color, and the Color and Hue blending modes enable you do just that to the extreme. Add a blank layer and change its blending mode to Color. Now any colors that you paint on the layer will supersede all other colors of layers below—just as you saw in Figure 3.16. In addition to altering the color of the composite, Color mode maintains nearly the exact values of the layers below as well. Say you start with an image of jeans that are dark blue. Paint your Color layer a variety of red; the blue jeans will now appear red but keep the same darkness and lightness of the original jeans—those worn edges at the pocket seams will still be lighter than the center, and the decorative stitching will still stand

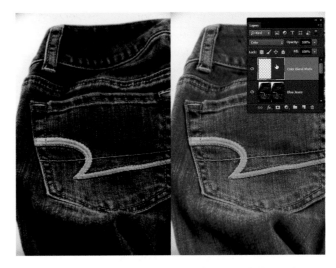

FIGURE 3.19 Painting on a layer set to Color mode instantly adds a vibrant color of your choice to the layer or layers below.

out (**FIGURE 3.19**). It doesn't matter whether you painted a dark or light red; Photoshop ignores values (lights and darks) on a layer set to Color mode. Another feature of Color mode is the control of saturation. Photoshop matches the exact saturation level of the color you are painting (vibrant versus more neutral), rather than sticking with the original composite material below it. This blending mode is quite a lot of fun and has many uses as you will see in the coming chapters. My favorite use is to get color controlled and totally under my thumb. From the reds and yellow of fire to the green of trees, this feature can make just about any item really pop in just the right way.

For more naturalistic color alteration, use the blending mode called Hue. With Hue, you again paint color on a layer to alter the layer or layers below, but Hue matches the saturation levels of the original content. Now you have believable color alterations with fairly little effort (**FIGURE 3.20**). You see this frequently with catalog designers as they use this technique to show a variety of color options, basing them all on a single product shot.

Multiply Without Math

Definitely one of my favorites, Multiply mode enables you to combine layers by adding the darks of one layer to the darks of others. This has an effect that the added layer becomes partially transparent because it ignores the white pixels completely (making them 100% transparent), but it darkens the composite by adding darks with each layer addition set to Multiply. This can be handy if you want to combine a layer and need added shadows or textured dark spots (**FIGURE 3.21**). This blending mode can also be used for controlling the color of the lights if you want to shift color within the highlights.

Screen

Screen mode can be useful for adding vibrancy and layering the lighter qualities of a layer. This blending mode works as the direct opposite to Multiply: Where multiply darkens the composite with each addition, Screen lightens with each layer that has lighter qualities; black equates to 0% opacity of the layer. For those pyromaniacs out there, yes, this is perfect for adding light flames to a dark composite! This is the main technique used in Figure 3.1 and Figure 3.21. Shifting the blending mode to Screen can also help lighten and color cast the shadows.

FIGURE 3.20 Hue blending mode preserves the inherent saturation of the layers below it and only alters the hue.

FIGURE 3.21 Choose the Multiply blending mode to add layers as darkening texture effects, such as the bark layer used on top of the wrist layer.

Lighten

Similar in many respects to Screen, Lighten mode adds the lighter elements of a layer to the composite. The key difference, though, is its comparison of the lights and darks to those of the composite. If the Screen layer has parts that are lighter than the pixels of the composite below it, then it will remove those lighter elements visible with full opacity (lacking the change in transparency range that Screen provides). Try adding stars to a very dark composite (or one made to look dark like this scene) and change the stars blending mode to Lighten. Only the light stars will come through (**FIGURE 3.22**, which also contains some additional masking done to keep the stars from joining with the buildings).

Darken It Down

Darken blending mode does the opposite of Lighten. Say you have something with a white background and you want only the things that are not white to be visible. Rather than deleting or masking or doing any other action that is a time-consuming pain, try changing the blending mode to Darken. All that light background will disappear like you're keying out a green screen.

Smart Objects and Styles

Masking and blending modes can take you only so far in a large-scale composite. Sometimes you need to dig in and resize, reshape, or otherwise transform layers, maybe even apply some special effects. Smart Object layers and layer styles can help you.

Smart Objects

Smart Objects are yet one more powerful tool in Photoshop for working nondestructively—therefore working smart (**FIGURE 3.23**). With layers converted to Smart

FIGURE 3.22 Here you can see the Lighten mode in action: I added stars to a sky that originally did not have any.

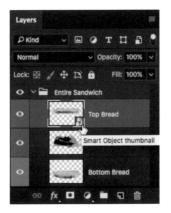

FIGURE 3.23 A Smart Object layer is indicated by a small icon in the lower right of the thumbnail. This layer is now ready for non-destructive transforming and filtering!

Objects you can nondestructively scale, transform, add Smart Filters, as well as warp a layer without permanently changing its pixels. This means you can shrink it down, click the Commit button (the check), and then scale it all the way back to its original size without losing a single pixel of detail. Smart Objects are essentially embedded Photoshop files used as layers within your file. If you have ever watched *Inception,* that's about how these things work—and just as mind expanding!

Pick a layer that you want to alter nondestructively, right-click its name, and then choose Convert To Smart Object from the context menu. You might find this works better on a layer without a mask, because the conversion appears to apply the mask to the layer—though it really places it inside the Smart Object. You can also convert a selected layer to a Smart Object by choosing Filter > Convert For Smart Filters. Both ways will allow you to apply most filters nondestructively (you can keep return-ing to them to change parameters, mask them, apply blending modes, or even turn off their visibility), as well as scale and transform to your heart's content!

> **TIP** You can alter the blending mode of many Smart Filters for even greater control—or experimentation! After adding a Smart Filter to a Smart Object, double-click the Edit Blending Settings button ▤ to the right of the filter name in the Layers panel. Within the Blending Option ([Filter Name]) dialog box select the desired blending mode from the Mode menu. And the best part is, it's nondestructive!

If for some reason you ever want to paint directly on the Smart Object layer or directly edit the pixels in some fash-ion, you will need to either rasterize the layer (destructive) or edit the Smart Object by itself (more on this nonde-structive Smart Object editing later). You can rasterize

the Smart Object by again right-clicking the layer's name in the Layers panel and then choosing Rasterize Layer from the context menu. Once you instruct Photoshop to rasterize the layer, however, the changes you made to the Smart Object cannot be undone.

In addition to transforming, Smart Objects are useful when you want to apply Smart Filters to a layer. These filters are a subset of those available to simple layers but have the added benefits of frequent revisiting and altering of the filter parameters and never losing detail or quality of the original—awesome! Smart Object layers do have limits to their intelligence, but with each new Photoshop release, these limits are ever dwindling. The most egregious drawback to date is not being able to use *every* single filter, and their general tendency to bloat file sizes (because you're essentially embedding Photoshop files disguised as layers).

Their true power comes from being able to store mul-tiple layers, adjustments, masks, and everything else associated with a full Photoshop file in a form that can be edited nondestructively within the Photoshop file. To edit a Smart Object layer, simply double-click one. This will open the Smart Object as a separate Photoshop file in its own tab or window (depending on how you display open files in Photoshop). From here, you can add more layers or edit content however you prefer—the trick is to save it when you've finished editing it (Ctrl+S/Cmd+S). Saving (not Save As, just Save) updates the Smart Object content in your original Photoshop file, and you can close that temporary tab or window once you are all done. Told you, it's *Inception!*

Layer Styles

Layer styles enable you to nondestructively apply some neat effects to the pixels of a selected layer. To display a menu of your options, click the Add A Layer Style

icon **fx.** or double-click off to the side of the layer name. Such effects as Drop Shadow and Outer Glow can be very helpful from time to time—and can be used in quite clever ways that may not seem obvious on the surface. I frequently use Outer Glow to simulate fire, lava, and on occasion some magic twinkle dust (or other mysterious glowing substances). Within the layer style options are ways to alter the color of a gradient for such things. There are truly loads more here with the right settings and alterations, so I encourage you to experiment and to follow other master experimenters, such as Corey Barker (www.coreysbarker.com).

For any layer style, you can control its amount with the Fill slider, which is located in the Layers panel beneath

Opacity. Like the Opacity slider, the Fill slider enables you to adjust the opacity of a layer from fully opaque to fully transparent; the difference is how Fill handles layer style effects. Fill enables you to decrease the opacity of the layer, while still keeping the opacity of the layer styles unchanged—definitely a neat feature. I use this at times when I want the effect of an outer glow without having to show the actual painted parts—the glow of the sun without the sun itself! This means you can apply a certain effect just in the parts you want it.

FIGURE 3.24A shows that delicious cheese sandwich once again, this time with a captivating radiance—created by a layer style containing a gradient-based Outer Glow effect. Compare that to **FIGURE 3.24B** where the Fill is

FIGURES 3.24A and **B** You can see both the layer content and the Outer Glow layer style in 3.24A, unlike in 3.24B where the layer Fill is set to 0% and only the outer glow is visible.

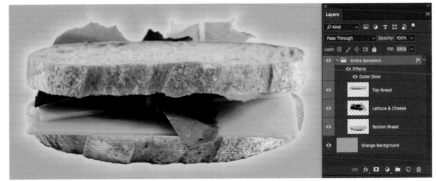

(A)

(B)

brought down to 0%, you can clearly see how the layer's filled pixels have disappeared leaving just the layer style.

In **FIGURE 3.25** you can see how this feature was used for painting in the Northern Lights using two layer effects (in this case an Outer Glow and Color Overlay). In this composite, I simulated the Aurora Borealis by painting on layers with various Outer Glow effects. I first added the layer styles to a blank layer, set Fill to 0% (so my paint would not show, just the effect), and simply painted wherever seemed appropriate! Granted, there are a few more things going on here to make it more believable, such as blur and some other layers that play around with coloring and the like. Still, the base effect is created from one layer and a layer style composed of two layer effects.

Conclusion

As you will soon find out in Sections II and III, the versatility and nondestructive editing power available through layer use is what makes Photoshop the powerful program that it is. From layer organization features to editing the smart way to blending modes, nothing is impossible or unnecessarily destructive, even when it seems like it should be!

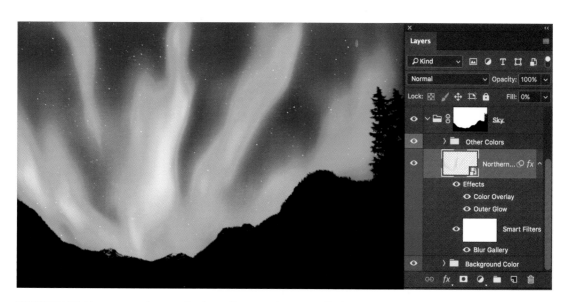

FIGURE 3.25 You can use layer styles in endless creative ways. To this simple night shot, I added a layer style made up of two layer effects (Outer Glow and Color Overlay) to paint in the glow from the Northern Lights.

CHAPTER 4

Favorite Adjustment Layers and Filters

COVERED IN THIS CHAPTER

- Curves
- B&W adjustment layers
- Color balance
- Hue and saturation
- Smart Filters
- Blur Gallery
- Sharpening
- Reducing noise
- Camera Raw filter

Remember your first few composites—those roughly cut and pasted, disjointed collages? Whether we like to admit it or not, we all go through this stage before honing our eyes and skills to craft an element of photorealism into our work. That element is what elevates a composite from a mere copy-and-paste-fest to a seamless new reality. The craft behind it is largely the craft of using filters, adjustment layers, and their masks (**FIGURE 4.1**). These features represent their own art form when used by a pro. Endlessly useful for a multitude of situations, they can be the difference between realizing your vision and consigning yet another project to the digital scrap heap of "not quite right."

Rather than giving you a hasty flyby of every adjustment layer and filter, this chapter will push deep into my four favorite adjustment layers (along with their subterranean features), as well as the Photoshop filters that I find come in most handy for composite work. This focus will get you going for most situations and provide a solid base for the more complex tutorials and projects in Sections II and III. For an even greater investigation into adjustment layers and a plethora of their uses, I highly recommend Scott Valentine's *The Hidden Power of Adjustment Layers*.

▶ Four Tears of Victory (2009)

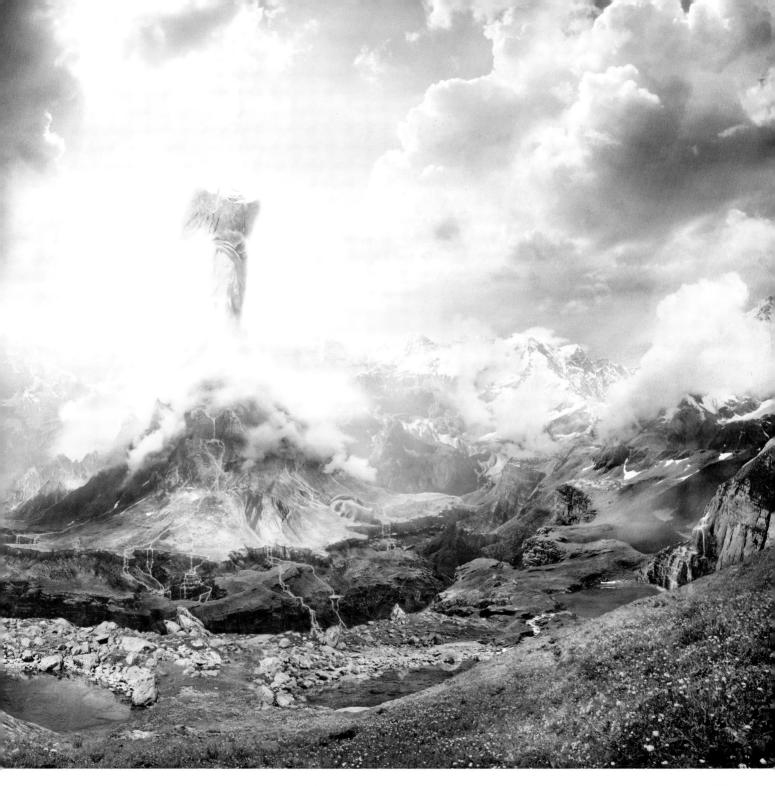

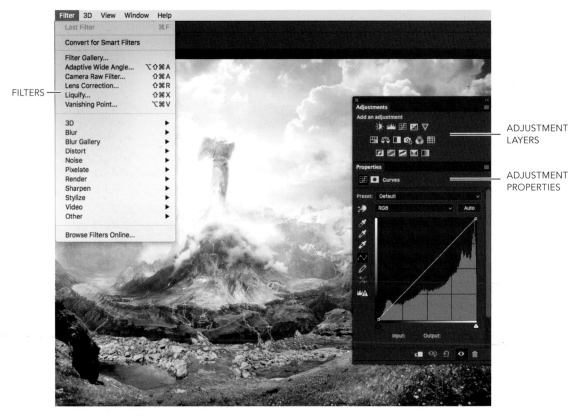

FILTERS

ADJUSTMENT LAYERS

ADJUSTMENT PROPERTIES

FIGURE 4.1 Filters and adjustment layers are essential for blending very different image sources into a seamless composite.

Adjustment Layers

When working nondestructively, adjustment layers are the professional way to go rather than choosing the destructive adjustments available from the Image menu. By making your adjustments as dedicated layers, each with an accompanying mask (**FIGURE 4.2**), you can later fine-tune or remove your changes without any permanent alterations or loss of quality. Just like standard layers, adjustment layers affect the layers directly below them in the stack and can be independently altered by themselves. When you just want to adjust a single layer, you can restrict an adjustment layer to a single layer or group by clipping it to the layer placed directly below it (as covered in Chapter 3). As a standard feature, every adjustment layer comes with a clean white mask for safe and nondestructive adjusting.

Although the Adjustments panel (choose Window > Adjustments to bring this up if it is not open) offers many choices, each with its own specialty, I have come to rely on four adjustment layers in particular. Whether piecing layers together seamlessly or correcting for some short-comings of an image, I use Curves, Black & White, Color Balance, and Hue/Saturation most heavily.

Curves

Of my top four, Curves is perhaps my most used adjust-ment layer and is by far the most versatile, as well. It is my go-to when something is just not looking right or when I need more control over the general lights and darks of an area, when I need to isolate a tone, and much more. A Curves adjustment layer enables you to nondestruc-tively shift tonal attributes of an image, making specific tones lighter or darker.

To add an adjustment layer to your image, make sure the Adjustments panel is visible (choose Window > Adjustments) and click the icon for the desired adjust-ment. In this case, click the Curves icon . The controls you need are housed in the Curves Properties panel (**FIGURE 4.3**). Dominating the panel is a graph of the tonal values in the image. The horizontal and vertical axes (represented by gradient strips along the bottom and left side of the Curves graph) represent the range of possible tones (from darks through midtones to lights) in an image. The diagonal line (the "curve") represents the value of each of the tones in the gradients as they compare to each other. This is basically a before and after situation. Here this is referred to as Input (the before) and Output (the after). The bottom gradient represents the image's original tones (input values) and the vertical gradient represents the tones you can shift and bend those input values to (the output values).

FIGURE 4.2 Each adjust-ment layer includes a mask for immediate nonde-structive erasing of the adjustment.

FIGURE 4.3 The Curves Properties panel con-tains both the controls to adjust the levels of darks, midtones, and lights in an image and a histogram that graphically represents the quantity of those tones present in the original image.

Notice that when you first apply a Curves adjustment layer, the "curve" starts out as a straight line. That's because the line shows the ratio between the adjusted and original tonal values in the image. Before any adjustments, the input and output values are the same, so the ratio at every point is 1 and the "curve" starts out as

a nice, even slope. Now, click the line to add a control point, and drag the point upwards. Notice that because the point is higher, it now corresponds to a lighter shade on the vertical gradient than on the horizontal gradient? By dragging up, you've lightened the original tone at that point, as well as along the curve. Dragging a control point down does the opposite.

For example, in **FIGURE 4.4**, I shifted a wide range of tones lighter by lifting the single control point (perhaps not the best aesthetic choice, but a good demonstration); to see how this works, pick any point along the new curve line and compare where it lies along the horizontal gradient (the original tone) to where it aligns with the vertical gradient (the new, adjusted lighter tone). This is a good way to remember how Curves works by default: Pull a point higher means lighter, pull it lower means darker.

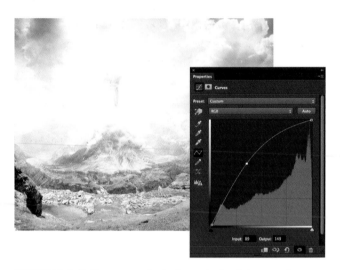

FIGURE 4.4 Pulling a curve's single control point upwards or to the left shifts the tonal values lighter and keeps the lightening effect proportional with all nearby tones as they are gently elevated along the curve.

> **NOTE** You can use Curves for adjusting color balance, as well, although I prefer to use a couple of the other adjustment layers for this work. If you choose to try Curves for colors, however, try individually adjusting the red, green, and blue channels separately rather than adjusting the default RGB, which controls them all in equal amounts. Choose a different channel from the menu to the left of the Auto button.

CURVES & MODELS

The curves histogram and the input and output axes look different depending on the color mode you are working in. When you work on an image in CMYK (or grayscale) mode, the default input and output gradients invert because of the nature of the color model. The CMYK model is subtractive (made by mixing CMYK inks or pigment), whereas RGB is additive (made by mixing RGB light).

If you prefer a specific model, you can change the graph's display: Open the Curves Properties panel menu, choose Curves Display Options, and select one of the Show Amount Of options. Light 0–255 is the default setting with black at 0,0; Pigment / Ink% orients white at 0,0.

POWER OF THE HISTOGRAM

Understanding the histogram, found behind the curve line in the center of the Curves Properties panel (Figure 4.3), will give you better control when working with Curves adjustment layers. The histogram is much like a speedometer in a car, giving you a readout of simple data on which you can base adjustments; knowing the current reading can help you adjust your speed (or image tones) to the desired level. Unlike a speedometer, however, the histogram does not respond interactively as you raise or lower a point on the curve. If you are looking for a current histogram that is continually updated with every change to the image, try the Histogram panel (look for it in the Window menu).

The data that the histogram represents is the full tonal range from dark to light of the image below the adjustment layer, presented as a series of peaks and valleys—or piles of light and dark pixels; the higher the peak, the greater the quantity of the corresponding tone it represents, which is shown below it in the horizontal gradient.

The histogram is helpful because it shows the relative quantities of each tone present, from all the deepest, darkest pixels (starting at the left by default) through the midtones to those spots of pure white (far right by default). If an image is heavy on dark pixels, the histogram will be more mountainous at the dark end of the bottom gradient. Likewise, a higher percentage of lighter pixels produces peaks towards the opposite end of the gradient.

Keep in mind, however, that histogram shapes have no connection with the quality of the image. Two images may be equally stunning but be represented by vastly different histogram shapes. With that said, you want to avoid having a histogram that does not take up the full range, ending short with a completely flat valley after a hill at either end of the spectrum, because it will appear washed out (lacking the contrast of full black and full white). These images will need further adjusting to increase contrast, such as with Curves or Levels to regain a fuller gamut of tones.

Curves Strategy

With a better understanding of the technical theory of Curves adjustment layers, consider some practical tips for using curves to their full potential:

- Don't try anything too radical. For example, a curve with a very exaggerated sideways S shape (doubling back on itself as in **FIGURE 4.5**) creates an inversion for some tones of the image, causing lights and darks to switch places with each other. (Try pressing Ctrl+I/Cmd+I on an image layer to see the full effect of this.) The power behind Curves adjustment layers is in the subtlety and gentleness of the curve that you make. Less is truly more!

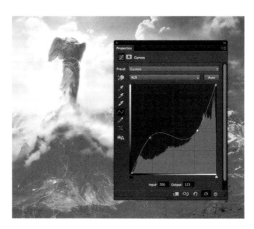

FIGURE 4.5 Curves that are too exaggerated end up looking pretty awful (leading to something like a posterizing effect) or producing inversions of lights and darks as shown here. Keep your adjustments gentle and controlled instead.

- Use two points to create a fully controlled contrast adjustment. Click to add two control points along the curve line, one toward the bottom darks and one towards the lighter end. Slightly drop the darks control point downward and similarly bring the highlights control point upwards for a punchier look!

> **TIP** Check out some of the contrast presets from the Presets menu as a starting point when playing with curves. This is a good reference and helpful for getting the hang of things—as it can be a steep learning curve after all!

- Use no more than three control points along the curve whenever possible. I usually stick to adding just one or two unless I am trying to isolate a very specific tonal adjustment. The more points you make, the higher the chances are that the image might begin to look "off" or inversion begins.

 It can be a good idea to try a stronger than desired curves adjustment (such as increasing the contrast by lowering the darks and raising the lights) as an experiment to see how the adjustment will affect the image. Then, you can dial back the intensity of the adjustment by dragging the Opacity slider in the Layers panel. Using opacity in this way gives you greater flexibility and headroom for your curves adjustment.

- Isolate a tone by using the On-Image Adjustment tool 🖐️, found on the left side of the Curves Properties panel, above the column of eyedropper icons. Move the mouse pointer over the image (it will turn into an eyedropper) and watch the curve—a phantom control point will move along the line of the curve showing the value under the pointer. When you reach the specific area or tone that you want to adjust, click the mouse button. Clicking adds a control point

to the curve at the value of the spot that you clicked. If you hold down the mouse button you can drag up and down to adjust the value of the control point directly. This can be helpful for those times when you need to find a spot at a specific value and shift it lighter or darker.

- Use the mask provided with the adjustment layer to isolate your Curves adjustment to specific areas of the image. Suppose you want to lighten one area to draw further attention to it, but you don't want it to lighten the edges of the image. As you adjust, focus only on the critical areas, then paint black on the layer's mask to remove the changes from areas you wish to be unaffected. Alternatively, you can also make a selection before adding the adjustment layer, and Photoshop will automatically adjust only the selected area, applying a layer mask to everything outside of the selection.

- Use a pair of Curves. One Curves adjustment layer can be helpful for controlling, say, the darks, but when you try to get the highlights right in the same curve, it changes too much or is harder to control. Adding a second Curves adjustment layer that finesses another portion of the tonal range of the image, such as the lights, will keep a more even tonal adjustment than trying to do it all in one go and getting dramatic with the curve shape.

- Clip the Curves adjustment layer to a single layer below it so that you can affect that clipped layer only. This is so important for composite work where images are taken from a wide variety of sources that you must match the lights and darks consistent with the background (**FIGURE 4.6**) or each other. To clip the adjustment layer, either click the Clip To Layer button 🔽 at the bottom of the Curves Properties panel or Alt-click/Opt-click between the adjustment layer and the layer directly below it.

SEVERAL PIECES
THAT ALL MATCH

TOO DARK
TO FIT IN

FIGURE 4.6 Adjust an individual layer by clipping the adjustment to it and then matching the lights and darks to the others around it. In this case, the piece was much too dark and needed a Curves adjustment layer to lighten it up.

Black & White

Although not specifically designed for the purpose, Black & White adjustment layers can replace hours of traditional black-and-white dodging, burning, and filtering to a swift move of the slider. True, this adjustment layer will turn the content black and white with the Normal blending mode, but by choosing a different blending mode you can control the lights and darks of each color of the original image separately to enhance certain features once in grayscale. Add blending modes to this adjustment layer and you have one powerful tone-controlling tool (say that one five times fast).

To begin, simply click the Black & White icon ▣ in the Adjustments panel; a new adjustment layer is added to the image, changing it to black and white using a default color conversion. Use the sliders in the Black & White Properties panel to adjust the values of each color individually and customize the conversion to your taste (**FIGURE 4.7**). Suppose you want a green (automatically converted to a mid-gray) to become an even lighter gray; find the green slider, and move it to the right to shift all the related greens lighter.

FIGURE 4.7 The mix-match of lighting amongst the elements ended up just being too overpowering in the composite image (left), so I added a Black & White adjustment layer (right) to alter the saturation (by lowering opacity of the adjustment layer) and values of separated colors.

If I want to use this in full force, that's when I will change the blending mode to either Soft Light or Luminosity before I move the sliders around. At lower opacities, the Black & White adjustment layer is phenomenal for subtly controlling saturation and the lights and darks of certain colors. In general, though, the power of moving around the darks and lights for each color has far-reaching benefits. For example, I photographed the elements of Figure 4.7 with a wide range of lighting color temperatures, edited them together with a certain vibrancy in mind, and then decided I needed to tone down the colors instead. I added a Black & White adjustment layer and then lowered the opacity to under 40% until it curbed the

saturation. From there, I further adjusted the colors to lighten the yellows and darken the reds and blues slightly to create a more contrast in the composition.

TIP The Black & White Properties panel's On-Image Adjustment tool 👈 (above the sliders) is especially helpful for times when you need to modify a specific color family quickly. Simply click the icon and then drag directly within the image to sample a color. Sampling a color within the image tells Photoshop to find the slider for the closest matching color in the panel (just one at a time); move the cursor left and right to adjust the color slider with the same result as using it directly.

Color Balance

As an adjustment layer, Color Balance ⚖ is a good choice for blending in layers whose colors don't match those of the other elements in a composite. Perhaps the images were shot in different lighting conditions, different cameras setting, or just have a different color palette in general. With a Color Balance adjustment layer, you can easily correct moderate differences. The Color Balance Properties panel contains three sliders: one ranging from cyan to red, one from magenta to green, and the last from yellow to blue. **FIGURES 4.8A**, **B** and **C** are a good example of better blending two images with Color Balance. The woman with the sword was too warm in color compared to the cooler background, so shifting the sliders over to the cooler sides (more cyan, blue, and just a hint more of green) helped dramatically with fitting the two images together. The sliders start out neutral at the center, so you easily can go back and forth to finesse the colors.

Although Photoshop offers many other ways (some a lot more refined and exacting) to help with color balance, this adjustment layer does a fairly decent job and is straightforward and quick. It works with very little effort or tweaking, making it my go-to choice in most cases.

Hue/Saturation

For quick color shifts and general desaturation, a Hue/Saturation adjustment layer 🖼 is also great for altering a selected color using color range (revisit Chapter 3 for a reminder) and shifting the color selection to an entirely new hue. Combining simplified features of the Color Balance and Black & White adjustment layers, Hue/Saturation includes a very basic, yet quick-to-use Saturation slider and can be good for simple neutralizing or color shifting. I find this adjustment layer especially valuable when I need to shift the hue of a specific color.

(A)

(B)

(C)

FIGURES 4.8A, **B** and **C** Color Balance is not especially refined, but it is quick, efficient, and wonderful for most color discrepancies. When I first composited the subject with the background, I discovered I photographed her with warmer colors compared to her new, cooler surroundings (A). To cool the subject down and match the scene, I applied a Color Balance adjustment layer (B) and (C).

FIGURE 4.9 A Hue/Saturation adjustment layer together with a mask created using Color Range (see Chapter 3) works especially well for isolated color changes; you can alter a selected color or limited portion of the image. Here I changed the ball from red to green.

For example, in **FIGURE 4.9** I needed a small green object down by the crib to help complete a compositional triangle of color. I altered a single color of the juggling ball in front of the crib (the ball is on its own layer) by using Select > Color Range. I selected what used to be the red patch and then added a Hue/Saturation adjustment clipped to the same layer. From there, I moved the Hue slider in the Properties panel until I settled on the proper green.

> **TIP** You can shift or neutralize a specific color range within the Hue/Saturation adjustment layer even without using a mask. In the Hue/Saturation Properties panel, simply select a color range from the menu below the Preset menu (Master is chosen by default). You can even restrict or expand the allowed color variation using the bottom color ramp, specifying only yellow, only red, or only colors between yellow and red, for example—endless possibilities for color shifting and saturation control.

Featured Filters

Somewhat related to adjustment layers are the filters that can be applied to a layer. Both filters and adjustment layers can dramatically alter the look and feel of an image, helping with seamlessness or adding a nice visual effect. Filters don't have a dedicated panel, though, and instead live within the Filter menu (see Figure 4.1). Although many of the filters by themselves end up looking too canned and obvious for most uses, there are the few described in the next sections that stand out as invaluable for composite work. Filters such as Smart Sharpen and Reduce Noise can help with quality differences and, like color adjustments, help match images from different sources. Blurs also come in handy as an effect when you need more control of the depth, mood, or motion. In Chapter 9, you'll use them to create sunrays.

Smart Sharpen

What makes the Smart Sharpen filter smart is its superior ability to analyze the image to better determine edge width—and that it can control simultaneously the amount of sharpening, noise reduction, and compensation for various kinds of blur, from motion blurs to lens blurs (**FIGURE 4.10**). This combination of strengths is more versatile than other sharpening methods (like Unsharp Mask) and is very useful when you need to match one picture element to another, as illustrated in Chapter 13.

Here's the basic rundown of the Smart Sharpen filter (Filter > Sharpen > Smart Sharpen): this filter has three main sliders:

- **Amount** (controls the strength of the sharpness applied)
- **Radius** (sets the pixel width of sharpening to be applied)
- **Reduce Noise** (controls noise reduction levels)

FIGURE 4.10 Smart Sharpen enables you to compensate for multiple kinds of blur and gives you greater flexibility than other sharpening methods.

When using Smart Sharpen, either on ordinary layers or as a Smart Filter on Smart Objects, keep a few tips in mind:

- When tinkering with the Radius and Amount sliders (and cranking them a bit high in many cases), it's often easy to create unwanted halos. Avoid these halos whenever possible. Not only do those they tend to look bad, but they're also a telltale sign of amateur sharpening or that you did not zoom in close enough to see what was happening. When the radius size is larger than the blurriness, you start to increase the contrast for parts that you shouldn't be increasing, parts that don't need it. Combine this with a sharpening amount that goes a bit overboard, and you have yourself a mighty halo on the outside of your edges. Start with a radius that matches the blur radius (how many pixels an edge is blurred across, typically 1 to 3 pixels for my own setup), then boost the Amount slider

until edges pop without a dramatic light halo. For Photoshop CS6 and older versions, this usually meant under 100%, but the CC version of this feature can easily push to 300% without overly adverse effects.

- Zoom in close to see what's being sharpened and what the effects are in regards to halos and noise and then zoom out to make sure it's actually having a good sharpening effect in a general sense. Using 100% zoom is excellent as an overall quality check as other zoom amounts (which may be helpful for catching some halos) use interpolation that is less than accurate when previewing. Playing with the sliders is always a tricky balance of possibly having too much sharpening and creating bad halos versus not having enough sharpening. Play with the zoom to check your work as you go. Along those lines, use this as a Smart Filter so you can return and adjust if you notice a halo later on.

(A)

- Click and hold on the preview image to the left of the sliders to see the layer's original state and then release to see the effect of the current Smart Sharpen settings. This is great for toggling a fast before-and-after comparison.

- Use the Remove menu to specify the type of blur you're trying to get rid of. In most cases, the Gaussian or Lens Blur setting works best. When you need to sharpen away some camera motion, choose Motion Blur and set the Rotation dial angle (to the right of the menu) using the line running through the center as a reference for the direction the motion blur is smearing (this fills in the Angle field automatically). From there, adjust the Amount slider until motion is looking a little more stationary (**FIGURE 4.11**). Note that this does not perform miracles on unholy amounts of motion blur—it's smart, not omnipotent. Also, nothing ultimately

(C)

FIGURES 4.11A, B and **C** Fix mild motion blur with Motion Blur chosen from the Remove menu (C). Adjust rotation to match the direction of the smear, and work with the Amount slider until satisfied. Compare the results (B) with the original image (A), which contains a small amount of horizontal motion blur as I didn't have a tripod with me.

(B)

When it comes to filters, Smart is just another way of saying nondestructive (as mentioned in the previous chapter). The incredible part is that you can edit the settings of Smart Filters at any time after applying them to a layer or remove them entirely without permanently changing the underlying layer. You can apply Smart Filters to Smart Objects only, however, so you must first convert your layer to a Smart Object. To do so, choose Filter > Convert for Smart Filters.

Be aware, however, that a couple filters cannot be applied as Smart Filters: Lens Blur (which can be simulated with the Blur Gallery's Field Blur) and Vanishing Point. I suggest creating a copy of the layer with Ctrl+J/Cmd+J before applying these filters. Still, for the rest of the goodies packed within the Filter menu, choosing Convert for Smart Filter is the nondestructive—and smart—way to go.

replaces taking good clear images to begin with, so take a look at Chapter 5 and brush up on your photography skills if you find yourself needing this filter for every shot you have! Still, blur does happen even to pros, and now you have a tool for it.

NOTE If for some reason you liked the legacy Smart Sharpen algorithm, you can always click the Additional Options icon ⚙ to roll back the Smart Sharpen effect.

Reduce Noise

When compositing images that vary widely in quality and other characteristics, the Reduce Noise filter is one more handy tool you'll be happy to have in your Seamless Editing Belt. Consistency is important for overall continuity and making those puzzle pieces blend without a trace is the challenge. Digital noise is often a hidden trip wire in underexposed images. Noise is a term used for randomized bits of unwanted visual static. Noise occurs when you take pictures with the amplitude of the sensor's

signal boosted (the result of a higher camera ISO), usually in low-light situations (Chapter 5 discusses this in more detail).

There's not a whole lot to this filter, but the Reduce Noise filter (Filter > Noise > Reduce Noise) does help by leveling out some of the bits of contrast and static generated from sharpening a grainy image and getting rid of high-ISO complications. Each camera model and brand handles noise differently, though, so keep that in mind as you evaluate your own images. I use this filter for concentrating just on color noise from my older Canon 7D images—definitely the most important part to focus on with this model. Color noise creeps in as randomized bits of color in particular and is fairly easy to get rid of without too many consequences, such as blurring the layer (**FIGURES 4.12A**, **B**, and **C**). With my Sony A7RII, the need to reduce color noise is less dramatic. The main idea behind noise reduction when compositing is to create a consistent look, so evaluate each image case by case to get all your sources clean and as closely matched as possible. The final results will speak for themselves.

(A)

(B)

(C)

FIGURES 4.12A, B and **C** The Reduce Noise filter works especially well for terrible color noise generated from lightening an underexposed or high-ISO image; here you can see the color noise in the lightened shadows of the rocks (A) the settings applied using the Reduce Noise filter to mitigate that noise (B), and the result (C).

Blurs

Ever notice a full sense of depth created from an image using a shallow depth of field? Some parts of the image blur as they get closer or further away. The tendencies to focus our attention in just the right areas and to create a sense of depth or motion are particularly helpful abilities of the various blur filters. Ever try to simulate a longer exposure with a motion blur? Photoshop CC comes with some fantastic blurs for a wide range of uses, from simulating a motion path to natural-looking lens blurs (**FIGURE 14.13**).

Blur Gallery

Photoshop CC is loaded with some brilliantly designed blurs. The Tilt-Shift Blur, Iris Blur, Field Blur, Path Blur, and Spin Blur are linked together within the same interface (the Blur Gallery)

FIGURE 4.13 Five blurs living under one roof is a helpful feature for getting just the right blur to an image.

and offer a wide range of control and blurring effects. The first three blurs on the list use "blur pins" that you click the image wherever you want to center a blur. My two favorite powerful and useful blurs for my own workflow are the Radial Blur and Path Blur, but here's a little information about each:

- **Field Blur** creates an effect similar to Gaussian Blur. But unlike Gaussian Blur, which affects an entire image, Field Blur lets you define multiple points of blur. Decide where you want to blur the image and click each location to set a Field blur pin. Drag the ring-shaped blur handle to adjust the amount of blurring. Use a different blur adjustment for each pin to vary the blur across the image. This is great for those moments that you require variable blurring of a layer!

- **Iris Blur** is similar to the Field Blur, but one-ups it with finer control and some added slick features—plus, it simulates a shallow depth of field effect! Rather than adding a generalized blur (like Field Blur) and a location to apply it, this blur affects an oval area whose

shape you can adjust. Drag the various control handles to set both the iris radius (oval size) and orientation, while also indicating the area where it begins to transition from sharp to blurry (**FIGURE 4.14**). When working with Iris Blur you can also edit multiple features within the preview area. For example, drag the default center blur pin (ironically, the point of sharpest focus) to a new location, or add additional blur pins by clicking elsewhere in the image. Drag the outer blur area ring to expand and rotate the iris radius to fine-tune where the full amount of the blur is applied (**FIGURE 4.15**). The four middle points help you adjust the inside oval that stays absent of blur (called the sharp area).

NOTE Not all blurs look and blend well when perfectly smooth. To jazz things up a little, add a pinch of noise to give just the right feeling. Click the Noise tab on the Effects panel in the lower-right corner of the Blur Gallery, then choose a type of noise from the menu and experiment with the sliders. Just remember, less is more here!

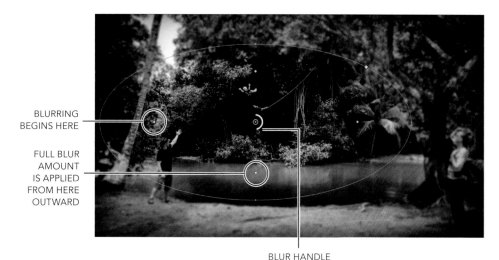

BLURRING BEGINS HERE

FULL BLUR AMOUNT IS APPLIED FROM HERE OUTWARD

BLUR HANDLE

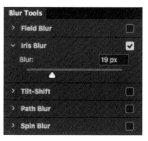

FIGURE 4.14 The Iris Blur filter lets you control where blur starts and how dramatic the transition is from sharpness to the full blur amount (set by the Blur slider).

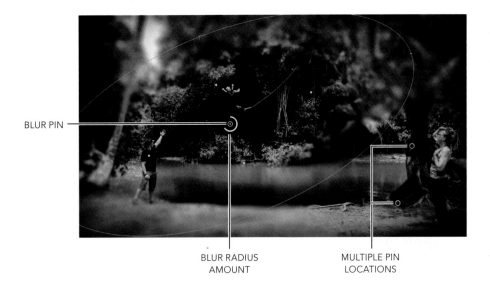

BLUR PIN

BLUR RADIUS
AMOUNT

MULTIPLE PIN
LOCATIONS

FIGURE 4.15 Iris Blur is wonderfully versatile as you can control the location of the blur, the severity of the blur, and several other customized options, as well as have multiple blur locations all on one layer.

TIP When using Iris Blur, Alt/Opt-drag the inner focus pins to move just one isolated point at a time (rather than the default linked set of all four). Sometimes it's best to have the sharpness area extended in one direction a little more than another, and rather than making another focus pin, you can simply move one of the inner sharpness points for this.

- **Tilt-Shift Blur** provides a nice double-gradient blur transition, much like the shallow depth of field you get when shooting something small, such as a miniature model set (or just shooting with a tilt-shift lens for that matter!). This can be a nice effect for those images with great depth and clear line of sight (**FIGURE 4.16**).

- **Path Blur** is one of my new favorites because it has a ton of creative potential, especially for creating realistic or customized motion blurs. For this blur effect, you can designate an actual path (or paths) of blur, drag sliders for Speed (to adjust the amount of the blur for your path or paths) and Taper, toggle on (or off) Centered Blur, choose Rear Sync Flash to replicate a flash, and more. I've been finding lots of neat uses Path Blur. It's especially perfect for adding perspective blurs (blurring towards a vanishing point), or adding unique twist or curve blur to a moving object, pet, or person, as in **FIGURE 4.17**.

- **Spin Blur** is the perfect go-to for adding motion to wheels or anything that rotates around a pivot point. You can designate multiple points for this blur, as well, making it your one-stop tool for creating realistic spinning effects from your carefully staged (and all too static) shot!

FIGURE 4.16 Tilt-Shift provides an interesting miniature look to an image making even the largest vistas feel more like a macro shot.

FIGURE 4.17 Before the Path Blur was added here, things were simply too static. Add a Path Blur to add life, interest, and motion to whatever subjects you can imagine.

Use Camera Raw as a Filter

Adobe Camera Raw (ACR) is a plug-in that enables you to make a plethora of nondestructive adjustments primarily on raw image files (described in Chapter 1). For instance, you can adjust color temperature, lights and shadow, and clarity, as well as use specialized curves and other color control elements. Chapter 5 will highlight some of the key features of editing raw files (and others), but no discussion of useful filters would be complete without mentioning that you can use most of the functionality of Adobe Camera Raw as a Smart Filter (**FIGURE 4.18**)! Choose Filter > Camera Raw Filter, then check out the ACR's main interface features, which I'll cover in more detail in Chapter 5. As a filter (especially a Smart Filter), this has great potential for composites and matching material.

TIP When you need to edit several layers at once with the same Camera Raw filter (such as composited pieces of an animal or subject), try combining the layers into a single Smart Object before applying the Camera Raw filter as a nondestructive Smart Filter. To so, first select the layers you want combined into a Smart Object (Ctrl/Cmd-click the layer names in the Layers panel to include multiple layers); then right-click one of the selected layers names and choose Convert to Smart Object. Apply the Camera Raw filter from there, and edit to taste. Not only does this simultaneously edit all the layers together as a cohesive Smart Object, but you can return to it at any time to the adjust the slider positions.

FIGURE 4.18 Camera Raw is unparalleled as an excellent Smart Filter; you get most of the same sliders and editing interface combined with the potential of working in Photoshop's layer environment—just brilliant.

Conclusion

With these four adjustment layer types and a handful of filters, you can do nearly all the major edits needed for seamless work—from matching any layer's look with another to syncing light and dark tones as well as color among layers. You can correct a multitude of discrepancies and even improve the overall look and feel of a composite with greater depth or motion. As you will see in later chapters, these adjustment layers and filters will help tremendously in just about any situation.

CHAPTER 5

Photography and Compositing

Photography is the backbone to compositing, and there's nothing like shooting all your own material for a project. It gives you total control over your creativity, so you are not bound by the parameters or dependency of always using stock photography. Consider the *Floating Journey* image I created for an online Craftsy.com course (at right) for example. Shooting my own background, barns, and subject while manually controlling the exposure for each shot enabled me to capture exactly what was needed for this scene—and it all added up in the end. Whether you use your cell phone's camera to capture texture images or a mirrorless or DSLR for important subjects, having complete control over the process will help you improve the quality of your composites and save editing time by taking the best photographs possible. This chapter covers some basic manual exposure mechanics and provides strategies for photographing with the composite in mind. While it is important to be able to shoot specifically for a composite in mind, building a quality photo archive of all your images is equally vital for the life of a believable composite—this way you'll be ready for any imaginary possibility!

▶ FLOATING JOURNEY

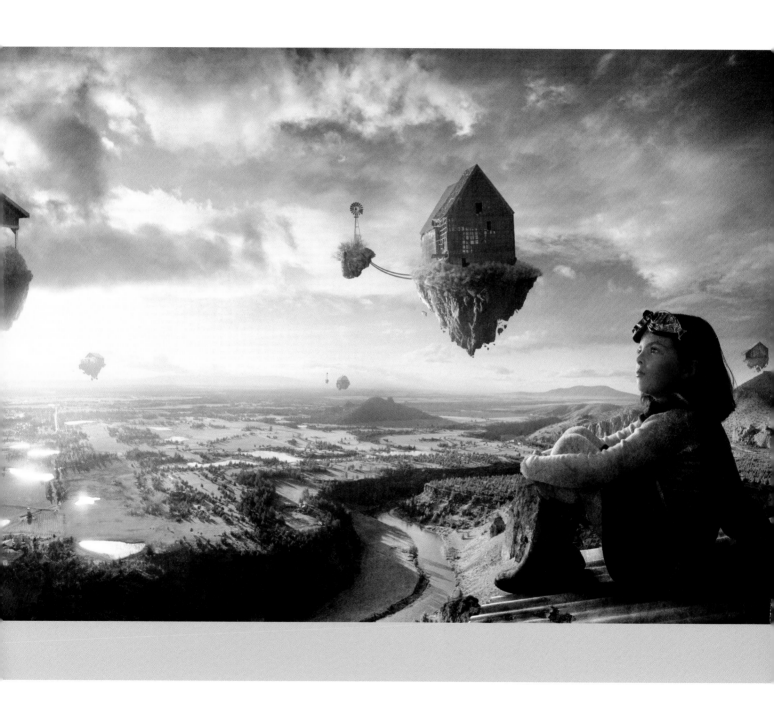

Inside My Bag

Perhaps surprisingly, I keep things fairly nimble and lightweight as far as gear goes, but what I do carry packs a powerful punch—I shoot like a butterfly and composite like a bee! Okay, that one stings—but seriously, being nimble definitely has its benefits, especially as my inclination is to combine imagery into awesomeness rather than capture it in one spectacularly perfect shot. Always on the go (usually chasing down a five-year-old adventurer/deviant), I literally can't be weighed down with equipment (or I will be left in the dust—or mud—or moss, for that matter), yet I still need to be prepared to capture quality material as it crosses my path.

These days I shoot mostly with a Sony Alpha 7RII full-frame mirrorless camera (I'll discuss this more later) and my LG V10 cell phone (for textures and small well-lit items—or to tether my Sony wirelessly). The LG is always on my person wherever I go. I do have other gear such as a Canon DSLR (and assorted lenses), a solid yet travel-friendly Vanguard tripod, and equipment for basic lighting setups, but unless I'm doing a major shoot, these things aren't my constant travel buddies. It is the sleek mirrorless 42MP camera combined with my raw-shooting smartphone that suits my purposes as I gather composite-worthy material. Both cameras have manual controls and complement each other handily—especially because I can use my phone to control my camera using Wi-Fi (more on this in the accessories section). Plus, they literally fit in my pocket and small camera bag.

Just as with workflows though, choose the gear you carry that's appropriate to *your* style and working situation. The main thing is to be thoughtful and strategic about your gear and shooting, bring what you need, and make the most of your options (even if they are overwhelming)!

Types of Cameras

There are countless types and varieties of cameras out there these days, from your cell phone and point-and-shoot models to fully controllable DSLRs and mirrorless cameras such as my Sony. Smartphones now offer built-in gadgetry and optics that may rival many early-generation DSLR camera bodies—and even shoot in raw like my LG! And technologies are continually getting more impressive. As mentioned, the options can be overwhelming. If you are poised to purchase a new image-capture device for composite work, knowledge of your options and their strengths will help you determine how each relates to your needs. Categorizing digital cameras is an ever moving target with hybrids of already hybridized varieties—smartphones with replaceable and add-on lenses, full-frame compact system cameras, and so on. You'll be able to make sense of them all, however, once you understand the three basic categories:

- Simple point-and-shoot and cell phone cameras
- Compact system, or bridge, cameras
- Mirrorless and digital single-lens reflex (DSLR) cameras

The sections that follow will examine some of the ins and outs of your general camera body options, specifically in relation to composite work.

Point and Shoot

Dedicated point-and-shoot cameras (with photography as their main function) these days are a step up from the cell phone variety and are easily portable and fully automated. This makes them great for spur-of-the-moment shots and grabbing textures nearly anywhere any time. They're also handy for getting an entire day-lit scene, such as a landscape, perfectly in focus at a decent

megapixel count that rivals many DSLR cameras. Smartphone cameras are improving at exponential and competitive rates and are also increasingly good at a number of shooting scenarios—and can even shoot in raw formats (DNG in most cases, a specification for packaging and interpreting raw files that is nonproprietary).

As a result, these handsets are now part of the point-and-shoot market and dominate the lower end of the spectrum—which isn't to say the images are of low quality by any means! It's quite impressive really. As mentioned, my phone does a decent enough job these days, but in the past, nearly a third of the shots I ended up using for a composite were taken with a dedicated point-and-shoot camera. And now the technology is staggeringly impressive. Dedicated point-and-shoot cameras are especially great at getting everything in a straightforward scene crisp and clear, which makes for very useful source imagery. For example, I took **FIGURE 5.1A** with my point-and-shoot camera, capturing the full depth of the scene nice and sharp for later use in a fantasy landscape composite (**FIGURE 5.1B**).

Likewise, my cell phone is often not just handy but perfect for capturing those added details you find on the go—such as textures. For example, one day while having my tank filled at a gas station I spied an awesome rusty texture on a nearby dumpster. Never without my phone (for better or worse), I switched over to manual mode (saving images in the DNG format) and snapped a couple pictures while my car's tank was filling. You can see in **FIGURE 5.2** how I used this dumpster rust in the *Floating Journey* composite. I needed to transform the flat gray prop-barn roof (shot in a studio) into an old rusty metal roof perch for the child.

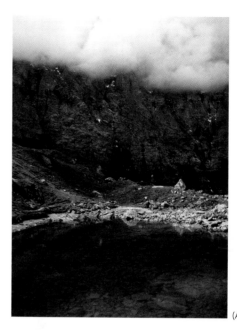

(A)

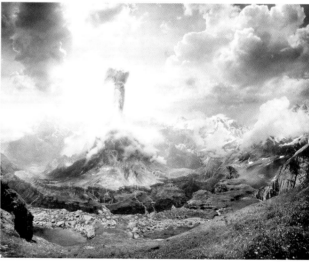

(B)

FIGURES 5.1A and **B** Point-and-shoot cameras are designed to make an image look good with little to no effort. I snagged this shot (A) on my little Canon PowerShot ELPH while hiking in Switzerland and used the water and rocks for a fantasy landscape composite (B).

(A)

(B)

(C)

Standard point-and-shoot cameras are limited by the very things that make them quick and easy: their default fixed lenses and, in some models, a lack of manual control for exposure. Yes, many high-end point and shoots now offer more control of exposure, and you can even add manual controls to cell phones by installing the right app. In general, though, point and shoots just don't have the range of creative flexibility as the other camera types because they're designed primarily for quickly and easily capturing memory snapshots and images on the go.

If, for example, you need a very specific background shot of, say, an indoor scene containing high amounts of contrast and at a certain shutter speed and low ISO (topics to be covered later in this chapter), these may not be the cameras for the job. You'll need at the very least either a bridge camera or, better yet, a DSLR or mirrorless camera. Even the entry-level DSLRs and advanced bridge cameras allow for pretty wonderful flexibility and control with focus and exposure—plus the ability to save raw files.

FIGURES 5.2A, **B**, and **C** I capture a rusty texture shot (A) with my cell phone and then used this image (along with various other layers and adjustments) to create the illusion of a rusty barn roof (B and C).

Where point and shoots excel is for stocking up your image archive on textures and other small pieces to blend into a composite. All varieties of point-and-shoot cameras are also awesome for building a library of location scouting references. This comes in especially handy if you would like to come back to a location and take a higher-quality shot with your pro gear. As mentioned, I always have some kind of camera on me just in case I come across something with potential. Even my five-year-old son often carries around a point and shoot (my old Canon ELPH), as even he knows the value of grabbing those interesting details (albeit a bit on the blurry side)!

> **TIP** Make the most of your point and shoot by regularly using the few preset shooting modes it does provide, such as the macro, action shooting, and landscape modes. These are designed to optimize the exposure quality for each specific type of shot (but may disable other settings, such as shooting in raw).

Compact and Bridge Cameras

Positioned between point-and-shoot cameras and DSLRs (and high-end mirrorless) in both camera size and capabilities, this category is simply exploding with variety (and brand competition). Compact, or bridge, cameras are also a perfect fit for many compositors, offering more flexibility than a point-and-shoot or smartphone camera, but less intimidating complexity in regard to gear and price than a DSLR or high-end mirrorless. Bridge cameras function much like their big brother professional mirrorless cameras, relying on a display screen (in place of a traditional viewfinder), but lack the robust lens capabilities and high-end sensors, features, and settings. Although many of these cameras still have a fixed lens, loads of new hybrids combine interchangeable lenses with point-and-shoot sleekness, and the results are quite

impressive. These are truly the best of both worlds if you aren't shooting at a professional level but still want to capture a wide range of quality imagery, often with raw and full-frame support (larger sensor size). Simply put, this is an awesome balance of manual control and fast-and-easy shooting.

> **NOTE** Each kind of camera has a different size category of sensor, which affects not just megapixel capabilities, but image quality as well. Full-frame sensors are larger (as their name implies) than the other standard sizes, such as the APS-C sensor in my old Canon 7D, and generally capture higher-quality images. To learn more, I recommend Khara Plicanic's *Getting Started in Digital Photography: From Snapshots to Great Shots* (Peachpit) for a full breakdown of sensors, lenses, and the rest—plus just about everything you'd ever need to know about digital photography.

DSLR and Professional Mirrorless Cameras

High-end mirrorless cameras and digital single lens reflex cameras (commonly known as DSLRs) provide the ultimate creative control. Their most obvious feature is their ability to support multiple lens sizes and types for all kinds of situations. Equally important, these cameras give you incredibly easy manual control over aperture, shutter speed, focus, color balance, and more. For the best of both worlds, many offer camera-assisted modes that enable you to manually control aperture or shutter speed while the camera optimizes other settings (although this ability is no longer exclusive to DSLRs). I use these cameras to capture the key components of any composite, especially for shooting subjects and wildlife, which often require both creativity and better control (and quality).

For instance, with mirrorless and DSLR cameras you have the potential to get much better optics as mentioned, but also a larger range of f-stops and noise handling settings, along with better processing power, autofocusing and light metering options, as well as minimal shutter lag. In short, I personally could not get along without a DSLR or mirrorless of some kind, but these cameras are not your run-of-the-mill, snatch-and-grab image takers. They require a little time to adjust before shooting. Also, DSLRs are nearly impossible to hide while out in public, so everyone around you will take note of your shooting. The primary benefits of creativity and control are well worth the extra time and weight to me. Like a skilled painter choosing various paints and brushes for just the right creative situation and look, we as photographers can choose just the right creative settings for exposure controls, focus, and post-production capabilities by shooting in raw with a DSLR camera. Shot on an APS-C size sensor exposing specifically for the highlights of the clouds,

FIGURE 5.3 Shooting with a DSLR or mirrorless camera lets you use a range of lenses and exposure controls, in addition to capturing images as raw files for more post-production editing flexibility.

FIGURE 5.3 shows the kind of base image you can capture with a DSLR and telephoto lens—a good combination of gear and settings for any number of composites.

Which Is Best for Composite Work?

If you can afford it, consider at least dual camera ownership: a high-end point and shoot (or at least higher-end cell phone camera) for unobtrusive, spur-of-the-moment image capture; and a powerful DSLR or mirrorless for circumstances when you need increased control and data. In most cases, a point and shoot won't slow you down with lens cap fiddling, sensor cleaning, manual aperture or shutter-speed setting, or focus ring twisting. This makes it more likely that you will use it frequently and, therefore, capture a greater variety of material as it goes where you go—after all, it's meant to fit in your pocket or bag. When you're not in a hurry and need to execute an exact exposure, mood, or other creative flair, turn to your DSLR or mirrorless camera, which will offer all the control and quality you need. If the point and shoot is your sketching charcoal, a DSLR is the fully stocked painting studio.

If you're on a budget, however, and must choose just one camera for all kinds of composite work, a bridge camera has the potential to meet a range of needs. If you're considering one, make sure it captures in a raw format. Being able to shoot raw images opens up a range of flexibility and quality control that leaves mere JPEGs in the digital dust. Although phone cameras are continually improving (exponentially), these cameras still work best as a secondary camera due to the lack of optical zoom compared to other camera types.

Whatever direction you may be leaning towards, definitely consult reviews and side-by-side comparisons. Sites like Digital Photography Review (www.dpreview.com) and Imaging Resource (www.imaging-resource.com),

for example, have all the latest specs, reviews, and comparisons you could ask for. Also I highly recommend visiting your local photography store to get a hands-on feel for equipment; what may sound nice as a technical stat list just may not be intuitive to you in the hand.

Lenses and Sensor Sizes

Your choice of lens can affect the image you capture as much as your choice of camera—as can the size of the sensor. Measured in millimeters, lenses excel at different tasks depending on their focal length. For example, short focal-length lenses, such as 8mm to 24mm on my Sony α7RII (full-frame 35mm sensor), are best for wide-angle shots, while focal lengths of 80mm and longer are designed for telephoto work. When considering what size or how many lenses you need, keep a few guidelines in mind:

- Sensor size is critical. Cameras that use "crop sensors," like my Canon 7D (Canon APS-C), can be less expensive and great for telephoto work when compared to full-frame sensors. But as its name implies, it uses a sensor that is smaller than a full-frame sensor and therefore captures a smaller (i.e., "cropped") image area using the same lens. In the case of this camera the amount of cropping is equivalent to increasing the focal length by a factor of 1.6. In other words, if you use a "normal" 50mm lens on a camera with a crop sensor, the lens acts like an 80mm lens.

 My full-frame Sony on the other hand would require a longer lens for the same amount of zoom; however, it has some major benefits. These include better low-light handling, wider angle of view, shallower depth of field, and a higher-quality image all around. In other words, full-frames sensors are great—although they usually have a price point to match, as they are more expensive to manufacture. There are also a range of smaller sensors and the larger medium format as well.

- Normal lenses (50mm for full-frame and 35mm for APS-C sensors as their smaller size crops the image) are those that closely resemble how our eyes naturally see the scene. These are great when you want to capture an image that makes viewers feel as if they were actually there or at least looking at the scene through a window.

FIGURE 5.4 When you don't have enough room in a scene to capture everything you need, shooting with a wider angle lens like this 15mm on a APS-C (not full-frame) grabs just enough to make it workable.

- Wide-angle lens (8mm to 18mm, 15mm to 28mm for full-frame) are useful when you're shooting in tighter spaces and simply can't cram everything into the scene otherwise. To capture all the elements I wanted to be included in the background of the composite in **FIGURE 5.4**, I needed a 15mm lens and to shove myself and my gear into the corner. These kinds of lenses are also good for developing a certain stylization, because the images may appear slightly distorted and warped looking. Be prepared to shoot with a wide-angle lens if you are matching another shot that was clearly also shot with a wide angle. Matching the focal length measurement does wonders for the final product. When the focal lengths of source images don't match, our eyes may not know exactly what is wrong with the composite, but they will definitely pick up that something is wrong!

- Telephoto or long lenses (80mm and larger) magnify parts of a scene for a zoomed-in look, as in Figure 5.3. Telephoto lenses are especially handy for capturing distant subjects or far away details that you intend to add into a scene at a similarly distanced placement. A telephoto lens lets you get nice and close without scaring off the wildlife, for example (or getting eaten, depending on the wildlife).

TIP If you can afford the expense, high-quality lenses are definitely worth their typically heavy weight, especially lenses with low-light capabilities (f-stops close to 1.4). Called fast lenses, these can still shoot at fast shutter speeds even in low light, providing greater shooting capabilities for a range of lighting scenarios.

Control Exposure

Buying a bridge or DSLR camera is one step towards getting higher-quality shots. The other is to break out of Auto mode (meant just for average conditions) and take control of your camera's three fundamental settings: shutter speed, aperture, and ISO. Once you understand each of these, as well as how they work together with reciprocity (an increase in one parameter needs to be balanced with a decrease in another to attain the proper exposure), you can customize how your camera captures an image and better gather more effective source material for your composites.

Shutter Speed

The shutter speed setting controls the length of time that your camera's sensor is exposed to light for a shot and is measured in fractions of a second (or whole seconds for longer exposures). If you want an image to have motion blur, keep the shutter open for a longer time with a slower setting (such as 1/4 of a second). For example, nighttime photographs of star trails across the sky and silky-looking running water shots (**FIGURE 5.5**) both use slow shutter speeds for long exposures (hours long for the night shot).

Likewise, if you want a sharper image, say to catch a bird's wings in mid-flap, as in **FIGURE 5.6**, shoot with a faster shutter speed (faster than 1/125 for capturing moderate motion). Depending on the camera and subject matter, settings slower than 1/60 of a second (often shown on the camera as just 60) may produce some motion blur during handheld shooting on most stock lenses and setups. (If you have rock-solid hands, however, you may be able to get a decently sharp image with 1/30 or even 1/15 of a

FIGURE 5.5 Water turns to silky streams of blur when photographed with a slow shutter speed, such as the almost one-second exposure used here.

FIGURE 5.6 At 1/4000 of a second, there's not much a fast shutter speed can't catch clean and sharp.

second on certain camera setups.) To avoid accidental motion blur, either use a tripod, make sure image stabilization is on (sometimes built into lenses, sometimes camera bodies—and not to be used with a tripod simultaneously), or increase your shutter speed if light and other exposure settings allow it (such as changing aperture, ISO, or both).

> **TIP** If your lens (or camera body) offers image stabilization (sometimes called optical stabilization), use it when you must have a slower shutter-speed to get the exposure you want. This will let you shoot at slower speeds for handheld shots, for instance, but won't let you freeze action like a faster shutter speed. Also, when using a tripod to shoot multiple shots for a single-scene composite, be sure to turn off the image stabilization. If you don't, when you use the Paste In Place command (see Chapter 7), you may find unwanted and misaligned edges in your composite caused by slight differences between shots. Overall, image stabilization is great for handheld work but presents problems when paired with a tripod—so don't forget to turn it off.

Aperture

Think of the aperture setting as the size of the pupil of the camera lens' eye. Dilated, wide pupils let in a lot of light; constricted, smaller pupils allow less. The area of light being let in is based on the size of the aperture radius, which allows us to control the depth of field of an image, meaning how much of the image is in focus and how much of the background is blurred (often referred to as bokeh). When a narrow beam of light passes through the aperture of the lens, it provides a greater depth of field, meaning everything near and far is nice and sharp.

When a wider beam of light passes through the aperture, it produces a shallower depth of field, meaning only a shallow distance is in focus; the wider splay of light rays landing on the sensor reduces the depth of field, because only some of those rays can be fully brought in focus by the glass.

Measured in f-stops, the aperture setting enables you to control the depth of field in your shot (**FIGURES 5.7A** and **B**). A large f-stop number, such as f/22, means a smaller aperture size (so less light can pass through) and a greater depth of field. Conversely, a low f-stop, such as f/1.4, has a larger aperture (letting in more light) and only a narrow range of distances from the lens is perfectly sharp.

> **NOTE** An f-stop refers to the focal length of the lens (say a 50mm lens) divided by the aperture diameter measured in millimeters. So a 50mm lens with an aperture diameter set to 25mm wide is a ratio of 2:1 and is known simply as f/2 (focal length over 2).

In general, though, when you need to let in more light to the camera, you have the option of a longer exposure (shutter speed, which controls motion blur) or changing the aperture's f-stop, which controls depth of field—so it is always a trade-off (such as when shooting indoors without a lot of available light).

> **TIP** If you are not so stupendous at math and can't calculate the appropriate f-stop for a certain depth of field, here's an easier way to remember it: Larger f-stop equals larger depth of field—smaller f-stop equals smaller (shallower) depth. Math be gone!

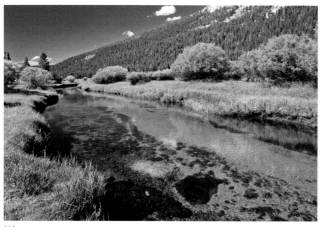

(A)

(B)

FIGURES 5.7A and **B** Smaller aperture size, such as the f/11 setting used in 5.7A, puts your entire scene in pretty good focus; wider aperture settings, such as the f/3.5 used in 5.7B, provides a narrower depth of field, focusing tightly on a single distance and blurring everything beyond and in front of that distance.

ISO

The third fundamental setting is ISO, which changes the sensitivity of the sensor, allowing more or less light to be recorded in the same amount of time. The higher the ISO number, the more boosting effect on the signal. Increasing light sensitivity in this way, however, comes at the price of noise, small, unwanted bits of randomized light and color contrast visible in your image. Low ISO settings, such as 100 to 200, produce less noise, while higher settings, such as 1600 and above produce greater amounts of noise (because the faint noise of the sensor is boosted along with the desirable parts of the signal as well). When available light is especially low and changing the shutter speed or aperture would cause too much blur, you can try changing the ISO to get the shot you want (**FIGURE 5.8**).

FIGURE 5.8 I raised the ISO to 1600 to get the proper exposure of the stars. Thankfully, the resultant noise almost blends in with the stars.

Master the Exposure Trinity

Mastering the exposure triangle of shutter speed, aperture, and ISO is all about reciprocity, that is, balancing the ways you control a properly exposed image. To attain the right look and exposure, you must achieve the proper ratio of give and take among the three exposure controls, which together are called the exposure trinity.

Assuming you have a properly exposed image when looking at your camera's light meter (you can see mine in **FIGURE 5.9**), if you then change one of the three exposure controls, you must compensate by changing another to retain the same good exposure reading (to maintain reciprocity). Both my Canon and Sony, like many cameras, operates in 1/3 stops, meaning if I move the dial controlling the shutter speed one dial click for a faster shutter speed, the camera's light meter shows that the exposure moves by one-third of a full stop to the left (saying I am under-exposed by 1/3 stop) and tells me I need to change either my aperture one click or my ISO by one click to compensate for the shift in shutter speed. This is the idea of reciprocity: change and compensation.

FIGURE 5.9 Here's a shot of what my own manual exposure controls look like on the Canon DSLR with a properly exposed and very well-lit scene.

Here's where the fun strategy comes into play and why give and take is always involved. If you want an image with greater depth, you will need a high f-stop and will have to compensate with slower shutter speed to let in light for a longer period of time (reciprocity). Now let's just say that there's a complication and you also have to freeze some moderate motion in this shot. Now you need both a higher f-stop (for depth) as well as a faster shutter speed (for frozen motion), both of which restrict the amount of light hitting the sensor—so then you may have to resort to boosting your ISO to compensate for both of the others (but sacrifice quality by adding more noise to the shot). Makes perfect sense, eh?

Although straightening out the exposure trinity may sound a bit complicated at first, there are many resources out there that can help you get a full grasp on the concept of exposure and reciprocity. For example, I recommend starting with Jeff Revell's *Exposure: From Snapshots to Great Shots, 2nd edition* (Peachpit).

Exposure control is really the power of complete image control and makes all the difference for ensuring you are getting what you need—and is well worth learning!

Accessories

Some accessories are nearly as important as your camera for getting good material for your composites. Here's a very brief breakdown of my favorites and how they can help raise your shooting from adequate to stellar.

Tripods Stand on Their Own

Get your hands and camera on a solid tripod for those moments when you need a sharp and controlled image. In low light, for example, a tripod is invaluable; with its added stability, you can take a longer exposure (because you don't have camera motion as with handheld shots), avoid noise, and still get away with a decent depth of field. As you shop, keep a few tips in mind:

- **A bubble level and a locking system.** Having your gear smash to the ground defeats the whole stability advantage. Look for a tripod head rated for your camera's weight that also has easy and secure ways to lock it down. Bubble levels on the head ensure you get the straight shot you want.

- **Soft padding grips on the legs.** Put grips on your tripod if you are planning to shoot scenes outside in the cold (or wet) for hours at a time. Touching a bare metal tripod may seem like a minor thing, but believe me, shooting in the cold can suck the heat right out of you—and if wet, things can get more than a bit slippery without grips. **FIGURE 5.10** shows a remote location in Washington where, because of my setup, I could hike, shoot, and relocate with relative ease.

FIGURE 5.10 Hiking through the snow to shoot scenes like this in the middle of nowhere requires a combination of rugged and smart gear; foam grips on my tripod's top legs makes setting up in the cold easier.

- **Balance weight and stability.** Make sure you choose a tripod that's both light enough to carry a distance yet sturdy enough for rugged use and the weight of your camera and lens. The material that a tripod is made out of matters a great deal in terms of cost, weight, and strength, so be sure to get one that suits your needs. Metal tripods can often have greater stability, but do weigh more, while carbon fiber tripods can be packed to just about any high peak.

- **Tripod head.** Where the camera attaches and balances on the tripod is also important. Something that I find invaluable in a tripod is a quick release system for attaching and releasing quickly at moments when I want to switch to handheld shooting. Also having bubble level on the head itself is invaluable for getting your image looking level without the need to crop in post-production. I find having handles for tightening and loosening the head rotation comes in handy for finessing where the camera is pointing and oriented.

FIGURE 5.11 Automate your picture taking by attaching an intervalometer to your DSLR; here you can see mine working with my Canon setup.

Intervalometers and Filters

An intervalometer is handy for those times you simply don't have enough hands to do it all. Basically, an intervalometer is just a remote trigger with a built-in timer (**FIGURE 5.11**). More powerful than the simple timer function of your DSLR, these devices can shoot in steady intervals, leaving you free to be in front of the camera posing for or positioning source elements. For example, every floating object in Figure 5.4B as well as those in the composites in Chapters 7, 12, and 15 were taken as separate shots using an inexpensive intervalometer connected to my DSLR on a tripod.

Filters can also be helpful accessories. For example, a polarizer does a wonderful job of cutting glare and minor reflections. A decent quality UV protection filter for each lens is also a fairly important but minor investment

if you plan to do crazy outdoor excursions for a lot of your shooting. When shooting hazardous environments, whether hiking in the mountains or avoiding ferocious pets, I've seen these little filters continually save expensive lenses as they take the hit or the grit, dust, mud, and so on—keeping the expensive lens glass behind it nice and safe.

Camera Applications

As we enter the age where the Internet of Things is increasingly common, the prevalence of Internet-capable cameras is actually pretty helpful. Although I often have to use an intervalometer for my Canon DSLR, my mirrorless Sony is connected to the Internet and can simply download a time-lapse app with the features I need. Camera manufacturers each offer their proprietary software and often charge for apps, but depending on your needs, an in-camera purchase or two definitely can be worthwhile. (For more on the apps for and capabilities of Sony cameras, I recommend Pulitzer Prize–winning photographer Brian Smith's various articles and books, found at www.briansmith.com.)

TIP Whether you use a Sony or other compatible camera, adding Phase One's Capture One Pro software to your laptop has some substantial benefits for compositing, such as real-time continuous image display during tethered captures—with the option of a super-imposed image of your choice! This can help you nail the perspective and position of separately shot imagery. Capture the ingredients and then bring them into Photoshop and make the magic!

Mobile Control

For cameras that have Wi-Fi capabilities, the smartphones and tablets are phenomenal aids for compositing. Download your camera manufactures' Wi-Fi remote app (such as EOS Remote for Canon or PlayMemories Mobile for Sony) and follow their instructions for connecting to your camera. Once you have a successful wireless tether, you can leave your camera set up while you bring the live view (displayed on the mobile device) with you as you go about adjusting the scene to perfection—no more running back and forth just to check a slight change!

A live camera view and the ability to trigger a capture all from your smartphone or tablet is incredibly helpful especially if you are orchestrating a complicated shoot—one where you are moving pieces, such as props, subject poses, animals, young children, and so on. You can even use it as a collaboration tool, showing your subjects where they are and how they are posed within the frame. But don't lose track of your pre-visualization of the composite scene as you shoot with this tech. Pre-visualization is when you imagine all the pieces together and the best placement for each element for the strongest message—all in your mind's eye! There's no app for that (yet).

USE TECH TO PUSH CREATIVITY, NOT LAZINESS

These days you can walk onto a scene with a Wi-Fi-tethered camera and mobile device that displays exact framing and composition. Tap one finger, and you've captured your shot. Guess what?

You're cheating. Seriously!

Technology keeps making the compositing process easier and easier—almost too easy. It's tempting to depend on the tech as a creative crutch, get lazy with your ideas or planning, and do everything on the fly. Don't fall for it. Technology also dramatically pushes the creative envelope, expanding composite potential. So instead, use the advancements to do more extreme creations and pre-visualizations. No amount of tech-aided trickery will turn a bad concept or plan into a good image. Invest in some creative foresight and good planning before you begin; then use the tech to execute planned awesomeness. Get inspired, not lazy.

It's also a good idea to stay at least a little humble and inspired by the past. Keep in mind all those early film compositors, such as Jerry Uelsmann and James Porto, or remember the nineteen-century glass-plate photography composite artists, such as Henry Peach and Oscar Rejlander. There was no wireless tethering going on back then, just incredible imagination and pre-visualization! Google some of these pioneers before you rejoin me with the high-tech composite cheating. You just might thank me!

Edit in Camera Raw

As mentioned earlier, shooting in a raw format allows for unparalleled nondestructive flexibility. The Adobe Camera Raw (ACR) plug-in in Photoshop enables you to efficiently work nondestructively with images in unprocessed file formats from all the major camera brands. (Each manufacturer uses its own proprietary method of storing raw data, as you remember from Chapter 1.) To access the ACR dialog box, first browse for the image or images using Adobe Bridge CC (always a good place to start with photographs in general). Double-clicking a selection of raw images will ferry them quickly into the raw editor, which is a default part of Photoshop but more like an anteroom. As mentioned in the previous chapter, the CC versions of Photoshop can use ACR as a Smart Filter—which opens the door for all kinds of new workflows and possibilities.

FIGURE 5.12 shows the Photoshop CC 2018 release of the ACR editing environment—don't worry if your version looks different. Sliders sometimes change both name and position with each release, but even so, most of the functions stay the same.

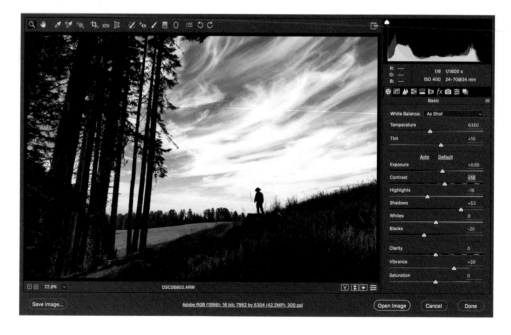

FIGURE 5.12 Adobe Camera Raw is perfect for adjusting such critical parameters as exposure, white balance, color, and contrast. This image was originally a bit underexposed, especially in the shadows and the color lacked intensity, so by making a few careful adjustments I was able to compensate for the original shot.

Adjust with Sliders

From color temperature to filling in shadows, Adobe Camera Raw (and raw formats in general) enables you to edit all of these pieces nondestructively by saving your adjustments and raw editing data in a separate external file called an XMP file with the same file name and .xmp suffix (GreatShot.cr2 and GreatShot.xmp, for example). If you ever make an edit and then want to move the image with the accompanying edits in tow, make sure to grab both files (the raw file and the XMP).

TIP Converting your raw files to DNG will save the raw adjustments you made within the DNG file (as opposed to in a separate XMP file) while still keeping those changes nondestructive. This is helpful for moving files around without having to worry about the XMP files full of adjustments getting separated.

I tend to stick to a general workflow of changing color temperature and tint first, then the exposure, followed by shadows (as I like to fill in a bit more detail in most cases), highlights, then contrast, and the rest as needed. In this order I can change the main pieces with dependable results and aesthetics that feel balanced. Then, I rely on the main editing environment of Photoshop and using layers (such as adjustment layers and masking) for the rest of my edits. Making a few specific raw adjustments before jumping into the full application and composite editing, however, is a good practice because you're working with the unprocessed file at this point and, therefore, greatest raw quality. The sliders I use most are:

- **Temperature** and **Tint.** The Temperature slider enables you to cool your image down (slide left) or warm it up (slide right) from the temperature your camera initially set as the white balance when you

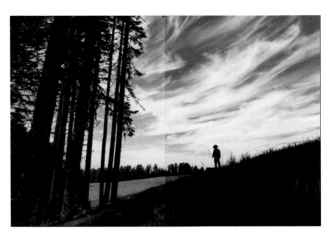

FIGURE 5.13 With the Temperature slider you can compare warm (at 9400K on the left) or cool (at 4500K on the right) versions of the same image.

captured the image (**FIGURE 5.13**). Often it's necessary to use the Tint slider in conjunction with the Temperature slider as warming and cooling don't always do the trick on their own; the overall image color can appear a bit off, needing more green or magenta. A good practice is to play around with these two sliders until neutral grays and whites are just that, neutral, neither cool nor warm cast. This feature when shooting in raw basically negates the need for setting white balance on the camera as it can be easily changed and controlled in post.

TIP Use the White Balance Tool 🖉 (I) to quickly pick (by clicking on) a white or neutral gray that ACR can then use as a reference for setting the Temperature slider. This is a good place to start if you are unsure of what temperature to go with.

- **Exposure.** Just as you can set your exposure in the camera, you can also do a bit of fixing after the fact with this slider (**FIGURE 5.14**). Even with highlights slightly blown, setting the exposure a little darker by sliding 1 or 2 to the left may bring back some details. The sensor records more data than is represented visually, and the Exposure slider gives you access to it. ACR can work in a 16-bit space, while JPEGs are mostly limited to 8 bit, meaning there is far more information available to work with while editing raw images (seen most clearly in exposure range and subtly incremental steps of value due to larger bit depth and tonal resolution).

- **Contrast.** This slider adjusts the image contrast, and I tend to use it after adjusting my shadows and highlights. This way I get the details I want in the image and then I make them pop with a bit of added contrast.

- **Highlights.** With this slider you can lower just the highlights, rather than adjusting the overall exposure when an image is just slightly blown. This can help bring in some details without affecting any of the other tones of the image. After I raised the overall exposure, for instance, Figure 5.12B had a few cloud highlights that were running a little hot for my taste, so I darkened them by dragging the Highlights slider left. This is a pretty big deal, especially if you have a shot that was slightly blown even before exposure adjustments, but this technique works with raw images only.

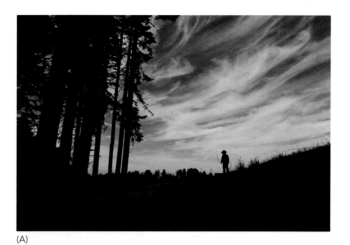

(A)

(B)

FIGURES 5.14A and **B** The original raw file (A) is more than a bit underexposed as you can see (even for a dramatic contrast aesthetic) as details are completely lacking in the darks. Increasing the exposure while decreasing the highlights to keep the clouds from getting too blown out pulled things out of the dark (B).

- **Shadows.** This slider is invaluable for getting some additional post-production fill light on shadowed areas. Sometimes photographing in high-contrast situations can't be helped during a shoot, but playing with the Shadows slider (formerly called the Fill slider in early versions of Lightroom) can help bring back some needed shadow detail. While Exposure helped in Figure 5.12, the shadows were still fairly intense—moving the Shadows slider brought out even more detail.

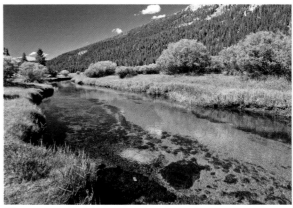

(A)

> **TIP** If you know you will be shooting in a high-contrast environment and using the Shadows slider to bring back details within the shadow, make sure you are shooting with as low an ISO as possible. Boosting shadows will also boost the noise within them.

- **Whites** and **Blacks.** These two sliders adjust the white and black points of the image, respectively. I don't usually touch these much unless an image is not even close to reaching full black or white. In effect, you can create more contrast with these sliders, but with more precision and isolation than the Contrast slider provides.

- **Clarity.** This setting can soften an image by reducing clarity (sliding to the left), or you can increase the value to make a high dynamic range (HDR) effect. Essentially, the setting creates contrast on an area-by-area scale, which is great for wringing an extra feel of grit out of textures or making shadows and contours of an object more dramatic. Use it sparingly, however, as the effect rapidly starts looking a bit wacky and over-stylized (**FIGURE 5.15**).

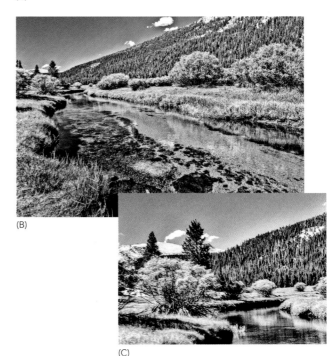

(B)

(C)

FIGURES 5.15A, B, and **C** Increasing Clarity on a raw image (A) uses the extended bit depth (larger gamut of lights and darks) to add localized contrast (B)—similar to the idea and look of mild HDR. This often results in noticeable halos around edges, such as the tree line (C).

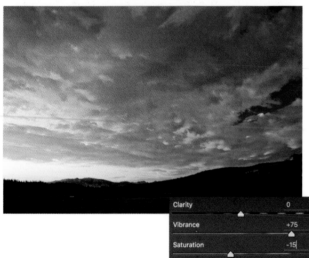

FIGURE 5.16 Alter the sky's hue intensity by first decreasing Saturation and then increasing Vibrance to compensate for a more general area saturation effect.

FIGURE 5.17 Click these icons to access and adjust various categories of adjustments provided by Camera Raw.

- **Saturation** and **Vibrance.** These two sliders often work in tandem; you might take out a little bit of saturation (the hue intensity of individual pixels) and then increase Vibrance slightly to compensate. Vibrance similarly affects the hue intensity, but on more of a general level, looking at groups of similar color. Rather than changing the saturation of each pixel's color, Vibrance adjusts areas that have color in common and increases the saturation of those colors only. Consider the sky in **FIGURE 5.16**, for example, which is made up of a variety of differing colors. This pair of sliders can generally help with creating a color-consistent look to an image: Lower the Saturation by, say 30, and increase the Vibrance to compensate for the desaturation. The result is smoother and averaged color that I find works well for larger areas.

> **TIP** Once you get a single shot edited the way you want, you can save the settings as a preset to apply to other images from the same shoot just from doing it the one time. Click the Presets tab and click the Create New icon ⬚ to create a new preset. Name it something memorable and descriptive and then click OK. You can then apply the preset as many times as you want (even to large groups of selected images all at once).

Other ACR Features

Beyond the sliders, the ACR dialog box holds quite a few sweet features, which will help you improve workflow and image quality before syncing the image into the composite. Below the histogram on the right of the window, a row of icons provides access to various tabs, each of which contains a collection of settings (**FIGURE 5.17**). The first icon ⚙ displays the Basics tab containing the sliders just discussed, which is the default view. Click the Curves tab ▦ to perform a preliminary Curves adjustment on

the image using a control similar but more refined to the version available as an adjustment layer within Photoshop. The Detail tab ⛰ opens the sharpening controls, which are quite helpful for some images with a slight amount of blur to them. Although it can't work miracles, it offers a large degree of sharpening flexibility that's not afforded within a Photoshop adjustment layer. Always apply and adjust sharpening first in this nondestructive raw setting.

TIP Cycle through before/after comparisons (or choose a specific way to compare) using the buttons below the lower-right corner of the image within ACR. These icons ▣▣▣▤ represent ways to better see the changes you made to the default raw file, which can be quite helpful to say the least!

Now here's the true workflow godsend of working with ACR and Adobe Bridge: batch processing! For example, you can select all the thumbnails (either inside folders or collections) for an entire shoot's worth of images within Bridge and open them all together within ACR. Once in ACR, if all your images from the shoot were shot with the same settings, location, and lighting (preferably), press Ctrl+A/Cmd+A to select all the images at once. Alternatively the click "hamburger" icon in the upper-right corner of the Filmstrip ▐ Filmstrip ☰ to open the flyout menu. From there, you can you can choose Select All. ACR applies every adjustment to all selected images, creating XMP files for each within the shoot's folder (though these files may be hidden from browsing in Bridge itself).

TIP Another method of applying several ACR adjustments to multiple files is by using presets. The Presets icon ▤ is the second adjustment tab from the right. After making your adjustments within the other tabs,

switch over to the Presets tab and click the New Preset icon (it looks like the new layer icon) ▣ in the lower right of this panel. In the New Preset dialog box, provide a useful name before clicking OK. You can now leave ACR and bring back however many images you want and apply this preset by clicking the name you provided within the Presets list.

I like to start by editing an entire shoot as one large selection to get the general scene looking right and then afterwards select individual image thumbnails within ACR to modify, touch up, and finesse the individual pictures. Sometimes a subject moves into different lighting or something changes slightly even when you keep the same camera settings; it's helpful to edit all the images together and then go in and adjust the particular shot.

NOTE You can still apply ACR settings to many images, even if they are not similarly shot, say they were from different scenes. Although it is possible to do this, the images may not look that great as each most likely started with a different look, and changing a slider for one may do something far different to the look of another.

TIP After adjusting sliders and settings within ACR, hold down Shift while you click Open; ACR will bring the raw file into Photoshop as a Smart Object raw image—still editable through ACR as an embedded 16-bit raw image within your file! The Smart Object will even remember your settings and let you edit every slider as if it just came from your camera all shiny and raw and not as an ACR 8-bit Smart Filter (covered in later chapters).

Shooting for an Archive

It's not always enough to take pictures for just memory or the visually artistic qualities of a scene or subject. Shooting for compositing is often its own category of shooting that comes from a combination of both archive and new artistic goals coalescing into a literal fusion of imagery. But building a useful archive of composite-worthy photographs takes some planning and forethought to capturing images that have great potential to be used in a number of situations. Part of this is shooting for not just subject, but also textures—those strangely isolated water, bark, tree, metal, stucco, and other shots that are nothing overly grand on their own but that combine with other images to help you create a new concept. Shoot more variety than you may feel is necessary, and always consider your POV and how you might capture useful images that can later be combined. While photographing, keep in mind the potential for future masking, cropping, or leaving that extra room in a simple scene to perhaps add things later; the more you do, the better off you will be when that great idea hits you.

For my own archive, I never reject an image (unless it's too poorly exposed to be discernable) because every image has the potential to be useful. So set aside large amounts of storage (and backup) for an archive and follow these tips for shooting for composite work:

FIGURE 5.18 Shoot fire in the dark with a dark background and fast shutter speed that is in the thousandths of a second to avoid blur.

- **Smoke and fire.** Use a fast shutter speed and a dark background to highlight the flames while keeping them clear and sharp. Put point-and-shoot cameras in Action mode, or increase your DSLR's shutter speed in Manual or Shutter Priority mode (**FIGURE 5.18**). Lingering shutters will produce motion blurring rather than a quick freezing of a moment. For the fire images in Chapters 8 and 10, I simply waited until night for a nice dark setting and then took fast exposures of a log dosed in lighter fluid.

- **Water.** How you approach this subject depends on whether you're photographing water for texture or water for a subject, such as a lake, river, waterfall, or ocean to place in your composite (**FIGURES 5.19A** and **B**). Sometimes the approach is more of a macro mode way of seeing images (when you need to get close with sharp focus), looking at how the water texture can be applied to other situations. Other times, your approach may be looking and shooting the water's big picture flow or resting state. In

either case, know whether or not the water is going to be captured moving quickly or slowly, needing great depth, or needing shallow focus (though usually the more depth the better as you can simulate focus blur in post-production). When shooting fast-moving water for texture work, for example, keep your shutter speed just as fast as the water itself. Lighting and time of day will also dramatically change outdoor water shots, so plan ahead to achieve the mood you're after. (If you want Golden Hour light, don't arrive at high noon on a rainy day.) Reflections and coloring also come into play with water; so find the right angle and POV (or just shoot a huge variety to be safe once you start the editing process). When compositing, reflections often have to match fairly closely so try to get a range of reflections that are more or less free of artificially identifiable objects or anything that stands out too much.

- **People.** When photographing people for a composite, keep the intended background image in mind so you can match the angle of the scene in which they will be placed. Is the background a wide-angle or telephoto shot? If you don't know exactly what the background will be, try to capture images with as little distortion as possible for greater flexibility later. A 35mm lens for an APS-C camera and around a 50mm on a camera with a full-frame sensor will get you started with an image that looks close to normal to the eye.

Give clear direction and feedback to adults and older children modeling for you. Describe the imaginary world of your composite so they can see what you see to help remove some of the awkwardness that naturally comes from posing. For example, I told the model featured in **FIGURE 5.20A** that a band of marauders with spiked cudgels was in the distance; she immediately reached for the sword and glared at them (beyond the

(A)

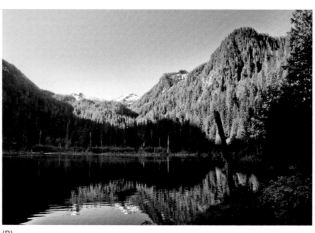

(B)

FIGURES 5.19A and **B** Take macro shots of water to use as a texture (A), as well as wide-angle images with greater depth of field so you can use water as a subject in your composite (B).

(A) (B)

FIGURES 5.20A and **B** Whether your subjects are adults or children, get them playing and imagining with you; your shots will come out much stronger for it.

FIGURE 5.21 Collaborating with subjects, especially children, can return engaging results as seen in this typical family moment from Chapter 15.

white wall in front of her). A couple variations of this, and the shots were perfect for Chapter 9's tutorial project.

For young children, make a game of things. Capture their attention with toys in the areas you want them to look or reach for (**FIGURE 5.20B**). Keep your shutter snapping quickly to capture that moment when the mood aligns. Stay flexible, and make it fun.

For older children, play at their level—collaborate with their imagination and narrative. Sometimes working in their ideas can be ridiculous fun as seen in **FIGURE 5.21**, a family portrait constructed from the family's ideas. (Okay, full disclosure here, the boys totally directed this over-the-top one from start to finish; I just helped facilitate their awesomeness.) In the case of the chapter's introduction image created with Craftsy, much more went into directing the girl—but the subject also has to eventually buy into the narrative for a convincing performance, especially with more subdued narratives. Sometimes it's more about shooting again and again until the nearly-imperceptible-self-conscious-smile (technical term) fades and the subject's mind immerses into the world you unfold.

- **Buildings.** Variety is crucial; photograph everything from futuristic glass structures to leaning and moss-covered barns. You never know what's going to be that perfect missing piece your future composition needs, so shoot a range of angles and directions. Don't stop with straight-on street views; shoot up from the sidewalk and down off the roof in all types of weather. You never know how the buildings will come in handy—sometimes just for textures and small pieces as seen in Chapter 16 or for a backdrop as in Chapter 9. Pay attention to the time of day and the reflections of sky. Because of this, clouds change the look of buildings, as do sunsets; so if you find an interesting building,

pick times of the day that bring out its interesting qualities (the golden hour at sundown or sunrise is a good one to start with). I photographed a cityscape during sunrise from atop a tall building, only to later find this lighting and perspective fit perfectly with a picture I took at sunrise from atop Half-Dome in Yosemite National Park. **FIGURE 5.22** shows the composite that resulted.

- **Landscapes.** These usually need to stand on their own as background shots; they typically make up the filler when used with outside composites. Shoot with an openness in the scene that has the potential for adding in other elements, like filling a spacious room with furniture. Shoot with a high f-stop to make sure the entire view is in focus. You can always blur after the fact, but you can't always take out blurring that occurs in the camera.

- **Trees.** One thing about these guys, they sure can hold a pose. When photographing them, consider your point of view and lighting, which can change their look dramatically. If you already have a composite scene in mind, move around to match it. I shot the tree in **FIGURE 5.23** from a nearby hill, for example, to capture a slightly higher vantage point and make it look right for the rest of the project demonstrated in Chapter 16. If you don't have a project in mind, give yourself flexibility by capturing a variety of images—also shooting in flat lighting whenever possible will let you paint more of your own desired lighting while editing.

- **Skies.** The perfect sky rarely pairs with the perfect landscape when I'm in the perfect position to photograph it, so I collect them separately and composite them together. Tilt your head back and take pictures of interesting clouds and skies any time you see them—cloud formations, rainbows, dramatic storm fronts, captivating sunsets. Sunsets come in handy for

FIGURE 5.22 Shooting buildings from various perspectives, even high up from the vantage of another building, as well as at unique times of the day provides greater potential for an interesting shot as a backdrop.

a variety of compositing uses, from color palettes and blending mode effects to boring sky replacements. **FIGURE 5.24** is a great example from Chapter 10, as I shot interesting wispy clouds pointing my camera straight up and composited them in at the horizon for an otherworldly look.

FIGURE 5.23 Trees at least stay still but need a good amount of coverage like buildings as lighting and POV changes the look dramatically.

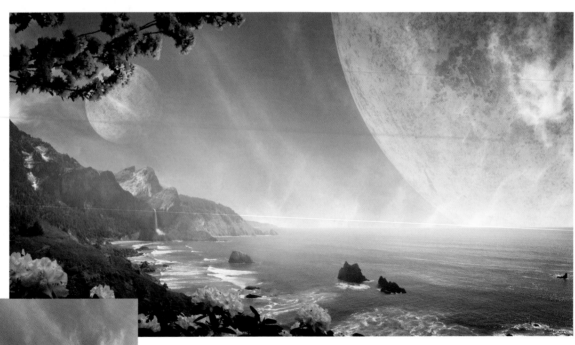

FIGURE 5.24 Interesting clouds and skies can be combined with other imagery in ways you may not originally think about, so shoot and collect whenever you come across something that has potential.

High-contrast scenarios such as sunsets and even high-lights on clouds can be hard to get right. One strategy is to always expose for the brightest elements. With a point and shoot you can usually do this by holding the trigger button partly while pointing it fully at the brightest area only; then without letting your finger go off the trigger, bring your camera back to the framing you wanted and click the rest of the way down (this of course works with other kinds of cameras as well). Smartphones will sometimes let you touch the spot you want to expose for and focus on, but again, each is different and the tech changes fast!

- **Animals.** Whether you are shooting birds, squirrels, or lions, proximity and posing are a challenge. Always be ready, and start snapping the shutter, preferably a fast one, as soon as you encounter interesting wildlife. If you have the opportunity, capture multiple points of view. Peering down from a lofty human height produces a very different effect than the skink-eye-level shot. **FIGURE 5.25** includes a squirrel photographed outside our kitchen window at just the right height for the composite in mind (granted, I now probably have well over 200 shots of this this twitchy critter). Remember though, wildlife needn't be wild; local zoos, farms, and even rescue shelters can yield the beast, fur, or hide you need.

Domestic animals are not typically any easier to photograph (unless they are sleeping). The shot of Bucksnort the dog in Figure 5.25 is a composite of perhaps ten different shots I took for this composite in a studio shoot with CreativeLive. Working in the studio does allow you at least to control angle and lighting. Pet owners and treats go a long way (but not that long!). Shoot fast, shoot frequently!

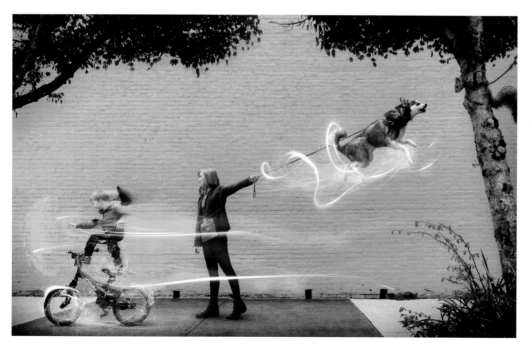

FIGURE 5.25 This image shot for a CreativeLive course had the added challenge of both domestic and wild animals. Honestly, the twitchy squirrel was quite a bit easier than the floating dog.

Light It!

Good lighting means good planning and control, whether it's by choosing the right time of day to photograph outdoors or creating a studio setup. Plan out the right angles to match the look of your shot to the rest of the scene. Good lighting preparation and consistency among your images lends power and credibility to composites.

For example, for the *Nature Rules* composite in Chapter 9, I needed to light and photograph a model (**FIGURE 5.26B**) to composite into an image of Montreal, Quebec, that I'd taken previously (**FIGURE 5.26A**). To help me, I enlisted my collaborator and friend Jayesunn Krump, an award-winning photographer and lighting expert. We based our plan to light the model on the lighting of the Montreal cityscape, getting just enough fill and key lighting and matching the angles of each (**FIGURE 5.26C**). Taking the lighting direction into account is vital. As Jayesunn explains, "The temperature and color cast can be adjusted in post-production, but you cannot readily change the direction of your light and shadows. Make sure that your shadows all fall in the same direction and are coming from the same relative direction with a consistent intensity."

FIGURES 5.26A, **B**, and **C** Start with an idea or example of the lighting you will be matching and plan accordingly. For *Nature Rules*, I used the initial city lighting (A) as a guide for the controlled studio shot (B), so the final composite blended credibly (C).

(A)

(B)

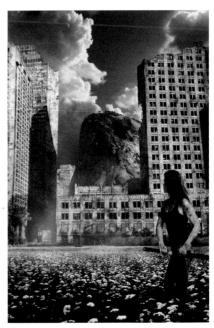

(C)

Diagraming your lighting setup can help you plan a better match. Making a top-down sketch of the lighting is just as important as sketching out your idea of the scene from the point of view of the camera. A view from above allows you to better see the lighting angles, almost as a 2D game of ping-pong. It doesn't need to be fancy, just play the angles! For example, **FIGURE 5.27** shows Jayesunn's lighting plan for one of his favorite location shots, *End of the Tunnel* (though because of the app simplicity, the diagram does not extend shadows accurately). As he explains it, "I set up a single flash unit with a Rogue FlashBender to camera right and aimed it toward the wall next to my subject. The light was bounced off of the FlashBender and lit up the tunnel wall and the side of the subject. I really like the way the hard light filled the scene and fell off as it traveled down the tunnel."

After you get the lighting angles arranged, you can adjust the quality of your light with light modifiers. Reflectors, diffusors, umbrellas, and even pieces of paper and foil can help modify and control the light to simulate various sources from harsh directional light to soft, nearly shadowless light (and everything in between). If you need to mimic clouds or other soft light, for example, try using diffusers to help spread out the area of the light source and soften the hardness of the shadows created by direct rays of light from a source point. I use an inexpensive 5-in-1 expandable reflector in most cases, but you can use nearly anything to control and shape your ambient light. Even the pros improvise; Jayesunn recommends inexpensive and readily available white-and-black foam core, because, "the white side makes an excellent reflector and the black is fantastic for soaking up light and deepening shadows."

The Traveler in **FIGURE 5.28** is another good collaboration project Jayesunn and I created together and an excellent illustration of lighting control through modifiers. We needed to have two light sources, a cool moon rim light and warm lantern key light, with very little fill outside of these two lights. With the lighting positions planned from a sketch of the scene, Jayesunn went with a warming gel and small softbox modifier to simulate the lantern and added a snoot over a white light above and behind to

FIGURE 5.27 Whether using a smartphone app or a paper sketchpad, try planning out the angles of your shot beforehand. This rough plan of Jayesunn's charts the angles from a top-down view.

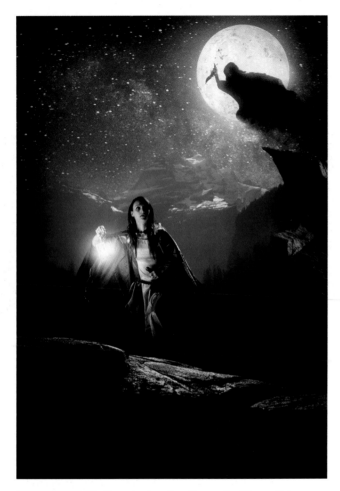

FIGURE 5.28 *The Traveler* is a shooting and editing collaboration with lighting expert Jayesunn Krump and myself. It was shot with precisely controlled and modified light sources in order to simulate a lantern's glow and full moon backlight.

simulate the moon. On the sides we used the black foam core flags (light blockers) to absorb some of those bouncing rays of light and create the dark night look. All in all our plan paid off and we had some great images to bring together in the final composite. For more of Jayesunn's work, check out JKrump.com.

> **NOTE** For a fun and free demonstration of the photo shoot and editing collaboration that produced Figure 5.28, you can visit the link https://youtu.be/SabKtN74TmE or search on YouTube using the keywords Traveler + Photoshop + Compositing. The tutorial should be towards the top of the search list. Disclaimer: Neither Adobe nor its affiliates is responsible for this video or its content, including out-of-date references, potential errors, or the two ridiculous collaborators and their nearly clever banter.

Conclusion

Strong composites come from strong photography. Get your source imagery looking good, and that's all there is to it. Okay, that's not quite all there is to it, but it's a good size portion of the compositing craft. Get control of your photo equipment, lighting, and raw files, and photograph everything to build a decent photo archive. If you do, you'll be well prepared for just about any idea that happens to jump in your head. After all, compositing is really an exercise in brain-photography: Capture and convincingly create the image that's in your mind!

TUTORIALS

CHAPTER 6

Prep and Organize Four Projects

The key to success behind every kind of composite is surprisingly simple: awesome prep work! You've already read how staying organized dramatically increases efficiency and avoids the general mayhem that can accompany a mega-sized editing process. This chapter puts that organizational theory into practice. You will learn about three categories of composites and practice the prep work needed for each. Along the way, you will create the starter files you'll need to complete the hands-on tutorials in Chapters 7, 8, 9, and 10. Think of it as setting the table now so you can dig into the meat and potatoes of the tutorials without delay.

Know Your Composite Style

To know how best to prepare for your composite, you need to know a little about the style of composite you're intending to make. I find composites generally fall into three categories, each of which benefits from a different type of prep work:

FIGURES 6.1A, **B**, **C**, and **D** Whether assembled from images in a photo palette (A, *Fire Play*), shots combined from a stationary point of view (B, *Good Kitty*), or images brought into Photoshop as tabbed windows (C, *Nature Rules*, and D, *Blue Vista*), projects benefit from organization and careful prep work before compositing.

- **Complex composites with multi-source layering, such as images requiring many pieces of textures or wide-ranging materials that have to be collected beforehand** (**FIGURE 6.1A**). In my setups, these images require a large photo palette. A photo palette is a separate file that contains all the components you may include in the composite. (I'll show you how to create one later in this chapter.) From this palette, you can then choose an entire image or only a small portion, like selecting and mixing paints on a traditional painter's palette. By

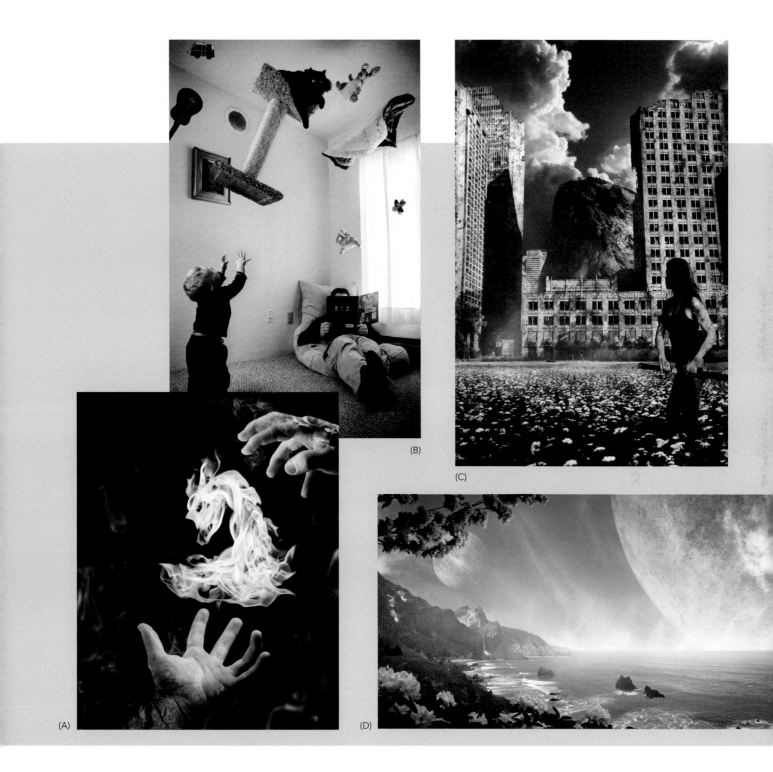

(A)

(B)

(C)

(D)

arranging all your pieces in one place, you can easily view your options before bringing images (or even small pieces of them) into the final composite.

- **Images mostly shot in one scene with similar lighting, positioning, point of view, and so on** (**FIGURE 6.1B**). Good Kitty featured in Chapter 7 is a prime example of this; all the shots needed for the project were captured at once, from one position and one lighting setup. Adobe Bridge is a better "palette" choice because it gives you better quality side-by-side comparisons and rating capabilities for your images. For these composites, you usually know the shots will fit; the question is which shots will have the best fit?

- **Composites needing fewer ingredients and layer options but still assembled from several different sources** (**FIGURES 6.1C** and **D**). These composites often aren't worth the time to create a separate photo palette. Instead, search for the choice images using Adobe Bridge and bring them in as either tabbed or floating windows within Photoshop to be used when ready. Tabbed windows (my default arrangement for multiple files opened at once, sometimes abbreviated to "tabs") are manageable up to a point in the workspace; my tipping point is once tabs can no longer be seen easily all at once. (The overflow items are listed on a menu accessed through the **>>** icon just to the right of the tab names.) These composites are also different from those shot in a single scene because the images may be spread across multiple folders rather than contained all within one folder.

> **NOTE** To open new documents in tabbed windows, open the Preferences dialog box (via the Photoshop menu on a Mac or Edit for PC users). From Preferences choose Workspace > Open Documents As Tabs.

Depending on your own style, you may mostly work within one or two of these categories, but they are all valuable to know how to prepare for as projects are not usually as straightforward as you first thought. From here on, I'll be walking you through my own way of prepping and organizing for each of these composite types. Following along with each will also get you set up with the right files for the next four chapters' tutorials, so be sure to get the resources needed and follow my lead.

> **NOTE** To download the resource files, register your book at peachpit.com/register. Sign in to your account (or create a new one) and enter the ISBN when prompted. You'll find download links on your Account page under Registered Products. See the introduction for more instructions. Because you are about to prepare materials for the next four tutorial chapters, you will need four folders of files: Chapter7_Resources, Chapter8_Resources, Chapter9_Resources, and Chapter10_Resources.

Creating a Photo Palette

For composites that are comprised of many different varieties of images or pieces of images, a good strategy is to have all your source images in one Photoshop document area. I used this workflow to create the *Fire Play* image in Chapter 8 (**FIGURE 6.2**). You can then draw image elements from that document, or photo palette, like paints from a traditional artist's palette, picking and choosing the perfect combination. Using a photo palette will also help keep your composite document clutter free, compact, and more manageable overall. Without a separate palette file, you're forced to choose between opening each image individually within Photoshop or bringing all the images into the final composite. Both of these

alternatives can produce messy, confusing, and overly cluttered workspaces.

With a photo palette, however, you can easily show or hide the visibility of each layer for identification, also see a thumbnail of the image for reference, and have the layer ready to select pieces from and copied at any moment. Yes, you could bounce back and forth from Photoshop to Adobe Bridge to look at whole images, but you'd also be missing the point as these larger projects sometimes require many smaller pieces and a lot of quick trial work to get the right look. Plus, you'd have to individually bring each image into Photoshop and the composite just to try it out, taking up precious time. Using a separate photo palette file, you not only keep all your images at your fingertips, you can also automate the process of bringing the images into Photoshop with actions (more on this in a moment).

> **NOTE** When possible, I like to work with two screens and a lot of RAM. This setup makes the photo palette an optimal workflow choice, because I have the room to spread out and can easily have two or more large projects open at once. Palettes do take both screen real estate and RAM to work perfectly but are ideal whenever possible.

The best way to learn is by doing, so in the sections that follow you will work through creating the photo palette you'll need for the tutorial in Chapter 8. (Be sure to download the Chapter8_Resources folder before you begin.)

Ferry Images into the Photo Palette

When loading a large number of images for compositing into your photo palette (such as the fire and smoke images), you can speed up your workflow either by using automated actions from the Actions panel or by using a

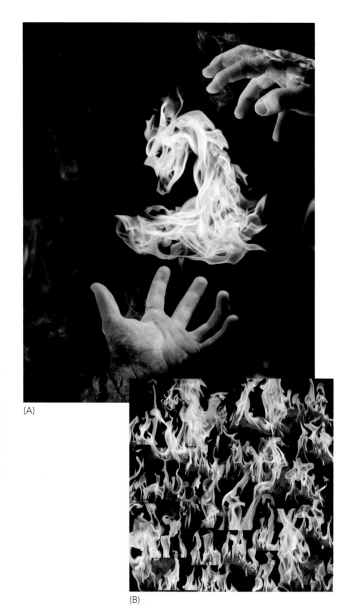

(A)

(B)

FIGURES 6.2A and **B** The prep work done in this section will get you ready to jump straight into playing with fire in Chapter 8, so it's well worth the time to do this right and not get burned later on! *Fire Play* (A) was created primarily from a collection of many images arranged in a single file I call a photo palette (B).

built-in feature within Adobe Bridge that imports a selection of images from a folder or collection as layers into a single Photoshop file. To use Adobe Bridge, select the images and then choose Tools > Photoshop > Load Files Into Photoshop Layers. Using the Bridge feature is quick and painless but at the same time doesn't have quite the flexibility of the actions method. For example, you can't bring in additional selections of images or edit an image individually before quickly bringing it into the palette. The actions method is Photoshop's robotic assembly line. Basically, you record a sequence of steps as an action, you assign it a name and keyboard shortcut, and then you can run the action to repeat the entire sequence with a single keystroke. Although both methods require a little preparation, they can also save you huge amounts of time in the long run.

To practice, in the following steps you'll create an action to copy and paste images into a *Fire_Play_Photo_Palette.psd* file, which you'll need for Chapter 8. You'll perform the copy and paste steps for the first image and then afterward expend no more effort than pressing a single key to bring in each subsequent image. To open the Actions panel, choose the Photo menu. Using actions requires very specific steps, so be sure to follow closely. If documents are in a different tab order or something else is clicked on once the actions begin, your results will definitely vary from mine. First, you will arrange your workspace for clean and easy action recording; then you will record the action.

> **TIP** If you prefer, you can skip using actions by selecting the images in Adobe Bridge and then going to Tools > Photoshop > Load Files into Photoshop Layers. This is especially helpful if you find actions to be a minefield of potential mishaps you'd rather avoid. If you do skip using actions, be sure to expand the canvas (press Ctrl+Alt+C/Cmd+Opt+C, and then input the pixel dimensions) and name and save this document using the same parameters as given in step 1.

WHEN TO USE ACTIONS

Actions can help you, but sometimes they offer more power than you need at a higher price of time up front—why rent an excavator to plant a handful of marigolds? Here are my general rules for moving and copying/pasting files into another document:

- Use the Place feature in Adobe Bridge (right-click an image and then choose Place > Photoshop from the context menu) when you want to bring one entire image (not just a piece of it) into the current composite as a Smart Object.

- Use the Move tool if you need to move fewer than three images. This includes dragging the contents of one image to that of another.

- Use the Marquee tool to select a *piece* of an image in Photoshop, and then copy (Ctrl+C/Cmd+C) and paste (Ctrl+V/Cmd+V) if you need to move between three and seven images.

- Record actions if you need to move more than seven images in a row. Using Photoshop's powerful action automation is a workflow godsend for repetitive procedures such as this.

1. In Photoshop, create a new document (Ctrl+N/Cmd+N) of 8000 x 8000 pixels so you can comfortably fit several layers side by side for comparison (**FIGURE 6.3**). Make sure you've chosen RGB Color from the Color Mode menu, chosen Black from the Background Contents menu, and set Resolution to 300 Pixels/Inch. Name the document *Fire_Play_Photo_Palette*, and click the Create button.

2. Make sure only the new *Fire_Play_Photo_Palette* document is open. If any other documents are open, close them now.

3. In Adobe Bridge, browse to the Chapter8_Resources folder; within it open the Fire folder containing the fire images. Select all the image files (Ctrl+A/Cmd+A), and then press Enter/Return to open them into Photoshop as separate document tabs (**FIGURE 6.4**). Find the subfolder named Smoke and do the same to bring the smoke images into Photoshop.

> **TIP** If you shot your own fire images in raw, select all the images once again (Ctrl+A/Cmd+A) in the Adobe Camera Raw editor (ACR) and then click Open (after you finish with raw edits, of course) to bring them all the way into Photoshop.

4. Without clicking any other document tab, switch to the original *Fire_Play_Photo_Palette* document using the tabbed window menu icon to the right of the tabs (**FIGURE 6.5**). Now you are ready to begin recording a new action.

5. Create a new action by clicking the New Action icon ▣ at the bottom of the Actions panel.

FIGURE 6.3 When creating a photo palette, use large dimensions that allow for enough room to spread out and look at several image layers simultaneously and efficiently.

FIGURE 6.4 My workspace preferences have Photoshop organize new or opened files as tabbed documents. The tabs are displayed in a row below the options bar.

FIGURE 6.5 The tabbed window menu comes in handy when you just plain run out of room for all those tabs.

6. In the New Action dialog box that appears, name your action Photo Palette Copy Paste. (Always use descriptive names; they're more helpful for future use.) The Function Key setting enables you to specify a keyboard shortcut to use to replay the action. Choose F9 from the Function Key menu (**FIGURE 6.6**). Take note that if you already have a shortcut set to F9, Photoshop will ask whether you mind bumping it for this new offering.

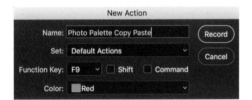

FIGURE 6.6 Creating a new action is like programing a robotic arm for a specific set of repetitive movements. You tell it what actions to take, and it remembers precisely.

7. After taking a steadying breath, click the Record button to begin. From here on Photoshop will record every step you take, so be mindful what you click and change!

8. Open the image tab to the right of *Fire_Play_Photo_Palette.psd*; then select the entire image (Ctrl+A/Cmd+A) and copy it (Ctrl+C/Cmd+C). If any of your flame or smoke images include adjustment layers or other multi-layer edits, make sure to copy and merge (Ctrl+Shift+C/Cmd+Shift+C) in addition.

NOTE Copying and merging lets you combine multiple layers into a single copy, but recording this process will result in a warning popping up when you play the action and Photoshop encounters an image that does not have multiple layers to copy and merge. If this happens, simply click Continue. Likewise, closing

a layer with edits will often generate a warning that the layer has not been saved before closing (closing is recorded in the step 9).

9. Close the document to return to the Fire_Play_Photo_Palette tab (be careful only to close and not click anything else).

10. Paste the copied image into the photo palette by pressing Ctrl+V/Cmd+V.

11. Change the layer's Blending Mode to Screen so that you can properly see all the flames or smoke without covering up others as you work. If you are unsure about this step, revisit Chapter 3 for a refresher on this blending mode.

NOTE Although changing the blending mode to Screen is helpful for this specific kind of composite (with a dark black background that you want to disappear), for other projects you may need the entire image to choose from as part of the palette. For these cases, changing the blending mode from Normal makes very little sense, so you should skip step 11.

12. Stop recording your steps by clicking the small Stop button ▢ to the left of the red Record button on the Actions panel. Your Actions panel will display your newly recorded action (**FIGURE 6.7**).

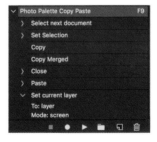

FIGURE 6.7 After you record an action, it displays in the Actions panel. If you did not need to copy and merge after copying, the action you created may be missing that step—not to worry!

13. Using the Move tool (V), make some visual room for the next incoming layer by moving the recently pasted layer out of the way—start in the upper-left corner (**FIGURE 6.8A**). As you use (in the next step) the action you just made, be sure to spread out your fire images so that they fill the entire canvas as shown in **FIGURE 6.8B**, and then do the same for smoke. We will organize a little more in the next section.

14. And now, the moment of truth! Try out your new action: Click the Play button in the Actions panel, and Photoshop will load the image from the tab to the right of the Fire_Play_Photo_Palette tab into the photo palette and close the image it copied, ready for the next image in line! For each new image, simply press the F9 shortcut (created in step 6) to load the next waiting image into the photo palette—workflow optimized!

> **TIP** As a somewhat easier way of playing an action that doesn't require remembering a shortcut or clicking the play button, try turning the designated actions into a button mode display. Open the Actions panel menu ▤; right there at the top is the Button Mode option. Toggling this shows the action names as easy to read and click buttons. For editing and other features, turn off Button mode.

15. Use this action for all remaining fire and smoke images, but remember to play the action only when the photo palette is the active tab. Whichever image is to the right of the currently active document tab will get added to that document tab, so make sure the active tab is the photo palette! Continue pressing F9 after moving the previously imported image until all the images are loaded and the palette is the only open document. Then get ready for some layer organization!

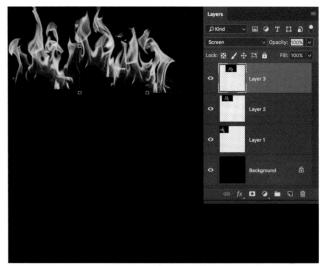

(A)

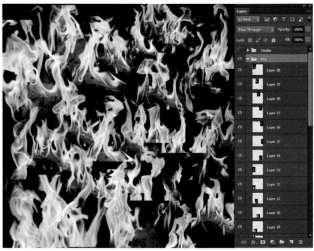

(B)

FIGURE 6.8A and **B** If you build out your palette with plenty of room for incoming images and each action iteration, you'll also make it easy to use as a palette.

Organize the Photo Palette

After you bring all the fire and smoke images into your palette, it's time to do a little housekeeping and optimizing for easier image selection. If you've already distributed all of the fire and smoke images across the entire palette, then you are off to a good start. Now it's time to do some layer management so the palette is useful as an artistic tool.

1. First, select all the smoke layers in the Layers panel. (Click the first smoke layer, hold Shift, and then click the last smoke layer to select everything between the two).

2. Put the layers into a group by pressing Ctrl+G/ Cmd+G, and name it Smoke (it will look like a folder on the Layers panel).

3. Repeat step 2 for the fire layers, housing them in a group called Fire (**FIGURE 6.9**).

Clearly labeled groups can help you more easily find the type of image you need. When evaluating the layers, isolate individual layers by Alt-clicking/ Opt-clicking the layer's Visibility icon. This will allow you to see just one layer at a time as a solo feature. The advantage is that no other layers clutter what you are looking at within that one layer. The downside is that you must again Alt/Opt-click the Visibility icon to make the rest of the layers visible.

FIGURE 6.9 Organize your photo palette by putting your images into groups.

TIP Photo palettes can be helpful but also chaotic. Try this for selecting specific layers when there is a bit of overlap: Right-click an image to open a context menu listing the layers overlapping that single point. If you, on the other hand, have a clear view of the layer without overlapping imagery, you can use the Move tool (V) and Alt/Opt-click the content to select the layer as if you had selected Auto-Select (found in the options bar).

Prep a New Document for Compositing

With the palette all ready to go, the next step is getting a new file document ready for your actual composite work. Although it's tempting to simply press Ctrl+N/Cmd+N and dive in, a little prep work will save you big headaches later. Your main composite document can benefit from the same attention you paid to organization and visibility in your photo palette. Try setting up the composite document for the project in Chapter 8 using the following steps to see what I mean.

1. Create a new Photoshop document (Ctrl+N/Cmd+N), and name it *Fire_Play*. Set Width to 4000 pixels, Height to 5000 pixels, and Resolution to 300 Pixels/Inch. Choose Black for the Background Contents setting and then click Create (**FIGURE 6.10**). Having a black background enables you to later play around with various opacities within the composite and not have to worry about white showing through.

FIGURE 6.10 When you create your main composite document, choose a size that leaves plenty of room for bringing in your high-resolution images.

TIP If you ever forget to set the background within the new document to black when you want white, or vice versa, when you create a new document, give this a try: Select the background layer over in the Layers panel and press Ctrl+I/Cmd+I to invert the colors

2. Next, set up layer groups or folders to organize the elements of your composite and help you find your layers when the project grows complex. Click the Create A New Group button ▢ at the bottom of the Layers panel to add a group to the document.

3. Double-click the layer group title to rename it something a bit more helpful, like Background.

FIGURE 6.11 Group your layers into folders with clearly identifiable names and colors.

4. Repeat steps 3 and 4 to create additional groups for Hands, Fire, Water, Bark, Smoke, and Effects.

5. Color code your groups, as well: Right-click near the layer's Visibility icon ⬤. From the context menu that opens, select a color for each group. When you're finished, your Layers panel will look like **FIGURE 6.11**.

 Color coding helps you find things just a little more efficiently and can keep you from putting something where it doesn't belong.

6. Save your file to the Chapter8_Resources folder; you'll need to whip out these fiery documents in Chapter 8.

Your photo palette and composite document are now prepped and ready for Chapter 8. When you get there, you'll see how this somewhat tedious work pays off huge dividends by the end. In addition, you can apply these same methods of building a palette to a wide range of composites with similar requirements of vastly different and numerous source material.

Rating and Filtering Images in Adobe Bridge

When working on a project in which nearly all the components are shot in one single location from one point of view (POV), with the same lighting set up, and so on, compositing becomes less about if images will fit in the same composite scene and more about which images fit the best for the desired composition. Chapter 7 is a good example of this kind of in-frame composite—plus there were more toys that were shot than used. You no longer need to create an entire palette to visualize and test out elements, because technically they all should work in some capacity. Because the images have so much in common, it then boils down to making yes-or-no decisions on individual shots within the series. Accordingly, the prep work for this type of composite involves rating images for the best composition options and filtering out the ones that don't work as well.

Adobe Bridge offers great tools for comparing and rating images and then loading the best into Photoshop (and the appropriate composite group) one at a time. Think of this as drawing from a loaded deck that's filled with all aces

and face cards. Play the right combination, and you'll do well. To demonstrate this preparatory process, I'll walk you through rating the image elements for the composite in Chapter 7 (**FIGURE 6.12**). This section shows the method

I used for this project, but I've already done it for you, so grab a refreshing beverage, sit back, and watch. You'll then prepare the composite file with the appropriate groups, names, and ordering hierarchy so you'll be all set to jump right in and play a killer hand in Chapter 7.

Download and Filter

Assuming you're following the photography advice from Chapter 5 and shooting your own images in raw with JPEG backups just in case, you'll need to do a bit of "pre-prep" before the main event in Adobe Bridge when preparing for your own projects.

Specifically, after shooting the elements for your composite, transfer the images from your camera's card into a descriptively named folder on your computer. If you start a naming scheme from the beginning, it will be easier to keep your composite organized.

Next, open Adobe Bridge, find the new folder, and filter out the JPEG images to leave only the raw files visible (**FIGURE 6.13**). Click the Filter tab, choose File Type, select Camera Raw Image so that only the raw images show up while browsing.

FIGURE 6.13 Filter out any JPEGs that made it into your folder as you want just the raw files; in this case they are my Canon's CR2 files.

FIGURE 6.12 The image elements for the *Good Kitty* composite (which you'll re-create in Chapter 7) were all shot in one session, so the prep work will mostly use Adobe Bridge.

Rating and Sorting

Adobe Bridge is made for browsing, rating, and sorting images (among some other pretty cool things, such as batch processing), plus it gives you quick access to editing them directly within Photoshop as you simply double-click an image to open it. When I first get a new batch of images straight from a shoot, I need to begin browsing through them to sort out the good from the bad. The star-rating feature of Bridge is all too perfect for this stage. The method I use to rate and choose the best images for a project is:

1. In Adobe Bridge, browse to the folder where you've stored your freshly captured images.

2. Choose Filmstrip from the menu of workspaces at the right end of the application bar (**FIGURE 6.14**). Setting your workspace to Filmstrip provides a nice horizontally scrollable series of the images in the selected folder, as well as large previews of selected images for better assessing and comparisons.

3. Go through your images, looking for those that have potential to work in your composite and those that just don't. You'll also find the inevitable on-the-fence images that have to be tested in certain image combinations. Rate all these images by clicking a one- through five-star ranking beneath the image thumbnail or by pressing Ctrl+1/Cmd+1 through Ctrl+5/Cmd+5 while a thumbnail is selected (**FIGURE 6.15**).

4. Filter the images to show only the best results. For example, press Ctrl+Alt+3/Cmd+Opt+3 to show all images rated three stars or better. Alternatively, you can choose a rating from the Filter Items By Rating menu, marked by the star near the right end of the path bar.

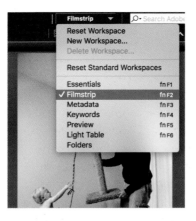

FIGURE 6.14 Change your workspace to Filmstrip for helpful side-scrolling lists and large image previews.

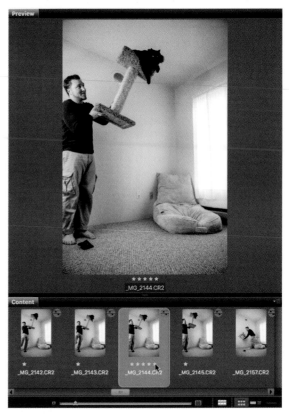

FIGURE 6.15 Rate the images in Adobe Bridge for better sorting and filtering abilities.

5. With only the best of the photo-shoot showing from the star rating filter, you can also do some early grouping by category (good cat shots, toys, and so on) with stacks, even keeping within Bridge. For the example, I selected all of the potential cat shots for *Good Kitty* by Ctrl/Cmd-clicking and then grouped them into a single stack by pressing Ctrl+G/Cmd+G. This does not bring them together in a new folder like grouping in Photoshop; instead, it produces a stack like in **FIGURE 6.16**. The number 3 in the upper left refers to the number of stacked files within the group. Notice how the files condense once stacked. To expand them within a stack, click the small upper-left number.

FIGURE 6.16 Group your similar images into stacks while working in Adobe Bridge. Here I stacked three potential cat shots together for later editing.

TIP Use the Collections feature in Adobe Bridge to gather files that share common traits into a virtual folder. This lets you view the images together in one location without actually moving them on your hard disk. To create a collection, select some files in Bridge and click the Collections tab. Click the Create A New Collection icon, and click Yes in the confirmation dialog box. While the new collection's Name field is still selected on the Collections tab, type a name for the collection. Add more files to a collection by dragging them onto the collection's icon.

To expedite the process of re-creating *Good Kitty*, I previously rated and sorted the necessary images (found in the Chapter7_Resources folder). To be thoroughly ready for the tutorial in Chapter 7, however, you will need to load these into a composite document.

Prepare the Composite

Preparing the composite document for a project that will rely on Adobe Bridge rather than a photo palette is similar but a bit simpler. To practice, you can create the composite shell you'll need to complete the Chapter 7 tutorial.

1. Open Photoshop, create a new document (Ctrl+N/Cmd+N), and name it *Super-Person*. Set Width to 3456 Pixels and Height to 5184 and then click Create. Although this number may seem somewhat random, it is the full resolution of the original files. (An alternative is to simply open your intended background image and begin just as easily from there.)

2. In the Layers panel, click the Create New Group icon five times to create five groups.

3. Double-click each folder's name to rename that group for the category of image it will hold: Reader, Super Person, Toys, Cat, and Effects (**FIGURE 6.17**).

4. Save the file in Chapter7_Resources, so you can be ready to pull it open again during Chapter 7.

FIGURE 6.17 Always set up groups to keep your image elements organized. You'll need these folders for Chapter 7.

Few Pieces, Big Payoff

Not all composites are about stitching together a plethora of many small pieces of similar material or about getting all material from one photo shoot. Sometimes you need only a few pieces to combine into a strong image. **FIGURE 6.18A** (re-created in Chapter 9) and **FIGURE 6.18B** (re-created in Chapter 10) are both good examples of composites made from my image archive and collections I set up in Adobe Bridge.

As I have already picked out the main images for these composites, your prep work here will focus mainly on organizing the composite files into groups that correspond to the visual depth of each respective composite. In this sense, some composites are more like a burrito, with the ingredients all mixed up and blended together, while others definitely need individual layering like a sandwich. In the end, paying attention to which objects must be seen in front and on top of another object and then ordering your layers to match will help you finesse the composition to perfection and ensure the best results.

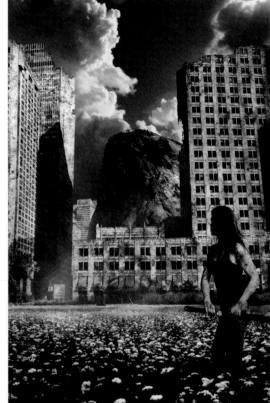

(A)

FIGURES 6.18A and **B** *Nature Rules* (A) and *Blue Vista* (B) are both composites that look complicated but required very few source images and equally little prep work.

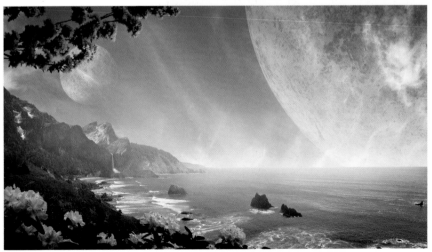

(B)

Nature Rules

You can practice keeping your layers in viewing order with the source files for the Chapter 9 project. Because creating groups always builds from the bottom up, here is the order in which you should create the groups knowing that the last group will end up on top of everything else as shown in **FIGURE 6.19**.

FIGURE 6.19 Here's the layer order needed for Chapter 9. Take note of which are on top and which are at the bottom as this matters in the final composite.

Each of these groups will have several layers and adjustments (and sometimes many such layers) that will be part of each group you just created (as you will see in Chapter 9), but what's really amazing about organizing your project by viewing-order grouping is the ability to keep the compositional placement of everything nondestructive right up until the end. Keeping each element in its own group based on depth will allow you to adjust, move, and transform each element until it all fits properly in the end, much like putting large sections of a jigsaw puzzle together for those final connections. Jump right in and try.

1. Download the *Chapter9_Resources* file, if you haven't already. You'll find all the source images for the Chapter 9 composite are in their respective sub-folders (named slightly different than the composite groups): Subject, City, Clouds, Mountain, Meadow, and Textures.

2. Create a new document (Ctrl+N/Cmd+N) and name it *Nature_Rules*. Set Width to 2667 pixels and Height to 4000 pixels to match my own composite's dimensions (although any 2 x 3 ratio will do). It's always a good practice keeping the resolution at 300 ppi in case you ever want to print your work. Click Create.

3. In the Layers panel, Alt-click/Opt-click the Create A New Group icon and enter "Sky" in the Name field in the New Group dialog box.

4. Repeat step 4 five times, naming the new groups in the following order: Mountain and bg City (for the mountain and background city), Main City, Meadow, Subject, and Effects. Notice that the first folder you created (Sky) appears at the bottom of the layer stack in **FIGURE 6.20**.

5. Save this project file in the same Chapter9_Resources folder to make sure all the source images and prepped files are altogether—no panicked hunting them down in a few chapters! Keep everything easy to find.

FIGURE 6.20 These groups will help keep the composition adjustable right up to final effects.

Blue Vista

The final composite of Section II, *Blue Vista* has some similarities in setup to *Nature Rules* with one notable difference—file size. Although both composites are similar in setup and layer ordering with groups, the big difference (aside from imagery) is file size. *Blue Vista* uses several 42-megapixel images and many Smart Objects as well, which tends to bloat a file dramatically. If created at the same dimensions as my original composite (**FIGURE 6.21**), the final results of Chapter 10 may be over 2 GB and need to be saved as a PSB (or TIFF) file due to the various Smart Object shenanigans going on here. If you find that the dimensions I give are too taxing for your system when the layers, adjustments, and Smart Objects start adding up, feel free to scale the entire image down by a third or even half by choosing Image > Image Size (Ctrl+Alt+I/Cmd+Opt+I). Be sure to keep the same width and height proportions if you do decide to downscale this planet-sized image (more on this in Chapter 10). Without

further ado, let's get this thing cooking! Or at least set the table as it were.

1. Just as the previous tutorials began, start by downloading the *Chapter10_Resources* file. After you open it, you will again find the imagery grouped into folders.

2. Create a new document (Ctrl+N/Cmd+N) and name it *Blue_Vista*. Set Width to 8809 pixels and Height to 4894 pixels, and make sure your resolution is 300 ppi. If you do resize this project in the future, notice that it is a 5 x 9 ratio; this will help you keep the same look as mine while you work. Click Create to finalize your settings.

3. Create your groups in the layers panel—this time there are four main groups based on depth: Background Sky (bottom group), Middle Ground Land & Sea, Foreground Flowers, and FX. After creating your groups, rename as shown in **FIGURE 6.22**.

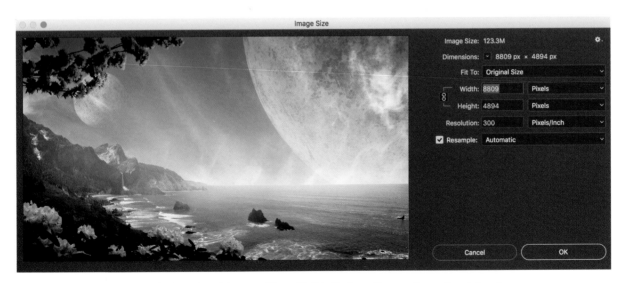

FIGURE 6.21 If Photoshop is having a hard time working with this file (usually experienced as delays in response and slight glitches), be prepared to resize it once you have jumped in to Chapter 10.

TIP If you Alt/Option-Click the Create A New Group icon ▢ , a dialog box will prompt you to input a name with each iteration. This method can be helpful for those times that you need to carefully include a name right from the get-go.

4. Now save this right quick so you can get on with the fun parts! Make sure the location is the same Chapter10_Resources folder where the other content for this project is hanging out, just waiting for you to play with.

Conclusion

I can't overstate the importance of having an image that is well organized from the start. Going back through my older projects is like looking at work done by someone stumbling in a dark room. Or maybe a cave. Although the end results still looked fine, nothing in my old composites makes any kind of sense organizationally, and the time I needed to make those old relics was ridiculous—exponentially longer than my current well-lit workflow. The hours of editing and finessing were a chaotic and frustrating experience I urge you to avoid partaking of yourself. Instead, embrace my revelation of the importance of being properly prepared early in the project. Think about what your project will involve—a complexity of images from disparate sources, many images shot under the same conditions, or relatively few source images—then choose the best method of prep work for the task ahead. In all cases, use groups to give your Layers panel structure and organization. Imagine your composites are like a bike trip: Do the heavy uphill pedaling first, and you'll find the rest to be downhill coasting and a lot more fun.

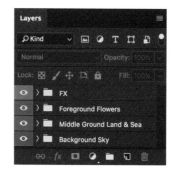

FIGURE 6.22 Organize and color code your groups for both easy viewing and depth purposes. Remember, the more distance something is from the composite's foreground, the lower in the layer stack it should go.

Making a Super Composite

A successful composite is all about verisimilitude: Even though we know it's not, we should feel the image is real. The composite should encourage us to suspend our disbelief and be enthralled with what we see. To do so, the image has to look just "right" and not distract with technical tell-tales. Photography's realism can lend credence to the new reality you construct from pure imagination, but it's no replacement for good Photoshop skills. Exceptional masking, color adjustments, curve adjustments, lighting, and even cloning all play a part in convincing viewers to believe.

Seamlessness and continuity are your foremost goals. In this project, based on an image from my Raising a Super-Child series (**FIGURE 7.1**), you'll practice making good selections for well-crafted masking, refining color and curve adjustments, balancing light for eye-flow, and even cloning pieces that need to be hidden or reconstructed. With these elements in your control, who needs superpowers?

Begin with the Background

Planning ahead pays off: Open the *Good Kitty.psd* composite file you created in Chapter 6, and you'll be all ready to start this chapter's example project. As you remember, the group folders for the composite (starting from the bottom of the layer stack) are Reader, Super-Person, Toys, Cat, and Effects.

▶ **FIGURE 7.1** In *Good Kitty*, I gave my son superpowers and our cat one more thing to put up with. When you combine multiple everyday shots into a new world like this, be mindful of continuity and seamless compositing.

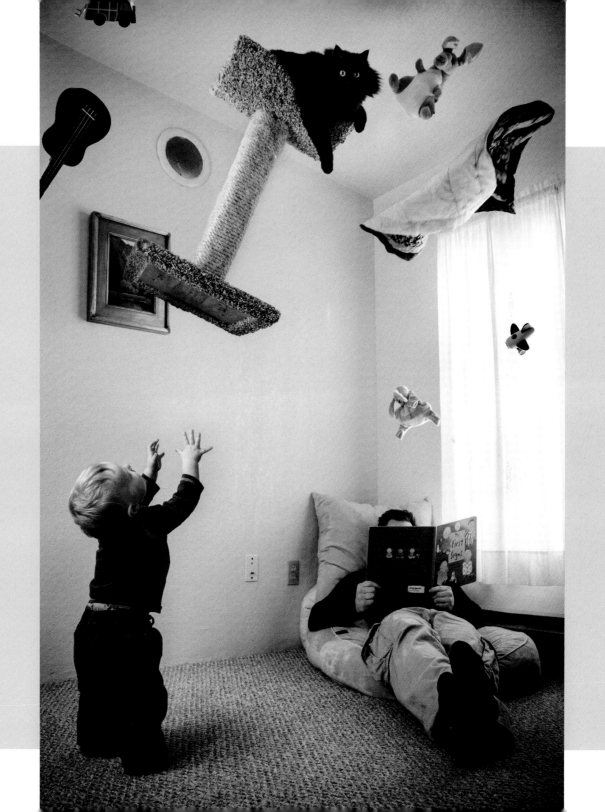

If you did not complete the prep work in Chapter 6, take a few moments to do so now. You'll find instructions on how best to prepare files for a composite like this in the section "Rating and Filtering in Adobe Bridge" and the steps for building the *Good Kitty.psd* file in the section "Prepare the Composite."

> **NOTE** To access the resource files from Peachpit.com, see the introduction for instructions.

To begin the composite, lay down your foundation: the main background image. When choosing a background, make sure it contains the essential base elements for your scene but is otherwise clutter free.

1. In Adobe Bridge, browse to *Reader.jpg* in the Chapter7_Resources folder. Because everything is happening around and on top of the jaded parent reading in the corner of the empty room, this image works well as the main background.

FIGURE 7.2 Right-clicking a thumbnail and choosing Place can save time and keep your workspace fairly tab free.

2. Right-click the thumbnail for *Reader.jpg*, then choose Place > In Photoshop from the context menu (**FIGURE 7.2**) to load the image into the active Photoshop document (*Good Kitty.psd*) as a Smart Object.

Using Place from Bridge works for the composite background image because you want the entire layer and not just a piece of it. If you used Place for all the layers and depended on large masks to hide the unwanted portions, the file size would get dramatically more cumbersome because you'd be saving quite a bit more data that you don't even need. So use the Place technique only when you need an entire image or at least the majority of it.

3. Back in Photoshop, press Enter/Return to place the image in the *Good Kitty* file. Drag the new layer into the Reader folder at the bottom of the layers stack. Again, this will be the base image so all other layers must be above it to be seen.

Paste the Pieces in Place

With the background in position, you can roughly block out the positions of the composite's other elements by pasting in the various pieces. After loading the pieces, you can make selections and masks as needed. One reason for holding off on the selections and masking until later is that not all the objects may work within your composite—a fact you may not discover until you start positioning (and repositioning) the pieces. Why put all that time and energy into selecting and masking, if it's potentially a no-go for that element? Sometimes you may need to do a rough initial mask right after bringing in an element, especially if it has parts that will interfere with seeing other elements at the same time. Don't, however, waste too much time with masking until you get the pieces in and know they will work with what you

have in mind. (For the example, I've simplified the process enough that you can mask afterward with little problem.)

1. Browse to the Toys folder of the Chapter7_Resources folder, and open *Rabbit.jpg* as a separate tab (**FIGURE 7.3**). As you may remember from Chapter 6, these tutorials expect you to display images as tabs rather than in individual windows.

2. Use the Rectangular Marquee tool (M) to draw a small rectangle selection around the bunny. (To make the necessary portion easier to select, I've blurred out the irrelevant areas.) Copy this section with Ctrl+C/Cmd+C. Be sure to select and copy more than you think you actually need. When it's time to mask, you don't want to discover you missed a piece—as can happen with tighter selections. Going back for more is quite the pain.

3. Switch back to the main composite file. Before you paste, select the Toys group folder so the layer you're about to add will end up where you want it. Now use Edit > Paste In Place (Ctrl+Shift+V/Cmd+Shift+V) to paste the bunny into the composite in the same position it occupied in the original, thus matching the location exactly. Close the *Rabbit.jpg* file once you've copied and pasted a usable section of it.

For a project like this in which all elements were shot in the same room under similar conditions, Paste In Place is a good way to add each object as it makes sure the lighting and backgrounds match appropriately. With a good selection, you can always move each object, but this method provides a good initial reference for matching and adjusting the pieces to perfection (**FIGURE 7.4**).

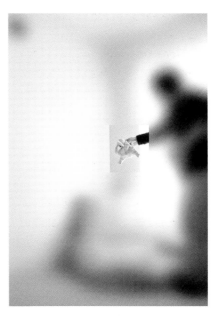

FIGURE 7.3 To help you make your rough selections more quickly, I've isolated the relevant areas of the source images and blurred the rest.

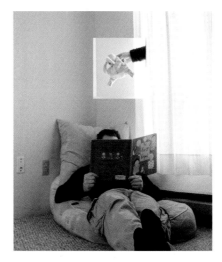

FIGURE 7.4 Paste In Place is the ultimate way to get the pieces in the right spot without having to bring in cumbersome full images, nor having to nudge the small piece into position until it fits.

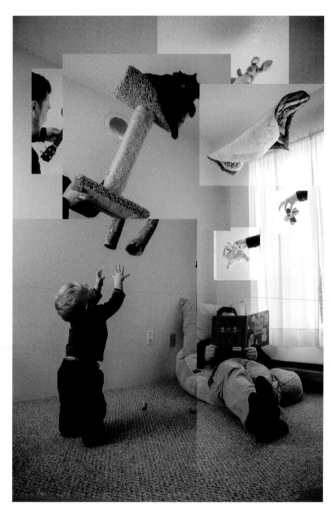

FIGURE 7.5 Block out the main objects in their original placements before further alterations. It's good practice to first place everything as close to where it was originally shot as possible and then to shift objects around later and only as needed.

4. Repeat steps 1 through 3 for the remaining elements from the Toys, Toddler, and Cat folders (**FIGURE 7.5**). Feel free to try your hand at some detail work with the ring-stacking toy on the floor (*Objects_and_Toys_5.jpg* through *Objects_and_Toys_14.jpg*, which I skipped in my own version). Also, make sure that the Cat (whichever cat image you chose) and Toddler layers are in their own group folders—and don't forget to label your layers as you work!

Remember, this is just a starting point for editing your composition; you can shift elements around more to your liking later.

> **NOTE** You may notice that not all shots align perfectly at times, whether from a toddler bumping your tripod or just from the force of your intense shutter release press. Careful selecting and masking will be able to save these elements just fine. Get the pieces close, and don't sweat the small things too much at this phase!

Select, then Mask

In most cases, it's a smart idea to get a good selection before masking anything (Chapter 12 covers some of the exceptions). Small objects, especially, benefit from this approach, which is why you'll be working next on the selections and then the masks for the floating toys.

The composite may still look pretty "off" at this phase, but don't lose heart. Because you're focusing on selections and masks only, the ever-changing lights, darks, and colors won't match yet. The day I had for shooting was partially cloudy, making shooting "consistently" a moving

target as the natural light I wanted varied wildly from moment to maddening moment. The result, as you can see, is that even with studio lighting fairly consistent coming from the left and then natural light flooding in through the window on the right from outside, each shot has its own subtle variation. You'll adjust the finer points to match the background lighting in the "Adjust Curves and Color" section. For now, concentrate on getting some good selections and masks. For each object, it's a good idea to turn off the visibility of the others around it as you work on this part.

1. Begin once again with the rabbit toy: Select the layer containing the rabbit, pick up the Quick Selection tool (W), and drag it around inside the bunny body to select it (**FIGURE 7.6**).

FIGURE 7.6 Select the rabbit with the Quick Selection tool (W), but be careful not to include the hand.

> **TIP** If the Quick Selection tool proves too difficult to use against a similarly colored background, try the Magnetic Lasso tool as this sometimes has better luck tracking a line/edge.

2. If the tool mistakenly grabbed some of my hand or the back wall as part of the creamy rabbit fur, press and hold the Alt/Opt key to toggle Quick Selection to subtraction mode and then Alt-drag/Opt-drag to deselect unwanted areas. Work a little at a time, toggling between selecting and deselecting. With each pass of this back and forth process, Photoshop refines its edge detection, trying harder to see what you might be seeing.

> **NOTE** If you're not getting the results you want, don't hesitate to try another selection method (see Chapter 2 for more). Find the one that works better for your techniques and workflow. Whether you're lightning fast and accurate with the Magnetic Lasso or prefer to paint what you want with the Quick Selection mask (Q), find your groove.

3. After everything is selected, click the Select and Mask button in the options bar to open the Select and Mask interface. Here you can make a range of selection adjustments including ways to avoid two of the most common masking problems: the abrupt sharp edge and the halo surrounding the object you are trying to select.

4. In the Select and Mask workspace, change the Feather slider to about 0.8 to soften those hard selection edges just enough to match the natural blur of the image. Any variation from the natural lens blur will contribute to making the composite look fake, like a collage cut out with dull scissors, rather than a seamless composite (**FIGURE 7.7**).

5. Set Shift Edge to –40 to pull the selection edge inward by 40. This will help avoid a halo of unwanted background pixels, which would become intrusively obvious if you moved the bunny to another location. Click OK when you're satisfied with the selection.

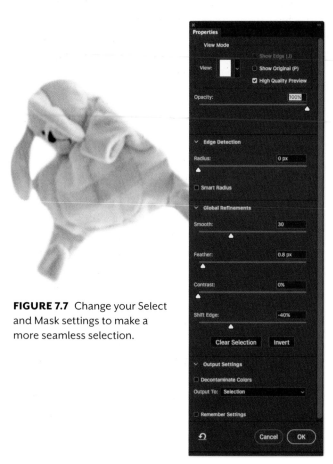

FIGURE 7.7 Change your Select and Mask settings to make a more seamless selection.

TIP For selections that get a little choppy with sharp and inconsistent edges, try slightly increasing the Smooth setting within the Select and Mask taskspace. This will help even out these small variations by averaging the path of the selection edge. Use Smooth in moderation, however, as too much can start making a big, rounded blob of a selection, especially in selection nooks and crannies!

Task Masker

With the initial edge refining done, your next task is to get the mask looking sweet and seamless. Because you took the time to perfect your selection, this part will be easier: Simply apply a mask and then paint with black for the remaining parts that need some fudging.

1. Click Add Layer Mask ◼ at the bottom of the Layers panel to convert your selection into a mask. The result may not be perfect, but it's a pretty good start that you can paint into shape.

2. Choose a soft, round brush with Size set to 10px and Hardness to 0. With full-opacity black, paint away the parts that stand out, such as the area with a little pink from my hand (**FIGURE 7.8**).

3. As is sometimes the case, Shift Edge took a little bit too much off in a few other areas, so you need to paint those back in with white. Keep the same brush properties, but press the X key to switch to white. Paint the necessary areas back in. If you return too much, just press X to swap to black to paint it out again.

FIGURE 7.8 Paint out the remaining pieces that still draw attention, like the pink halo that remains from my hand.

That's one toy done! Repeat the selection, refining, and masking steps for each of the flying objects. Don't worry that you can't totally mask out the hand holding the bottom of the cat's scratch post; you'll address this with the Clone Stamp tool in the "Clone This" section. For the cat's hair and the post's carpeting, try the Refine Edge Brush tool found in Select And Mask. Originally designed for selections like hair, it does fairly well on a range of materials with fine details along the edge. (Chapter 9 digs into this tool in detail.)

> **TIP** To isolate the layer you're working on and better see your adjustments, turn off the visibility for other layers by clicking the Visibility icon ⊙. I recommend this, especially for parts that overlap and conflict. To solo a single layer completely, Alt-click/Opt-Click this "eye-con" for the layer you want to keep visible, and all others will have their visibility turned off all at once—just don't forget to again Alt-click/Opt-Click the same eye to bring them all back.

Kiddos and Shadows

The toddler truly does have superpowers in this composite: His mask must be seamless and believable to sell the image's conceit. If it isn't, the entire image falls down around him. Luckily, getting this crucial piece right is easier than the rest of the masks in many ways.

For your own project, always be on the lookout for the critical pieces that break the verisimilitude of the scene. Perhaps the most common example within composite work is the shadows around the feet of a subject. Unlike with floating objects, which usually do not cast any obvious shadows, our eyes instantly know when shadows of something touching the ground are off. For such critical pieces, we need to take a different approach to masking, something a little smoother and trickier: a transitional mask that is painted rather than selected.

1. Without selecting anything at this point, add a mask to the Toddler layer using the usual Add Layer Mask button ▢.

2. Select the Brush tool and pick up the same soft, round brush, but change its Size to 100px in the options bar and paint black on the mask to soften all the visible edges. This will ensure that there is no digital grease buildup (edges are easy to forget about) from painting this layer's mask. After getting rid of the hard edges from pasting, change the brush size to 500px. This larger brush enables you to paint with an even softer radius that provides an even feathering and transition from one image to the other as you mask—the larger the soft radius, the smoother the transition. Paint with black the outside of the toddler and his shadow using the mask of the layer. Be extra careful not to mask out part of his shadow or hands, however; this would undercut the realism you're after (**FIGURE 7.9**).

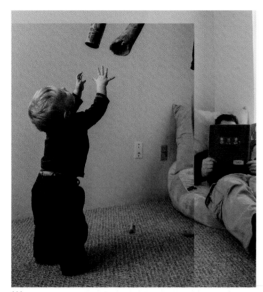

(A)

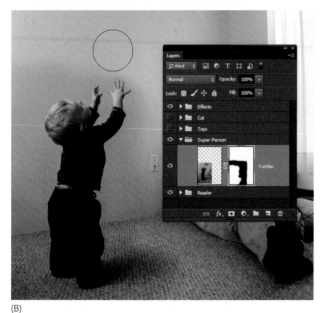

(B)

FIGURE 7.9 Mask out the hard edges (A) created from pasting—and be sure to use a soft brush at 100px. After removing the sharp edges, get the smooth transitions just right using a carefully finessed brush with the size of 500px (B).

3. Decrease the brush size again to 300px (press the [key), and paint around the fingertips. You need a small enough brush to get between the elements you want (the hands) and those you don't (the didgeridoos they reach for), but a large enough diameter for a soft transition from the Toddler layer to the background.

> **TIP** While photographing my son Kellen for this project, I quickly learned that making an awesome game out of the session is the way to go. Catching the right mood is vital. If your toddler model isn't feeling it, don't even think about trying to shoot. Reschedule, seriously.

Adjust Curves and Color

As mentioned earlier, despite careful planning for consistent lighting when shooting source images, sometimes you can end up with minor and even dramatic variations between shots. Even with a consistent lighting setup inside, ambient natural light may change as the day progresses. Or maybe your studio is like my house, where a heavy power load in another area noticeably drains the lights. (Tip: Never attempt a photo shoot while your washer and dryer are churning.) You could correct these differences in Adobe Camera Raw, true, but what if you don't have that option? Perhaps you're working with JPEG files supplied by a client and don't have the same raw data file to work with. Curves and color balance adjustments are the answer. Remedying exposure inconsistencies is an incredibly important skill to develop, and the *Good Kitty* composite gives you plenty of opportunities to practice.

1. The toddler commands the viewer's focus, so concentrate on fitting that layer into the composite first (**FIGURE 7.10**). Click the Toddler layer, and add a Curves adjustment layer ▦ from the Adjustments panel.

2. Clip the adjustment layer to the Toddler layer so that it does not affect any other layers during the adjustment: Click the Clip To Layer button in the Curves Properties panel ⬚ or Alt-click/Opt-click between the Curves adjustment layer and the Toddler layer. You will notice the cursor change from the pointer hand to a slashed down arrow next to a white rectangle (newer versions) when you hover between the layers; when you see this cursor change, it means that once you click, it'll clip that adjustment layer to the Toddler layer.

3. Add a control point in the middle of the curve and make a gentle adjustment upwards. Take a look at **FIGURE 7.11** and notice how little is changing; yet that masked edge simply disappears (well, aside from color differences).

 To better finesse the Curves control point, click a point to turn it solid black (which indicates that the point is selected) and then use the arrow keys to nudge it into just the right spot. To match the example's settings, enter 172 in the Input field (represented by the bottom gradient) and 192 in the Output field (represented by the side gradient); you will find these fields directly below the curve and histogram graph (you may need to expand the Curves Properties panel downward to see these).

Color Control

Curves help immensely but aren't the total fix. The color is still a bit off. When the reading dad was photographed, the light was a warmer temperature than when the toddler was photographed. The difference isn't dramatic, but like most things when compositing, it all adds up in the end! You can correct for this sort of color shift with a simple Color Balance adjustment in no time at all.

FIGURE 7.10 Notice how the lighting in the Toddler layer differs from that of the background? With one Curves adjustment, it will become nearly invisible.

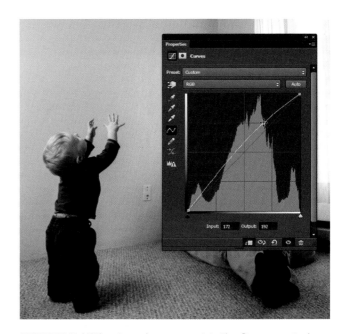

FIGURE 7.11 Without much movement to the Curves control point, you can successfully make the dark edges along the mask disappear.

1. Add a Color Balance adjustment layer by clicking the ⚖ icon in the Adjustments panel. Make sure this layer is above the Curves adjustment layer. As a rule, I try to always adjust color after a Curves adjustment because adjusting lights and darks will also affect the color with saturation changes.

> **TIP** To use a Curves adjustment layer without it changing the saturation along with the contrast, switch its blending mode to Luminosity. This doesn't give as refined control as a Color adjustment layer, but it does provide fantastic consistency with the existing hue and saturation.

2. To clip the Color Balance adjustment layer to the Toddler layer, select it and then press Ctrl+Alt+G/ Cmd+Opt+G or use whichever clipping method you prefer for your workflow (**FIGURE 7.12**).

3. Within the Color Balance Properties panel (double-click the Color Balance adjustment layer thumbnail to pull this up), make sure the Tone menu is set to Midtones, and then shift the color sliders to make the cools in the Toddler layer become just a hint warmer. Watch the wall along the edge of the mask as an indicator as you adjust. If one layer's wall is a little more yellow, then the other layer's has to match (even if these are masked out because you're not adjusting only the walls for better matching here, but the subject as well). For the example, I settled on +4 for the Cyan-Red slider, 0 for Magenta-Green, and –8 for the Yellow-Blue slider, moving it closer to yellow (**FIGURE 7.13**). Clicking the Visibility icon 👁 repeatedly on the Color Balance adjustment layer will give you a closer look at the before and after for this adjustment.

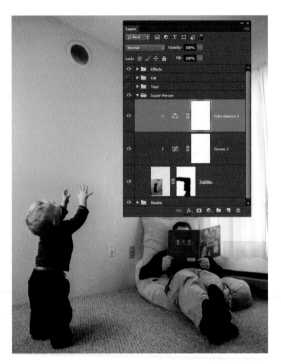

FIGURE 7.12 Make sure that both adjustments layers are affecting only the Toddler layer by clipping them to it.

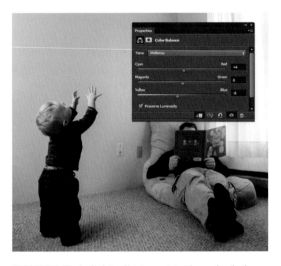

FIGURE 7.13 A slight adjustment to the color balance of the Toddler layer matches it with the background.

Fix a Group of Toys

That's the lighting and color fixed for one source element, but there are still lots to go, right? Yes, but here's the good news: In Photoshop CS5 and later, you can clip an adjustment layer to an entire group folder, meaning you can adjust the layers it holds all at once instead of one at a time. This solution works for the Toys folder because all the toys were shot while the sun blasted through that side window, flooding the room with light. The toy layers all needed to be knocked down some shades and desaturated at the same time. Although a couple layers in there still may need further adjusting, clipping Curves and Color Balance adjustment layers to the Toys group folder will improve the layers to a pretty close match of the background image.

> **TIP** As an alternative to clipping to an entire folder, give this a try. If you change the blending mode of the group folder from Pass Through to Normal, all unclipped adjustments within the folder have the same effect of being clipped. This can create a few complications and limitations at times—but also has advantages, such as being able to change the adjustment layer order within the group and not have it affect certain layers that are above it!

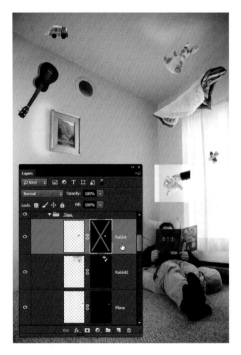

FIGURE 7.14 Temporarily disable the rabbit's layer mask by Shift-clicking the mask.

1. The rabbit is once again a good starting reference. Even when you plan to alter an entire group, it's a good idea to focus on one layer that is representative of the lights, darks, and coloring of the others. Start by temporarily disabling the mask of the rabbit so you can better see that background wall you need to match up. Shift-click the thumbnail of the Rabbit layer's mask. A red X appears across it, indicating that it is temporarily disabled (**FIGURE 7.14**).

2. Add a Curves adjustment layer (click the Curves icon), and place it directly above the Toys group folder; now your adjustment will affect all the toys in the group rather than just one literate rabbit. Clip this layer to the group folder by pressing Ctrl+Alt+G/Cmd+Opt+G.

3. Open the Curves Properties panel (double-click the Curves adjustment layer thumbnail), and create a control point in the very center with one click along the diagonal line. Drag the point straight down until the rabbit's background wall matches the values (lights and darks) of the background image. You will notice again that changing the curves also changes the color (unless of course you change the blending mode to Luminosity, but there will still be slight adjustments to make regardless because the brighter lighting also made the toys more saturated to begin with). So, after adjusting the Curves, ignore the bad saturation for now; just focus on the darkness of the wall (**FIGURE 7.15**).

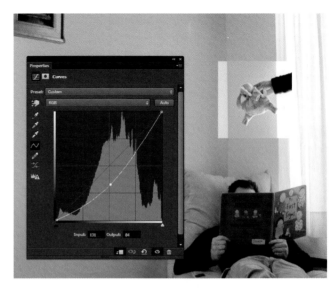

FIGURE 7.15 Match the values with curves first before adjusting color; make sure that the walls have the same lightness or darkness.

4. To make that wall a lot less yellow, create a new Hue/Saturation adjustment layer (click the 🔳 icon in the Adjustment panel), place it above the Curves adjustment layer, and create a clipping mask as explained in step 2. With this new layer you can quickly control the saturation for all the layers in the Toys folder.

5. Double-click the new layer to open its Properties panel if it is not already open and then move the Saturation slider to the left to –46, which seems to be the sweet-spot for controlling that vibrant yellow that came out of the previous Curves adjustment (FIGURE 7.16). Enable the rabbit's mask once again, this time with a single click on the mask thumbnail, and take a stroll around the composition to check the other toys and flying objects. Aside from a couple smaller adjustments, this worked pretty well!

TIP I often pair Curves with Hue/Saturation adjustments layers either as linked layers or in their own group folder with a single mask. They work exceptionally well as a team, one always compensating for the other, and both super quick to adjust.

FIGURE 7.16 Using a Hue/Saturation adjustment layer is a quick way to control saturation changes that are heightened by a Curves adjustment.

COMPOSITION

Once you finish masking and adjusting, take a moment to think about your whole composition before you begin finessing the smaller details. Evaluate the overall busyness and general eye-flow, meaning where the viewer's eye starts and moves around the image as if reading it and discovering details and meaning. Mainly, I'm looking for balance. For the *Good Kitty* composition, for example, I decided:

- The focus should be around the toddler, so any clutter right around him was too distracting.

- The placement of the garbage truck originally competed with other elements but was also a perfect object to relocate elsewhere for better balance.

- Positioning the ukulele partly out of the frame created more of an open composition, hinting that more of this scene was floating just out of view. Containing all elements too perfectly within the frame can look "off" and is a hard problem to pinpoint at times.

- The picture frame enabled me to add an intentional collision as a pressure valve to everything else being very neatly spaced for the most part. Even just throwing in one or two items that aren't perfect can help viewers believe what they're seeing.

Clone This

Despite careful planning, something occasionally goes awry in a shoot, something that can't merely be masked out or adjusted. Heavy objects—such as a cat balanced on a scratch post—often need properly leveraged support, and your hands or props can't always be tucked away out of sight from the camera. For these situations, turn to the Healing tools. Specifically, by cloning content onto a blank new layer, the Clone Stamp tool provides a nondestructive way of fixing the hands or other unexpected objects that show up. To fix the scratch post, for example, try using the Clone Stamp tool to paint some cloned bits of post on an empty layer above the original content.

1. In the Layers panel, click the Layer icon 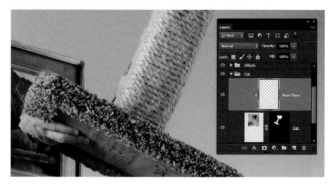 to create a new blank layer on which to do your clone stamping. Name the layer New Clone, and place the new layer directly above the Cat layer within the Cat folder. Because you're going to use Clone Stamp on this new layer, you can instantly trash it and start again if the operation goes wrong (or use the Eraser as an undo tool).

2. Alt-click/Opt-click between the layers to clip the New Clone layer to the Cat layer and ensure both layers use the mask you created for the scratch post in the "Task Masker" section (**FIGURE 7.17**).

3. Grab the Clone Stamp tool, and using the Sample menu in the options bar, choose Current & Below Current & Below to specify which layers you want the tool to affect. Now you can clone from the current layer (which is empty) and layer below. Keeping your work as separate layers as much as possible is always the best practice.

FIGURE 7.17 To keep the edits nondestructive, you will use the Clone Stamp tool to paint the cloned content on a new layer (New Clone) that is clipped to the original (Cat).

FIGURE 7.18 Pick a sample point location (marked by the +) that is very similar to the area that needs fixing (marked by the circle) for a seamless effect.

NOTE Clipping to a masked layer can become a gotcha for Clone Stamp, because you will see the cloned content only as far as the mask owned by the layer it is clipped to. If you masked out too much, you might not be able to see the portion Clone Stamp needs to work. To solve this, either unclip your cloning layer or adjust and expand the mask of the layer it was clipped to.

4. Find an area similar enough to your problem spot that it will work as a cure, and Alt-click/Option-click to set your sample point. For the example, I clicked directly above where the hand was gripping the scratch post because this area is very similar and free of fingerprints (**FIGURE 7.18**).

5. With the sample point set, begin painting over the hand area on the scratch post. I paint in small strokes or dabs so that they are controlled and nothing accidentally gets cloned (such as the same hands, only further down!). Watch where that sample point target is moving along with each stroke. Set a new sample point and continue cloning if you run out of clean material.

> **TIP** In the options bar, toggle on Aligned Sample if you want the Clone Stamp tool to keep the sample point consistently spaced from your cloning so it follows at an equal distance set by you. Uncheck Aligned Sample if you found a single spot you want the sample point to return to after each stroke or click. This can be helpful for times when there is just a small area available to clone from. Rather than resetting the sample point, keep Aligned Sample off.

Further Alterations

You can clone the rest of the scratch post's corner to fix where the hand holds it on the bottom, but this will take a little more craftsmanship (**FIGURE 7.19**). Here are some good strategies for fixing this large section and others like it:

- Change the sample point frequently, and piece it all together without too many cookie-cutter instances.

- When you find a clean area with a fair amount of stroke room around it, set your sample point and then go to the options bar and uncheck Aligned Sample. (This may or may not be toggled on, so always double-check which way you are using this tool). With Aligned Sample off you can paint in new spots while having your sample point return to the original spot after every stroke.

- To better see what you are actually cloning, expand that area of the mask on the layer below, especially if you have it clipped. You can do this by switching over to the paintbrush and adding some white to the needed areas to grow the mask outward.

- For areas looking a little too blotchy and uneven, try changing the Clone Stamp Opacity to 20% and go over a larger area using a sample point with lots of room for tracking. This will even things out and give you a cloning airbrush effect.

FIGURE 7.19 Keep clone strokes small and vary the sample point, and you'll be surprised what wasn't actually there to begin with.

Fine-Tune Lighting and Effects

As the final touch to my composites, I fine-tune the lighting for better emphasis and eye-flow within the composite. Frequently, areas of the composite compete for attention (or perhaps lack enough contrast), and final lighting effects can add the subtle changes that make the difference between bland and eye-catching—and believable as well! To practice this, you'll create six effects for this final Effects group folder. These effects are definitely within the vein of my own series aesthetic that generally has strong contrast, muted yet warmer tones, and controlled vignettes (**FIGURE 7.20**).

1. Darken things down and up the contrast: Create a new Curves adjustment layer within the Effects group folder (**FIGURE 7.21**), and paint with black on the mask just in those places that you don't want this darkening effect to affect. Typically, this means masking out the things that are already pretty dark, such as the cat, shadows, and toddler's dark pants. These already have just enough detail and don't need darkening. On the curve line itself, create a control point in the middle and drag it gently downward.

FIGURE 7.20 I include this standard set of lighting and effects layers with each composite in some form.

FIGURE 7.21 Use Curves to gently get the darks and lights the way you want them; I usually start with the darks.

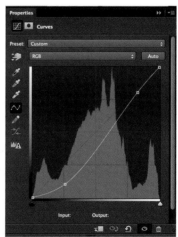

2. Repeat step 1 to control the lights. Again, paint with black in all the places that don't need lightening. I painted out everything that stood out as a little too light, such as the scratch post highlights, the curtains, and the slight vignettes (created in step 1 by adding in a little more darks) I wanted to stay dark. Much like moths we're always drawn to the lighter elements. Knowing this, I used a lighter center and darker outer edges to control eye-flow to the subjects and floating objects. I dragged upward on the curve at a point to the right of the middle.

3. Again in the Effects folder, create a new image layer (i.e., not an adjustment layer) and set its blending mode to Overlay. You'll use this layer to customize the lighting in the image. It gives you the ability to dodge and burn nondestructively by painting with white and black, respectively (more on this in the next chapter). Mainly I use this effect for focusing eye-flow by lightening up the center with painting soft, low-opacity islands of white and darkening the image corners with stronger vignettes (**FIGURE 7.22**). This will dramatically shift color in a bad way at times, so it needs to be followed up with some form of color control. Also important to my own workflow is creating masks for each of these effects layers, because sometimes it's easy to intentionally overdo an effect. The mask lets you dial back the effect to get just the right amount of alteration.

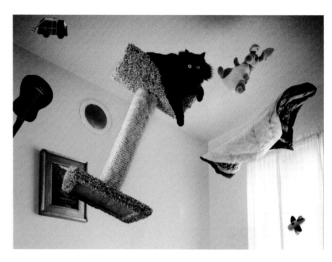

FIGURE 7.22 Use an Overlay layer for nondestructive dodging and burning by painting with white and black.

4. Control blotches of unruly color with a low opacity Black & White adjustment layer ▣ placed above the previous effects layer. This unconventional use of the adjustment knocks out most of the offending color discrepancies created by the lighting changes and helps create greater continuity throughout the piece if you drop the layer's opacity to under 20%. This is just enough to mute the scene, yet still retain enough color for the viewer to buy into it. The coloring will be mostly made up for in step 6 as you add vibrant warmth to the scene.

5. Sometimes you may also have to do some manual color control after heavily adjusting the lights and darks of an area (saturation can increase even in areas that were fairly neutral). One way to control color is to add a new layer set to Color blending mode, Then, you can paint in the exact color you want applied

to the composite (again, the next chapter goes into more detail). So in short, you can choose a color that is more appropriate (such as the plain wall) with the eyedropper, and paint this in those places that are still color deviants or unruly.

6. Lastly add a customized warm filter (**FIGURE 7.23**) via another new layer set to Overlay blending mode with a warm yellow-orange spilt across it by the Bucket tool ![icon]. Change this layer's opacity to 15% and you have the effect you see in the final image. I find this to be a much more successful filter than the built-in Photo filters because it handles colors and the highlights specifically in ways that enhance and it doesn't muddy in any way.

The only thing that remains at this point is a nice and controlled cropping to complement the placement and arrangement of the objects. This is the final touch to getting a balanced composition, so be sure to include and exclude what feels right. The scene was shot on a fairly wide-angle lens, so there was definitely room to play with here as far as cropping. In **FIGURES 7.24A** and **B** you can see how I decided to crop the image for the best composition, including the subjects, while still cutting off a floating object to allude to the idea of a larger scene outside of the framing. This is called an *open composition* and allows for the viewer to infer what's beyond the viewable scene. Whatever aesthetic choices and effects you go for, just make sure it looks and feels intentional and consistently controlled—that makes all the difference!

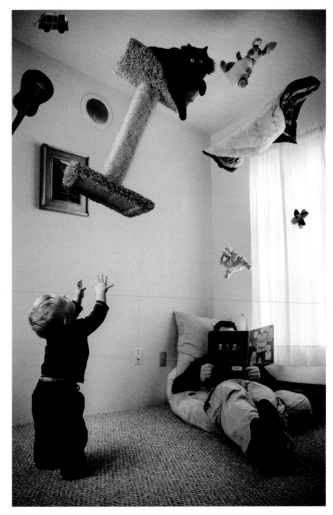

FIGURE 7.23 I like to create a custom warm filter with a low-opacity Overlay layer covered with a warm and gooey yellow-orange.

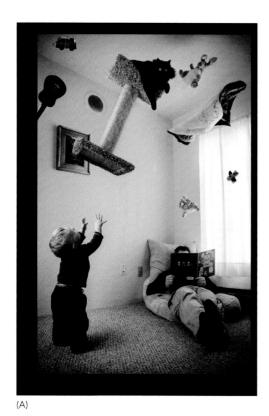

(A)

(B)

FIGURES 7.24A and **B**
The complete image (A) showing in black the section I planned to crop out as I worked on the image, as compared to the final composition with that section out of the picture (B). Literally.

Conclusion

The core components of any believable composite come from taking control of as many variables as possible, from color to lighting to the splicing together of layers with varied masking techniques suitable for the situation. It all makes a difference—especially in a composite that we want to believe is real! In this first tutorial, you've learned a solid core of skills: how to successfully match source elements using clipping masks, adjustment layers, selections, and mask painting, as well as how to control lighting and color. These features are not limited to enhancing the secret life of toddlers by any means, as you will see in the next three tutorials and Section III's project walkthroughs! Practicing and expanding these techniques can lead to all kinds of new possibilities, such as playing with fire (trust me, just keep reading).

CHAPTER 8

Blending Fire

Everyone has a little bit of pyromania in them, so what better way to learn about blending modes than by playing with fire? Sculpting Photoshop flames is certainly easier than working with the real thing—just as using blending modes to control transparency and layer interaction can be a quick and effective alternative to using masks. In this exercise, you'll create some magical fire play using blending modes to control certain kinds of opacity. As an alternative to masks, this technique can save you the time and frustration of trying to perfect selections or refining a mask to perfectly outline a flame or object that may not have perfect outlines. Wispy smoke, for instance, is nearly impossible to mask in all its detail, blur, and subtle contrast. Instead, you can pull out a blending mode, such as Screen, and turn the dark background transparent.

Fire and smoke are particularly helpful examples for this technique because their light against dark contrast and intricate nature make using traditional masks difficult. Images like *Fire Play* shown in **FIGURE 8.1** make us reach for creative solutions to visual challenges. As you work through the steps to re-create the image, you may even discover some innovations of your own.

▶ **FIGURE 8.1** *Fire Play* gives you hands-on experience with fire, smoke, and blending modes—the only way to learn!

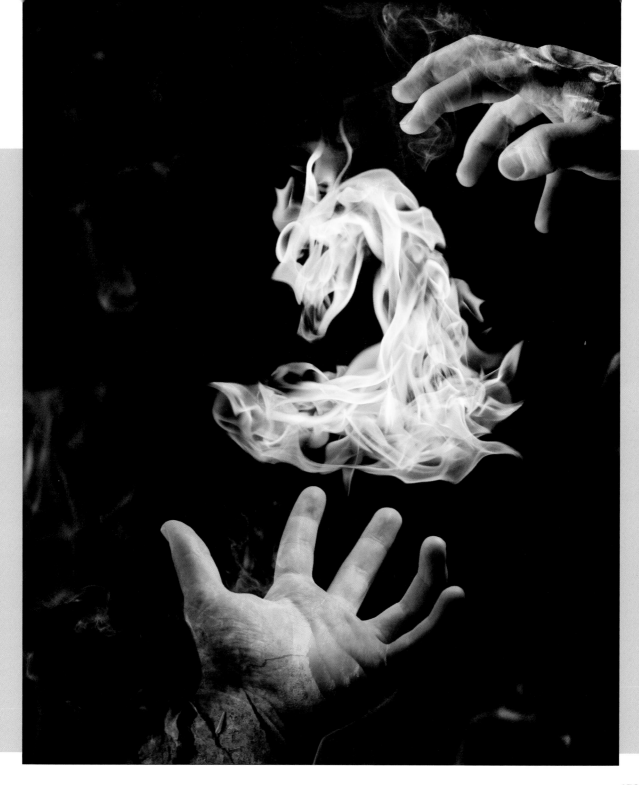

Prep for the Composite

Projects such as the *Fire Play* composite use many small selections from different images and are much easier to manage when separated into two files: a main composite document to work in and a second file to draw image elements from, like a palette of photographs with which to paint. Remember creating the photo palette (*Fire_Play_Photo_Palette.psd*, **FIGURE 8.2**) and composite document (*Fire_Play.psd*, **FIGURE 8.3**) in Chapter 6? Now's the time to put all that great prep work to good use; open these two documents in Photoshop and get ready to composite.

> **TIP** For this kind of composite, having a second monitor (or at least one with lots of real estate) is a huge benefit as you can use one screen for searching out and copying image pieces, and the other for the main workspace and composite build.

If you did not complete the prep work in Chapter 6, take a few moments to do so now. You'll find instructions for downloading the source files, as well as an in-depth description of how best to prepare files for a composite like this in the section "Creating a Photo Palette." Alternatively, you can jump start your project file with *Fire_Play.psd*, a composite file complete with groups and labels that's included in this chapter's folder of resource files (Chapter8_Resources).

> **NOTE** To download the resource files, register your book at peachpit.com/register. Sign in to your account (or create a new one) and enter the ISBN when prompted. You'll find download links on your Account page under Registered Products. See the introduction for more instructions.

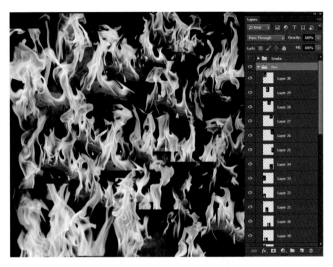

FIGURE 8.2 A photo palette, like *Fire_Play_Photo_Palette.psd* shown here, gathers your source images together into groups for easy searching.

FIGURE 8.3 Gather the layers of your main composite document into groups with clearly identifiable names and color-coding.

Handle the Hands

Before you can put blending modes to work, you need some elements in your main composite document. The best place to start is by bringing the hands into the *Fire_Play.psd* document, as their placement dictates where everything else will go in the composition. As you begin, try to visualize how you might want to use the smoke and fire. For example, I wanted to play with depth, so I knew I needed to have some room for blurring some of the smoke as well as a place to grow a little fire demon between the hands. Don't worry if you're still undecided. Because this composite will be built nondestructively, you will be able to adjust as needed while you work.

FIGURE 8.4 Bring both hands into Photoshop as individual files before moving them into the composite document.

1. If you haven't already, open *Fire_Play.psd* in Photoshop now.

2. From Adobe Bridge, browse to the folder Chapter8_Resources/Hands and open *Hand1.jpg* and *Hand2.jpg* as separate documents within Photoshop (**FIGURE 8.4**).

SHOOTING SMOKE AND FIRE

Taking your own pictures is a huge step in having complete control and ownership over your work. If you are up to the challenge, here are some tips for shooting fire and smoke:

- Be sure that you have a dark background so that the flames or smoke show up well with good contrast.

- Use manual focus, the fastest shutter speed, and the smallest aperture you can while still getting a usable exposure. The fast shutter speed will reduce the risk of motion blur, and the small aperture (remember, this means a large f-stop number) will enable you to capture greater depth. If your scene is too dark to do both, always put more priority on the fast shutter speed. Just be sure to double-check your focus on at least one usable flame source in the shot.

- Shoot the fire and smoke separately. For smoke, use a clamp-light, a lamp, or even controlled natural sunlight to illuminate the smoke, but avoid lighting the background at all costs. Shoot the fire from a side angle into darkness for good results. Nighttime works well for this.

- Incense works well for shooting clean and visible smoke trails, plus you can wave it around to generate the shapes you desire.

- Use a tripod for shooting the smoke. Either that or use a strobe or speedlight—just make sure you control the light to only illuminate the smoke and not the background (such as shooting with a snoot).

Remember, you will need to get as many clear images as possible for a good composite. For this composite, in addition to fire and smoke on black backgrounds, you'll need:

- Hands occupied with sorcery on a black background

- Rusty metal or something equivalent

- Shallow moving water in sunlight

- Cracking bark

3. To bring the hands into the *Fire Play* composite document, press V to switch to the Move tool; drag either hand image up to the Fire Play tab to open the composite's window; then, without letting go, drag the hand back downwards to drop it in the newly opened window. Repeat for the second hand. I find this method more efficient than having multiple documents open side by side, plus keeping a limited number of documents open as tabs really does help everything stay organized and easy to locate as you work.

4. After bringing each hand into the composite, file their layers away into the Hands group in the Layers panel.

5. Rename each hand layer so that these layers have the same names as their file names, and move the hands around with the Move tool (V) so that they roughly match the position in Figure 8.1.

Remove Backgrounds Using Blending Modes

The hands are in position, but their blocky backgrounds are in the way of the new background you'll add to the composite. Instead of using traditional masking to remove them, you can simply change the blending mode settings for the hand layers. Not only does this method save the time and effort of masking, it can provide better fidelity of edge detail, such as hair, shadows, and other elements that are tricky to get right. Because the background of the hands is nearly black and the planned background won't be lighter than the hands themselves, you can apply a Lighten blending mode to the hands as a shortcut around making a mask for each hand.

1. In the Layers panel, click the Hand1 layer to select it and then choose Lighten from the Blending Mode menu near the top of the panel (**FIGURE 8.5**). Repeat for the Hand2 layer to change its blending mode to Lighten, as well.

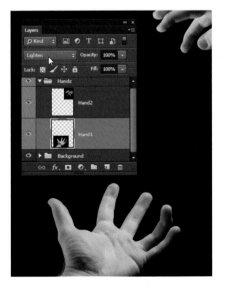

FIGURE 8.5
Changing the blending mode to Lighten will remove a layer's dark background by blending it with the composite's overall dark background underneath.

2. From the Other_Textures folder of the resource files, bring *Dark_Rusty_Metal.jpg* into the main composite to add a background texture of rusty metal. Place it toward the very bottom of the layers stack, just above the black background as well as inside the Background group (note that in my provided starter file, the all-black layer is within the Background group as well). Rename the new layer Background Texture. The background rusted metal texture is a good, very dark base that provides interest and a little contrast against the fire, smoke, and hands (**FIGURE 8.6**).

Using a blending mode can be a great timesaver, especially for dark background situations like this project in which the brightness value that determines if content is visible or not is set so low. With this method you bypass making a selection and refining its edge until it's just right for masking. Take note though that this only works for some layers with dark enough backgrounds and light enough content to show through above the other layers, but when it does work, it looks great!

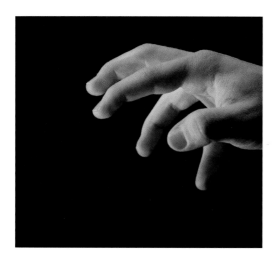

FIGURE 8.6 Lighten mode lets the hands contrast nicely against the dark rusty background.

TIP If you notice parts of the background showing over the image, change the blending mode back to Normal, and use a standard mask on your image instead. You can also try keeping the Lighten blending mode and adding a Curves or Levels adjustment layer. Clip this adjustment layer to the layer you want it to affect and shift the black point and other tones of the layer until they disappear.

TIP The Blend If feature is another option for knocking out just the black (or white in some cases) background of a layer—and it doesn't require a blending mode change or a clipped adjustment layer. Double-click the layer's thumbnail to open the Layer Style dialog box. In the Blend If section at the bottom, change the left value slider for This Layer to 10. This will make just the darkest areas go invisible—like magic and helpful for a number or uses.

Rough Sketch the Fire

The stage is set with a background, and the hands are ready. Now they need some fire to sculpt. Before they can sculpt, however, you need to sketch. A visual guide, even a rough one, can be especially helpful when the creative possibilities are as overwhelmingly limitless as they are here. Using the Brush tool and an Outer Glow layer style to mimic fire's glow, you can sketch your ideas into the composite (**FIGURE 8.7**). Sketching with a flame-like effect can help establish a better mood for visualizing your ideas. Then, you can find and fit together the flame's elements with your sketch as a guide, which is much easier than sculpting fire from scratch.

Take a few moments to draw inspiration from your photo palette before you click the Brush tool, though. For my

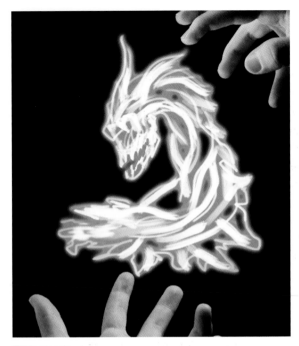

FIGURE 8.7 A quick sketch with an outer glow as a fire simulation effect will help you visualize your ideas and get the composite started.

sketch, I saw shapes within the photo palette that could be interesting if used as a creature; one in particular looked like a demon skull of some kind. In general, I wanted my fire to begin as a fairly amorphous but cool-looking blob and then to take shape, like it was being pulled into existence by the hovering hand. Your idea may differ, but the sketching process is the same.

1. Start your sketch by making a blank new layer and dragging it to the top of the layer stack so it floats above everything else. Name this layer Sketch.

2. Pick up the Brush tool (B), and set the Foreground color to white. Make sure your brush opacity is also at 100% as this can be an unexpected gotcha.

3. To roughly simulate fire's glow, add a layer style with an Outer Glow effect applied. Double-click the Sketch layer's thumbnail to open the Layer Style dialog box, and from there select Outer Glow in the Styles list (left).

4. Click the name Outer Glow in the Styles list to display the options for the effect (**FIGURE 8.8**).

In the Structure section, notice that the Screen blending mode is chosen by default to emphasize the lights in the glow effect. You'll use the same mode to blend the flames.

FIGURE 8.8 The Outer Glow checkbox must be checked and the name selected to access the Outer Glow effect's options.

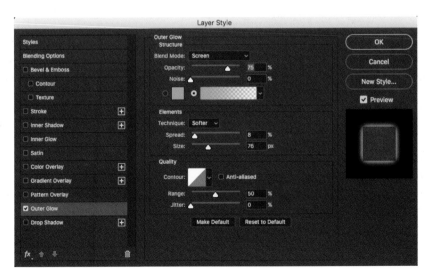

5. A custom gradient that transitions from yellow-orange to red as it disappears in opacity will produce a more flame-like glow. In the Elements section, set Spread to 8% and Size to 76 px, and then click the gradient graphic in the Structure section to open the Gradient Editor (**FIGURE 8.9**).

6. In the Gradient Editor, click the bottom-left color stop and adjust the color to a fiery yellow-orange. Click the bottom-right stop and adjust it to red. You can match my fire gradient in Figure 8.9 or adjust to taste. Click OK to close the Gradient Editor and then OK again to close the Layer Style dialog box.

FIGURE 8.9 Create a custom gradient by changing the two color swatches below the gradient bar.

7. Try a few white paint strokes; the gradient Outer Glow effect gives your strokes a similar look to fire without the heat. My strategy for the sketch is to try some general variations, but not to get too detailed. You want to leave the details up to what you might find within the fire itself.

Browse and Position Your Flames

Meanwhile, back at the photo palette, a number of perfect starter flames are just burning to be used. When looking for pieces to patchwork into a semblance of your fire demon sketch, focus on the small elements that could work or that interact in interesting ways: two entwined flames twisting together or a rogue wisp that has a nice curl and wave. These unique pieces can be used in many different ways (sometimes repeatedly if layered well), so try them out by placing them around the composition, flipping, scaling, warping, puppet warping, and rotating until something looks right or just plain cool. Playing with the images and how they fit is a lot like building with Legos; it's not just about how an individual piece fits, but also how they all fit together. Because you'll be pulling samples from an unaltered and separately saved photo palette, the process is all nondestructive, so you can make as many attempts and alterations as you need.

Solo for Better Viewing

Recognizing what fits is sometimes easier when you can see all your layers at once, and at other times it's easier when you can view each piece individually. Called *soloing*, the process of isolating a layer for individual viewing is a handy technique for any composite. Give it a try as you select your first flames.

1. Open the photo palette file, *Fire_Play_Photo_Palette.psd*, if it isn't open already. By default, the visibility of each layer is the same as when you last saved it, but that most likely includes many layers, all visible at once. Don't worry, you don't have to manually turn off the visibility for each layer one at a time (a combination of crazy and tedious) to view interesting layers in isolation.

FIGURE 8.10 Here's a piece that is soloed for possible use as part of the fire demon/dragon head.

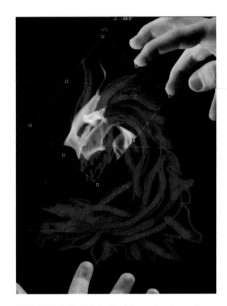

FIGURE 8.11 With the Move tool, position and rotate your first fire piece over the sketch.

2. To solo an individual layer, such as Layer 25, Alt-click/Opt-click the Visibility 👁 icon for the layer you want to see by itself. That layer will remain visible while the others disappear. You can bring back the visibility of all other layers by again Alt-clicking/Opt-clicking the same layer's Visibility eye icon.

 If you change the individual visibility of additional layers after you solo a layer, however, be warned that the Alt-click/Opt-click toggle will no longer work. You will have to toggle the visibility for each layer separately to bring them all back. So, when you solo, remember to bring everything back the same way before working with other layers.

3. Once you spot a piece of flame that looks usable, make your first selection with the rectangular Marquee tool (M) on the layer containing the flame you intend to capture. For example, try to capture the piece of Layer 25 shown in **FIGURE 8.10**; it looks vaguely like a skull of some kind, a good base to build on. (Of course, if you have a different fiery vision, choose another layer that better fits it.)

 Always select a generous amount more than what you intend to use to leave yourself extra room for masking seamlessly. In addition to using Screen mode, masking with flame is usually done with a soft brush to avoid obviously fake edges, so you'll need room to feather the edges. I go by the gentleness of the fire's gradient as a guide for how to mimic this transition, so take a look at the softness of the fire's edges and make sure you grab enough room in the selection to mimic the feathering.

4. Before copying, make sure the correct layer is selected and visible (we all miss this from time to time). Copy the selection (Ctrl+C/Cmd+C) and then shift back over to the composite image tab and paste (Ctrl+V/Cmd+V) with the Fire group selected.

5. Drag the pasted layer (in this case the skull shape) into the Fire group if they ended up in a different one and then move and rotate your fire image into a good position in the composite with the Move tool (V) (**FIGURE 8.11**).

> **TIP** To make matching the sketch easier, lower the opacity of the sketch so you can see multiple layers at once as you place the various fire shapes.

Mask and Blend

Once a flame is in position, the next stage is to seamlessly fit it into the composite. You can do this in two steps: Change the blending mode, and create a mask.

1. With the first fire layer selected, choose Screen from the Blending Mode menu. This mode will be applied to all subsequent fire layers as well.

> **TIP** If an entire group needs the same blending mode and the layers do not overlap with each other, try changing the group blending mode to alter all the contents at once. This affects blending with layers outside the group only, however, and not how the group's layers blend with each other if, individually, they remain set to Normal. For overlapping images within a group, such as the flames, you will still need to change the blending mode for each layer so that they keep adding light pixels on top of one another for your fire creation.

As you may remember from Chapter 3, Screen lets the lights of a layer show through, while progressively darker areas (like the background) become increasingly transparent. Screen mode is a good choice for the fire, because we want only the light from the flames to be visible, while the rest becomes more transparent as the pixels get darker (**FIGURE 8.12**).

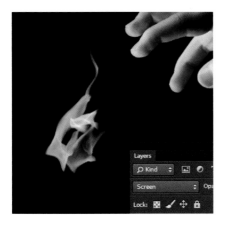

FIGURE 8.12 Screen mode allows the lights to glow through while leaving out the darkness by making it transparent.

2. To remove the unwanted portions of the fire, click the Add Mask ▣ icon and paint with black directly on the mask in all the areas you want the fire to disappear. For me, this means using a soft (Hardness set to 0), round brush that can mimic the smooth gradient of the fire itself; anything sharper will stand out as an edit. Let the fire be your guide for this. Change your brush size to match the gradient width rather than controlling hardness.

Be sure to paint with 100% opacity black; half measures always fall short of removing what you want and instead leave you with a greasy mess by the end of the composite. Suppose you set the opacity to only 90% as you paint. It may look like you masked out portions of the flame you didn't want, but really a slight 10% may be left behind here and there. Although the fraction sounds insignificant, it can build into a thick layer of digital grease when added to strays left behind by other layers. Don't trap yourself into tracking those pixels through the layers to remove them; simply paint at full opacity and flow and bypass the problem. In **FIGURE 8.13** you

SCREEN, LIGHTEN, MULTIPLY, OR OVERLAY: WHICH TO USE WHEN?

Blending modes are a lot like a box of chocolates—seriously. You really don't know exactly what you're going to get. You can, however, get pretty good at guessing once you know the shape and look of them. The effect of some blending modes may not be easy to predict when combined with other layers, but you can make a fairly close educated guess by keeping some things in mind.

Use Lighten for an element's layer when:

- The content you want visible is lighter than the background you are placing it above and the background is very dark.

- You want a very dark background to be invisible and lighter content to stay completely visible

- Dark content is awkward or challenging to mask out, or you don't have the time to get it just right.

Use Screen when:

- You need a gradient rather than an on-or-off threshold of opacity for content as it gets darker, as is the case with the fire.

- You want to blend lighter content on top of other light content.

Use Multiply when:

- You want to darken content with a texture, much like a deep stain.

- You want to see darker details (such as scrapes, grease, shadows, or other dark texture pieces) of this layer mixed with the other layers below at once, but just the darker elements such as scrapes, grease, shadows, or other dark texture pieces.

Use Overlay when:

- You want some of the best of both Multiply and Screen, with the darks of a layer darkening the content and the lights of a layer lightening the content.

- You want to dodge and burn nondestructively with white and black painting.

- You want to colorize or make a custom photo filter controlled by layer opacity.

can see the small portion of the current layer's mask that I painted—shown with the red overlay (pressing the \ key will show the mask just as if you made a selection and used Quick Mask mode).

TIP You can change brush size and hardness quickly by dragging on the image. In Windows, press and hold Alt while right-clicking (Mac users press and hold Control+Opt while left-clicking) to open the on-image display. Drag up or down to change hardness and drag left or right to change size (right makes it larger while left is smaller). To be sure the brush hardness does not change (from 0 hardness) with resizing, drag in a slight upward diagonal or, at the very least, initiate a horizontal movement first as this will create a priority of size change as long as there is with continual movement in a general horizontal direction.

Duplicate and Vary

When you find a particularly useful flame, you can duplicate it to use in two places at once. Press and hold the Alt/Opt key while using the Move tool (V) to drag the fire element you want duplicated. Wherever you drop the fire piece, Photoshop duplicates it on a new, separate layer. It's a good idea to immediately move, rotate, or scale the duplicate layer (**FIGURE 8.14**). Making copies like this can be extremely helpful for filling in more flame areas and shapes, but don't get carried away—when all is said and done, you don't want viewers to easily point out your repeated flames. Duplicating instances works best usually when in combination with other layers that can hide and add variety to the duplicate to help it look less like a cookie cutter copy. Again, think of Legos: All pieces look very similar, but their combination then becomes original. Adding varying rotation, scale, and changes to the masked out areas goes a long way to obscure conformity.

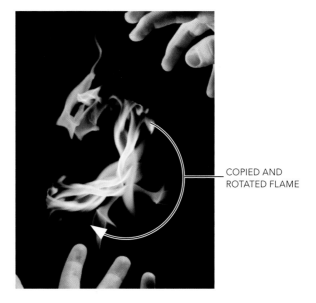

FIGURE 8.13 Paint with 100% black on the mask where you want to conceal the fire. Press \ to see in a bright red where you painted on the mask.

COPIED AND ROTATED FLAME

FIGURE 8.14 Cloning fire is always a blast, but it is also dangerous. If you get carried away, too much cloning can leave your image looking entirely too fake. Use variation and masking to help stamp out uniformity.

For example, if you copy a previously used flame, make sure to add your own variation to it for the seamless effect. Add better variety by transforming it with the Move tool (V); try scaling, rotating, and flipping the image to get the best results and control of the fire. Some parts of the flame may be more identifiable than others, so use the Brush (B) tool to mask these out in the duplicate or even bury them in another flame. The more you add on top of these layers, the less obvious the duplicate is to spot.

> **TIP** To access the hidden Move tool features, be sure that the Show Transform Controls checkbox is checked in the options bar. Refer to Chapter 2 for all the hidden things you can pull from the Move tool as you work.

Try to avoid drastic differences in scale, however. Drastic size changes to fire are especially noticeable and can look like a miniature or artificially large fire, if you're not careful. Keep enough consistency to look like the flames are of the same scale, but enough variety to not distract the eye with telltale conformity.

Puppet Warp the Flames

Editing a layer with the Puppet Warp feature has the potential for complete control over a flame and is a technique well worth learning. Puppet Warp can be incredibly helpful for shaping something very specific and refined as it enables you to move every little bend in the flame to perfection.

To understand Puppet Warp, think less about puppets and more about spandex. When you select the Puppet Warp tool, it covers the visible portion of your layer with a mesh that reacts like a pliable, stretchy, spandex-like material. In the mesh, you then place pins from which you can pull, twist, and move the mesh-covered layer,

giving you absolute control. Puppet Warp's primary function is also its major drawback, however: It bends and warps *connected* pixels, including the background. To manipulate an object only, you need to separate it from its background so that the background does not also have a mesh and changes applied to it. To better understand how to use Puppet Warp, try creating a more controlled variety of flame.

1. Copy a long flame from the palette, and paste it into *Fire_Play.psd* (**FIGURE 8.15**). Turn it into a Smart Object by right-clicking its name and then choosing Convert to Smart Object from the context menu.

2. Change the layer's blending mode to Screen, and place this flame in the Fire group off to the side so that you can practice with it by itself. The choice is yours, but I temporarily turned off visibility for the other fire layers.

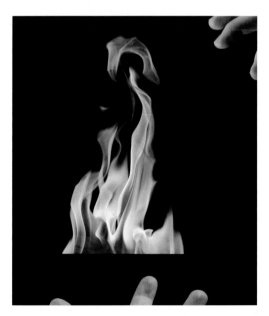

FIGURE 8.15 Choose a long flame, such as the one that came from *Fire007.jpg*, to practice warping.

3. For Puppet Warp to work best, you need to remove the flame's background so that the tool's mesh is isolated to just the flame. To do this, you'll create a temporary mask optimized for Puppet Warp by using Color Range to select the background black color. To begin, double-click the layer's thumbnail to open the Smart Object within a new tab.

4. Choose Select > Color Range, and select Invert in the Color Range dialog box (**FIGURE 8.16**). Because the black is much easier to select in this layer, you'll select the parts that you *don't* want. Click the black background to the side of the flame, and set the Fuzziness slider to 100. This setting makes sure that all those pieces that are *nearly* black are included in the initial mask. Any remaining bits will create small islands of warping mesh, so get rid of as many of the extra pieces as possible. Click OK when finished with your color range selection.

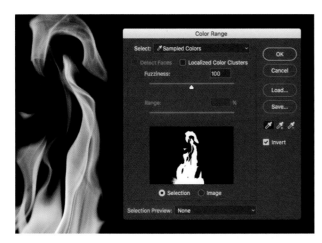

FIGURE 8.16 Color Range enables you to mask based on colors sampled from the layer; in this case, all the black background.

TIP You can also get a half-decent selection of the flame by using the Channels panel. In this case, select the Red channel thumbnail (it has the most contrast) and then click the Load Channel As Selection icon at the bottom of the Channels panel. Return to the Layers panel, and create a mask from the selection. Although it misses some of the nuances of the flame, the channel selection method does okay overall. This tried-and-true selection process is always good to test for tricky selections. Just remember to use the channel with the greatest contrast and include the portion of the layer you want to select—red happens to be good for flames.

5. Add the mask by clicking the Mask icon and use a 100% opacity round brush with black selected to mask out any remaining bits of fire you don't want to warp; I masked out everything but that long side stretch and the top flare (**FIGURE 8.17**). Save this edited Smart Object by pressing Ctrl+S/Cmd+S; that closes the tab and updates the layer back in the main composite.

6. Now you're ready to use the mask you created to apply Puppet Warp (**FIGURE 8.18**) as a Smart Object filter. This lets you warp the layer nondestructively; you can return again and again to the warping mesh without being locked to one attempt! To create the Puppet Warp mesh, choose Edit > Puppet Warp. If you do not see a mesh appear over the flame, make sure that Show Mesh is toggled on the options bar.

The mesh connects everything in a tension framework that controls how the pixels are stretched and moved. You'll add pins to the mesh at key points; they serve two purposes. Each pin can act as a handle for manipulating the mesh; pins can also act as anchors holding the mesh in place. Dragging a pin to pull the mesh exerts the most tension at the pin's location and progressively lessens further away from that pin.

7. Before adding any puppet pins, it's a good idea to expand your mesh well beyond what is currently visible as it could otherwise create harsh cutout edges that make things less than seamless as you bend the flames to your will. To do this, use the Expansion control in the options bar to give yourself plenty of wiggle room; I suggest a number between 12 px and 40 px. Some meshes can be expanded only so far before they double back on other content making a

FIGURE 8.17 Mask out the extra pieces you are not interested in warping.

FIGURE 8.18 The Puppet Warp mesh shows the framework for how tension is distributed throughout the layer.

blob-like mush of a mesh—so move the slider right up to the point before this happens and keep the edges from spilling onto one another.

8. Add pins along the inside of the mesh by clicking in various evenly spread locations throughout the flame (**FIGURE 8.19**). These are the points where the puppet strings attach and give you control.

9. Click and drag the pins to manipulate the flame (**FIGURE 8.19B**). As with most things in Photoshop, though, less is usually more. Don't do anything too extreme; instead, work on mild adjustments for the best effect. With that said, it's always good to experiment with how far you *can* push an effect before it looks off. Figure out the limits and pull back accordingly.

TIP Not happy with the warping you created and possibly moved on from? A wonderful thing about Smart Objects is that they allow you to change your mind and readjust! Double-click the words "Puppet Warp" below the Smart Object in the Layers panel to re-enter Puppet Warp and continue editing.

TIP Add some rotation around a pin by holding down Alt/Opt and hovering around a selected pin; you will see an option for grabbing a rotation circle around the pin. As a warning, though, don't click the pin itself while holding down Alt/Opt as it will delete the puppet pin instead. Oops!

(A)

(B)

FIGURES 8.19A and **B**
Pins are the control points in Puppet Warp that you use to manipulate the mesh into a new configuration.

The Puppet Warp feature is like warping and the Liquify effect on steroids. It goes further than working with just one kind of spandex as well; there's a range of hidden features packed into this tool. To improve your results, keep these tips in mind:

- When using Puppet Warp with objects that need to keep smooth edges, make sure to add pins in the middle areas only. Adding pins toward the outside will pull the edges outward rather than simply bending the main content in a more general and cohesive way.

- Selecting a pin and pressing the Delete key removes the pin, which makes things nice and simple if you get one too many going on. Think puppet, not pincushion.

- Holding down Alt/Opt enables you either to cut the selected pin (like the Delete key) or rotate (instead of move) it when you click just outside of the pin. Notice that the pointer changes to a rotate symbol.

- The options bar holds powerful adjustments for your mesh. Here you can increase the mesh density (helps with precision), change the mode of the mesh and the way that the mesh reacts to pin movement (like switching from spandex to a water balloon), and expand or subtract the edge of the mesh (with the Expansion slider).

10. With the flame now warped to perfection, I recommend you turn off the Smart Object's mask. For some of the flames, you may notice the mask took out the darker nuances as it vanished to black. Disable the original mask by again double-clicking the Smart Object's thumbnail to open it in another tab and then Shift-clicking the mask thumbnail. Just like that, it is disabled. Now save this Smart Object (Ctrl+S/Cmd+S) to update the original composite.

You should notice greater detail in the flame now. Be sure, however, to mask out the pieces of this Smart Object layer that don't work as part of your creation! Add a fresh mask for this Smart Object (using the Create Mask Icon ▣) within the composite and paint with black and white like you would any other layer mask.

Liquify Fire and Smoke

Much like Puppet Warp, the Liquify filter can be incredibly helpful for customizing your pyrotechnics. To use Liquify on flame or smoke, initiate the process with the same first two steps as you used with Puppet Warp. This will again make the selected layer into a Smart Object. Then choose Filter > Liquify (Shift+Ctrl+X/Shift+Cmd+X). Once inside the Liquify interface, keep these tips and strategies in mind:

- Use the Forward Warp tool (W) for pushing and pulling the flame pixels around, but keep the brush size large (200 to 500) as a smaller brush will create fake-looking ripples if done too intensely. Larger pixel movement allows you to mold the general shape without it looking like too drastic a deviation. You don't want to step over the threshold of the merely unnatural into the realm of cheesy and too fake.

- Work with Show Backdrop toggled on and Opacity set to 50% so you can see how your edits look with the rest of the composite and other flames (**FIGURE 8.20**). Choose All Layers from the Use menu to make sure that you see the entire composite as you warp.

- When Liquify is combined with Puppet Warp, you have two options for minimizing visual complications and cutout artifacts around the flame edge. Option one is to use Liquify first and Puppet Warp second. For some algorithmic reason, this tends to leave the edges cleaner. The other option is to leave the Smart Object mask in place after working with Puppet Warp (see step 10 of "Puppet Warp the Flames"). Keeping

the mask in place helps to ensure that your edges are clean, but you lose the benefit of the bit more detail in the shadows that you gain by disabling the mask.

Shape the Fire

Continue to bring in additional fire layers piece by piece, and much like carving, use the natural tendencies of the object to accentuate your creation. Fire has a grain of sorts, a flow, and it moves and twists in intricate and beautiful ways, which you can use for a more convincing look. Forcing something too much can break its illusion and beauty, however, so be flexible and willing to change your plans based on the natural direction that the flames

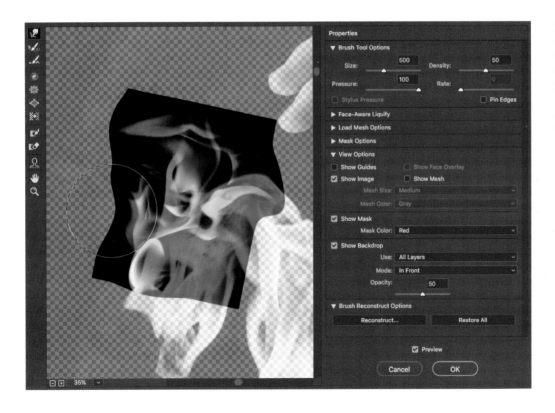

FIGURE 8.20 The Liquify filter is a great way to push the laws of physics a bit within your composite; just make sure to choose All Layers with Show Backdrop selected.

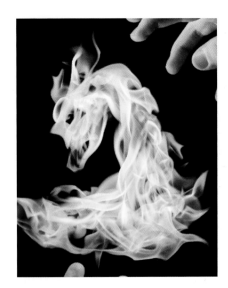

FIGURE 8.21 Pulling fire from abstract shapes is mostly about looking at the flame's natural tendencies and embracing them (or at least pieces of them).

FIGURE 8.22 Pay attention to your edges as you work, but let the flames generate the inside material and texture.

want to move. For example, I imagined the dragon/demon head differently in my original sketch, but a piece of fire naturally twisted into an interesting jaw line, so I went with it, then suggestions of teeth formed from another flame, and then some mane-like fire tufts seemed to fit into place after dragging a piece toward the neck (**FIGURE 8.21**). All in all, work intuitively and don't overdo it!

This may sound daunting and complicated, but once you bring some flames together, you'll be pleasantly surprised at the actual simplicity. Keep these tips in mind as you sculpt:

- Be mindful of the general shape you sketched and look for pieces that complement that outer edge. The inner filler doesn't need the same amount of concentration; let the flames themselves do most of the work (**FIGURE 8.22**).

- If the fire flow is going in one direction, see if you can continue where one flame left off with the edge of another. This way you can seamlessly guide exactly where your flames are flickering without it looking too choppy.

- Adding more flame layers on top of one another adds to the density and illusion of a 3D form (versus a flat shape) and can be used to simulate better dimensionality.

- Flames don't just vanish from bright yellow to straight black, as this ends up making the yellow a bit muddy-looking, especially when done digitally. So try to avoid masking right up to the brighter yellow portions of the flame—our eyes can notice the difference. Instead, stay closer to the reds and oranges with the mask whenever possible (otherwise you may have to do some fancy color control for those edges).

- Duplicate a layer for a stronger effect. To add intensity to a layer that has a great shape but not enough strength to really glow through, duplicate the layer by pressing Ctrl+J/Cmd+J. With Screen as the blending mode (the default if the layer is copied from a layer with this blending mode), the lights add to the lights and simply make it much more noticeable without making the color or gradients look bad.

In my own version, I worked quickly and didn't over think it. There's something to be said for keeping your image more suggestive and elegant. Too many details may be harder to get right in the end.

TIP When a flame mask has been painted straight through the white-hot center parts—our eyes spot this as just a bit too unnatural, even for flames being formed with magic (**FIGURE 8.23**). To counter this off-looking transition from the white-and-yellow flame to the dark background, first observe that flames always have at least some kind of orange-and-red transition before disappearing to nothing. Simulate this by creating a new layer and clip it to the questionable flame layer. Pick a rich color somewhere between dark red and orange and paint with a soft brush along the white edges you created from the mask. Just be sure your mask extends beyond where you are painting outside the flame!

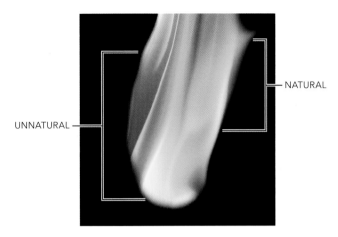

UNNATURAL —

— NATURAL

FIGURE 8.23 Bright yellow fading directly to black looks unnatural and off compared to the natural tendencies of fire to fade to deeper and darker orange.

Blend Smoke and Hands

With your fire well in hand, it's time for some smoke from the hands. The smoke in *Fire Play* rises from the hands and fingers rather than the fire—it's magic, remember. Working with the smoke images is very similar to working with the flames, only a little simpler as they don't need to look as controlled. In addition, because the smoke was shot with a dark background, you can again use Screen mode to remove backgrounds and aid with masking as you did for the fire (**FIGURE 8.24**).

1. Open the photo palette file, *Fire_Play_Photo_Palette.psd*, if it isn't already open. Deselect the Visibility icon (the eye) of the Fire group if flames are visible, and make the Smoke group visible instead. Follow the instructions in the "Solo for Better Viewing" section to isolate interesting smoke layers for inspection, if you need to.

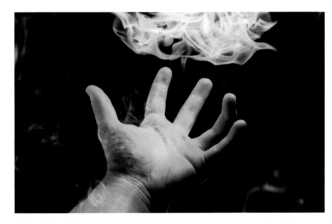

FIGURE 8.24 The smoke layers use the same Screen blending mode as the fire but also need some extra scaling and blur filtering to create more depth to the overall image.

2. Find some smoke you like, use the Marquee tool (M) to select pieces of it, and then copy (Ctrl+C/Cmd+C) it from the photo palette. Paste (Ctrl+V/Cmd+V) it into your composite, and use the Move tool (V) to position it, as you did with the fire. (Don't forget to store the layer in the Layer panel's Smoke group to stay organized.)

For the original *Fire Play*, I wanted the smoke to be rising from the forearm and top hand to add a little more mystery to the image and subject. I found some that looked like they were curling in a way that worked nicely with the composition and hand placement, specifically *Smoke011.jpg* and *Smoke013.jpg* for the bottom hand and left edge smoke.

3. As you did for the fire layers in the "Mask and Blend" section, change the new smoke layer's blending mode to Screen from the drop-down menu at the top of the Layers panel to remove its background.

4. Again as for the fire, mask out any unwanted portions of the smoke that don't quite work as you planned. Mask with a textured brush and stroke in the direction of the smoke for more seamless masking results (**FIGURE 8.25**). This is especially important for composites like this one that use quite a lot of semi-transparent elements that need to blend on top of one another.

If you brush against the direction of the smoke, the result may look unnaturally faded where it shouldn't be. The smoke has more stringy elements than the fire, and you need to work carefully with them to be convincing.

FIGURE 8.25 Use a texture brush for masking the smoke and be sure to paint with the flow direction starting from the outside.

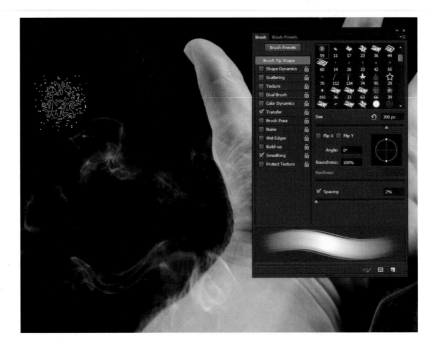

Add Depth with Smoke

With just the hands and flames, the image appears a bit flat overall, creating a rather passive and objective scene (**FIGURE 8.26**). By comparison, an image with full dimension makes us feel like we're actually there in first person (known as the subjective point of view). As you arrange your smoke, you can also use it to create just a little more depth to the composite. You can emphasize depth with scaling to simulate perspective (the closer the object, the larger it appears) and by creating an intentional depth blur to mimic something that's close and out of focus because of a shallow depth of field. By now, scaling with the Move tool's Transform controls should be quite familiar. To practice blurring to mimic depth, try your hand at applying a few filters:

1. Find a couple long strings of smoke and scale them way up so that they look close to the viewer's vantage point. (I used the layer I created from *Smoke011.jpg* for this part.) This gives the illusion that the smoke continues out of the frame for a more open composition, as if we're getting just a window glimpse into a larger scene (**FIGURE 8.27**). Pick up the Move tool and make sure that Show Transform Controls is toggled in the options bar. Shift-drag a corner transform handle to constrain the proportions while transforming.

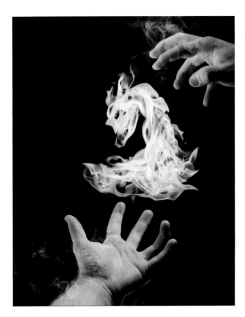

FIGURE 8.26 Before adding smoke, the image appears very flat and dimension-less; adding an extremely close foreground object such as blurry smoke can help with this.

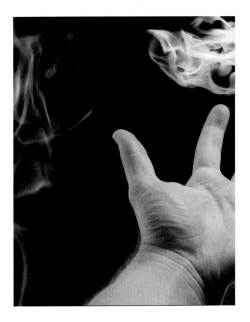

FIGURE 8.27 Enlarging a couple smoke layers can add more depth as if they are closer to our vantage point, and not just limited to one plane.

2. While scaling helps, the secret is in the Lens Blur filter. With the same long wispy smoke layer active, choose Filter > Blur > Lens Blur. This blur adds a special twist that nicely resembles the natural shallow depth of field blur made by a camera lens and large aperture opening.

> **TIP** To use just about any filter nondestructively, turn your layer into a Smart Object before blurring. Right-click a layer's name, and choose Convert to Smart Object from the context menu. This will let you apply Smart Filters that can be turned on and off as you work. The Lens Blur, however, is the only blur not yet accessible for Smart Objects, So, if you are looking to use that specific resource-gobbling effect as I did here, make a copy of your basic layer with Ctrl+J/Cmd+J before editing further.

3. Moving the Blur Radius slider to the left decreases the amount of blur, while pushing it to the right increases the amount of blur. Play with the settings that are brought up until you're satisfied with the look of the blur. Be patient while waiting for the results; your computer may need a moment or three to crunch the required calculations for this filter.

For Figure 8.24, a radius of 72 px looked right for keeping the smoke identifiable while obviously out of focus (**FIGURE 8.28**).

> **TIP** To run the same filter and settings on another smoke layer, simply select the other layer and press Alt+Shift+F/Control+Cmd+F. In addition to saving time, it also ensures you apply the same settings as for the previous filter for better consistency.

FIGURE 8.28 Find a blur radius that helps create a shallower depth of field for close smoke.

Blend Textures to Enhance

My first version of *Fire Play* felt unfinished somehow, sterile and not gritty enough. The reason, I decided, was the lack of other textures in the hands. Textures applied in combination with blending modes can add another level of finish that really makes a composite shine, or in this case, crack and peel. Specifically, I found that applying a bark texture with Multiply mode added gritty darks and made the smoke feel like it was coming from burnt crags in the bottom hand and forearm (**FIGURE 8.29**). To find a combination that works best for your own images, I encourage you to try several textures and modes; watch the changes in mood and look for one you like. For now, you can practice the process with the *Fire Play* composite:

1. Copy and paste into the composite a nice bark texture from the Other_Textures folder in the chapter's resource files. I chose *Bark.jpg* for my version.

2. In the Layers panel, change the bark layer's Layer Opacity to 50%, and position the texture over the lower forearm (**FIGURE 8.30**).

 Temporarily lowering the bark's opacity will enable you to see both the layer and where it's going, making alignment easier. Make sure to return Layer Opacity to 100% once you are done moving it around.

3. Change the blending mode to Multiply to mimic the look I chose for Figure 8.29.

 I liked this result, but some of the other blending modes had different but equally awesome effects on the hand. Next, take a look at all your other options.

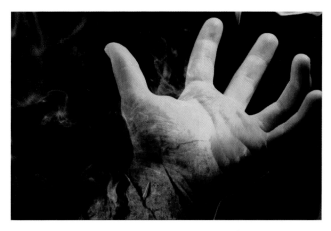

FIGURE 8.29 Bark from a tree created a surprisingly cracked forearm when applied with Multiply blending mode.

FIGURE 8.30 Change the layer's opacity to 50% to better see where exactly you're placing it.

4. Choose Color Burn (the blending mode after Multiply) in the drop-down menu and notice how it changes the look of the forearm—and don't worry about the bark image going beyond the forearm at this point; this will get cleaned up at the end. To move to the next blending mode (Linear Burn), press Shift++(the plus key). Your image will change to reflect the new mode's effect.

> **TIP** Cycle through blending modes at will with Shift ++(plus) to go down through the list or Shift+-(minus) to cycle up the list. Warning: If you have a brush tool selected, Photoshop has a tendency to prioritize changing the brush's blending mode before the layer's. This is definitely a gotcha if you were just painting on the layer you are trying to change.

You can continue to use your keyboard to cycle through the blending modes to compare how they look in your image (**FIGURE 8.31**). I usually go through all of them quickly a couple of times to narrow down the list of likely candidates visually.

5. Repeat steps 1 and 2 to apply the water layers to the top hand. (The water files are located in this same Other_Textures folder.) Change the water's blending mode to Overlay to add in lighter elements while simultaneously darkening the darks; essentially use the layer as a dodge and burn template. This effect brings more attention to the idea of elemental magic and fits in nicely as a contrast to the bark texture of the other hand (**FIGURE 8.32**).

6. Don't forget to always mask out portions of the texture that aren't necessary. Nothing ruins a composite faster than a texture extending past the boundaries of the layer you want it to affect. And, of course, be sure to clean up any digital grease that occurs along the way.

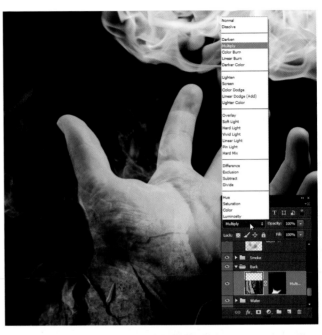

FIGURE 8.31 Cycling through the blend modes is an easy way to test out effects for the optimal look.

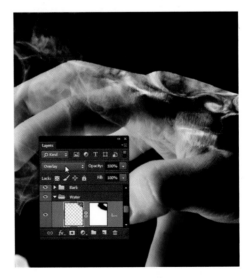

FIGURE 8.32 Applying a water texture with a blending mode set to Overlay gives the top hand a distinctive look.

Play with Color

With all the elements and textures in place, it's time to balance the image with appropriate warm and cool colors. You may have noticed that aside from the fire, everything is lacking in strong color up to this point, especially the gray smoke. Looks kind of weird, doesn't it (**FIGURE 8.33**)?

When a source, such as the fire, emanates a warm light, the particles around it, such as the smoke, hands, and other reflective surfaces, need to reflect the warmer light as well. This reflection can help create a sense of continuity and stronger cohesion to the parts of the image; without that reflected light the image elements still feel very separate.

In addition to adding warmth to various parts of the image, accentuating areas of the image with contrasts helps, in this case accentuating cool colors against the warm. This warm and cool effect can help create greater dimension, because visually, warms tend to pop out at us and cools tend to recede. (Fine artist Hans Hofmann may not care for the subject matter here, but he'd definitely like the theory behind it!) You can balance the colors in a few steps:

1. In the main composite, add a new layer and place it inside the Effects group. You'll use it to control the warm colors, so name it Warm.

2. Change the Warm layer's blending mode to Color. Now, any color that you paint with on this layer will be applied as the dominant colorant of the entire composite.

3. With the Eyedropper tool (I), pick out a warm hue from the fire itself; some yellow-orange combination should do well for this (**FIGURE 8.34**).

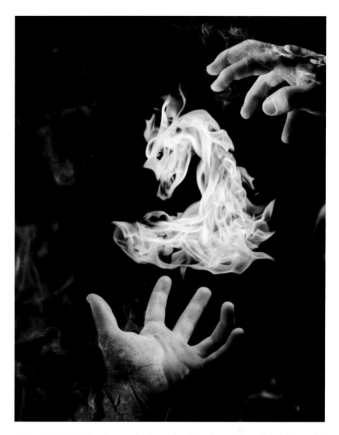

FIGURE 8.33 The image lacks cohesion, but it's nothing that Color blending mode layers and some additional painting with warm and cool colors can't fix.

FIGURE 8.34
The Eyedropper can be especially handy for matching an established color palette like the flames.

4. Now paint away! But don't get too heavy with this. Instead, paint with a low opacity (under 10% to start) and a soft brush with a radius of about 800 px (yes, this large to begin with for general coloring). The idea is about subtlety and making it feel "right," so avoid going too much the other way with getting color happy. In mine, you can see I painted some of the closer smoke and some more on the hands and forearm (**FIGURE 8.35**).

FIGURE 8.35 Be strategic in where you paint warms and cools so it makes sense with what you are seeing as the source of warmth.

5. Create a second new layer, label it Cool, and again, change the blending mode to Color. In the Layers panel, drag the Cool layer above your Warm layer so that it supersedes it. If you want the cools to be seen at all, then they must be above the warm layers as any layer with the blend mode set to Color will supersede all other colors below it. I generally start with warm because that's the main color family needing to be represented. Cools are more of a contrast effect for subtly making the warms a little more dramatic without actually increasing their saturation.

6. Begin painting with a rich blue from the Color Palette panel (you'll find it at Window > Color if yours has gone astray). Try to be even more subtle with your painting, adding just enough to contrast against the warms from the fire. I focused on the area behind the top hand and other places more or less out of direct reach of the fire's glow.

Curve the Mood

The final couple stages are mainly about finessing the whole picture and, in this case, taking control of the darks and lights a little more. These adjustments also help set the mood of the composite. One of the best ways to control the mood and contrast is with a Curves adjustment layer. The strategy behind this is that when you make the darks a bit darker or the lights a bit lighter, Photoshop

adjusts the rest of the values proportionally along a curve, which takes some of the worry out of getting each value just right. At the same time, it also allows for greater control and customizing compared to the simplified Contrast adjustment layer.

For the original *Fire Play*, I wanted a mysterious, gritty, and darker mood. Although the hands looked less sterile, much of the scene still felt a bit too light and the hands still lacked much of the intensity and contrast of the rest of the image. Adding a Curves adjustment layer is just the ticket for a dramatic effect, as you'll see.

1. Create a new Curves adjustment layer using the Adjustments panel, and place it directly above one of the hands (**FIGURE 8.36**).

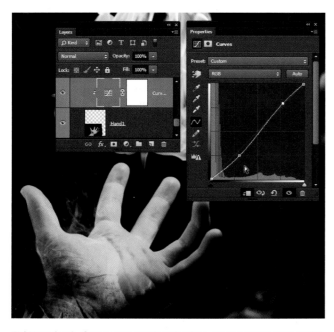

FIGURE 8.36 Curves are perfect for fine-tuning lights and darks in the image as long as the curve shape doesn't depart too dramatically from the diagonal.

2. As a default, the adjustment layer affects everything below it, so turn the Curves adjustment layer into a clipping mask for the hand by pressing Ctrl+Alt+G/Cmd+Opt+G. Alternatively, you can Alt/Opt-click the line below the layer or click the small clipping icon 🔲 at the bottom of the Adjustment Properties panel.

3. Increase the contrast within the Adjustment Properties window by making two new points along the diagonal curves line (click along the line to add a point).

4. Select the bottom curves point (it will turn solid black), and use the Down Arrow key to nudge it further down just a little bit. Select the upper point, and nudge it a bit higher with the Up Arrow key.

 Making the darks darker and the lights lighter is a good use for Curves, but they also have quite a bit of control for a lot of subtlety compared to similar adjustments, such as Levels. Refer to Chapter 4 on adjustment layers for more on how Curves works and why it's an awesome choice for just about all scenarios of light adjustment.

5. When you find an appealing contrast and finish adjusting the curve shape, duplicate the adjustment (Ctrl+J/Cmd+J) layer, move it directly above the other hand layer and clip it with Ctrl+Alt+G/Cmd+Opt+G. Now both hand layers have the same effect applied.

6. Add a final global adjustment layer to the entire composite by placing a new Curve adjustment layer at the top of the Effects group, name it Global Curves. Use this layer for a final adjustment of contrast to either lighten everything up uniformly or darken things down even more. In the original *Fire Play*, I lightened things up very slightly. In general, I use a

final Curves adjustment above everything to add just a little bit more overall lightness, darkness, or general contrast to the composite depending on what I'm going for in the end. The same methods are still used as stated in step 3, but on a much more subtle level with this adjustment—to the point where it may not even be noticeable for most people yet still has striking effect.

Dodge and Burn with Overlay

Curves does an excellent job enhancing the composite's lighting, but to add that final polish, you need a blending mode. Specifically, a new layer set to Overlay mode allows for complete dodge and burn control, for lightening and darkening, respectively. It's happily nondestructive too, making it a wise and fun choice for final lighting alterations and adjustments to eye-flow.

Sometimes even after the Curves adjustments, a few pieces will fall a bit flat, so I used an Overlay layer to compensate for these trouble spots. Be mindful, however, that less is usually more with this effect. If you start to notice halos or something just looking "wrong," back it up and try again, perhaps on a new layer with the old layer disabled for later comparison (**FIGURE 8.37**). To find that balance, I like to go slightly overboard intentionally before reducing the layer's opacity to something more subtle. Because the dodge and burn changes are on their own layer, you can always return and increase or decrease the effect through the layer's opacity. You can practice with your fire composite.

TIP Do not make these last adjustments until you are completely satisfied with the placement of elements within the composition as these edits are not clipped

to individual layers as before. Because they are placed in the top group, above all the other groups, they work on a global level.

1. Create a new layer, name it Dodge and Burn, and add it to the Effects group above the Global Curves layer to make your final global adjustments.

2. Set the new layer's blending mode to Overlay.

3. Thicken up all those parts of the flame demon that seem a little weak and too transparent by painting with white at just 6% opacity on the Dodge and Burn layer. For my version of *Fire Play*, this was especially important in the neck and around the head; lightening these areas helped me better define exactly what I wanted to show up.

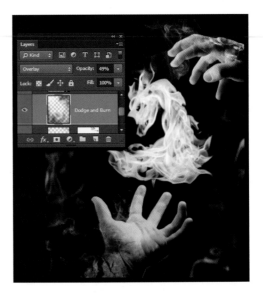

FIGURE 8.37 Dodge and burn nondestructively with an Overlay blending mode, but always remember to keep the effect subtle. Use a low opacity brush (less than 10%) as you work for best results.

4. Bring out a few more highlights in the fingers and palms as well with the same technique. If fire were really that close, these parts would definitely be fairly bright. Plus, lightening these areas gives a little better eye flow and emphasis toward the flames and forming creature.

5. In the same way you lightened (dodged) the flames and fingers, you can darken down (burn) the shadowy wrists to perfection. In the Dodge and Burn layer, paint with black at a low opacity to darken areas and white to dodge (**FIGURE 8.38**).

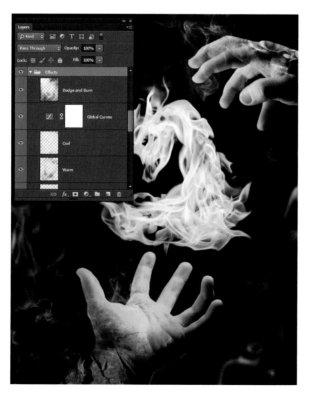

FIGURE 8.38 Edits on the Dodge and Burn layer work on a global level as they are within the Effects group, which is above the rest of the groups.

Alternately, you can create a second layer specifically for burning if you prefer to separate the two types of changes, as you did the warm and cool colors. Just remember to set the new layer's blending mode to Overlay. This can be a nice method as each layer can be controlled with its respective opacity sliders, making it a nondestructive win-win.

Conclusion

The blending modes used in this exercise—Lighten, Screen, Multiply, Color, and Overlay—are all incredibly powerful tools for any number of composite challenges, even those not dealing with creative pyromania! Whether you need to drop out a dark background, alter the color of a sky, enhance the lighting on a subject, darken and age an object with texture, or any number of possibilities, these techniques are truly invaluable. So when you come up against a creative wall, try to pinpoint the kind of effect you need to happen and see how a blending mode changes the situation. For further demonstrations of creative uses for blending modes, check out Chapters 9, 10, 11, and 14. Meanwhile, if you'd like to share your own final version of *Fire Play*, head on over to the book's Facebook page: www.facebook.com/Photoshop-with-Bret-Malley-575012755931254.

Atmosphere, Grit, and Demolition

COVERED IN THIS CHAPTER

- Removing distortion with the Adaptive Wide Angle filter
- Atmospheric perspective
- Hair selection with Select And Mask
- Color and light alteration
- Texturing for mud, dirt, and decay
- Building demolition
- Depth separation
- Creating sunray

Let's face it, life is messy, and sometimes your composites need to be too, especially scenes of catastrophic survival. Immaculately clean photos of models and cities can be transformed into a gritty scene of decay and sword-filled drama with the judicious use of a few filters, textures, atmospherics, and, of course, hair selections. In this, the deepest chapter in the book, you'll not only learn to salvage a clean but distorted background with the Adaptive Wide Angle filter, but also how to age and weather a scene while working with textures, scenery, atmosphere, color, lighting, and building demolition. As you re-create *Nature Rules* (**FIGURE 9.1**), this project will take you through the steps of shooting in the studio to planting flowers in streets of a new era.

Gather Your Resources

A complex-looking composite doesn't always need a vast number of source images. As you remember from Chapter 6, *Nature Rules* is composed of only six main groups of layers. Open the *Nature_Rules.psd* composite document you created in that chapter to reacquaint yourself with its folders. If you did not complete the prep work in the "Few Pieces, Big Payoff" section of Chapter 6, take a few moments to do so now. Alternatively, you can use the jump-start file *Nature_Rules_Jump-Start_File.psd*, which is included in the Chapter9_Resources folder. Either way, get ready to dig in some digital dirt.

▶ **FIGURE 9.1** You may never jump into a post-apocalyptic scenario like *Nature Rules*, but a sword helps—as do good hair selections. This composite is primarily comprised of five central images: a meadow, model, city, mountain, and some clouds.

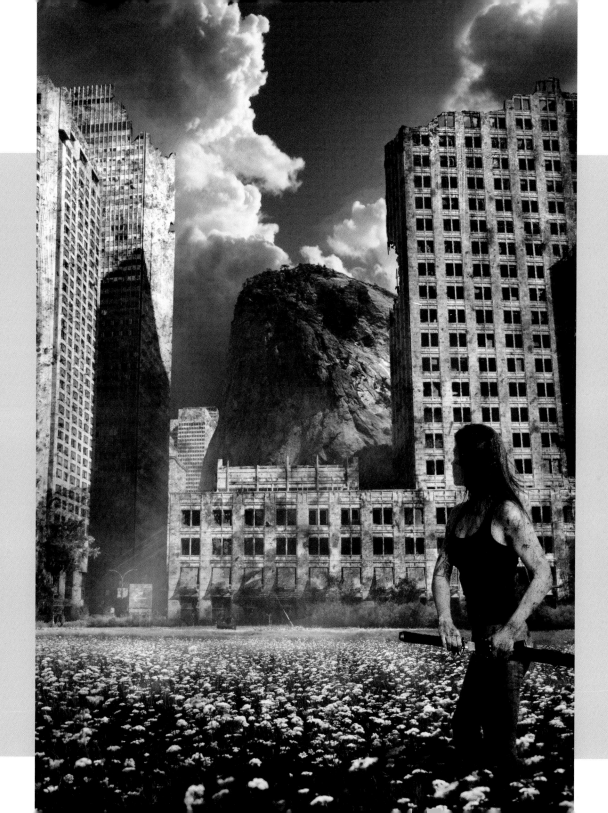

FIGURE 9.2 Shot with a wide-angle lens, this Montreal cityscape shows a good deal of distortion and exaggerated perspective; it needs to be altered to lessen the effect and better match some of the other key shots.

Straighten Up with the Adaptive Wide Angle Filter

It happens: You find the perfect background location for your composite puzzle, take a nice wide-angle picture, sit down to edit, and—wait, did the camera do some editing of its own while you were busy looking at the actual scene? None of the other pieces look right; the background, which was shot with a different lens than the rest of the material, has too much distortion. Perspective distortion, such as in **FIGURE 9.2**, is as common as it is a pain, but it is correctable (to an extent) with the help of the Adaptive Wide Angle filter. With version CS6, Adobe revamped the filter capabilities of Photoshop and introduced the Adaptive Wide Angle filter for a number of fixes. Found in the Filter menu, the Adaptive Wide Angle filter enables you to correct a fair amount of distortion from angular perspective shots. Before you move forward with any kind of masking, it is important to first get the main shots looking the way you need them to be for detailed compositing, meaning distortion free and easier to match with a range of other shots. For example, I shot Figure 9.2, a cityscape of Montreal, Canada, with an 18mm lens, and it suffers from that bend and distortion that shooting on a wide-angle (short) lens naturally imparts to the edge of a building. Because the photo of the model doesn't have this kind of distortion, the city can definitely use some adjustment before being composited with her and the flowering meadow—the perfect chance to practice with the Adaptive Wide Angle filter!

1. Using your favorite method, browse to the Chapter9_Resources folder and then the City folder to find the *City.jpg* file and bring it into the *Nature_rules.psd* composite document within Photoshop. Be sure to place it into the group named Main City, which will house all the city layers and the city adjustments for the rest of the composite.

2. Select the City layer, and make a copy (Ctrl+J/ Cmd+J). This gives you a clean copy to jump back to if things go wrong (and they often do).

3. To ensure a nondestructive workflow, you'll apply the Adaptive Wide Angle filter as a Smart Filter, which you can readjust at any time. First, choose Filter > Convert For Smart Filters to convert the City layer into a Smart Object (**FIGURE 9.3**). Now scale this Smart Object with the Move tool (V) until it fits the entire frame and then choose Filter > Adaptive Wide Angle to open the filter's editing window. Here you'll find some neat tools to help correct for the wide angle and perspective distortion (**FIGURE 9.4**).

4. The controls in the Adaptive Wide Angle window like to change as new versions are released, so I'll focus here on helping you get the image looking as close to the original scene as possible—so you can manually alter the angles of individual edges afterward. In the CC 2018 release, leave Fisheye chosen in the Correction menu (the default). Next, move both your Focal Length and Crop Factor settings all the way to the right. In my case, this is a Crop Factor of 10 and Focal Length of 7.2. Your adjustments for the City layer need not match *mine exactly* as CC releases vary on how this feature works, but adjust the slider positions until you see the least amount of added distortion. Even though the image was shot with a wide-angle lens, I found these settings produced the most desirable results; they didn't try to pinch or overly compensate for the distortion, leaving most of the adjusting to my eye and manual control. These settings will change with each shot as they are meant to correct for lens distortion, so a good strategy at this stage is to play with the settings until they get you close to the original scene and leave it up to the next steps for fixing those angles and edge curves.

FIGURE 9.3 Smart Objects and their Smart Filters enable you to keep resizing and adjusting a layer until you are satisfied with its filter, scale, and position, without degrading the quality with each adjustment.

FIGURE 9.4 The Adaptive Wide Angle filter can be a great way to manually straighten any edge you want.

FIGURE 9.5 To straighten edges, click two distant points along each edge.

5. To straighten and align the image's edges, first select the Constraint tool (top-left icon). In the large image area, you'll use the Constraint tool to draw lines along edges that you want to be straight. As you add a line, you may notice that it bends with the slight curve of the building edges (how cool is that?), and each line adjusts the image immediately once two points are created. To try this out, click once along an edge to set a starting point, move the pointer, and then click again to set an end point somewhere on the same edge (**FIGURE 9.5**). Using Figure 9.4 as a *general* guide, add several lines at the building edges. Make sure to include both horizontal and vertical lines.

 I started with the outer edges of some of the buildings, as adjusting these will set the overall rotation and stretching of the entire image. Once you begin rotating some of these lines (demonstrated in step 6), it helps set up a good distortion correction base to work from—and until each line is manually rotated, it will move freely, pivoting with other rotation adjustments; altering a rotation (even the slightest bit of a change) anchors the line/edge from moving.

6. Rotate a line by first clicking a line to select it; notice the small circles that appear. By dragging these rotation points (similar to rotating with the Move tool), you can change the *angle* of the straightened edge, rotating everything that was on that line to precisely match the angle you choose (**FIGURES 9.6A** and **B**). For the example, I shifted the angles from leaning inward to a little more straight up and down.

NOTE If angles are adjusted too much (such as high-rises being too perpendicular), things will look "off," so keep at least a little of the original perspective as you go. The idea is to lessen the wide-angle effects so the image meshes better with the other imagery, but not go so far to create another problem you will have to compensate for.

Click and drag the rotation anchor points to adjust all lines roughly as I did in Figure 9.4. I corrected a good amount but left a little bit of perspective because I still wanted the buildings to feel dramatic and large—and even possibly a little tipsy for added effect. This is generally a subjective choice, so rotate these until you see something that works for you. For the example, I kept rotations fairly small and controlled to not overly distort the image too far the other way.

TIP Hold down Shift while dragging a rotation anchor point to rotate at exact 15-degree increments or to jump the rotation to a nice 90-degree alignment. This can really help for those moments that you know you want something straight up and down or horizontal but just can't eyeball it the way you want. Alternatively, you can also right-click and choose Vertical or Horizontal from the context menu.

7. When you're satisfied, click OK to exit the Adaptive Wide Angle window. In the Layers panel, notice that the City layer, which you converted to a Smart Object, now has an associated Smart Filter (and separate mask) that you can enable and disable to see a quick before-and-after view (**FIGURE 9.7**). Use the Move tool (V) to scale this layer until it fills the frame.

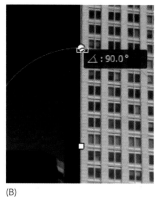

(A) (B)

FIGURES 9.6A and **B** To begin, the building clearly needed straightening (A). When you adjust the angle of a line, Photoshop provides the exact angle as you rotate it (B).

FIGURE 9.7 Smart Objects can have Smart Filters applied to them, enabling better nondestructive editing. You can apply, change, or remove the Smart Filter at any time.

Mask Montreal

For the *Nature Rules* composite, you need to break apart the newly straightened city and infuse it with a quite a bit more nature. But first, you need to mask the city to separate it from its current environment. To make the initial mask of the city, start with using Quick Selection to select the sky; because it's a nice gradient containing shades of blue, it's easier to select. Then, you can invert the selection to apply to the buildings instead—much simpler than selecting the buildings by hand, eh? Finally, Select And Mask will help you fine-tune the selection even further before you create the mask and let loose the nature.

1. Grab the Quick Selection tool (W) ![icon] and begin painting a selection of the sky starting at the top. Work your way down and around until the sky is surrounded by an army of marching ants.

2. Invert the selection so it applies to the buildings by pressing Ctrl+Shift+I/Cmd+Shift+I or by right-clicking it and choosing Invert Selection from the context menu. Now when you apply a mask, only the buildings will remain.

> **NOTE** If you forget to invert a selection before entering Select And Mask, Photoshop has you covered! Just click the Invert button within Select And Mask.

3. Subtract both the dark, shorter skyscraper and the small background skyscraper from the middle of the selection: Hold down Alt/Opt to turn the Quick Selection tool into subtraction mode and paint over the building, including the top by the sky to be sure no edges remain. If the tool selects the shadows of the tall right building as well, release Alt/Opt to return to addition mode and paint with white to return the shadows. Work a little at a time, toggling

between adding and subtracting from the selection to get exactly what you need selected.

4. Notice that the city's edges have a slight blur. Any alterations and lens corrections will ever so slightly blur the image as well, and you need to simulate this slight blur to make the selection seem more natural (and less like a fake cut-out collage with too sharp edges). To do so, click the Select And Mask button in the options bar to open the Select And Mask workspace. In the Properties panel, shift the Feather slider to 1 px. To avoid slight halos from the selections, set Shift Edge to about −40% (**FIGURE 9.8**). Click OK when you're satisfied with the refinements.

> **TIP** When refining the edge of a selection, always make sure to zoom all the way in (hold Alt/Opt and scroll up with the mouse or trackpad over the area you want to zoom, or press Ctrl/Cmd+ or Ctrl/Cmd-) so that you can actually see what you are refining. What may look just fine from afar is actually quite bad when you edit close up.

5. Click the Add Mask icon ![icon] in the Layers panel to add the mask to the selection. Although you can do this straight from Select And Mask, I prefer the manual way so that there is never any confusion as to what is being masked—plus I have the option to keep playing with the selection.

> **TIP** To paint on a mask in straight lines (which is handy for buildings), click one end of the edge then Shift-click the other end; Photoshop will paint everything in between in a perfectly straight line at the current Opacity setting. While using a tablet, if you notice that the opacity is attenuated even when pressing at full pressure, try turning off pressure sensitivity.

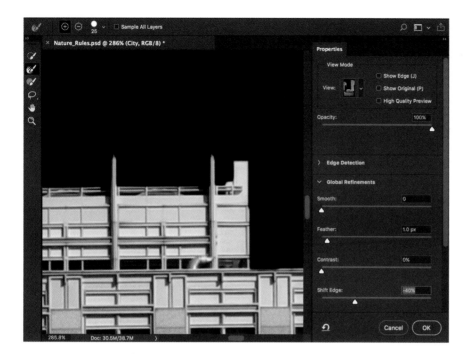

FIGURE 9.8 Refine the edge of a selection for a more seamless effect; adjusting Feather helps match natural edge blur, while reducing Shift Edge can prevent selection halos.

Preliminary Demolition

Although many atmospheric enhancements are finishing touches on a piece, some are easier to put in place if you do a bit of preparation early in the composite. In this case, the decaying look of the buildings will be easier to accomplish if you do some demolition to the mask now. Plus, removing the top section of the building on the right will help you situate the clouds when you're ready to add in the new sky. To make room for the mountain, you also need to change the depth of the small background building as well. A little advanced planning like this can eliminate frustrations and reworking later.

Just remember that your demolition does not need to be well crafted at this moment as you can (and will) refine exactly what the destruction looks like later in the project. For now, crudely smash off the top of the building and fig-ure out your general shape for the remaining composition. For mine, I wanted a sloped angle to the tall building at the right to help bring the eye-flow down-ward toward where the mountain, meadow, and subject were going to be

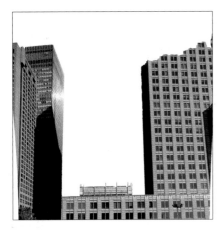

FIGURE 9.9 Select the areas you roughly want to demolish, such as the top of the right skyscraper.

FIGURE 9.10 Mask out the areas of the city that you want to demolish for later enhancing with greater decay detail.

placed. The more subtle hints you point in the conceptual direction you want, the better control of the composite and eye-flow you will have. A line here, a light spot there, exaggerated contrast, and use of color are all useful tools.

1. Using the Quick Selection tool (W) set at 50 px in size, select a general area you want demolished from the right skyscraper. Again, this can be very rough as your goal at this moment is to make room to add the clouds to better balance the composition (**FIGURE 9.9**).

2. Paint your selection with full opacity black to remove it from the scene. (Go ahead; make some demolition sounds while you paint. The more you can get into the play of your work, the more fun you'll have and the better the end result!) Alternatively, you can use the shortcut of Alt+Backspace/Opt+Delete to fill the selection with your foreground color (make sure this is black).

TIP To better see masked areas, especially those building edges, vary your background layer from time to time. In the starter file I provide, the background starts as black, but by selecting the black layer and pressing Ctrl+I/Cmd+I you can inverse this background color to white. You may see this inversed background from time to time throughout this chapter.

3. Rough out any other demolition sections you may want and check for any selection edges that didn't quite work as intended. To clean these up, use a small, round, and soft brush to paint the areas you want masked with black and the areas you want visible with white (**FIGURE 9.10**).

4. Check that you fully masked out the dark middle building and the smaller background in the "Mask Montreal" section. Zoom in close to be sure there are no lingering pixels, as you don't want digital grease to pile on the mountain you'll composite into this space. Although the little building doesn't need to be demolished like its shiny blue neighbor, you will later move it *behind* the mountain layer to add depth. For now, just make sure it's out of the way.

Mask the Meadow

With the city more or less ready at this point, the next phase is to bring in the meadow and mask out the tree line from its source picture (**FIGURE 9.11**). Adding the pretty meadow flowers and lush green will provide a great contrast and clash of moods to the concept of gritty survival and structural decay. The meadow also provides a neat way to obscure the swordswoman's feet. Feet have a way of being the first thing to look "off" when you try to combine a controlled studio shot with an environment, as you'll learn later in the "Select the Swordswoman" section.

1. From the Meadow folder of the Chapter9_Resources folder, open *Meadow.jpg* and place it into the composite document's Meadow group. Remember to keep the Meadow folder above the Main City group; layer ordering is especially important because it directly corresponds to the stacking depth of each section.

2. In the Layers panel, change the Meadow layer's opacity to 50% so you can see the city horizon and the meadow simultaneously; then use the Move tool (V) to place and scale the meadow to fit at the bottom of the two side buildings (**FIGURE 9.12**). I got decent results with little effort by matching the tree line with the first prominent building. After the meadow is more or less in position, return the opacity to 100% and press Enter/Return to confirm the move and transformation.

FIGURE 9.11 This shot I took of Bell Meadow in the Sierra Nevada Mountains has similar enough depth, lighting, and POV to fit nicely with the city scene.

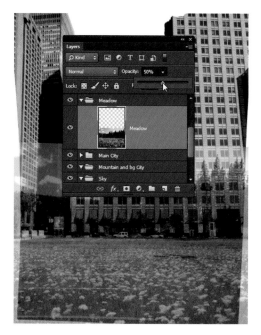

FIGURE 9.12 Changing the opacity to 50% lets you see both layers just enough to find a good place for the meadow.

FIGURE 9.13 A brush with some splattered texture can greatly assist in painting a more convincing organic edge for the mask.

3. Click the Mask icon ◉ at the bottom of the Layers panel to add a mask; then paint out the Meadow layer's sky and trees with black using a round, soft brush (or if you use a harder brush edge, be sure to return the brush hardness to 0 when finished) at full opacity until just the edges of the tree line are left. In addition, I left in a few bushes and trees to incorporate into the scene for better blending, but the choice is yours.

TIP Double-check your masking coverage by pressing the \ key to display your masked area in the default red. Because this tinted area is actually a mask, you can still paint with black and white to conceal and reveal. If you notice spots not covered with red (or covered spots that shouldn't be), fix them. Take the time to check for stray pixels as you work to avoid digital grease buildup. Even for a gritty composite, you want the mess to be controlled and not accidental. This makes a big difference in the final results.

4. Choose a textured brush with some speckling in it, such as Spatter (**FIGURE 9.13**), and paint with black in an up-down motion following the natural contours of the foliage. This better simulates the organic edges of the meadow, trees, and bushes, helping the layers to blend more naturally.

Shrink your brush size (press the [key or Ctrl+Alt/Control+Opt-drag left), and zoom way in to get this part just right. If you see part of a bush's light green continue in a certain direction, work with these tendencies and don't just bulldoze through them; it will look bad if you do. The more you can let the pictures do the painting for you, the more it will feel "right" in the end.

TIP Anytime you paint too far, press the X key to flip your paint selection, toggling between painting out (black) and in (white) the mask. If black and white are not your default foreground and background colors (or you are not one hundred percent sure), press D to restore them to their rightful place.

Move a Mountain

Okay, we've watered the parking lot, which is sprouting quite well; it's time to move mountains. Specifically, you'll add an image of a solid granite mountain from my own stomping grounds in Yosemite National Park between the decaying skyscrapers. Adding the mountain is easy; the trickier bit is making good selections and painting the mask to ensure the new cloudy sky shows behind the mountaintop, as well as the detailed vegetation along the edge.

1. Copy *Mountain.jpg* (**FIGURE 9.14**) from the Chapter9_Resources folder of source files into the composite document's Mountain and bg City group. (Again, see Chapter 6 for how best to search for and bring images into Photoshop and the composite if this is still a challenge.)

2. Use the Move tool (V) to position the mountain between the skyscrapers so that the trees are hidden but room remains to bring back that smaller building you masked out along with the shiny one (**FIGURE 9.15**).

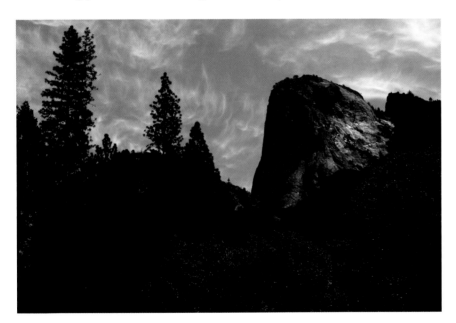

FIGURE 9.14 This mountain eventually will replace that shiny skyscraper; for now, put it in the Mountain and bg City group.

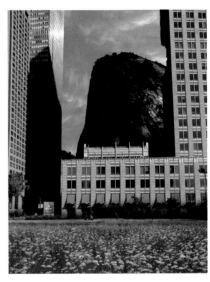

FIGURE 9.15 Move the mountain into position covering up the unwanted parts and leaving a place to return the background city to the left of it.

3. Select the bulk of the mountain with the Quick Selection tool (**FIGURE 9.16**). If you grab some of the sky by accident, hold Alt/Opt to subtract from the selection (or click the 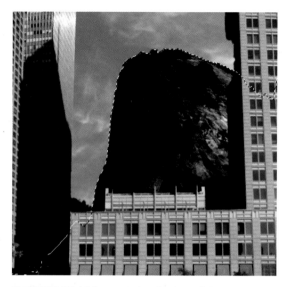 icon in the options bar). In the next steps, you will refine the selection to properly include the trees and shrubs.

4. Click the Select and Mask button in the options bar. In the resulting workspace, add a slight feather (.6 px or less) and set Shift Edge to –13%.

5. Staying within Select And Mask, switch over to the Refine Edge Brush Tool (R) if it's not already selected; then paint around the mountain perimeter to select those unruly shrubby areas in detail (**FIGURE 9.17**). When satisfied with the selection, click OK.

6. Once satisfied with the selection, click the Create Mask icon ◉ in the Layers panel to turn the selection into a mask.

7. Tidy up the edges of the mountain by again painting with a textured brush as you did with the meadow shrubbery. Work from the outside in to simulate organic edges and be sure to be zoomed in completely.

TIP If you ever have a mask that is too soft in certain areas or even has a tiny bit of halo sticking out, you can try this trick, which is like putting parts of the mask through a pencil sharpener, whittling the soft spots into a sharper edge! To sharpen a mask selectively like this, change your brush to Overlay mode in the options bar. This will simultaneously sharpen and shift the mask inward toward the black wherever you paint black along the edge. This can be very useful for getting rid of those last halos that were missed in the selection edge refining. Just remember to change your brush back to Normal mode when you're done!

FIGURE 9.16 Make a rough selection of the mountain first.

USE THE REFINE RADIUS TOOL ALONG THE EDGE

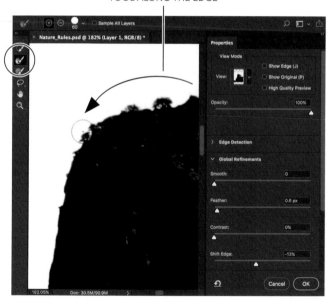

FIGURE 9.17 Use the Refine Edge Brush tool when you have bits of edge detail that require special selection.

8. Remember that small building you masked out? It's time to bring it back. Sandwiching the mountain between the near and distant buildings will give the illusion of depth. In the Main City folder, disable the City layer's mask by Shift-clicking the mask to the right of the layer thumbnail in the Layers panel. Select the City layer, if it is not already selected.

9. Now that you can see the background building, make a Marquee (M) selection of the light-colored background city, leaving some room for a mask as shown in **FIGURE 9.18**. Copy this selection (Ctrl+C/Cmd+C), and use Paste in Place (Ctrl+Shift+V/Cmd+Shift+V) to paste so that it doesn't get placed somewhere else in the composition. Move this layer down in the stack until the city piece is directly beneath the actual mountain layer in the Mountain and bg City group. Does that long folder name make a little more sense now? Always try to think ahead so that you don't have to pull out the duct tape to patch problems later.

10. Mask out the sky and other buildings of this wee layer using the same methods as you did for the main city image.

FIGURE 9.18 Select the small background building and copy and paste in place. This will then allow you to move this building to behind the mountain you worked on earlier.

Practice Cloud Control

Adding dramatic clouds can change the entire atmosphere of an image. As a cloud photography addict, I can attest to the importance of developing your own database of images so you have a good array of choices—from dramatic foreboding to shining optimism. When searching your options, carefully consider the lighting. If lighting in the cloud image doesn't fit your scene, viewers will notice. They may not be able pinpoint the problem to the clouds, but they'll notice something is "off." You may not have to match *exactly*, but pay close attention to the direction of the highlights and shadows if you want it to be believable. Remember, the shadow changes direction on an object only when we see something at a different angle in relation to our own POV (or obviously if time passes). So if the sun is to the east of one object, it's to the east of all the objects!

For *Nature Rules*, adding clouds will be dramatically simpler because of the previous masking work you did to the city and mountain. The only task that remains is matching the contrast and other pieces that can help make the cloud layer visually fit into place.

1. From the Clouds subfolder of the Chapter9_ Resources folder, bring *Clouds1.jpg* into Photoshop as a tabbed document and then move it over to the composite with the Move tool (V). Alternatively, you can use Adobe Bridge and the Place feature (right-click an image thumbnail and then choose Place > Photoshop from the context menu) to bring the entire image over as a Smart Object. If you want a piece rather than the whole object, however, you still need to use the tab method.

2. Scale the clouds down using the Move tool (V) and drag the layer into the last group, Sky (**FIGURE 9.19**). See Chapter 2 for a refresher on scaling and other Move tool hidden features.

3. Add a Curves adjustment layer to bring a bit more contrast to the drama: Click the Curves Adjustment icon ▦ in the Adjustments panel and then create a bit more contrast by dropping down the darks and raising the lights as shown in **FIGURE 9.20**.

4. To clip the Curves to that sky layer, Alt/Opt-click between the Curves and the Clouds1 layer in the Layers panel (**FIGURE 9.21**). Alternatively, click the Clipping icon ▮▯ in the Layer Properties panel. Either way, this will tie the adjustment to this Clouds1 layer. This is useful if you want to apply a mask in the future and ensure that only the clouds are affected by the adjustment layer.

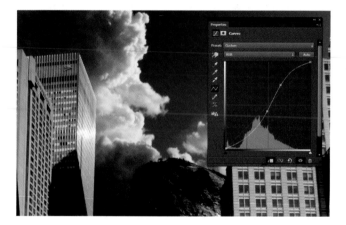

FIGURE 9.20 Curves control clouds very nicely as they are so full of tonal range; this adjustment allows for pinpoint accuracy on the final cloud mood.

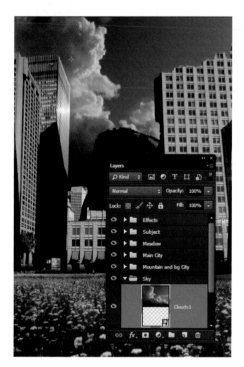

FIGURE 9.19 Move the clouds to the correct depth, the bottom of the layers stack.

FIGURE 9.21 Clip the curves adjustment to the Clouds1 layer; if you decide to mask the Clouds1 layer later, the clipped adjustments will show on the visible cloud layer pieces only.

5. At the moment the composition is too left-side dominant and looks off balance. Adding more clouds will balance it out, filling the emptiness in the right sky. Bring in the *Clouds2.jpg* file, and place it in the Sky group above the Cloud1 layer and adjustment.

6. Next comes Cloud2. Bring this image into the composite, and place it just above the other cloud and adjustment. Cloud2 features a little more back lighting and works better placed closer to the sun's direction; it just needs to be masked to match. Click the Create Mask icon, and choose a large, soft, and round brush. With a low opacity setting, work around the edges until you come to the highlights. Make sure to mask out everything but that one small backlit element. The transition of the sky to highlights can be synced best with another Curves adjustment, so for now leave the mask alone when you reach the highlights (**FIGURE 9.22**).

7. Create another adjustment layer, place it above Cloud2, and clip it to this layer (Ctrl+Alt+G/ Cmd+Opt+G on the adjustment).

8. Click the adjustment to bring up the Adjustment Properties panel, if it is not already up, and add another two control points along the Curve's default diagonal as you did in step 3. Shift the darks downward, and bring the lights up ever so slightly. Look for that sweet spot where the cloud matches the background sky and other clouds nearly perfectly—no need for detailed and fancy brushing (**FIGURE 9.23**).

FIGURE 9.22 Mask out everything right up to the cloud's highlights.

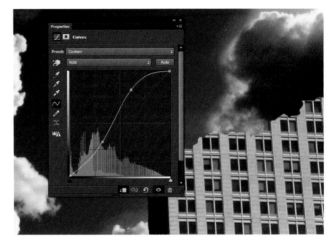

FIGURE 9.23 Control the cloud tones with a Curves adjustment layer to match the larger cloud and sky.

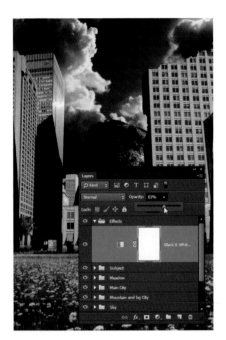

FIGURE 9.24 The Black & White adjustment layer helps desaturate the image when set to a lower opacity. 63% opacity does quite a bit toward creating a more cohesive and wonderfully cheerless look.

Cheer and Color Control

The elements of the scene are coming together quite well; however, overall it just looks too happy and cheerful—not good for a scene supposed to depict decay crushing all the cheer from the world (yes, aside from the pretty flowers). The composite's color palette needs to reflect this melancholy. Adding a global adjustment at this point will help later additions of textures and other dramatic adjustments to fit in seamlessly without the colors accidentally looking too garish.

1. Click the Effect group to open it, and add a new Black & White adjustment layer from the Adjustments panel ▣. This instantly makes everything completely black and white, which may seem a little extreme but makes a necessary starting point.

2. Reduce Layer Opacity to about 63%. This will help control the color intensity for the remainder of the project and instantly creates greater continuity as you work (**FIGURE 9.24**).

Combine the Studio and the Outdoors

Seamlessly adding a studio-photographed model into an outdoor scene provides some interesting lighting, texture, and atmospheric challenges. This is really a three-part operation: selecting the model (and especially her hair) correctly, refining the mask to make her look as if she is standing in the scene (for *Nature Rules*, a field of flowers), and adding clipped textured layers so that the studio model blends into an outdoor scene without standing out horribly. Often it is imperative to have multiple pose options to better match the mood and direction you plan for your composite.

Selections

For *Nature Rules*, I've provided three different poses of model and ex-Marine Miranda Jaynes that I photographed in the studio with the help of lighting-Jedi Jayesunn Krump (**FIGURE 9.25**). For the example, I chose the side-draw (*Pose1.jpg*), because it drew the viewer's eye in the direction I wanted. All of the options have their own intimidating flair, however, so you can work with any of these poses just as well.

FIGURE 9.25 Photographing several poses of your subject gives you more compositing flexibility. Choose one that best matches the idea and composition you are going for.

1. First, choose the pose you'd like to use from the Subject folder in the Chapter9_Resources folder, bring it into the composite document (either with Place or the tab method), and put it in the Layer panel's Subject folder. Don't forget to label as you build up your layers; this one should be called Subject.

2. Turn the layer into a Smart Object (right-click to the right of the layer thumbnail and then choose Convert to Smart Object from the context menu), and scale it down until Miranda fits your vision of the composition.

 For the example, I scaled Miranda to just under half the height of the scene from head to feet. This way she is close enough to identify with as viewers, but far enough away to make her feel especially isolated.

3. To select Miranda and separate her from the studio background, select the Magic Wand tool (Shift+W) . Deselect Contiguous in the options

FIGURE 9.26 The Magic Wand selected most of the background in the entire scene with Contiguous off and Tolerance set to 30. Shift-clicking with Tolerance set to 10 can help grab the rest.

FIGURE 9.27 To feather the hard selections edges and yet avoid feathering the hair, break the refining into two steps. First, feather the edge of the entire selection in Select And Mask and click OK; then again open Select And Mask, this time using the Refine Edge Brush tool to select the hair. This takes out the feathering done earlier on the hair, like rinsing out shampoo!

bar, set Tolerance to 30, and click in the center of the background behind Miranda—giving you fairly large selection automatically. For parts and pieces that weren't included the first time, change your Tolerance to 10 and Shift-click on the remaining tone. The Magic Wand tool works well in this case because of the uniformity of the background (**FIGURE 9.26**); if there was clutter or other what-not, you would need a different set of selection tools.

4. Press Q to enter the Quick Mask mode, choose a large, solid brush in white, and finish off what needs to be included in the selection with a few strokes. (Likewise, if part of Miranda's skin was selected by accident with the Magic Wand, take this time to deselect it by painting with black.) Press Q again to exit Quick Mask mode and then press Ctrl+Shift+I/Cmd+Shift+I to invert the selection to encompass Miranda instead of the background.

5. For best results, you'll use Select And Mask to refine the edge selections in *two* stages: feather and shift the edge of the selection, and then in the next step you can do the hair selections. Click the Select And Mask button and then adjust the Feather slider to 0.5 px to give the edge a slight blur, matching the sharpness of the image itself. Set Shift Edge to −40% to fully eliminate any halo (**FIGURE 9.27**). Click OK when the edge looks like it fits with the selection (ignoring the hair for now).

6. To refine the hair selection, click Select And Mask again. Just as you collected the mountain's shrub details, brush the Refine Edge Brush tool (R) across the hair to capture the small flowing strands, turning the rather chunky and awkward selections of hair into a fairly precise selection (**FIGURE 9.28**).

7. After all the hair strands are selected, click the Add Mask icon at the bottom of the Layers panel to see how the selection turned out within the composite and its new background.

FIGURE 9.28 Use the Refine Edge Brush tool for selecting complex hair with amazing simplicity.

8. To eliminate any stray halos that are still lingering, pick up the brush, select Overlay mode from the options bar, and paint with black. This will tighten the selection toward white a little and also sharpen it as well, so use this technique only in moderation. Always be sure to change your brush back when finished.

Alternatively, you can paint using the default Normal mode with a small and soft brush along the edge. This is my preferred method, but brushing accuracy counts heavily. Also make sure to paint in any holes that came from the original Magic Wand selection; these typically occur in lighter areas such as the sword, hands, or pants.

Standing in the Thick

How do you keep your subject's feet on the ground? Although well rooted to the studio floor, once in the composite document, Miranda stands on top of the grass with her feet visible (for now). This common problem looks just totally wrong and can ruin the effect of an image. My solution for the example was to take her legs off just below the knee, creating the illusion of her legs vanishing into the meadow grass and flowers. If this seems too daunting, you could scale your subject large enough so that her feet continue off the bottom of the composite, as if she is standing very close to your own POV (see Figure 2.23). To help you decide, here's how the vanishing into the meadow version works:

1. Start by painting directly on the subject's mask. Grab either a spatter brush or some other textured brush such as Rough Round Bristle from the Brushes panel; paint with full-opacity black to mask out the feet and legs. Stroke from the ground up, mimicking the blades of grass and the flowers. Don't get too detailed until you know exactly where you want to

place the subject in the meadow, however. Each time you shift the subject around, the meadow will look different by the legs and will need adjusting on this mask. You may need to touch up this mask toward the end of the project when you settle on final placement (**FIGURE 9.29**).

TIP A more nondestructive method of masking out the feet that allows for greater flexibility is to create another group to place the Subject layer inside. This allows you to add a mask to this group and use it to paint the disappearing legs (while leaving the original mask alone in case you change your mind). This also allows you to unlink 🔗 the mask from the group and move each independently until satisfied with the results.

2. Adding shadows to better match the scene's lighting and transition will add depth and greater realism. Click the New Layer icon 🔲 at the bottom of the

Layers panel to hold the shadows, change its blending mode to Overlay, and name the layer Shadows. Create a group above the Subject group, label the group Shadows, and move the Shadows layer to it. As you begin painting more and more desired shadows, it's a good idea to start labeling these layers and groups more specifically as you find the need. In my final example PSD file, you may see that I labeled a group Shadows at Feet.

3. Switch to a soft brush once again, lower its opacity to 10%, and gently paint in some shadows to the left of the subject and around the lower legs. The low opacity setting enables you to work incrementally (**FIGURE 9.30**).

Again, the shadows need not be too perfect at this stage; you'll need to return to this layer and readjust them depending on where you shift the subject and how you finesse the image.

FIGURE 9.29 Mask out the feet and legs to get a better idea of placement.

FIGURE 9.30 Shadows help dramatically when you first bring a studio subject into the natural world.

Muddy the Model

Nothing adds atmosphere and gritty reality to an image like a little dirt and texture. The studio Miranda is in is simply too clean to match the post-apocalyptic mood of this composite. Surviving in the wild roughs up a subject. Adding in some textures goes a long way to change the entire feeling of the image, with surprisingly little effort.

1. From the Chapter9_Resources folder, grab *Cookie_ Sheet.JPG* (**FIGURE 9.31**) from the Textures folder, and place it directly over the subject within the composite and above the subject in the Layers panel. Label this layer as Muddy. Metal textures are amazing for a number of uses, and scratched and stained cookie sheets, such as this one, are excellent source material—just you wait to see what we cook up in the next chapter!

2. Change the Muddy layer's blending mode to Multiply so that it will darken the subject with all of the textured elements.

3. Press Ctrl+Alt+G/Cmd+Opt+G to clip the Muddy layer to the visible pixels of the subject only (or Alt/ Opt-click between the two layers in the Layers panel).

4. Move, scale, and rotate the texture with the Move tool (V) until you align the blotches and stains to places that look fitting to you. For the example, I wanted to pull out some obvious scuffs and scrapes on the arm, so I found an area that looked promising and shifted it until it had good coverage (**FIGURE 9.32**).

FIGURE 9.31 A metal texture from a used cookie sheet has so much potential for texturing. Always be on the lookout for things like this!

FIGURE 9.32 Move the metal texture around until you get some marks in places like her arms and face.

5. The scratches help, but Miranda is still far too clean and part of what stands out is her lighter pants. Instead, let's make them nearly black and rough them up a bit. To darken these and add some additional wrinkles and stains at the same time, bring in *Falls1.jpg* (also in the Textures folder). Find a good spot for this granite texture that matches the crease direction but avoids the water. I found the rocks just to the right of upper Yosemite Falls ended up working well (**FIGURE 9.33**). Label this layer as Dark Pants and be sure it is placed directly above the subject in the Layers panel.

6. Change the Dark Pants layer's blending mode to Multiply, and clip it to the subject (Ctrl+Alt+G/ Cmd+Opt+G), if it is not already clipped.

> **NOTE** Avoid too many textures overlapping with each other as this turns mere mud flecks into a swamp! You don't want to drown the subject; just add some texture in selective places. Use a mask on the texture when appropriate to avoid too much texture overlap (this mostly goes for the skin). Alternatively, you can also play with some of the other blending modes to see if a texture has better results that way.

7. Although the pants definitely darkened down in my version, so did half her arms and torso. If you run into the same problem, add a mask and paint out everything except where you want darker pants (**FIGURE 9.34**).

Color and Lighting

One of the main things that currently feels ill-fitting is the exact source of the lighting on the subject (not to mention how dark and muddy she is compared to the rest of the image). Although Miranda was shot in fairly neutral

FIGURE 9.33 Find a spot of granite to use to darken the pants with the Multiply blending mode.

FIGURE 9.34 With a pinch of granite and a little masking in the mix, the pants are dark and muddy!

lighting with a definite direction that was appropriate, to look natural in the composite, the Subject layer needs greater emphasis and more warmth from the sun, as well as cool colors lurking in the shadows. The specific color and lighting adjustments your image will need depend on several placement variables, so replicating the exact effects in *Nature_Rules.psd* may be difficult. You can, however, use the following steps as a guide to get you started.

1. Create a new layer, and place it above the last texture used just on the pants. Make sure this new layer is clipped to the one below, change its blending mode to Overlay, and label it as Highlights. Now you're ready to dodge and burn the lighting and shadows nondestructively (**FIGURE 9.35**), similar to the fire and smoke in Chapter 8.

2. Choose a soft, round brush and a low-opacity white. Paint along the pants where the sun would be hitting on her right side (Figure 9.35). Call this layer Highlights, because that's what your painting provides.

 Don't go too crazy with painting in lighting, because it can quickly look painterly and fake. Keep it basic

and as natural looking as possible. Think of the sun's location, and use what little lighting direction is still left on the subject as an indicator of what to emphasize.

3. Create a second new layer, this time above Highlights, and repeat steps 1 and 2, naming the layer Warm Highlights and using a warm yellow-orange to simulate the warmth of direct sunlight. Studio flashes just don't replicate the sun's warmth in the same way without using gels or playing more with color temperature.

4. Also on the Warm Highlights layer, add a little more dimension and contrast to the shadows by painting in some faint blue in most of the shadows. In natural sunlight, this is the typical occurrence that Monet and others studied endlessly—what they wouldn't have given for an Overlay blending mode with colors (**FIGURE 9.36**)!

FIGURE 9.35 With an Overlay mode layer clipped to the subject, you can paint exactly the kind of lighting you want.

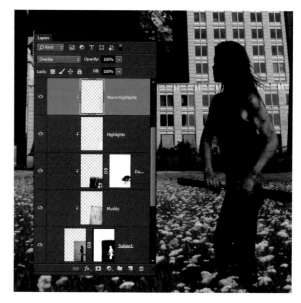

FIGURE 9.36 Warm highlights and cool shadows add subtle dimension with a big final impact.

A closer look at the layers of the original *Nature Rules* will reveal I also added a little more texture to muddy the hair and a Curves adjustment to darken just the hands and create a more convincing shadow for them. Both of these decisions used the same texturing and lighting methods already covered, just in smaller detail (**FIGURE 9.37**). Try your own combinations of these various techniques while you piece together what enhances your composite and what does not.

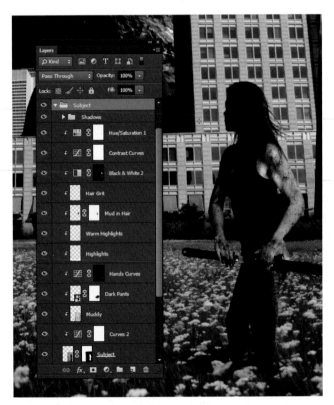

FIGURE 9.37 Work in small and controlled layers. They can add up to dramatic changes by the end.

TIP Don't underestimate the power of taking a break. Nothing is more important than getting some separation and returning with a fresh perspective, especially when you're trying to get something to look "right."

Complete the Demolition and Decay

In "Preliminary Destruction" you began taking jagged chunks and pieces out of buildings with the intent of finishing later. Well, it's later. Not only will you return to the original mask to paint out additional pieces, you can add slight shadows to the destruction by painting black on a layer directly underneath the city. To complete the effect, broken buildings need broken windows, which you can supply with the Magic Wand tool and a bit of painting. Some gritty textures like granite and rust can make a dramatic difference, as well. There is no exact science to this; you can make your scene as damaged or clean as you like. The more texture and demolition, the more age the structures seem to accumulate.

1. Just as you did with texturing the subject, bring in a layer of rusty metal (*Rust1.jpg*) from the Textures resources folder, and drop it directly above the City layer within the Main City group (**FIGURE 9.38**).

2. Change the new layer's blending mode to Multiply for nice, dense corrosion. You'll lighten this up in a little bit, but, for now, you just need to get things blending nastily.

3. Clip the rust layer to the city's mask by Alt/Opt-clicking between the two layers in the Layers panel (**FIGURE 9.39**).

4. Also from the Textures resource folder, bring in *Half_Dome.tif* to add some variation to the corrosion, destruction, and general weathering of the right-side building. I liked this piece of Yosemite's Half Dome because it has good highlights, dark stains, and downward streaks. Again, clip the new layer to the mask of the city and change its blending mode to Multiply.

5. The textures also make the building look dramatically darker, so lighten it by adding a Curves adjustment: Click the Curves icon in the Adjustments panel. Clip this new layer to the city's mask by clicking the small clipping icon at the bottom of the Adjustment Properties panel.

6. Add two curve control points to the default diagonal curve line by clicking high and then low along the line. Move the upper control point fairly dramatically to lighten the building enough to feel like it's still in the sun. As you can see in **FIGURE 9.40**, my version maxed out the lights just after that mid-range histogram peak. The lower control point simply keeps the darks anchored while you lighten the midtones in the next step.

FIGURE 9.38 Rusty metal has a great way of texturing and aging just about anything.

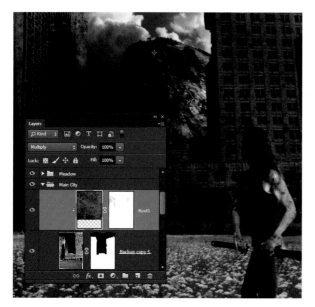

FIGURE 9.39 Clip the rust layer to only affect the visible pixels of the city.

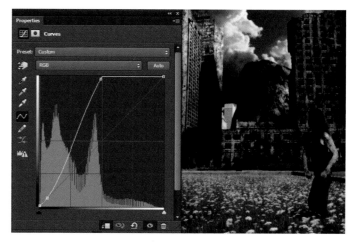

FIGURE 9.40 This Curves adjustment layer is a dramatic shift but effective in lightening up the buildings.

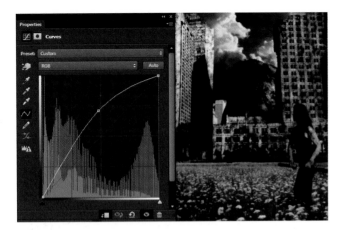

FIGURE 9.41 The second Curves adjustment layer gently lightens all the midtones to balance out the darkness that textures brought to the buildings.

7. Create a *second* Curves adjustment layer for a more subtle adjustment to the midtones, and clip it to the City layer just like the previous adjustment layer. Add one control point and gently bring up the entire mid-range as shown in **FIGURE 9.41**. Sometimes one layer is just not enough to adjust subtle emphasis at specific tones; multiple Curves adjustment layers can give you multiple levels of control.

8. Repeat steps 1 through 7 to apply a similar corrosion process to the last glowing beacon of shiny civilization: the small background building.

Smashing Windows

Broken windows impart a haunting, mysterious, not to mention menacing, aura to any building, leading viewers to wonder who might be watching from all those hidden places. Magic Wand selections and a bit of black paint are all you need for this effect. Again, the severity of destruction is up to you. For the original *Nature Rules*, I wanted

a vast majority to be missing or have just small fractured pieces remaining. If I wanted to have complete control, I might paint these exactly right, pixel by pixel, but there's a much quicker way that does a half decent job and it uses Magic Wand selections.

1. Make sure that you have the original city layer selected (not the mask, not an adjustment), and then pick up the Magic Wand tool (W).

2. Set Tolerance to 20 in the options bar, and be sure that Contiguous is deselected.

3. Click an average window. Because the Contiguous toggle was off, portions of all the windows are now selected. Zoom in close to be sure (**FIGURE 9.42**). This obviously saves a great deal of time compared to carefully painting window by window.

4. Create a new layer, and make sure it is placed directly above the top of the clipping group that includes the City layer. Name this layer Window before moving on.

FIGURE 9.42 As long as Contiguous is deselected, selecting one window will select similar portions of all windows.

5. Grab a black brush at full opacity, and paint in all the selected window areas. Repeat steps 3 and 5 until you demolish the windows to your satisfaction. Rather than filling all the selections with black, painting allows for greater control over the amount and location of the black. Sometimes you can use a small scatter brush to add some variation and selective painting, if some of the edges of the glass did not break the way you had in mind.

6. Deselect (Ctrl+D/Cmd+D) so you can work outside of the selection, and zoom in close with some of the windows for final touch ups and custom painting on the Window layer. While the Magic Wand technique did a great job overall, you also can use what was painted as a base for more fine-tuned and precision window shattering (**FIGURE 9.43**).

Shadows of Destruction

Masking chunks out of a building is a good start, but proper shadows really sell the illusion of believability. For a final convincing appearance, try these steps.

1. With the City layer active, zoom in close to the top of the large building on the right so you can more accurately cause some mayhem.

2. Shrink your brush down to 6 pixels (press the [key), and paint with 100% opacity black on the mask to bring sharp and messy edges to your previous roof demolition. Take a look at **FIGURE 9.44** for some visual aid; it shows my own roofline demolition.

3. Add dimension to the roughed-up edges by bringing in some shadows. Create a new layer, place it directly beneath the City layer, and label the layer Shadows.

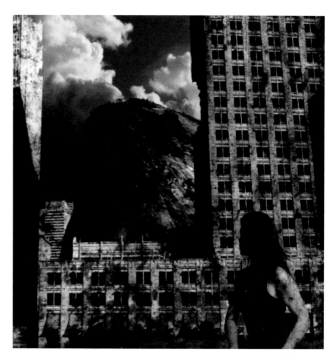

FIGURE 9.43 Painting black in many of the window selections instantly makes the building feel more ominous and believable.

FIGURE 9.44 Compare this finely tuned destruction to the quickly roughed-out building demolition in Figure 9.9.

4. Paint with the same 6-pixel brush along the edges that feel like they need greater depth using **FIGURE 9.45** as a guide. If it looks as fake as a paper-thin B-movie set, add some thickness along the edges. From the ground perspective, you would see this thicker part of the wall on the underside or left side, but adding in parts here and there enhances the impression of things not breaking clean; making parts look like angled smashes is definitely good too.

FIGURE 9.45 For a more convincing effect, add in a bit of shadow and mass behind the masked city.

Add Atmospheric Perspective

Some debris in the air further heightens a scene's reality, especially a dirty and destructive scene like *Nature Rules*. A thickness of dust and atmospheric perspective adds depth and separation of the subject and background, as well. With the subject staring off into the distance, adding more obscurity and atmosphere can help foster an ominous and foreboding feeling that also works well with this piece. The idea is to have viewers wondering what exactly she's looking at in the distance and wonder why she may be drawing her sword. The more you can leave details to the imagination of the viewer, the more immersed they'll feel in your scene and contribute to the narrative themselves. For this section, you'll create the base atmosphere that you'll enhance further in the final effects and finessing phase.

1. Create a new layer (click ▣), name it Dust, and place it in the Meadow group above the Meadow layer.

2. You're essentially going to paint a smoggy haze into the scene, so pick a pale and fairly neutral yellow from the Color panel (**FIGURE 9.46**). While white has a washed-out look, a pale yellow fits into the scene, adding both color and the feel of reflective particles. Choose a very soft brush, change your brush Opacity setting to 5% in the options bar, and adjust the brush size to between 400 px to 600 px.

FIGURE 9.46 Use the Color panel to choose a custom atmosphere color to paint into the scene.

3. Everything you want to obscure near the line where the meadow meets the foot of the buildings, paint with multiple strokes. Keep your painting denser closer to the ground and then slowly pile it higher and higher as if it is rising into the rest of the city (FIGURE 9.47). Be sure to add enough variety to make it feel natural, such as gentle plumes of haze here and there. (Chapter 13 dives deeper into customizing brush settings for a more natural textured atmospheric buildup.) Keep in mind that the farther away something is, the more atmosphere that accumulates between it and the viewer, so make your painting thicker in those areas you want to have greater depth.

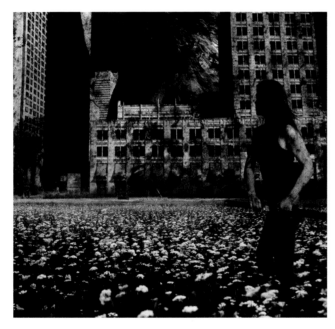

FIGURE 9.47 Adding atmosphere by painting can bring a lot more depth and mystery to the composition.

Finesse the Final Effects

Despite this chapter's fairly methodical steps, projects never quite go that smoothly. I find myself working on an area, moving on to another, and then returning to readjust something earlier on to harmonize with or enhance later changes. That's largely what this last stage is about: those adjustments and final layers that help make the entire composite fit neatly together with a better overall balance and cohesion.

Here we have the three areas that still need attention: color, shadows, and lighting. You'll first be working in the Effects folder at the top of the layers stack, so your adjustment layers and effects will affect the overall composite.

Color Continuity

Although you muted the color dramatically with the Black & White adjustment layer you added at the end of the "Practice Cloud Control" section, it didn't go quite far enough with creating a continuity and general mood. As a personal preference, I enjoy warmer tones in a final image. In this project, adding a bit more warmth emphasizes the feeling of dusty post-apocalyptic air and drab greens and blues, making the viewer look for patches of sunlight filtering through the vast buildup of smoke high in the atmosphere. A new layer will help you quickly warm up the composite:

1. Create a new layer and place it into the Effects group above the Black & White adjustment layer. I usually call this layer Warm to help me remember what it does.

2. Choose the Bucket tool (G), and pick out a warm yellow-orange from the Color panel.

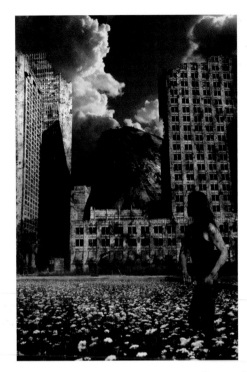

FIGURE 9.48 Adding a warm color spill on an Overlay layer brings greater continuity and color control to the composite.

What's nice about working within a group, such as the Subject folder, is if the folder gets moved, so too will the shadows you paint across the entire meadow.

1. Open the Shadows group you created *within* the Subject group back while working on the subject's shadow.

 Because Overlay mode darkens the darks when painting with black but mostly leaves very light parts alone (as they don't contain much to darken), some of the light flowers at Miranda's feet weren't shaded when you first added shadows with an Overlay blending mode.

2. To fix this, create a new layer above the first Shadow layer (name it Dark Flowers for easy reference), leave the blending mode set to Normal, and paint with a low-opacity black (press 1 for the shortcut of 10% opacity) directly on this new layer. Aim for the light bundles of flowers that the first shadow layer at Miranda's feet missed. Again, use the example file included to see the extent of my flower shading (**FIGURE 9.49**).

3. Spill the bucket across the layer with a single click—you can't miss! Change the blending mode to Overlay and lower the layer's opacity to 11%. You want just enough yellow-orange to add a subtle flavor of warmth to the piece, without looking like the photographer failed to set the white balance correctly (**FIGURE 9.48**).

3. Create another blank layer above Dark Flowers (each shadow layer will be placed above the next from here on out), name it Shadow Field, and change its blending mode to Overlay. You'll use this layer as the main darkening component for the entire meadow as well as to better blend the subject's legs with the grass.

Shadows and Meadows

With all your elements in their final places, you can return to adjust the shadows needed to get the subject looking like she actually belongs in the meadow. Some of these shadows involve adjustments to the entire meadow to help create continuity for where the subject is standing.

4. Paint with the same low-opacity black brush, this time at about 400 px in size; you want gentle but large changes. This brush size specifically helps with creating an effect of the meadow being partially under a cloud, with full sunlight only at the edges where Miranda is looking. **FIGURE 9.50** illustrates how painting in this way changes the coherence and mood of the image.

FIGURE 9.49 If light flowers are in the shade, they need to look like it; painting with a low-opacity black on a Normal blending mode layer is a simple and effective solution.

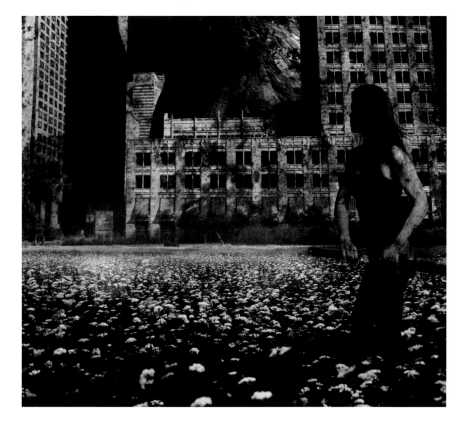

FIGURE 9.50 Play with the shadows and contrast of the meadow to create a more dramatic mood and create a slight vignetting effect to give the bottom of the image more closure.

(A)

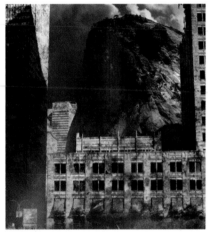

(B)

FIGURES 9.51A and **B** Paint a spot with a speckled brush (A); then blur it using the Motion Blur filter to simulate sunrays (B).

Glare and Global Lighting

To continue the effect you created by adding atmosphere and dust to the scene, you can bring in additional glare and even sunrays. Unlike the layers sitting within the Meadow folder, however, these layers will be global effects. If you're not done remodeling yet, keep working on that and come back to these steps when you're all finished.

1. For the first of the final lighting effects, create a new layer, name it Glare, and place it above the Warm layer in the Effects folder.

2. Using the Color panel, choose a light cream color in the yellow family. Select the Brush and change the size of the default round and soft brush to 175 px.

3. Paint some final touches of atmosphere, a little thicker this time compared to the first round back in the "Add Atmospheric Perspective" section. To start, change the brush opacity to 5% or less. Add it to the same places as where you first created some dust and atmosphere but spread outward onto the other buildings as well. This will help ensure that the depth looks right. Notice that the buildings at the edges of the meadow need to be lightened as well. Even just a slight haze painted on top of the black windows will make the building feel more distant and convincing overall. In a landscape photograph, shadows are true black only when they are very close to the viewer's point of view; get this wrong and viewers will notice!

4. Slight hints of sunrays can help give a more tangible feeling to the scene and enhance its atmosphere. To add some, first create a new layer in the Effects folder, and name it Rays. Choose a nearly white cream color and a large (400 px) speckled brush, opacity at 100%. On the Rays layer, paint one single speckle instance (just click somewhere in the middle of the scene).

5. Choose the Motion Blur filter (Filter > Motion Blur) to give the painted area a nice 600-pixel smear (**FIGURES 9.51A** and **B**). Switch to the Move tool (V), and stretch the blurred paint stroke into a long shaft of sunlight (Show Transform Controls must be selected for this). You can move and copy this layer where you need it and blend it in appropriately with masking like the rest of the layers. To flare the rays outward, hold Ctrl/Cmd while you drag a transform point outward (**FIGURE 9.52**).

6. A pair of Curves adjustment layers will add the final lighting effects. The first will lighten the buildings and make the places with atmosphere and glare glow a bit more. Add a new Curves adjustment layer, name it Glare Curves, and alter the curve line to gently boost just the highs. Keep the darks anchored as shown in **FIGURE 9.53**. Invert the mask with Ctrl+I/ Cmd+I so that you can then subtly paint in just where you want these glare spots emphasized with a white, large, and soft brush. (See the mask of Glare Curves in Figure 9.55 for a guide to where and how much white I painted on my version.)

7. Create a second Curves adjustment layer to lighten everything up as a whole, while still keeping the clouds from blowing out by getting *too* light. Name the layer Final Curves, and place it above Glare Curves in the layer stack. Adjust its curve line to raise the midtones and darks as shown in **FIGURE 9.54**.

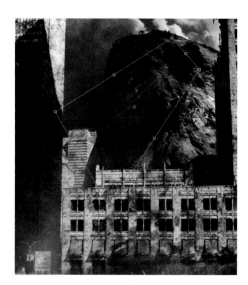

FIGURE 9.52 Flare the rays outward by holding down Ctrl/Cmd and dragging one of the corners outward before moving the rays into exact placement.

FIGURE 9.53 Glare curves should focus on boosting some of the lighter elements a little bit more, while anchoring the darks to make sure they are not touched in this heavily masked layer. Mask out everything except the few areas of glare, such as the buildings and atmosphere.

FIGURE 9.54 As one last touch, the darks across the entire image needed to be lifted just enough to get across daylight yet still staying gritty and contrasting to work with the dire theme—you can't have it too light and nice looking!

The strategy of including separate Glare Curves and Final Curves layers is to control exactly which darks and which lights are highlighted with two separate masks and two variations of Curve adjustments. Final Curves is also gently boosting, but boosting everything together without painting on the mask.

In both adjustments layers, be sure to paint with black on the Curves mask in the areas you don't want the Curves to affect, such as the already lighter cloud spots if that is still a problem area at risk of getting blown in your own composition. Take a look at the provided Photoshop file to see how I used these

last curves within the composite (**FIGURE 9.55**). The general strategy for final lighting adjustment is about a combination of overall balance (getting things light and dark enough as a whole) and subtlety helping with eye-flow. In the *Nature_Rules.psd* example file, notice that I lightened the entire area around the subject to draw just enough attention and emphasis to this part of the composite. At times I will also create another layer in this group called Lighting Effects that allows me to lighten and darken to taste and mood. I encourage you to play around with your own final touches at this point to see how you can control the look and feel.

FIGURE 9.55 Paint with black on a final lightening Curves adjustment so that areas such as bright clouds do not get blown out and overly distracting.

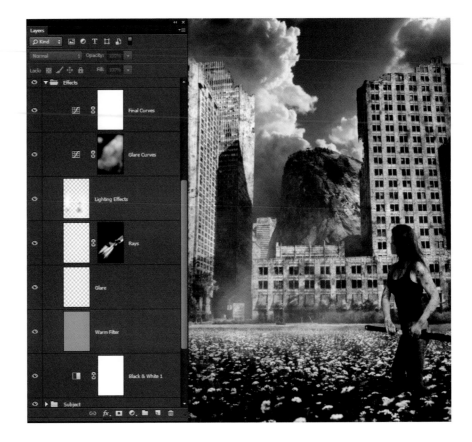

Conclusion

If your final image didn't turn out exactly like the example, that's okay! The goal of these tutorials is to help you improve your eye, as well as your technique. As it is, there could be a bit more work done on lighting and the rest, but part of good projects that stay fun is knowing when to say enough is enough. *Nature Rules* is a challenging project to get looking perfectly "right," but with enough breaks and adjustment revisions to each section, a seamless and foreboding composite is all but guaranteed. Regardless of the direction you took the project, you should definitely have a better understanding of how to create greater depth with atmosphere, how to make good hair selections, the power behind clipped adjustments, and even how to alter the perspective and distortion of a wide-angle lens. I'd say that those alone are some powerful tools with which to face the daunting compositing world.

Fantasy Worlds from Everyday Images

COVERED IN THIS CHAPTER

- Inspirational imagery
- Mask painting
- Clipped adjustments
- Seamless detail work
- Healing and Clone Stamp
- Group folder masks and blending
- Painting atmosphere and depth
- Compounded Smart Objects
- Blurring methods
- Composition strategy
- Overlay color effects

Inspiration comes from all kinds of places—and to each their own source! Composites benefit and grow from our interests, and collecting inspiration images everywhere you go has advantages beyond filling your archive. When you come across two or more shots with matching POV, depth, and focal length, combining them into something amazing becomes all the easier—sometimes ridiculously so. *Blue Vista* combines two of my own favorite landscape sources, Yosemite National Park (the waterfall and mountains) and the Oregon Coast into a whole new world (**FIGURE 10.1**). To re-create it, you'll blend together diverse scenery with masks, targeted adjustments, healing and cloning, and global edits (like the blue effect). Perhaps the most challenging and fun part will be using compounded Smart Objects to create moons from simple sources, such as cookie sheets and rusty metal—now let's get this composite cookin'!

▶ **FIGURE 10.1** Inspired by my favorite landscapes, *Blue Vista* combines familiar sources into a re-imagined blue world with at least two moons. This image and its general construction were originally revealed in a class I taught on fantasy landscapes during CreativeLive's Photoshop Week.

Gather Your Resources

Like *Nature Rules* in the previous chapter, this composite requires a basic folder setup of four main groups. If you did not create the *Blue_Vista.psd* file already, go to the "Few Pieces, Big Payoff" section of Chapter 6 and follow the steps for *Blue Vista* now. Or, you can cheat and just open the starter file called *Blue_Vista_Starter.psd* in the Chapter10_Resources folder. In the same folder, you'll also find a completed, smaller version of this project called *Blue_Vista_Complete_Small.psd*; use it to check your work if you so desire.

> **NOTE** To access the resource files and videos, just log in or join peachpit.com, and enter the book's ISBN. After you register the book, links to the files will be listed on your Account page under Registered Products.

Anchor the Scene to a Mountain and Horizon

Some fantasy scenes are compelling as they focus primarily on a foreground or subject, or sometimes the background is what adds to the verisimilitude. In *Blue Vista*, it was neither. The imagery that lends the most authenticity to the scene is the mountain ridge, waterfall, and horizon line of the ocean; in this far-reaching alien landscape, these combined images are what I am calling the middle ground (as the background elements are even further away). When originally sifting through my archive for inspiration, three images in particular caught my imagination (**FIGURE 10.2**). These were a great place to start because the rest of the layers depend on the two drastically different locations of mountains and coast meshing well together. Lucky, the three images matched fairly well in perspective, POV, and focal length. What more could you ask for?

(A)

(B)

(C)

FIGURES 10.2A, B, and **C** Source images can come from extremely different environments, and sometimes the more drastic, the more fantastical and epic. It helps if your imagery has a bit of a "wow" factor built into already as these locations do.

Okay, you could ask for consistent lighting directions, and you may have noticed that the lighting direction does not match earthly expectations when these shots combine. Thankfully, this is a *fantasy* landscape. If you were going to make something more terrestrial than an alien blue planet with multiple moons (and possibly suns), then you definitely could not overlook this kind of lighting mismatching and get away with it unscathed. Because the plan is literally out of this world, however, it gives you plenty of leeway to play more with the source imagery. Every shot you gather may not be a perfect match, but sometimes it's important to go for the concept and emotion of what you are portraying. In this scene, it is most important to focus on seamless textures, depth, and value (light and dark) transitions, and less on color and lighting. The planet has a blue cast, after all, and possibly multiple suns. We'll never know for sure about those suns, but you can set the foundation imagery with confidence.

1. With your starting Photoshop file open and the groups properly set up, use Bridge to open the *Yosemte.CR2* file, which is located in the Mountains folder of Chapter10_Resources. Use your preferred method to bring this entire image into the composite, and make sure it ends up in the group called Middle Ground Land & Sea. Name this layer Yosemite.

> **NOTE** Many of these base images are raw files, so feel free to do some basic Adobe Camera Raw editing if you so desire. (For the most part, I left my examples alone unless otherwise stated.) After opening each image in ACR, click the Open Image button (Open Image), and proceed to move the images into Blue_Vista.psd (hint: either copy and paste the image in or use the move tool). Whatever edits you do in ACR, make sure that they all keep a fairly consistent look for easier compositing editing.

2. Next, open *Ocean1.CR2* (located in the Ocean folder) and place it directly above the Yosemite layer (**FIGURE 10.3**). Label this layer Ocean1.

3. You may have noticed that in the final composite, the Yosemite layer was flipped horizontally. Flip yours now: First, select the Yosemite layer and switch to the Move tool (V). Click an edge of the Yosemite image to first initiate a transform, and then right-click the image itself to bring up the transform context menu. Choose Flip Horizontal and press Enter/Return—boom! You just flipped a mountain.

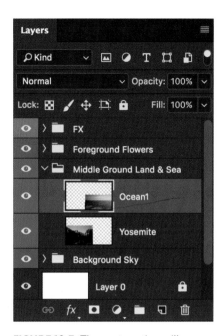

FIGURE 10.3 The next section will cover the masking, so getting the layer order correct now is important. Place Ocean1 above Yosemite, and make sure they are both in Middle Ground Land & Sea.

4. While you're rearranging landscapes, drag your mountain into place. With the same Yosemite layer selected and the Move tool still equipped, move the same layer to the far-left, bottom corner. This Yosemite layer will determine the horizon for the rest of the ocean images.

5. Now select the Ocean1 layer, and move this image until it partially overlaps Yosemite. Place it right where you want the ocean's horizon to be, as shown in **FIGURE 10.4**.

6. Add the shoreline image (*Ocean2.CR2*), and place this image sandwiched between the other two layers, both in the Layers panel and image workspace. Label this layer Ocean2 for consistency.

7. Repeat step 3 to flip Ocean2 horizontally, and then change Ocean2's opacity to 50% in the Layers panel. Using the Move tool, reposition Ocean2 so it nicely aligns with the waterfall plunging down into some trees before it reaches the shoreline (**FIGURE 10.5**). Now bring this layer's opacity back up to 100%. Perfect! Now comes the fun part of blending these seemingly disparate images seamlessly together.

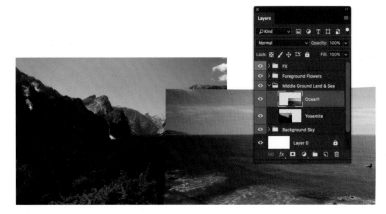

FIGURE 10.4 Get the ocean horizon more or less in place by overlapping the Ocean1 image on top of mountains you want to block out.

FIGURE 10.5 Change Ocean2's layer opacity to 50% and arrange the shoreline where it has the most fitting look and feel. I aligned the shore just below the waterfall and mountains.

Smooth Masking, Seamless Results

Before pouring in the rest of the ocean, you first need to get the coast in ship-shape order. As things stand, it's a bit blocky looking overall. To smooth out the shore, you'll just jump straight into painting on masks; you don't need an exact selection. Think of it as sculpting with clay, where you shape and reveal the awaiting form below.

1. Prepare the shore by selecting Ocean2 and clicking the Mask icon .

2. Pick up your Brush tool (B) and make sure the new mask of Ocean2 is selected. For this transition, as well as most of the others in this composite, a soft, round brush is just about all you need (although feel free to experiment, especially with the Spatter brushes when you begin painting the edges of trees and mountains). Set your soft, round brush to 400 px, and paint the mask's basic shape and area roughly into place. Let the waterfall show through as well as most of the mountainous ridge to the left.

3. Paint with a smaller brush size in areas that you need better detail and accuracy in the mask. In **FIGURE 10.6A** you can see where I painted the mask (pressing the \ key shows the mask in bright red), while **FIGURE 10.6B** shows the nearly seamless results that the mask creates.

 As you paint around the rocky peak section above and to the right of the waterfall, make sure to use a small brush (still soft) for greater detail and control. **FIGURE 10.7** shows a close-up of the mask in this section. Pressing \ reveals most of the problem spots in red. Increase brush hardness and size to wipe up any remaining mess. Remember to keep one finger on X as you work so that you can swap back and forth (between foreground and background colors) with

(A)

(B)

FIGURES 10.6A and **B** Paint the mask with a soft, round brush, changing to a smaller size for smooth transitions along detailed edges (A) and then admire your results (B).

FIGURE 10.7 Painting with a small (10 px), soft, and round brush lets you grab those edges of the peak and customize the look of the mask.

default black and white (D). And don't forget to make your brush soft again for new mask painting. You will soon do a larger mountain ridge selection to take out the sky, but for now it's important to get the specific look you want in this detailed transition spot (not including the sky).

NOTE Keep an eye out for digital grease, especially when painting in this style! It's easy to leave behind some leftover pixels that aren't fully masked out, but Chapter 3's "Digital Grease and Masking" sidebar offers strategies on avoiding greasy buildup.

4. Now it's time to switch to Ocean1, so make sure that the layer's visibility is turned on by clicking the Visibility icon ⬥. Create a blank mask for the layer by selecting the Ocean1 layer and clicking the mask icon ⬥.

5. Paint out the left edge with black. Assuming you left the raw file unedited as I did, ignore for the moment how much darker this image is than the others. Instead, focus on which you features you want to reveal from the layers behind Ocean1 and which features you would like to cover up with the layer's ocean and waves. **FIGURE 10.8** shows my mask painting choices, but I encourage you to try your own variations. This is a fantasy planet—there isn't one right look!

Adjust Value and Color with Clipped Layers

Although a vital first step, masking is clearly not enough to attune images into seamlessness. Next comes targeted adjustments to sync values (lights and darks) and color

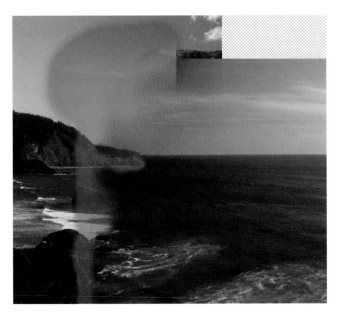

FIGURE 10.8 Mask out the hard edges of the image, and paint around natural features you want to keep from the layers below. Remember, white reveals this ocean layer, black conceals.

from one image to the next. This is very much like tuning instrument strings and matching one resonant note with another. At the moment, unless your name is John Cage, Ocean1 is making a cringe-worthy sound! In this section, you will add adjustment layers clipped to individual pieces to various middle ground elements, tuning your images into harmony.

1. With Ocean1 layer selected in the Layers panel, click the Curves Adjustment icon ⬚ to create a new Curves adjustment layer. Double-check that this new layer is directly above the one you want to alter—otherwise it's like tuning the wrong string (which does happen)!

2. Clip this Curves adjustment layer either by holding down Alt/Opt and clicking between the two layers or by clicking the ⌐▢ icon in the Properties panel.

3. Lighten Ocean1 by adding a control point along the diagonal line and dragging upward. Play with one or two control points until the image resonates with the others and those masking borders disappear (again, don't worry about the sky, just the ocean). You can see in **FIGURE 10.9** that two control points do the trick quite nicely, one for keeping the darks from getting too light and one for raising the midtones and highlights up and away from muddy-looking waters.

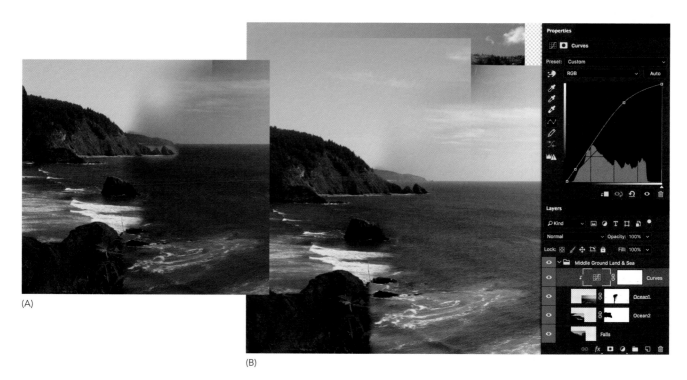

(A)

(B)

FIGURES 10.9A and **B** Adding a Curves adjustment layer clipped to Ocean1 allowed for lightening the individual layer to better sync with the lighter imagery behind it.

EDIT RAW FILES AS SMART OBJECTS, NOT SMART FILTERS

To tap into the full power and flexibility of raw images (both .CR2 and .ARW files), bring them into Photoshop as Smart Objects. Once a file is a Smart Object, whatever original adjustments you made in the Adobe Camera Raw plug-in will be kept, even after the image is fully transferred into Photoshop as a layer. Here's how to do this:

1. Open the raw image in the Camera Raw plug-in, and make your adjustments.

2. Before you open the image in Photoshop, hold down Shift to change the Open Image button to Open Object (Open Object) instead. Sneaky, I know. Click Open Object to bring the image into Photoshop as a Smart Object—fancy that!

3. The image opens in its own tab (or window, depending on your workspace), so the next step is to bring it into the composite file. A mere copy and paste will not bring the raw data and editing capabilities of this image with it, so drag the Smart Object directly from the Layers panel. For documents that open in tabs, drag the Smart Object to the composite file's tab header, wait for a couple seconds until you see that you've switched documents, and then drop the layer onto the composite imagery or Layers panel. For images that open as separate windows, drag the Smart Object into the window of the composite you want to added it to. Alternatively (because there are about ten ways to do any one thing in Photoshop), you can instead right-click the Smart Object's name in the Layers panel and choose Duplicate Layer from the context menu. Within the Duplicate Layer dialog box, choose the composite's document for the Destination selection. Bam.

4. Once the Smart Object (raw file) is in the right layer and place, double-click the Smart Object to open the Camera Raw dialog box again and adjust the sliders— all nondestructively!

With this capability, you can use the robust raw file data (which is otherwise reduced once a file is brought into Photoshop) nondestructively as a Smart Object that can be edited again and again. This could, in many cases, take the place of having to clip numerous adjustments to a layer or group. There are of course advantages to both methods (Camera Raw plug-in adjustments versus clipped adjustment layers), so try this out and make the call as you work. I suggest using the Smart Object method when you come across these conditions:

- The entire image (and not just a piece) needs to be brought over into a composite (although cropping within ACR can help with this, as you'll see later in the "Tree Blossoms" section).

- When substantial color and value adjustments may need to be done to the image. It's not that adding an adjustment layer can't do the trick; in the case of heavier image adjusting, the raw data file has more information to play with and can often end with higher quality results.

- If you do not need to use clipped adjustment layers to make simple and quick adjustments that you then need to replicate to other layers and groups.

Add Islands and Other Details

The "sell" of a believable composite is not just in its big picture look but also in its details and their placement. As mentioned, you do not have to follow my lead in this image creation, but here's how you could add, say, small islands of rocks and match them to the rest of the scene; this expands upon the previous two sections with masking and clipped adjustments. The small islands are also a good learning challenge because the image source (*Ocean3.CR2*) is fairly different from the others. The trick to using differing imagery is finding the elements that successfully *do* tie them together. In the case of **FIGURE 10.10**, you can move the horizon line to match the composite scene's because the height of where the image was shot still matches. Here's the process for adding small islands of rocks using this image:

1. Within the *Blue_Vista* composite, create a new subfolder inside the Middle Ground Land & Sea group: Click the Create A New Group button ▢, and then move this subfolder to the top of its group, so the little rocky islands will stand above the other water. Label this folder as Islands (**FIGURE 10.11**).

2. Open *Ocean3.CR2* as a new window or tabbed window in Photoshop. Using the Marquee tool (M), select the image's top third before copying (Ctrl+C/Cmd+C) and pasting it (Ctrl+V/Cmd+V) into the *Blue_Vista* composite document. Just like a couple of the other images so far, flip this pasted segment horizontally with the Move tool (V). Next, place this layer into the Islands group you created in step 1; label the layer Ocean3.

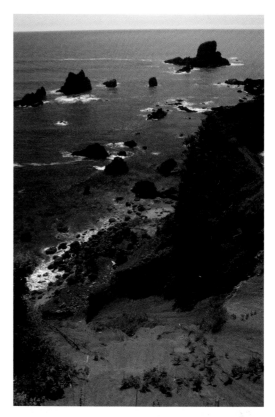

FIGURE 10.10 *Ocean3.CR2* is a great example of how you can use imagery that seemingly would not work due to its many differences; however, because a couple critical aspects *can* match up (such as horizon lines and the height of where the shot was taken), you can successfully blend the rocks into the scene.

FIGURE 10.11 To keep all of the rocky island layers together in one spot within the middle ground, create a subfolder called Islands.

3. Create a new mask for this selected layer by clicking the Add Layer Mask button ⬛ while holding down the Alt/Opt key. Doing so creates a new mask filled with black that completely conceals the layer. Now you can paint in just the pieces you want to use with white.

4. You will need to paint in the rocks, but a better idea of where they are behind the curtain of the new mask would help. Here's the trick: Temporarily change the mask's density to better see where to paint with white. To do this, double-click the mask's thumbnail to open its Properties panel, and then lower the Density to 70% (**FIGURE 10.12**).

5. Now you can see where you are painting, like a pro. Use the Brush tool (B) and paint white using a soft, round brush. Again, in red you can see my completed mask in **FIGURE 10.13**; vary your brush size (using left or right bracket keys) from a 7 px size for the rock edges to a 30 px size around the ocean surf.

6. Return the mask density to 100% (again using the mask's Properties panel) once you have defined the rock shapes to better see your painting work. Now it's time to clip some adjustment layers to these guys.

7. To begin adjusting the layer's darkness, create a new Curves adjustment layer by clicking the Curves icon 📈 in the Adjustments panel. Make sure this adjustment layer is directly above the Ocean3 layer.

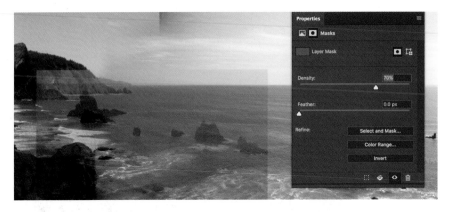

FIGURE 10.12 When a mask is all black, you can use the Properties panel to change the density. This gives you a temporary view of where to paint with white and reveal parts of the layer. Use my example as a reference for placement as you work on your own version.

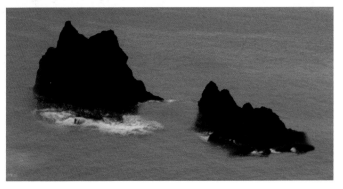

FIGURE 10.13 Paint on your mask with greater detail (7-pixel brush) along the upper rock edges, and a larger brush (30 px) around the ocean surf.

8. In the Adjustment Properties panel, click the 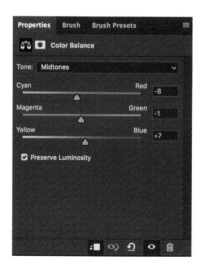┌─┐ icon in the Masks pane of the Properties panel to clip this layer to Ocean3.

9. Create two subtle control points along the curve line, one for boosting the darks (left side) and one for limiting the highlights so that they do not get overly light (**FIGURE 10.14**).

10. Next add a clipped Color Balance adjustment layer by first clicking the Color Balance icon and again clicking the icon to isolate the effect to Ocean4.

11. Add more of a bluish tint to the midtones by dragging the first slider toward Cyan (–8), the second slider toward Magenta (–1), and the third toward Blue (+7) (**FIGURE 10.15**).

12. With the color now in the right ballpark, or realm, or what-have-you, the areas of water still lack the intensity in color of the surrounding layers, so now add a Vibrance adjustment layer by clicking the icon.

13. To get those blues and greens vibrant like the rest of the water, increase the Vibrancy slider to +73 and Saturation to +2.

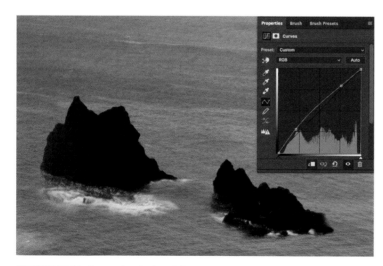

FIGURE 10.14 Boost the darks of Ocean4 while limiting the highlights using two control points along the curve line.

FIGURE 10.15 Add more of a blue cast to the rocks and ocean with a Color Balance adjustment.

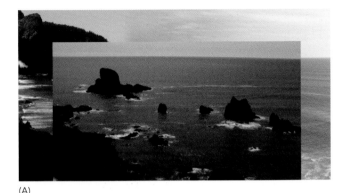

(A)

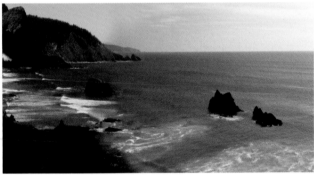

(B)

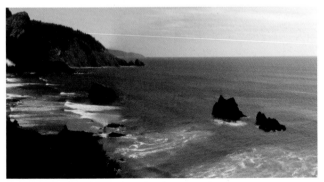

(C)

FIGURES 10.16A, B, and **C** Look what the tide brought in: the plain Ocean4 layer in correct position (A), the final mask I went with in my version (B), and the final results from masking clipping adjustments (C).

At this point, you should have the basic adjustments matching with the rest of the imagery. Don't fret if things are still a bit off here and there, because you'll be blasting this scene with blue up the wazoo later. Now, however, is a good time to return to the Ocean4 layer's mask and paint in any other details you would like to take from this layer. You can see in **FIGURE 10.16** that I kept some of the shore elements by going back and painting white in those areas of the coast that abruptly ended from underlying imagery. If the effects of the adjustments are ever too much for parts of that image you paint into existence, don't forget that each adjustment comes with its own mask! You can paint with black on those parts that seem a bit too adjusted.

A number of odds and ends still need a bit of adjusting and cleaning up. Some you can take care of with more isolated adjustments; others may require patching with additional pieces of ocean (I provided extra images in the resource folder for just this purpose) or some healing and cloning. In fact, you may have noticed (if you painted your masks similar to mine) that there is currently a stick floating in the middle of the waves—and not in any realistic kind of way! Let's toss that sucker for good.

> **TIP** Sometimes even with smooth masks and precise value and color adjusting, the angles still feel off. In these cases, don't be afraid to convert an ocean layer into a Smart Object and use either Warp (right-click the image after choosing Edit > Transform > Warp) or Liquify to bend edges upward or downward. With organic material you can get away with pushing and pulling the landscape without much notice, especially if it helps make things look more seamless.

Clone and Heal the Ocean

In this digital fantasy world, we have the power of cleaning up the ocean and beach with a click of the button (or several). Specifically, let's focus on the stick in the surf of my own version, as well as any problem spots you'd like to eradicate from yours. In any case, here's what you need to do:

1. Create a new layer with the Create A New Layer icon 🖫. Place this layer directly above the Islands folder, and double-click its default name to call it Healing.

2. Once you find a spot needing some healing attention (and after your main compositional elements are in place within this section), switch over to the Spot Healing Brush tool (J) 🩹 and make sure that Sample All Layers is selected up in the options bar ☑ **Sample All Layers**. This will enable you to draw from the composite's pixels while painting *only* on the Healing layer.

3. Zoom in tight, and begin painting with a brush size that's just larger than the content you are taking out. **FIGURE 10.17A** shows the problem spot I'm focusing on, while **FIGURE 10.17B** shows how painting over the area with the Spot Healing brush does exactly as it advertises—it heals the spot!

4. Next comes some cloning for those spots for which you want to specify the exact look. Create another new layer, this time called Clone.

5. Select the Clone Stamp tool, and find an area that could benefit from some foam or another spot that doesn't yet have the right look to it. Identify another spot that you could use to fill in the problem spot. Be sure to select Current and Below from the Sample menu in the options bar before continuing.

(A)

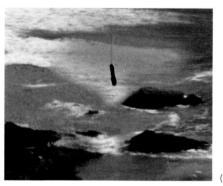

(B)

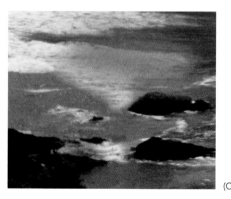

(C)

FIGURES 10.17A, B, and **C** The branch left over from masking represented a problem spot perfect for healing (A). Paint along the stem, and with each stroke, it begins to vanish (B) and (C). Search out and find any other spots that stand out to you while zoomed in. I use the Spot Healing tool on some surf to the left, as well (C).

6. Hold down Alt/Opt to set your sample point with a single click (on the spot you want to clone from), and then begin painting in the area you are intending to add the sampled content to. Remember to choose from multiple targets as you go and work in small controlled strokes. **FIGURE 10.18** shows an example of some ocean cleanup work to make transitions just a little bit less noticeable.

HEALING AND CLONING TIPS AND CONSIDERATIONS

Have a spot from another image you just know would work to clone into the composite? Well, the Clone Stamp tool allows you to do just that! Open the image tab or window you would like to clone from as the source, hold down Alt/Opt, and single click the spot (sample point) you want to begin cloning from. Jump back over to your Clone layer in the composite and begin painting in those spots. Once you get the hang of it, this feature rocks. I recommend opening the images in side-by-side windows for maneuvers like this (Window > Arrange > 2-Up Vertical). It may not show you the source sample point crosshair, but you can at least see the image as a general reference.

Whether you are healing or cloning, also be sure to keep an eye on the options bar before you begin editing—specifically, take a look at the Aligned feature. Definitely go back and review Chapter 2 if you need a refresher on these tools and features. Otherwise, check out the number of amazing Clone Stamp features and options that are hanging out in the Clone Source panel (Window > Clone Source), just waiting for you to use them. Things like rotating the sample source, flipping the source, and even remembering up to five different sample points you can toggle between. Seriously cool stuff stashed in here!

PROBLEM AREAS

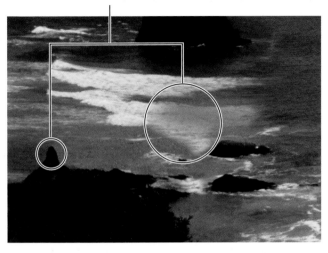

SAMPLE POINT SOURCES

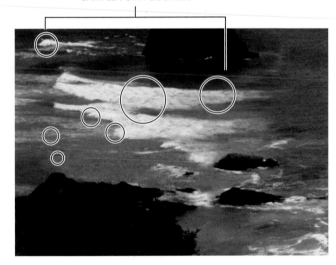

FIGURE 10.18 The ocean surf transition between Ocean1 and Ocean2 is not as blended as it could be; using the Clone Stamp tool and sample points of various sources of sea foam as you work, you can piece together some more passible details.

One Mask to Rule Them All

So far, you've created the main foundation of the composite and given it a backbone and structure. Next it's time to bring in those other elements, some otherworldly, some pleasantly banal. But first, you need to be sure the horizon is masked and ready for a more interesting sky. For this part, you can create one single mask that covers the entire middle ground horizon line.

1. Grab the Quick Selection tool (W), and make sure that Sample All Layers is selected in the options bar so that it does not matter which layer is selected. Begin painting along the bulk of the sky until all sky pixels are captured in a marching ants selection.

2. Switch over to the Magic Wand tool (Shift+W to cycle to the next tool in the same drawer as Quick Selection), and again, make sure that you are sampling from all layers. Click on any of the black or transparent checkered areas. The selection should now look something like **FIGURE 10.19**, if you also have your black background's visibility turned off like I do. I periodically toggle back and forth with the background's visibility as it helps me see bits that I've missed and also gives me a fresh way of looking at the scene as I work.

FIGURE 10.19 Select the entire sky area using a combination of Quick Selection and Magic Wand tools.

3. Select the Middle Ground Land & Sea group, and click the Mask icon while holding down Alt/Opt. This will effectively use the inverse of what you have selected and create a mask ready for a new sky.

4. Double-click the mask thumbnail to pull up the Mask Properties panel, and click the Select And Mask button to enter into the Select And Mask workspace.

TIP Select And Mask does not always work as well straight from making the selection, especially when the selection includes multiple layers and will be applied to a group. It's a little bit easier to instead create a mask first, then go into Select And Mask afterward—just be sure to select Sample All Layers at the top.

5. Use the Refine Edge Brush (R) along the mountainous horizon to clean up any remaining sky bits left over. Be sure to not dip too far into the tree line or rocks as you go. Click OK when you have the horizon looking like **FIGURE 10.20**.

FIGURE 10.20 Use the Refine Edge Brush to paint along the mainline horizon within Select And Mask.

TIP If you ever notice any halo after adding in a sky (next section), you can always return to Select And Mask for the Middle Ground Land & Sea group mask and play with shifting the edge (between –30% to –100%). If you also ever need feathering, you can add this nondestructively within the Mask Properties panel using the Feather slider. As mentioned in Chapter 9, larger composites like this often require jumping back and forth with small finessing and adjustments.

Sky Transformation

A large part of any fantasy or sci-fi imagery is harnessing the sweet spot between captivatingly strange and somehow believable. In this case, the sky will speak volumes as you lay on the layers. Usually in composites you try to get all the pieces aligned in regard to perspective and point of view. Sometimes, however, it's important to intentionally create an oddity—as long as it can be blended well with other imagery. The wispy clouds in **FIGURE 10.21** were interesting on their own and worth taking a picture of from my driveway, but I knew even when shooting that the image had more potential to it. You can easily transport them into another world.

1. Open the *Clouds.jpg* file (inside the Clouds resource folder) into the *Blue Vista* composite. Move this layer down to the Sky Background group. Label this layer as Sky before moving on.

2. If the sky image is not yet a Smart Object (which depends on your method of bringing in the image), right-click the Sky layer's name, and choose Convert to Smart Object from the context menu. This way you can move and scale nondestructively to your heart's content; use this freedom to experiment.

3. Switch to the Move tool (V), and while holding down Shift, drag a corner transform control point outward to scale the image larger, all the while keeping the proportion constrained. Expand the Sky layer until it sits edge to edge (or a little beyond).

4. Position the sky image until you have some wispy elements coming straight out of the ocean (**FIGURE 10.22**). This provides an otherworldly look and raises some questions and intrigue about this place—or at least it will once you get it looking less like a collage!

Build Up the Atmosphere and Depth

Both the land and sky look good, but in between the two, the transition is a bit thin. Fantasy scenes often have a certain quality and depth to them, which is frequently created with good amounts of atmosphere buildup. This technique also adds even more depth—hence the term atmospheric perspective. You dabbled with this in Chapter 9, but here you will be taking it further, literally. The main thing to keep in mind while working is that the further the distance appears, the thicker the haze of atmosphere. Thicker haze means a decrease in contrast and most significantly, lightened darks and midtones, as well as more build of up of the bluish tint contributed by the presence of water vapor in the air. Here's a painterly way to go about this:

1. Create a new group called Atmosphere, and place this directly above the Middle Ground Land & Sea folder but below Foreground Flowers group.

2. Create a new layer inside this folder, and call it Atmosphere1. (This way there is no guessing when you need to return here to make adjustments or additional atmosphere layers.)

FIGURE 10.21 Strange clouds have potential for striking imagery, especially when used in unexpected ways.

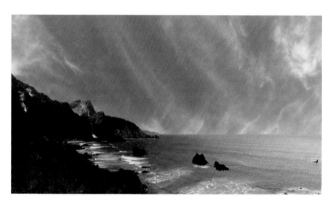

FIGURE 10.22 Here you can see just how alien some ordinary clouds make this horizon look.

3. Pick up the Brush tool (B), and using your favorite soft and round brush, begin painting white along the horizon, sky, and water. To start, use a low opacity of 10% and a flow of 10%. If you have a tablet, make sure you have Pen Pressure selected for the brush's Transfer property.

In either case, start with a large brush, say 1300 px to lay down a gentle buildup of particles and depth. Paint the thickest along the water horizon (greatest depth), but don't forget to also softly paint into the sky (**FIGURE 10.23**). Work with a smaller brush size (300 px) for adding density closer to the horizon.

NOTE If you are seeing a dramatic white line along the horizon of the water (due to water reflecting sunlight or bright sky from all those distant waves), go back to the Middle Ground Land & Sea folder and paint in a darker blue-green color on a new blank layer. You can use the Eyedropper tool to pick a blue from the water to get the color just right. Alternatively, select a stretch of ocean directly below the horizon (use the Marquee tool); then with the Atmosphere group's visibility off, copy from all the visible layers (Ctrl+Shift+C/Cmd+Shift+C) and paste (Ctrl+V/Cmd+V) this water along the horizon (still at the top of Middle Ground Land & Sea folder). Mask out hard edges and leave no seams behind (consider playing with the layer's opacity).

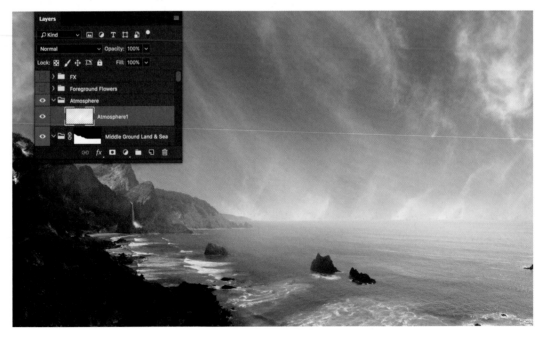

FIGURE 10.23 Add depth and atmosphere by painting low opacity white with a soft and large brush size (300 to 1300 px) on a new layer called Atmosphere1.

4. To ensure a smooth and seamless atmosphere, blur your work. With the Atmosphere layer selected, go to Filter > Blur > Gaussian Blur. Move the slider from the pop-up dialog box to 50 px. As this is being applied to a layer and not a Smart Object, the filter is technically a destructive edit; this is one of those exceptions as the effect has only benefits in this situation and really no drawbacks. Plus, you can continue to paint directly on this layer without having to jump into a Smart Object tab (or window), which would take away the context of a background.

> **NOTE** Working with large brush sizes above 300 px (even with hardness down to 0 and low opacity and flow) creates banding, noticeable lines that are not a smooth and seamless transition gradient. This happens because the soft and round brush was originally created at a certain pixel dimension, and expanding beyond that original size expands what were smooth small steps into larger, more obvious jumps. A workaround to this effect is to blur your work afterwards with a filter or Blur tool. Also, increasing a file's bit depth can help increase the number of dark-to-light steps possible within the document. When professionals opt for 12-, 16-, or 24-bit images, this is a main benefit they are going for. In this project, however, a blur does quite nicely!

Smart Objects and a Cookie Sheet Moon

Finally, as promised, the "fun" part of this composite: moons from a cookie sheet and rust! It also has its challenges, as you'll be doing a more advanced Smart Object edit of a composite within a composite, which is also within a composite. Think *Inception*, and you have the right idea. Here's the basic recipe, although much of this can be done to taste:

1. Create a new document (Ctrl+N/Cmd+N) titled *Moon* with dimensions of 4000 by 4000 pixels and a transparent background (for Background Contents, select Transparent). This will give you a decent-sized lunar sandbox to play in. Save this file to the Chapter 10_Resources folder.

2. Using your own method of choice, bring in various textures as layers from the Textures folder provided in the Chapter 10_Resources folder. In **FIGURE 10.24**, you can see I start with a square section of the cookie sheet (Texture1 layer on the bottom) and then add in two others I pre-baked just a bit with some healing and cloning to take out some spots. Revisit Healing and Cloning Tips and Considerations if you are fuzzy on how to do this.

FIGURE 10.24 Starting with the more golden-colored cookie sheet, add a few textures one atop the other.

3. Now change the blending modes of the textures. This is definitely a subjective aspect (and you could play endlessly here), but Overlay blending mode works nicely for both Texture2 and Texture3 layers (**FIGURE 10.25**). This is in part due to the cookie sheet, which is neither light nor dark. Overlay blending mode will lighten and darken the texture using the light and darks spots of the two layers set to this blending mode.

4. Next you need to tone down that yellow coloring, which is definitely getting a bit intense. Create a Black & White adjustment layer, and change its opacity to 70%. You starting to see it yet? That nice scorched and scarred look? Perfect—well, almost so.

FIGURE 10.25 Change the blending mode of Texture2 and Texture3 to Overlay.

5. For the last part of this mini-composite, you need to create a perfectly round mask. Select the Elliptical Marquee tool and hold down the Shift while dragging your selection from one image corner (*exactly* on the corner) to the diagonal corner (*exactly* on the corner, again). It is better to be just a pixel inside the layer if you have to be off a little.

> **TIP** Ever know that you need the tool from the toolbar just below the visible one in the same drawer, but can't remember its shortcut for the life of you? Here's a cool trick to help: Hold down Alt/Opt and click the tool in the toolbar; you can cycle through to the next tool with each click. Don't worry, it's not lazy, it's just efficient! Or so I tell myself.

6. In the Layers panel, select the topmost layer (the Black & White adjustment layer), hold down the Shift key, and click Texture1 (assuming it is at the bottom of the stack as I have it). This selects all three textures in the Layers panel. Now, press Ctrl+G/Cmd+G to group them.

7. Click the Mask icon ◉ at the bottom of the Layers panel, and watch it slice off the extra material—just like a cookie cutter! Label this group with the name Textures (**FIGURE 10.26**).

8. Here's where you take Smart Objects to another level. Right-click the name of the Textures group, and select Convert to Smart Object. Any time you would like to play with other textures or blending mode arrangements, just double-click this Textures Smart Object and you are able to edit and save within another tab or window.

9. Currently things are looking flat, so let's get more rounded with the Spherize filter. Within the *Moon.psd*, select the Textures Smart Object, then go to Filter > Distort > Spherize. In the Spherize dialog box, slide Amount to 100% (**FIGURE 10.27**). Repeat this step one more time for an even greater spherical effect (Alt+Ctrl+F/Control+Cmd+F).

NOTE If you are not getting results like in Figure 10.27 from your Spherize filter, try going back (Ctrl+Alt+Z/Cmd+Opt+Z) a step or two and crop (C for the Crop tool) with the Square ratio as well as Delete Cropped Pixels selected in the options bar. Make sure your crop border touches the pixels right on the edge of the moon before accepting the crop. Now try step 9 once more.

FIGURE 10.26 After grouping the textures and adjustment layer together, mask out a perfect circle for the shape of a moon. Or, perhaps a really burnt cookie.

10. Time to sharpen. You may have noticed exactly why this filter is under the Distort section, especially as those center pixels are quite blurry from expanding and distorting outward. To compensate, go to Filter > Sharpen > Smart Sharpen. Set your Amount slider to 450% and Radius to 1.8 px before clicking OK (**FIGURE 10.28**).

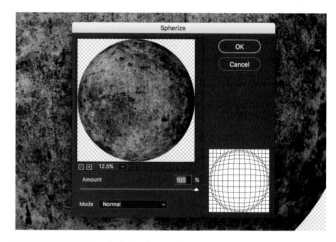

FIGURE 10.27 Apply Spherize to the Textures Smart Object with Amount set to 100%.

FIGURE 10.28 Apply a Smart Sharpen Smart Filter as a simple solution to all that Spherize distortion.

11. In the Layers panel, drag the Smart Sharpen Smart Filter name down to the bottom of the Smart Filter stack. The reason for putting that Smart Sharpen guy at the bottom is that as the top filter, it was affecting the image first (and it was already plenty sharp at first), it was only after the Spherize bonanza that things got blurry. Just like layer order, filter order also matters! Save your *Moon.psd* file (Ctrl+S/Cmd+S).

12. Last step for orbital entry to the main composite: Bring this file into *Blue Vista* as, you guessed it, a Smart Object. Traverse over to the *Blue Vista* composite tab or window, go to File > Place Embedded, and then search for and place the *Moon.psd* file. Once it is placed, press Enter/Return to accept the placement. Move this Smart Object into the Background Sky group, placed at the top of the folder's stack. That definitely was not one small step—but the view is nice (**FIGURE 10.29**)!

NOTE Place Linked will keep your file smaller but will always be pointing to where it thinks the placed file should be located in relation to the file it is placed in. When trying to choose between Linked versus Embedded, remember that Linked is more like an address book. If someone moves, the address book does not update itself, nor does a linked file. So just be careful to keep all your linked files in one folder (ideally the same as the container file) if you go down that path. Or just take out the potential for missing assets and make a larger, but safer, file with all sources nested inside—embed!

FIGURE 10.29 The *Moon.psd* is now a Smart Object itself and inside the *Blue Vista* file.

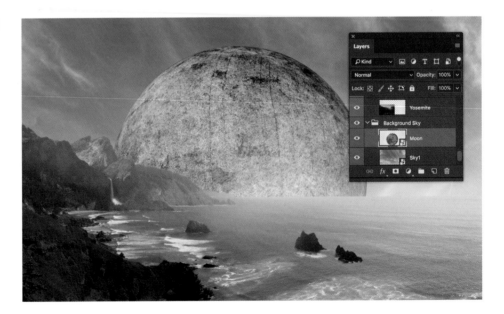

Launch Moons Seamlessly into Orbit

So you now have a super moon! Or perhaps a planet-sized wrecking ball, or at least something Indiana Jones would be running from? In either case, it doesn't look quite done, regardless of just how much of a compounded Smart Object it is. Why not fix it, and add a second one to boot?

1. First off, change the Moon Smart Object's blending mode to Screen and lower the opacity to 30%. This will allow only the lighter elements to come through and still keep the sky blue atmosphere.

2. For this next part, use the Move tool (V) with Show Transform Controls selected in the options bar. Move the lower-left corner until it is floating just above the islands, and then drag the upper-right corner transform point until the moon is about the size shown in **FIGURE 10.30**. This can be moved and played around with at any stage of the composite. Just get it big for now.

3. Add a Curves adjustment 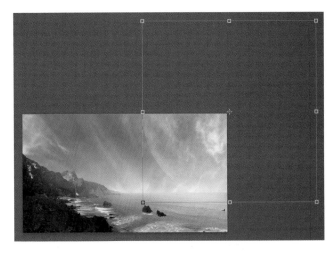 to lighten parts of the moon back up. Clip this Curves adjustment to the Moon Smart Object with the icon in the Adjustment Properties panel.

4. In the Layers panel, select the Curves adjustment layer and Moon Smart Object (Ctrl/Cmd-click the layer name) and press Ctrl+G/Cmd+G to group them into a folder. Label this group as Large Moon.

5. Make a new group by clicking the icon in the Layers panel. Label this group Small Moon, and move it just above the Large Moon folder—but not inside!

6. Make a copy of the Moon layer by holding down Alt/Opt while dragging the layer into the Small Moon folder. This will essentially make a new copied

FIGURE 10.30 The moon was large, but not large enough for the composition, so you need to transform it into something even larger.

reference to the same Smart Object information; any changes you do to one (after opening the Smart Object and saving) will alter the other as well. If you want to make them separate Smart Objects, each editable individually, right-click the Moon layer's name and choose New Smart Object Via Copy.

7. Change this small moon's opacity to 55% so it has a nice faded look to it (but not too much, yet!). Next, move and scale down this new moon using the Move tool (V). After getting it the right size and position, add just a twist of rotation so that the scrapes are not straight up and down on the surface (**FIGURE 10.31**).

8. Next you need to add some lunar shadows to give some additional depth and dimension. Create a new layer, and place it directly above the Moon copy layer. Label this layer as Shadow1.

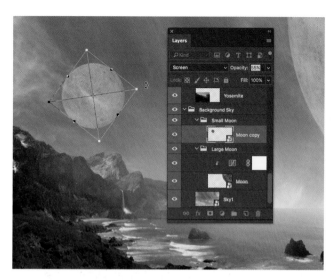

FIGURE 10.31 Rotate the smaller moon so that some of the linear lunar scratches are not vertical.

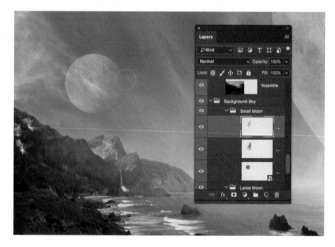

FIGURE 10.32 For moon shadows, paint lightly on two layers, one set to Overlay blending mode, the other set to Normal.

9. Usually I'd say to create a clipped layer (by holding down Alt/Opt and clicking between Moon copy and Shadow1), but there's a slicker way to do it this time: Change the blending mode of the folder to Screen! All shadows you paint on new layers will only make the moon vanish more into the sky (just don't paint with any light colors).

10. Change the Shadow1 layer's blending mode to Overlay before selecting the Brush tool (B) with a 500-pixel soft brush. On the lower-right side of the small moon, paint with a low opacity (10%) black and Flow set to 100%. Painting with an Overlay blending mode will darken the midtones and darks while leaving the highlights to be less affected. Because this folder is set to screen, any darkening simply makes the moon vanish in atmospheric blue.

11. Create another blank layer called Shadows2 placed directly above Shadows1. Do not change the blending mode of this layer. Instead, keep the blending mode as Normal and paint with black very lightly on all the areas (even the highlights) that you want to evenly vanish more into the sky. This is again a very subjective step, but take a look at what I did in **FIGURE 10.32** as a guide.

For final touches and adjustments, this is definitely a place to play and experiment. One thing to try on the large moon is a more interesting texture clipped directly to the Moon layer in order to give it some visual emphasis and dimension (**FIGURE 10.33**). It also adds a bit more contrast to the strange cloud and helps with eye-flow. You may want to return to this part once you have more of the pieces and final effects in place. Bookmark it, and move onward.

ADDED RUST

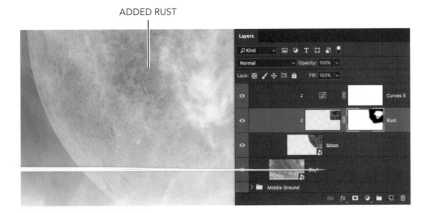

FIGURE 10.33 Add other details like bits of rust or other textures directly in the composite and clipped to the Moon layer. Play with blending modes, masking, and opacity to see what you can come up with.

Create Dimension, Add a Foreground

Next, you need to search out a shrubbery—or you may not get past this part. Luckily, I provided some passible foreground candidates shot from overcast spring days here in Oregon; check in the Chapter10_Resources folder, specifically the one called Flowers. The raw shots are actually not that great exposure-wise, which makes them the perfect challenge for this project and learning to use tricky content. The one thing that does work in these shots is the angle these were shot from, so we'll use that and finesse the rest.

1. Open *Flower1.ARW* into the Adobe Camera Raw workspace. Make any initial edits, but know that you will be bringing this image in as a raw Smart Object. Hold down the Shift key, and click the Open Object button [Open Object].

2. From the *Flowers1* file that you opened in Photoshop, drag the Flowers1 Smart Object layer over to the Blue Vista window or tab (if working in tabs as I do, hover over the Blue Vista tab for a few seconds to fully switch to being able to edit). Drop this layer into the composite file, and move it into the Foreground Flowers group (**FIGURE 10.34**).

FIGURE 10.34 Bring in Flowers1 as a Smart Object raw file. This gives you greater flexibility with the look of the image and later editing.

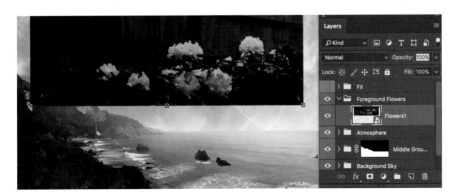

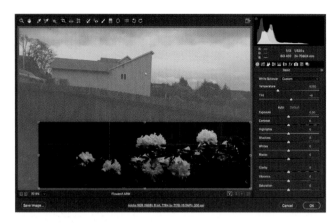

FIGURE 10.35 In Camera Raw, crop out everything but the area just around the flowers.

FIGURE 10.36 Use the Quick Selection tool to capture all the leaves and flowers that are going to be part of the foreground.

3. Double-click the Flowers1 Smart Object to again pull open the Camera Raw dialog box.

4. Select the Crop tool, and drag across the area of flowers you want to keep (**FIGURE 10.35**). Click OK to return to the composite with the newly trimmed Flowers1. This will help create a smaller mask footprint (both in pixel size and file size) in the next steps.

5. Switch to the Quick Selection tool (W), select the leaves and flowers as best you can going back and forth with adding to the selection and subtracting (hold down Alt/Opt) when the selection grabs a bit too much (**FIGURE 10.36**). If it seems tricky, that's because it is. My diabolic nature led me to take a picture of green leaves on a grassy background. Good luck! But seriously, just take it slow, adding, subtracting, and varying the brush size with left and right bracket keys. Again, this is great practice as not all images you will work with have perfect isolation.

NOTE Remember, the smaller the Quick Selection brush size, the finer and closer together points of contrast it will look for. Also, each time you add to the selection and then subtract from a selection, Photoshop will become more and more discerning with what it includes with each consecutive pass.

6. Once you have a decent selection, go into the Select And Mask taskspace (click the Select And Mask button in the options bar) and move the Shift Edge slider to –100% and the Feather slider to 1 px. Hold off on further feathering for now; click OK to finalize this as a selection.

7. Assuming there are no other pieces you've missed, click the Mask icon 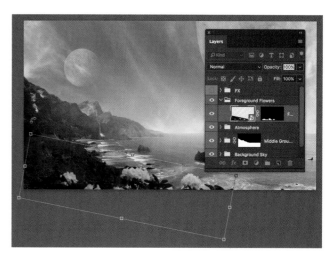 to turn the selection into a mask.

8. Use the Move tool (V) to scale and rotate the flowers (**FIGURE 10.37**) into some kind of believable arrangement that both anchors and frames the composite.

9. Repeat steps 1 through 8 (replacing step 1 with other flower images provided) for including additional flowers to the foreground filling in the lower-left corner. Remember that as they stack left and closer to our view, they should also be scaled slightly larger to add to the effect that we're more or less perched in, yes—a shrubbery. Onward crusaders!

FIGURE 10.37 Scale and rotate the first set of flowers into position with the Move tool.

OPTIONAL BLUR FOR INCREASED DEPTH

For some fancy depth blurring (and potential processor murdering), try using a mask combined with Lens Blur to create a depth map to control blur amount. It provides a reasonable facsimile of an actual lens blur (the blurred background you get when you photograph an object using a shallow depth of field).

Make a rasterized copy of a Smart Object (such as the bushes), add a blank mask, and use a large, soft brush to paint black onto the areas you want more in focus. At first glance, this seems to hide the part of the layer you most want to see, but the mask tells the Blur filter to ignore those key areas of the layer and blur the rest.

In other blurs, such as the Blur Gallery options, Blur settings are measured in pixels. With this Lens Blur

method, the mask's control of opacity sets the blur amount; the greater the layer opacity (white parts of the mask), the larger the blurred pixel amount. The more transparent the layer (areas painted in black on the mask), the smaller the blurred pixel size. Full black painted on a mask means completely sharp, no blur applied! The trick is to paint the mask with a large and soft brush to simulate a gradual transition that mimics gradual blur from depth.

Once you're satisfied with the mask, choose Filter > Blur > Lens Blur. You will then be able to see how this feature uses the mask as a blur effect control. After playing with the sliders to taste, click OK. Finally, disable (Shift-click the mask thumbnail) or delete the mask to see the final results. Super cool, right?

Tree Blossoms

The next part to building the foreground is adding in those blooming branches in the upper left. Fortunately there's only one image layer you need to work with and the selection process is in *some ways* easier. Keep in mind as you are working that these elements do not need to look perfect in regard to coloring because you will be adding in that dramatic blue. For this part, get the mask right and then adjust the look and feel as part of the final process. So, let's get started with the tree flowers.

1. Create two new groups directly above the Flowers1 and Flowers2 layers. Label the bottom group as Bottom Flowers and the top group as Top Flowers. Place the two bottom flowers in the Bottom Flowers folder.

2. Open *Top_Flowers.ARW* from Adobe Camera Raw as a Smart Object raw layer (see steps 1 and 2 from the previous section), and move this layer into the Top Flowers group.

3. Double-click the Top_Flowers Smart Object thumbnail in the Layers panel (once it is inside the *Blue Vista* composite) to open the ACR workspace. Rotate clockwise ⟳ and crop this image so that it appears like **FIGURE 10.38**. Click OK to save this edit and go back to the rest of the composite.

4. With the Move tool (V), move into position and scale the image in the upper corner until it matches **FIGURE 10.39**.

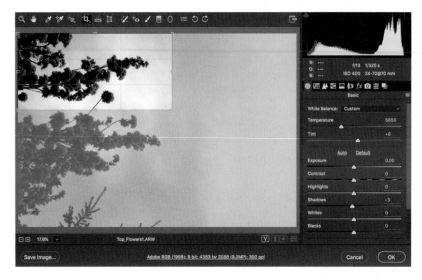

FIGURE 10.38 Rotate the image clockwise and crop it so that only the corner branches remain.

FIGURE 10.39 Move and scale the blossoms into place using the Move tool (V).

5. Use the Magic Wand tool (W), set Tolerance to 30, and deselect both Contiguous and Sample All Layers in the options bar. This will help grab all those scattered pieces of sky in the branches.

6. Select the light-gray sky by clicking first on a lighter spot of the sky and then holding down Shift while clicking the slightly darker section of the sky. These two points should be enough for the main selection needed. If you see gaps, keep adding to the selection (or check your settings again in the options bar as something could be wrong there).

7. Open up Select And Mask, and press the Invert button before panic ensues (you may recall we selected the sky rather than the flowers, hence the inverse). Once inverted, move the Feather slider to 1.5 px and the Shift Edge slider to –100% before clicking OK (**FIGURE 10.40**).

8. You may have noticed a stick and flower ball floating there below the branch you want to keep. Press Q to bring up the Quick Mask red overlay. Pick up your Brush tool (B), and being careful not to paint out any of the petals of the main branch, paint with black on the floating branch. Press Q once again to exit out of Quick Mask mode when you're done.

TIP To invert a selection without going into Select And Mask, press Ctrl+Shift+I/Cmd+Shift+I. This comes in handy more than you think as sometimes, it is far easier to select the opposite of what you want to select and mask.

FIGURE 10.40 Within Select And Mask, make sure to add a 1.5 px Feather and Shift Edge all the way to the left (–100%) to really bite into this petals and take out halos.

9. Click the Mask icon to create a mask from the selection. If the lighter edges are still popping out a little too much, there are several ways to compensate for this. The easiest by far is to paint the mask black along the edges with a low-opacity (10%), soft, and round brush until they are just slightly faded into the background (**FIGURE 10.41**). You will be changing the color around dramatically soon enough (I know, I know, you've heard this before), so don't worry too much about the off color temperatures ranges throughout.

TIP Sometimes in situations similar to this (where the image background is uniformly lighter or darker than the content), the Blend If feature is a neat option to try out. This is where the layer style properties can have the image vanish if it meets a certain criteria, a threshold (not unlike the Darken and Lighten blending modes). You can get to this feature by selecting the layer and clicking the Layer Style icon _fx_ then Blending Options. From there, the bottom section contains the Blend If parameters. A simplified translation to these settings goes something like this: "Show the pixels of this layer if they are between these values (0 being black, 255 being white) or if the underlying layers are between these values." To take out light pixels (such as an overcast sky), drag the This Layer right-side slider point to the left until you have the desired effect. In this case, the light sky should start disappearing. This process can leave hard edges at first, so the next step is to create a smoother transition; hold Alt/Opt while dragging one half of the same slider point. The gap of values between those two halves is the transition from opaque to transparent— visible to invisible!

Other adjustments and effects can be useful here, such as painting in a clipped Curves adjustment just on some of the lighter petals to give it a bit more dimension. This could be one of those places you return to however, so perhaps hold off on anything too dramatic until you get that blue cast thrown in the mix. We will return with a clipped Curves adjustment in the end, so keep going, the finish is in sight!

FIGURE 10.41 Paint with a low-opacity black on the mask just along the edges to help them blend in just a little bit better with the background.

Blue the Vista

Okay, the main elements are in place, and we are ready to begin pulling it all together with some final effects. This is the stage in which you can make some larger aesthetic choices about eye-flow, balance, and figure out where exactly an adjustment is needed (though there is a group called FX, it's not always the place to put all the final fidgeting and finessing elements). But we're getting ahead of ourselves here—let's make this planet blue!

1. First off, you need to tone down the other colors from this composite with a low opacity Black & White adjustment layer. Select the FX group you created in Chapter 6, and then press the Black & White adjustment layer icon ▣. Bring the opacity down to 20% on this adjustment layer. This will, in effect, tighten our palette and help with color unity.

2. Create a new blank layer in the FX folder and place this above the Black & White adjustment layer. Label this new layer as Blue.

3. Pick up the Bucket tool (G), select the *perfect* blue, and begin a finger drum roll on a nearby surface (**FIGURE 10.42**). With the Blue layer selected, click anywhere in the workspace to spill the blue evenly across the scene. Yes, the solid blue image is anticlimactic; it's not just you.

FIGURE 10.42 This is the blue I chose by clicking the Foreground color swatch to open the Color Picker; yours does not need to be this exact color, but it is a good place to at least start.

NOTE Alternatively, you can use the Hue/Saturation adjustment layer, as it will not fiddle around quite as much with your gray conversions (when compared to Black & White adjustment layer). If you are not planning to be adjusting the color value sliders in the Properties panel of a Black & White adjustment layer, then Hue/Saturation is the way to go. I personally like the option to adjust color values later, but either adjustment will work here.

TIP A New Fill Layer with a solid color (Layer > New Fill Layer > Solid Color) is a great alternative to try here as you will get a live preview of the color you select from the Color Picker. This solid color is also easy to change later; after the layer is created, edit the color by double-clicking the layer's thumbnail, and choose a new color—just like that!

4. Now change the blending mode of this layer to Overlay and Opacity to 70% (**FIGURE 10.43**). Much better, eh?

TIP For other color variation and experimentation with the ease of a slider, create a new Hue/Saturation adjustment layer clipped directly the Blue layer. Move the Hue slider around and adjust the spilled color to taste. Awesome, right?

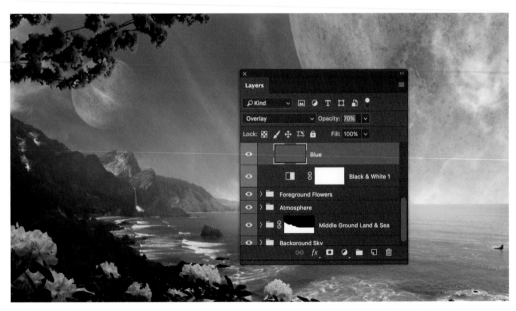

FIGURE 10.43 Change the Blue layer's Opacity setting to 70% and the Blending mode to Overlay for the coloring effect.

Final Touches and Composition Strategy

The final touches and effects will vary dramatically to your taste and is more about strategy than technique. Asking questions at this stage is important so you have an idea of what you are going for here. These are some things to consider for composites like this before you begin finessing with some recommended adjustment layers in the numbered steps.

- **Eye-Flow:** Where do you want the eye to enter the image and follow? How do you keep the eye moving and contained within the frame (and not led off)? Identify a point of interest, such as the waterfall, and use lightening and darkening to lead the viewer around. Consider adding slight vignettes to the corners or even re-positioning the elements at this stage. After all, each piece of this puzzle is grouped and organized rather nicely—use that!

- **Balance:** Which parts are competing or just off and distracting? What part of the image has the greatest emphasis, and should it be the emphasis at all? How can you make it more dramatic or, instead, make it more subtle and subdued? Have a reason why. So far in this image, the flowers pop out a bit too much, and the interesting skyline and clouds do not pop out enough.

- **Depth:** Where does the image still feel flat or uninteresting? What can you do to adjust the individual pieces to help add dimension? If color is not being used for helping with depth (cool colors can help recede parts of an image while warm colors brings things forward), then how can you use lights, use darks, and emphasize atmospheric perspective to better create a sense of depth?

To that effect, **FIGURE 10.44** shows the before and after I have added various adjustments keeping these strategies in mind. Specifically, the Top Flowers need more dimension, so a Curves adjustments can be clipped to that folder and painted in. With the image being a bit on the flat side, increasing the lighter elements of the image, especially in the clouds and water greatly helps in adding depth. Also, the eye is led off to the right (**FIGURE 10.44A**), so adding a vignette and some nondestructive burning can help balance out that ocean corner and keep our eye moving back up to the white cloud in front of the moon (**FIGURE 10.44B**).

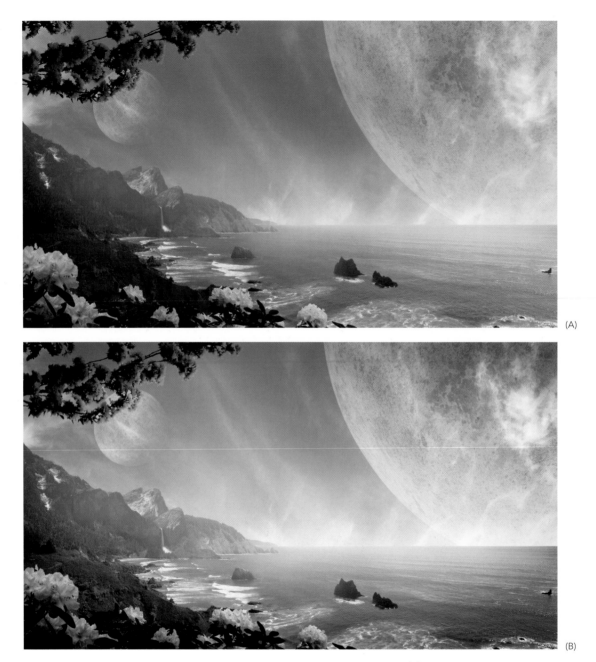

(A)

(B)

FIGURES 10.44A and **B** Compare the image just after applying the blue overlay (A) with the version that includes the various adjustments and edits to help with eye-flow, balance, and depth (B).

The sections that follow contain some steps in creating layers that I use to make these final edits, specifically how to create a nondestructive dodge layer, burn layer, Curves adjustment, and clipped localized layer affecting a group (and nothing else).

Create a Global Dodge Layer

This is fantastic as a global effect for lightening up parts of the image that still feel a little dark. Although these steps show the global use of this layer, dodge layers are extremely helpful for targeted adjustments as well (by clipping the dodge layer to another layer or folder). In the case of *Blue Vista* as whole, it can help create better depth and balance for the image. Here's how:

1. Create a new layer, and place it at the top of the stack in the FX folder (where all global edits should go from here on). Label this layer as Dodge.

2. Change the blending mode of this layer to Overlay. You can get similar variations of this effect using other blending modes, but Overlay is a great one to start with.

3. Grab your favorite round and fuzzy brush and switch to painting 6% opacity white (press D for default black and white colors and then press X to switch the foreground color to white). Keep the brush size huge (2000 px is even good here). Leave no obvious indications you're painting all over the picture, just subtle effects with a big overall impact (**FIGURE 10.45**). The left the side in particular seems a bit dark, so lighten that up first and focus on the waterfall, ocean surf, and wispy horizon.

FIGURE 10.45 Use a large and soft brush for this section of global editing—even going as large as 2000 px.

> **NOTE** From here on out, only paint with low-opacity white on this layer (otherwise it will not have a dodge effect and the name will make our minds explode). Keeping dodge and burn separate is not necessary but can be helpful for more precise and controlled editing, especially as you can mask out aspects of each layer if you go too overboard. Painting back and forth with black and white on one single dodge and burn layer can make an indescribable mess if you get carried away.

Burn and Vignette Layers

Just like Dodge, this separate layer is helpful for leading our gaze around the image—and even containing our eye-flow from being led off the page.

1. Repeat the same first two steps from the "Create a Global Dodge Layer" section, only name this layer Burn instead. Again, keeping it separate can be helpful as we're going to be doing different things with this layer. Make sure this layer is above Dodge.

2. Using a similar large, soft, round brush, paint low-opacity black (6%) in the areas you want more intensity and deeper darks. Specifically, painting the edges and corners like a vignette is helpful for eye-flow containment, especially in that lower-right corner. If you ever go overboard here, changing the layer's opacity is an easy way to pull back some of the intensity of the effect you painted in.

3. Add to the vignette effect by creating another blank layer called Vignette. Keep this layer's blending mode set to Normal as you paint with faint black in the corners. Start by painting off the edge of the image and working your way inwards (**FIGURE 10.46**).

Global Curves

Here is where we finalize the flow with a Curve adjustment layer or two getting the right lights and darks going on for the entire image. Overall, adding in some of these effects so far has made the entire image a bit darker than necessary—so lighten things up!

1. Create a new Curves Adjustment layer ▦, and add it to the stack of the FX folder.

2. Lighten up the image with one or two control points until those lighter highlights really pop (**FIGURE 10.47**).

3. Mask out whatever you see as too strong of an adjustment. Keep using that same soft and round brush.

FIGURE 10.46 Paint a slight vignette starting just outside the corner of the image so it is thickest at the tip of the corner.

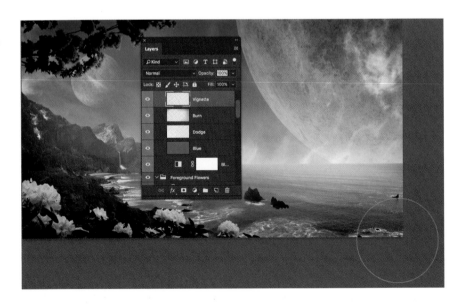

4. Create another Curves adjustment layer (placed above the first), this one controlling and focusing specifically on the darks and creating a bit more contrast. Go a bit overboard, and then pull back this layer's opacity to 28% (**FIGURE 10.48**).

FIGURE 10.47 Create a Curves adjustment layer that brightens the entire image, especially focusing on the highlights.

(A)

(B)

FIGURES 10.48A and **B** Get the darks in the image punchier with another curves adjustment layer keeping them deeper and mysterious (A) then pull back the opacity, in this case to 28% (B).

FIGURE 10.49 Clip localized Curves and other adjustments (and layers) to groups as you balance the various image pieces.

Localized Edits

At this point in a composite, I personally tend to jump back and forth, working globally and then locally by adding some clipped layers such as Curves, Color Balance, or dodge and burn layers where things stand out in each part of the composite (such as flowers, a moon, and so on). Good examples of this can be seen in the Flowers group (both top and bottom) shown in **FIGURE 10.49**. The only difference between these and the other layers in this section is that localized means they are clipped. As you may recall, to do this you place the layer directly above the layer or group you want to affect and hold down Alt/Opt while clicking the line directly between the layers (or group). And that does it—edit and adjust to suit your own aesthetic desires for this world!

Conclusion

Phew! At this point you are literally a world-creating, super-powered being and can read through Section III with a keen eye for the techniques used in this and the other tutorials from Section II. From working with raw files to working on eye-flow strategy with global edits, you covered a ton of information here. Now put it to good use in your own creations. Don't forget to check your work with the small version of the file I've provided in the resources— and post your own final results on the Facebook page: www.facebook.com/Photoshop-with-Bret-Malley-575012755931254.

Mastering Elemental Textures

Being able to bend and alter textures and colorful elemental forces is just one of the fascinating and addicting aspects of working with Photoshop—and the genesis to *Control*. In this project, I mixed my wife's face with water, added fire to a piranha I photographed while in Peru, and borrowed the eye from a frog hopping around the Erie Canal (**FIGURE 11.1**). Although this may sound like a Frankenstein-esque composite, color control and textures helped me blend everything to create a surreal play on humankind controlling and manipulating the rest of the natural world.

This project is also a good study in being inspired by source images rather than working to some initial plan. Sometimes in compositing you can go out and shoot what is needed (as I did for the face), and sometimes, you can work around imagery that you already have that inspires you and begs your Photoshop sensibilities for additional creativity (as the piranha did). In this project, you will see how I worked from both directions to come up with a fun experience and satisfying end result.

▶ **FIGURE 11.1** *Control* combines a piranha, a frog, fire, rust, water, and my wife Erin. Adding some textures, blending modes, and layer styles I transformed them into raw elemental powers.

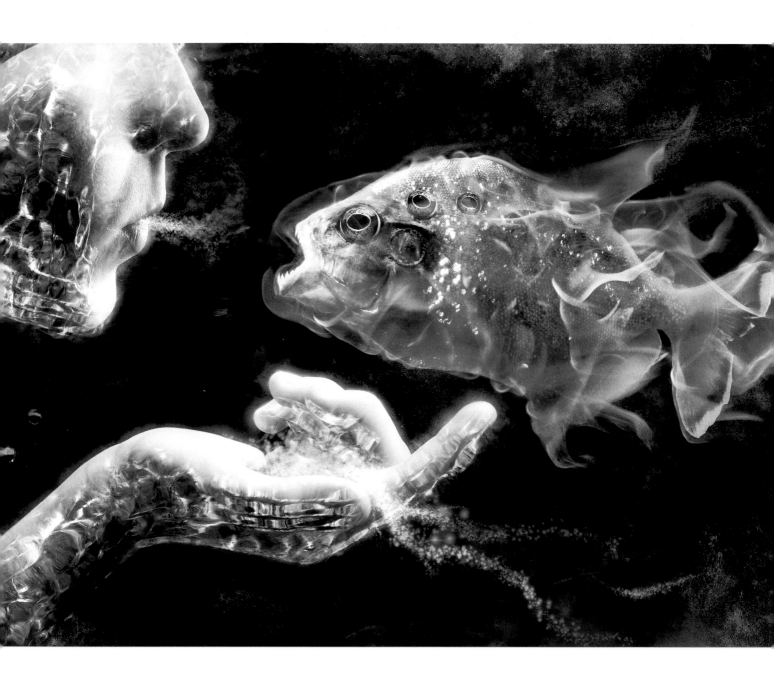

Step 1: Fish for Inspiration

It can be a great idea to look through your photos and get inspired to create something new! My inspiration for this image began with the shot of the stunning gold piranha (**FIGURE 11.2**).

Once I began looking at the fish for a potential scene, I sketched out an idea of a face close up, but it really didn't come together until after looking at my source imagery for other ideas and textures, such as old pictures I took during a camping trip of shallow river water over granite (**FIGURE 11.3**). Looking at these two shots I could see how I might mold the water into various shapes around a close up face and hand. After that idea, the composite just needed a good balancing element, which, of course, led to my images of fire. A bit more searching of the archive yielded a frog that would add to the surreal theme (**FIGURE 11.4**) and some metal with a long and rusty history to serve as a backdrop (**FIGURE 11.5**).

To supplement the composite material found within my archive, I still needed to shoot original content for the face and hand. I planned the lighting based on a quick sketch and brainstorm of surreal light more or less coming from the glowing fish. For the shots shown in **FIGURE 11.6**, however, I wanted the key light to be generally coming from the direction of the fiery fish to add to the effect of the fish glowing as well as provide a good amount of contrast between the hand and background. So, armed with a meager clamp light and compact fluorescent bulb, I put up a dark sheet behind my wife Erin and fired off a few shots with her face and hand fairly close to the light.

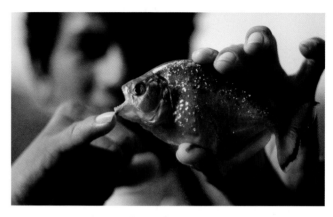

FIGURE 11.2 This shot of a gold piranha caught in the headwaters of the Amazon was the central inspiration for a surreal creation.

FIGURE 11.3 Shallow water running over sunny granite or other rocks can create a multitude of interesting shapes and forms for this kind of project.

FIGURE 11.4 This fellow was quick, but my shutter speed was quicker. Nature shots also often require immediate action, so don't hesitate when you have the opportunity.

FIGURE 11.5 Metal textures can have a plethora of uses; an abstract and dynamic background is definitely one of them.

FIGURE 11.6 These shots only had to conform to the imaginary lighting scenario of a glowing fire fish without worrying about maintaining a perfectly realistic pattern of light.

TIP For close-up images like these that aren't visibly connected, shoot them separately so you have more control and better mental focus on what needs to be changed or adjusted for each. Get the hand just right, for example, and then concentrate on the face in a separate shot.

Step 2: Get Organized

Because this composite's source images hailed from vastly different sources, I wanted to see the workable images together for better comparison and previsualizing. Following the same procedures discussed in Chapters 6 and 8, I first compiled a photo palette for the fire and water images separated into two groups (**FIGURE 11.7**). I also created black-and-white copies of the water images for better discerning of shapes while obscuring the original tinted content. Having grayscale copies of the water let me look for natural forms more objectively as the patterns are easier to pre-visualize and connect. For the remaining elements, such as the background texture and subject, I picked the best shots in Bridge and brought them into Photoshop individually.

> **TIP** Pull the photo palette's window down and to the side if you have space on your screen. For example, I keep my photo palette document open on one of my monitors and piece things together in the composite document on my second monitor.

Also as recommended in Chapter 6, I made a group for each section of the composite, as shown in **FIGURE 11.8**. Finally, I brought in the main elements of the composite by copying and pasting them from their own documents and then moving each image layer into its proper place within the composite image (**FIGURE 11.9**).

> **TIP** When you need an extra level of grouping and separation, create subgroups within the groups you already made. This works for subcategories within a larger category too, such as drops of water within the water category of images.

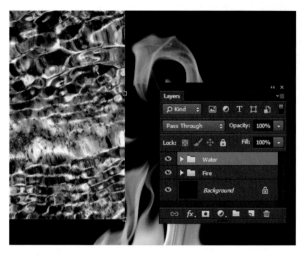

FIGURE 11.7 The categories of fire and water let me look at the textures separately, keeping my workspace clutter free and tab free as well.

FIGURE 11.8 In prepping your composite file, make sure to include both groups and subgroups when necessary.

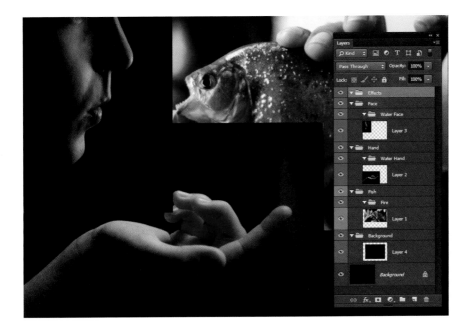

FIGURE 11.9 Once you start a group scheme, make sure to stay with it and don't leave any important layers in the wrong group.

Step 3: Convert to Smart Objects

To work with the main images as nondestructively as possible while scaling and doing other transforms, I decided to convert them to Smart Objects. This way I could later finesse the composition and scale based on the actual source objects to see how they looked next to one another. As discussed in Chapter 3, you have better quality control and greater flexibility with edits like transforms and filters when you use Smart Objects. You can return to the edit and keep adjusting it right where you left off—and there's no quality loss. Converting to Smart Objects *before* masking is important, because during conversion Photoshop will unfortunately embed any mask you made into the Smart Object. This has the effect of seemingly erasing the masked-out content—and makes it cumbersome to edit and adjust the mask on the fly within the composite. Each time you wanted to edit the mask, you would have to open the Smart Object. The best approach is to convert your main layers to Smart Objects as soon as they are brought into the composite. With this in mind, I converted the hand, face, and fish to Smart Objects by right-clicking on the layer name and then choosing Convert to Smart Object from the context menu (**FIGURE 11.10**).

FIGURE 11.10 Smart Objects are great because they let you transform a layer and apply filters nondestructively.

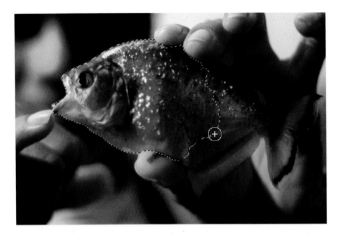

FIGURE 11.11 Quick Selection does wonders selecting images with a reasonably clean edge on the subjects, such as this fish.

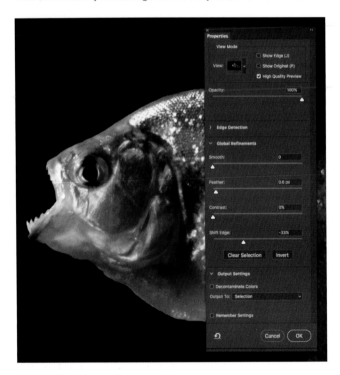

FIGURE 11.12 Using Select And Mask on a selection allows for edge feathering and biting a little into the selection to avoid any accidental halos.

TIP If you need to edit an element (such as by painting, healing, or cloning) of your Smart Object, you have two good options. To keep edits easily accessible directly within the composite, first try to add them to a new layer placed above the Smart Object. For cloning or healing with this technique, make sure to sample from both the current layer and the one below. Your second option is to double-click the Smart Object to edit it in a new tabbed window. All edits you make to this Smart Object must be saved (Ctrl+S/Cmd+S) in order to take effect within the main composite. If you truly need to destructively edit and rasterize the layer for any reason, you can always right-click the layer and choose Rasterize. This will make all visible changes to this layer (including areas hidden by masks) permanent, so do this carefully!

Step 4: Mask the Fish

All the extra backgrounds of the source elements needed to be masked out to give me a better idea of the layout—and a good place to start was by making a good selection of the fish. I used the Quick Selection tool for the fish because it had good clean edges for the tool to cling to as I selected around the scales (**FIGURE 11.11**). I then refined my selection edge using the Select And Mask workspace (accessed by clicking the button of that name in the options bar). I made some adjustments (seen in **FIGURE 11.12**) to feather the edge ever so slightly and shift it inward to avoid any extra halo that might show up.

TIP If the Quick Selection tool mistakes vaguely similar pixels and includes far too much in a selection, hold down Alt/Opt and notice the brush gains a small minus inside the brush area. Now you can deselect areas you

do not wish to retain. The more times you go over an area adding and subtracting, the more discerning and particular the Quick Selection tool becomes as it can tell you are trying to select something specific.

TIP This piranha example is also the perfect kind of shallow depth of field image for using Select Focus Area, which analyzes the image and does an astonishing job of making a selection based on what is in focus. Select Focus Area provides only a starting point usually, and you'll still need to make a few adjustments and apply the Select And Mask options before creating a mask.

Next, I added the mask by clicking the small Add Mask icon at the bottom of the Layers panel 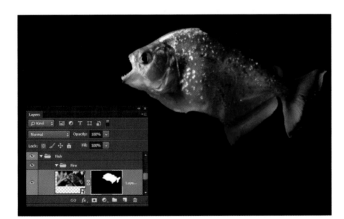. As you can see in **FIGURE 11.13**, the mask worked pretty well, but the fish definitely needed some scale reconstruction around where the fingers were holding it, but I'll get into that in step 6.

FIGURE 11.13 Once a mask is applied from a selection, you can always adjust it by painting with black and white.

The rest of the images required similar selecting, refining, and masking.

TIP If you want to make a mask immediately from your Select And Mask refining, check out the Output Settings section at the bottom of the Properties panel. There, you can choose Layer Mask from the Output To menu and click OK to go straight to creating a mask. The next time you go through Select And Mask, however, your output settings will persist. If you want to stay within a selection after clicking OK, change Output To back to Selection. I tend to keep my output to creating a selection and manually add the mask afterward with the Add Mask icon.

Step 5: Scale the Smart Objects

Working with something as a pre-visualized and loose concept is vastly different than seeing the actual images together and adjusting them to fit better, so it's a good idea to always stay flexible in your planning and execution—that's why I turned these layers into Smart Objects back in step 3.

As mentioned earlier, converting the main layers to Smart Objects can greatly help as insurance against destructive editing. As Smart Objects, a composite's layers can then be altered repeatedly in all kinds of ways without destructively editing the original content. Because they add an extra step, using Smart Objects might seem like a limiting way to work if you want to start touching up the actual raster pixels of the layer (never a preferred edit as it is destructive). Once you take that step, however, Smart Objects can be scaled, warped, or stretched; have their blending modes changed; and even have most filters

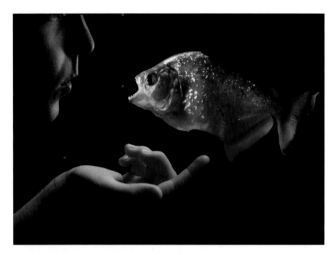

FIGURE 11.14 Scaling objects as Smart Objects lets you keep adjusting throughout the entire project history without diminishing the original quality of the layers.

applied to them (in the latest versions of Photoshop). Plus, you can always go back to re-adjust your edits. In short, they are *amazing* for composite work. This feature is especially handy for a nondestructive workflow and staying flexible with the project and image sources.

To make room for the hand and face, I shrunk down the fish a little and also played with the scaling, positioning, and rotation of the hand and face until the composite felt right and had a good compositional balance (**FIGURE 11.14**). Finding that sweet spot is a very subjective process, but there were a few things I was specifically looking for within the composition: Eye-flow, creating a sense of motion, and imbuing a sense of balance to an image are all part of the process and key for thoughtful consideration. Such extra finessing will definitely be noticed in the final result!

Step 6: Give the Fish a Froggy Glare

The real fish eye from the gold piranha was intense looking, but not as wicked and menacing as the frog's eye from the Erie Canal, so the fish definitely needed an eye-job to look this disapproving. Plus, it needed to be moved over a little. In fact, he needed more eyes altogether (obviously). I decided to swap out the fish's own eye for three copies of the frog's eye in decreasing sizes.

To ensure the original would be unharmed if my surgery went wrong, I made a copy of the fish layer and deactivated the original's visibility by clicking the Visibility icon next to its thumbnail 👁 ; this is akin to storing away a digital negative of the layer that I can always return to if things get too experimental even for a mutant three-eyed fish covered in flames (**FIGURE 11.15**).

FIGURE 11.15 Duplicate the operational layer; keep one to edit and one to save as an invisible backup.

Because the fish had been converted to a Smart Object, I double-clicked the fish thumbnail in the Layers panel and clicked OK in the resulting prompt, which told me that I could edit the layer in a separate document. Photoshop then opened a new document just for the Smart Object where I began my eye operation. Each time I saved this new document (Ctrl+S/Cmd+S, not the Save As function, just Save), Photoshop updated my composite with the new changes. This ability can definitely take the complexity of projects up another notch as you could even have Smart Objects within other Smart Objects—pure genius. Sometimes called *dynamic linking*, this is a workflow godsend for certain projects. Back to the one at hand, I first made a duplicate of the layer (Ctrl+J/Cmd+J), and then I selected the Lasso tool and drew a selection around the original fish eye. A right-click brought me the context menu (**FIGURE 11.16**), where I chose the Fill command. (Alternatively, pressing Shift+Backspace/Shift+Delete will do the same.)

In the dialog box that opened, I chose Content-Aware from the Contents menu and clicked OK; the selection filled in quite nicely and was all prepped to have some frog eyes added on top (**FIGURE 11.17**). Afterward, I saved and then closed the document. Back within the main composite I could see that my newly copied fish layer had been updated accordingly.

> **TIP** You can also use adjustment layers while editing Smart Objects as a separate document, and Photoshop will save these layers as part of the Smart Object. When you go back to your main composite, you will see the adjusted layer as a single Smart Object. Return to editing it once more by right-clicking the layer's name in the Layers panel and choosing Edit Contents from the context menu. The adjustment layer will be hanging out with the rest of the Smart Object layers.

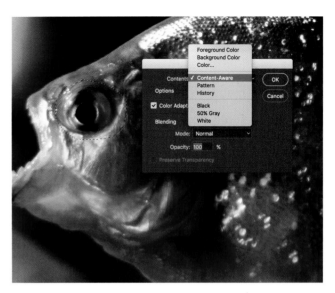

FIGURE 11.16 Content-Aware Fill is great for those instances when you need to replace an object that stands out with a nearly seamless background based on the selection's surroundings.

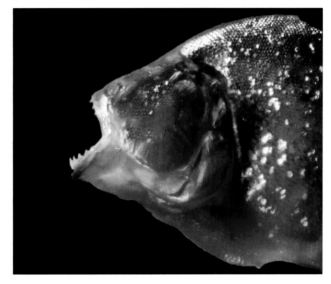

FIGURE 11.17 Content-Aware found the surrounding scales and blended them in nicely (for a mutant fish about to be set on fire).

FIGURE 11.18 Copy multiple instances of a layer by holding down Alt/Opt and dragging the image to a new location.

With the fish now eyeless, I needed to obtain a donor eye from the frog image. Quickly masking out everything but the bulging eye itself, I made two copies of the layer by selecting the Move tool (M) and Alt/Opt-dragging the image within the canvas workspace. Rather than just moving each eye as the Move tool typically does, Photoshop instead created clones that could immediately be transformed to create a bit more variation (**FIGURE 11.18**).

I needed to apply the same tonal adjustment to all of the eyes. Because Photoshop CC can apply clipping masks to groups, I put all the eye layers in a group, selected them, and then created a Curves adjustment layer clipped to the group. Doing adjustments to multiple layers this way is much more efficient than making three new curves, each doing the same adjustment. In the Curves adjustment layer I lightened the lights and darkened the darks (increased contrast), moving the two control points on the curve until each eye popped with the same contrast as the fish.

> **TIP** The more you can use clipping masks in clever ways, the more time you will have for spending on other work. Your use of them will increase steadily as you realize their potential.

> **TIP** You can also change the blending mode of the group to Normal and place the adjustment layers inside the group. This has the same effect as clipping adjustments to a group but keeps the adjustments a more neatly organized, as they all hang out inside together. When a group's blending mode is set to Normal, however, all other blending modes of layers inside that group will affect and interact with the layers within that same group only. Remember, when you isolate an adjustment's effect to a group with this technique, you also isolate the effects of the individual blending modes of other layers within this same group—just like a soundproofed room.

Other fishy operations included adding some copied scales to where the fingers had been pressed against the body. This scale reconstruction worked in much the same way as the eyes: I masked and copied material from other parts along the edge of the fish to keep a decent continuity. Knowing also that the fish would soon be covered with fire, I didn't spend a great deal of time striving for seamlessness by limiting the appearance of duplicated scale patterns.

Step 7: Harness Fire and Water

Fire and water are mesmerizing in their own right, but control their shapes and color by morphing them into something impossible (and just a hint wicked), and you have the ingredients for purely riveting visuals that can be applied to any scenario. When using fire and water as textures, forget what you know about physics. Try to see the images for what they are: a fascinating mix of light and dark shapes, gradients, patterns, and random variations. Look beyond the obvious and concentrate on what you *see* in the images, not what you know about fire and water, to find and harness pieces that match the main composite elements, meaning the curve of a face, hand, and shimmering scales of a fish for *Control*.

Starting with the fish, I wondered how glowing scales might look wreathed in fire, so I studied the fire photo palette and singled out shapes that seemed to match the contours and flow of the fish (**FIGURES 11.19A** and **B**).

Scooping up the water sources and moving them into place was much the same as working with the fire. When searching out the water, I again concentrated on the form of the pieces and matching shapes to the ripple. Sometimes I would see a section that could work as an underlit fingertip with the right warping or the glowing curve of a knuckle. The process was definitely a squint-a-thon that needed heavy-duty imagination processing power, but again, I had to find water only approximately close to what was needed to match up, as I would later warp these images to perfection. In the end, I found a few pieces with ripples that alluded to a three-dimensional form, which I could easily mask and warp to match the subjects' forms (**FIGURE 11.20**).

(A)

FIGURES 11.19A and **B** Fishing through the fire photo palette, I found a piece (A) that seemed to fit perfectly around the fish head as a glowing exterior element (B).

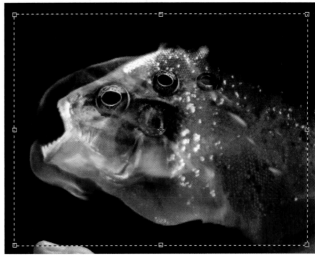

(B)

FIGURE 11.20 Finding the ripples that looked like they curved around a form took some careful searching but had great results once pieced together.

HOT TIPS SETTING FOR SUBJECTS ON FIRE

As you look for fire pieces to combine with parts of another object, keep these strategies in mind:

- Match shapes by ignoring the angles at which they were shot. Very much like a jigsaw puzzle, keeping a piece oriented exactly as you picked it up doesn't help fit it in place. The Rotate tool (R) is your ally in this task; it's very helpful for working at different angles without having to transform and rotate the actual layer. Press R and then simply drag as if you are rotating a puzzle piece by hand. Double-click the Rotate tool icon 🖑 to return to the default orientation.

- Get with the flow and movement. Fire acts much like water, and water, like skin, conforms to and covers any shape. When you see a subject and perceive forward motion, however, matching the flames to this expectation can have a positive result. In this case, I found the edges and tips of some of the flames and matched them to flow behind the fish.

- Try flames as filler, but don't over plan where they fall. Part of the illusion is the image not looking too perfect so that viewers will buy into the randomized quality of natural fire.

- Experiment with limited scaling, making sure the flames feel consistent and not so varied that the result is collage-like. When some flames are larger, the edges may be noticeably softer compared to flames that have been scaled down and have sharp edges to them. Our eyes pick this up, and the illusion gets disrupted.

- Be absolutely sure to mask out all flames not associated with the subject you are covering (in this case, the fish). You can help control this by placing all the layers associated with the subject into a group and adding a mask to the entire group to find those stray bits of hot digital grease.

For more advice on playing with fire, take another look at Chapter 8.

TIP Take your time looking for matching textures and work on a small scale, piecing the composite together like a 1000-piece jigsaw rather than a 100-piece puzzle!

To ensure the water and fire pieces shined rather than obscured, I changed the blending mode for each fire and water layer to Screen. As for the *Fire Play* project in Chapter 8, everything in the layer that was darker than the composite disappeared, and everything lighter came through brilliantly (**FIGURE 11.21**). This technique is especially helpful with any image in which the background is truly dark and the lights are nice and bright.

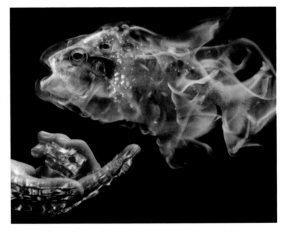

FIGURE 11.21 Changing the blending mode to Screen makes fire flash and water glitter by visually removing their darker portions.

Step 8: Warp and Liquify

Photoshop shines at bending reality and offers two great options just for this purpose: the Warp transform and Liquify filter. With the pieces scaled and positioned roughly into place already with the Move tool (V), I alternated using the Liquify filter and Warp to transform selections of water and fire to become perfect curves in the wrist, chin, thumb, and elsewhere. In general Warp is like bending, squeezing, and twisting a photograph. Liquify is like the photo is made of fingerpaint you can squish and distort and push around. One pushes and bends those out of place things back into workable shape, while the other takes a more dramatic approach with precision alteration so you can modify as needed.

> **TIP** You can apply both Warp and Liquify to Smart Objects nondestructively. If a Smart Object has been warped, returning to the Warp transform will allow you to get back to exactly where you left off. Liquify can be applied as a Smart Filter, meaning you can turn it off, delete it, or even mask it. Maximizing editability (technical term) with these texture layers is crucial, and Smart Objects most definitely increase your editing power.

Warp enables you to stretch and bend pixels based on a three-by-three grid and Bézier curve handles (**FIGURE 11.22**). To access this feature, I selected the Move tool and a layer intended for warping and then clicked the edge of the bounding box to activate the transform mode. I then right-clicked the image to bring up the Move tool's Transform context menu (**FIGURE 11.23**). From this context menu, I selected Warp and began warping each layer as needed by pushing or pulling the Bézier curve handles as well as dragging across the grid to squash or stretch the image as necessary.

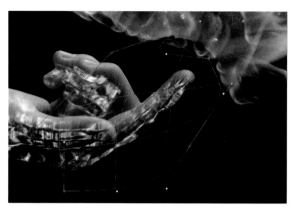

FIGURE 11.22 Warp is a good tool for bending pixels to fit exactly how you want.

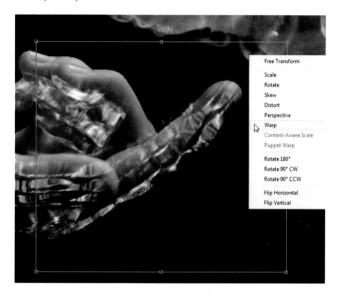

FIGURE 11.23 Left-click an edge of a layer with the Move tool and then immediately right-click to bring up the context menu containing the Warp command.

> **NOTE** Show Transform Controls must be toggled on in the options bar for you to access Warp and the other transform features of the Move tool.

For better results using the Warp tool, especially for such textures as water, keep a few tips in mind:

- Think of dragging the parts you want pushed and pulled like smearing bits of clay. The parts under your finger (or in this case the pointer) move the most dramatically while the rest move less so but are still clearly connected.

- Control the outer edges and the general shape of the layer by moving the warp handles that adjust the curve strength and direction of the *outer* edges. To bend a layer like this to fit a finger's curve, for example, I move the outer handles toward the direction I want the edge to bend, which gives me a great element of control.

- Don't overdo it! Warping something that already has dimension to it, such as the water texture, can cause the layer to start looking a little flat and you'll lose what you originally found interesting about its texture.

Liquify, on the other hand, was great for those places that called for a little more dramatic form sculpting, such as around the face, specifically near the chin. In **FIGURE 11.24** you can see where I did my warping with the Forward Warp tool within Liquify rather than a general transform grid. To do this, I first selected the layer of water in need of a more controlled ripple shape and then chose Filter > Liquify. This brought me into the Liquify interface. This is where many images go for total reconstruction, but, as with the Warp transform, less is usually more.

Needing to pull and stretch some of the pixels around, I opted for the Forward Warp Tool (W) and a Pressure of 40. This gave me some definite pull, but not enough to make an accidental muddle quickly. Another important feature to this interface is the Show Backdrop option. For compositing purposes, this is gold. I set Opacity to 50% and chose All Layers from the Use menu, and In Front from the Mode menu. I was able to push and pull the

FIGURE 11.24 Use the Forward Warp Tool (W) to push and pull pixels into just the right position and overall appearance, such as increasing the 3D form as well as shape accuracy.

appropriate water pixels with small controlled strokes—all the while seeing what it looked like with the other layers. Once satisfied with the sculpting, I clicked OK and then proceeded to mask out the hard-edged bits.

> **NOTE** Liquify is (for better or worse) optimized for face and body modification and has some eye-popping capabilities for sure, but it is also fantastic for things like textures and pulling out and sculpting a bit more form from something two-dimensional and flat. Just remember: Too much adjustment to any image will start looking a bit wonky, so moderation is key when you use this tool!

Step 9: Cool the Fiery Fish

Although enveloping a fish, the fire still looked normal at this stage and was not pushing far enough into the surreal and mysterious for my taste. To defy viewers' expectations (and physics) a bit more, I decided to swap the fiery warm colors for their polar opposites: the cooler blue-violet tone of deep, icy water. A Hue/Saturation

adjustment layer was just the thing I needed for color-changing magic. For me, keeping the scene more mono-chromatic lent itself to a more dream-like setting and has a nice continuity effect—plus it's always mesmerizing and visually fascinating as warm colors suddenly become cool.

For further continuity, I decided to adjust color for the groups containing the fish and fire shots altogether rather than working on the elements piecemeal. I selected the Fish group, which contained everything fish related, and created a new Hue/Saturation adjustment layer (click the icon in the Adjustment panel) just above the folder. I shifted the Hue slider far left until all the fire and fish became the same cool blue-violet. To make sure the change affected only the Fish folder, I then clipped the adjustment layer to the folder below it by clicking the small Clipping icon in the Properties panel (**FIGURE 11.25**).

> **NOTE** As you are working with many new layers and groups, remember that new layers always appear above the selected layer—unless a group is selected, and then the new layer is created inside of that group.

FIGURE 11.25 Adjusting the hue can be fun to watch, but the secret is in clipping the adjustment to the layer or folder directly underneath the adjustment.

Step 10: Control Color but Retain Depth

After adapting the fiery fish to the cool end of the spectrum, I needed to fine-tune the entire composition's look and feel with some global edits. These are the kinds of edits that, for the most part, are best to perform once the arrangement, positioning, and specific edits of the individual elements are more or less locked down. Part of this global editing process is getting a good idea of continuity as it can seriously help a composite. With this in mind, I decided to create a layer that turned the rest of the composite into rich blues and violets to match the flaming fish.

Why not just turn everything blue-violet all at once? Although it may seem like an extra step, the best practice is to get the colors of each section close to your final intent before doing a global color adjustment and masking. This way the color alterations don't have to be shifted quite so dramatically at the very end of the project causing it to look flat and less rich with subtle varieties. In the case of the fire, it's best to use the natural color gradient of the flames and scales, shifted to a range of cool colors, rather than making it a flat global color adjustment. Think color shifting versus color replacement with a single color.

To control the composite colors as a whole and match the fish's cool colors while also giving them additional accents and richness, I created a new layer and dropped it into the Effects group. I then filled the entire layer with royal blue by clicking once with the Bucket tool (G)—a bit dramatic and shocking. The first time you do this is a bit unnerving, as it feels like you knocked over a can of paint across the canvas. Luckily, a simple change of blending mode finishes the effect. Specifically, I set the blending mode of the new wall-of-blue layer to Color; instantly my other images came back, only bluer (**FIGURE 11.26**). Changing a blending mode to Color like this adds the layer's colors to the composite even where there was no color or very little to begin, such as desaturated areas with more gray tones

FIGURE 11.26 The Color blending mode is wonderful for infusing your own custom color but can come off a little strong, so it's always a good idea to back off the layer's opacity a little.

like the desaturated water. Initially the color always comes off too strong and needs adjusting in either opacity or masking (as in this case) to sit better within the composite, so always bring it back below 75% to start with. For *Control*, I attenuated the Fill to a pleasing 64%.

> **TIP** As an alternative to spilling a color on a new layer, try creating a Color Fill layer (Layer > New Fill Layer > Solid Color) to give you greater flexibility in the color selection. Creating a layer in this manner immediately opens the Color Picker dialog box and lets you choose a color then and there, allowing you to preview the chosen color with a live update of the fill color spread across the layer. It also already comes with a mask and not only can use blending modes, but also can be clipped like all other layers.

Because the fish already had its own cool alteration with subtle variations created by shifting the hues of the flames and scales, I also needed to add a mask to this Color layer so it applied to only the background, face, and hand, but not the entire fish. When comparing the variety of hues created from shifting the color (using a Hue/Saturation adjustment) versus spilling a flat color with a Color blending mode, the latter method (using Color blending mode) feels forced and flat as we expect flames to have a more dynamic and varying look to them—even blue ones!

> **NOTE** At this point in the composite I had settled on the scale and positioning of each main element and could safely add some global effects and masks tailored to fit the entire composite. Alternately, you could always apply one of these layers to the folder of each group and clip it for more isolated control as I did with the fish.

Other colors I added in a similarly controlled manner (masking and changing the blending mode) were a vibrant and deep red and a very regal violet, each on separate, additional layers (**FIGURE 11.27**). With these two layers, however, I changed the blending mode to Overlay rather than Color to control tones in addition to color and because Overlay does not change colors so aggressively. For more on blending mode differences, see Chapter 3 or check out a great book on the subject by Scott Valentine, *The Hidden Power of Blend Modes* (Adobe Press). Having each color layer separated out this way allowed me to paint just on their masks with black and white, flipping back and forth efficiently by pressing the X key (be sure to press D first to reset these black and white defaults). I used masks heavily with these two layers starting with an inverted mask (invert by pressing Ctrl+I/Cmd+I after creating the layer or by Alt-clicking/Opt-clicking the Add Mask icon) so that I would have better control over the distribution of color and not cover the fish.

FIGURE 11.27 Three main layers control the composite's overall color. Each had its own mask for better isolation.

Step 11: Brush in Magical Lighting

What surreal image is complete without some magic wind-spirits flying about? To brush in these flowing wisps for the mouth and hand, I first created a new layer and placed it in the Effects group, making sure it was directly below the Color layers so that whatever I painted using white would be colored to match the scene. To create the scattered brush effect, I started with the basic soft brush and toggled on Shape Dynamics, Scattering, and Transfer in the Brush Settings panel (**FIGURE 11.28**). Painting with a Wacom tablet (or other tablet with pressure sensitivity), I was able to change my pen pressure to control the shape and opacity of what I was painting, which was perfect for streaking small controlled waves of this brushstroke around the image.

FIGURE 11.28 Even a simple round-and-soft brush can be modified within the Brush Settings panel to become something dynamic and interesting.

TIP If you want to create a dynamically changing brush without the luxury of a tablet, select the Shape Dynamics item in the Brush Settings panel and then choose Control > Fade and set its value to 100 and the Minimum Diameter to 20%. This won't exactly replicate the look that you can achieve with a tablet but will create a tapering effect that can be stroked first in one direction and then the other.

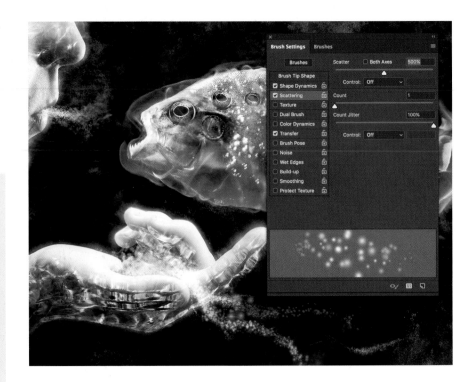

I added a small Outer Glow layer style effect to complete the look. With it, each little scattered burst of white paint from the brush had an added glowing effect contributing to the fantastical and surreal nature of the piece. This also helped the brush stroke feel less flat. I added the layer style by clicking the Add A Layer Style icon 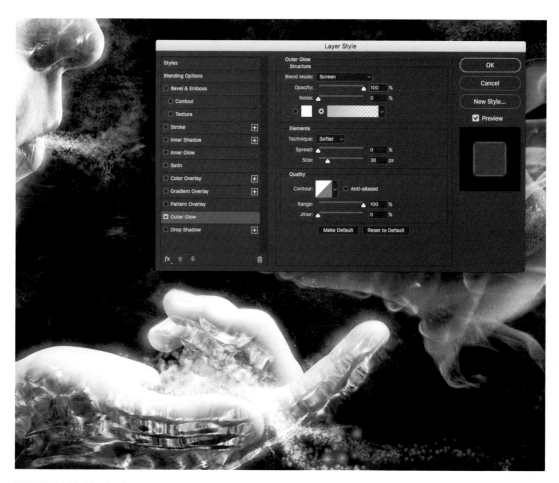 at the bottom of the Layers panel and choosing Outer Glow from the menu. When using Outer Glow, don't go too far overboard with the effect; keep the size limited to a gentle coloring and thickening of the brushed dots (**FIGURE 11.29**).

FIGURE 11.29 The final result with an added Outer Glow layer style meant magic in the air!

Step 12: Glow

Although it may not be the glowing waterfalls of Tolkien's Rivendell, the composite definitely needed to have some of its sharp edges softened and made to feel as if glowing light was blooming from the lighter elements.

For the final effect of the composite, I again created a new layer in the Effects folder and named it Glow. Switching brushes back to the simplicity of the soft, round brush, I gently painted (with Opacity set between 5% and 10%) around the bright and sharp areas that needed an extra glare and softening to them, such as the hand and face and various lighter parts of the water (**FIGURE 11.30**). This helped increase the feeling of bright glowing light, made it more dreamlike, and softened up the edges in a subtle but pleasing way.

> **TIP** Making the glow slightly uneven can add a subtle effect of shimmering. When a glow is overly even, it loses this shimmering quality because everything appears equal all the time.

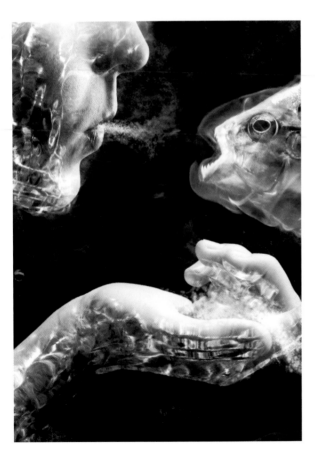 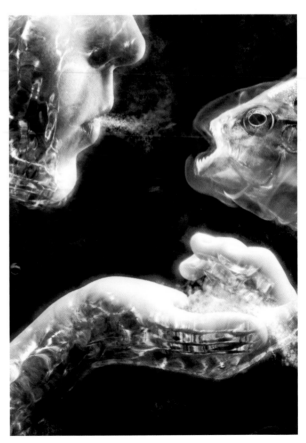

FIGURE 11.30 Compare the image before and after adding the final Glow layer—a small layer with a big impact!

Conclusion

Working with textures, especially fire and water, can be daunting and always meticulous but so very rewarding in the end. This project is a good example of how regular, everyday photography can be used to inspire a new world of imagination, one where controlling a strange, fiery, frog-eyed fish is as easy as blowing in its face with glowing breath. The main concepts to take away and apply to other projects, however, are the power of color control over textures, such as water and the rest, and the potential of finding inspiration in a strong initial image. What was very much the everyday banal soon became the extraordinary and intriguing in *Control*. Have the digital courage to chase down your surreal dream and bring it to life piece by piece.

MARIO SÁNCHEZ NEVADO

http://aegis-strife.net

Mario Sánchez Nevado is a Spanish freelance illustrator and art director. His studio, Aégis, is focused on bringing digital art to the covers and packaging of music bands and publishing houses all over the world. One of the very few illustrators with the Master Award in illustration in two consecutive editions of Exposé, Mario has had his work exhibited in New York City's Times Square and Creatives Rising. Although Mario's work depicts obscure and surreal environments, his messages often point to ideas of enlightenment and self-conscience.

How do you use color theory in your composites? How does it affect the meaning of your work?

The use of color is a key in my illustrations. I use it to create certain moods, because, for me, the emotional impact at first sight on my images is very important. I tend to create harmonic palettes for the surroundings and turn into complementary or contrasting colors for the focal points of the compositions, so they grab attention and establish a starting point to "read" the image in the direction I want. I really like reds for this matter, especially when they are contrasting with blue.

How do you create such great depth from tiny pieces of flat images?

It's important to use photos with neutral and flat lighting as much as possible, with no hard shadows cast, so you can more easily build on it. You can then create something homogeneous by hand painting the lighting over the photos, directing it from the sources you establish and adapting it to the atmospheric conditions if the action is taken into an environment. It's crucial to keep in mind the depth of field.

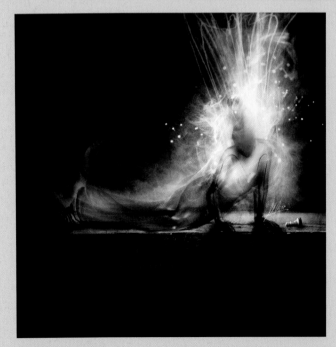

A DYING WISH, 2007

▶ BETRAYAL, 2012

Deliberation, 2012

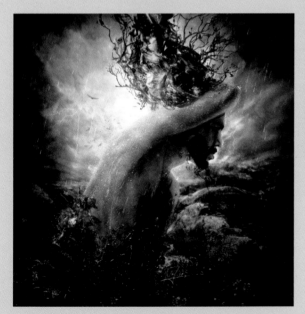

Charade, 2013

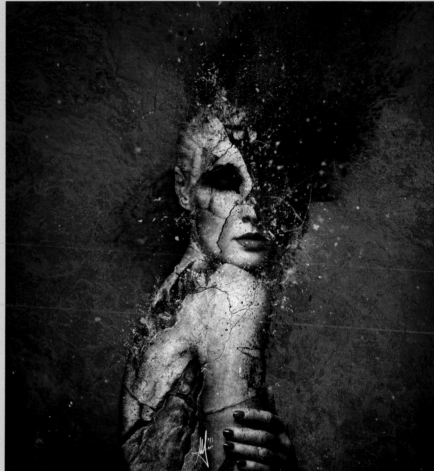

Indifference, 2011

What does your planning process look like?

It has two variations. The spontaneous one is the most common. I just sit in front of the computer and let my imagination flow. It is like throwing things to the canvas and seeing what happens. Then, when I know what is actually happening, I take total control over it to build a narrative and make of it an effective communicating illustration, changing elements and adding or subtracting new items or atmospheres. The other way is when I plan every single aspect of the image if it's been conceived in a very specific way. So there would be a set of sketches and a list of resources I might need, then the relevant photo shoots and the combination of everything in Photoshop.

What's your secret weapon as far as tools or other Photoshop features?

Well, this might surprise you, but after years I have realized that the Brush tool has almost everything I need. When you need high-end finishes, you better do everything little by little by hand, like painting the lights or the small details like particles on the air and such.

How many layers are typical for one of your composites?

As my illustrations tend to go from very complex, baroque-like compositions to very simple ideas, it really depends—usually, no less than 40 or 50 layers for very simple artworks. I use many adjustment layers, so for the most complex ones I think I can end up with around 500 layers.

Where do you get your source material?

I try to photo shoot or paint everything by myself. I often plan trips for photo shoots on natural spaces, so I can have images of landscapes, textures, several items, and so on. I tend to contact several friends for modeling as

NIRVANA, 2012

well. But it is hard to gather everything you need, so sometimes I end up taking a look on royalty-free stock websites, both free or paid ones, but I really try to use only my own resources.

Do you have any tips or suggestions for others following in your footsteps?

To quote Doris Lessing, "Talent is actually something very common. The rare thing is perseverance," and Charles Bukowski, "Find what you love and let it kill you." I couldn't sum it up in any better way.

What's been your greatest success as an artist?

To be able to make a living out of what I love the most. But also, the chance it brings me to get to know myself and my environment in a deeper way. ∎

CHAPTER 12

Put Daddy Down, Please!

▶ **FIGURE 12.1** No parents, cats, or babies were harmed in the making of *Put Daddy Down, Please*. One plant did get a little disheveled but is recovering wonderfully.

Many parents see their children as amazing, but what if a baby really did have superpowers?

One night, after putting my own little super-dude to bed, I quickly sketched out what I thought could be a fun idea to try someday. The next morning I made the sketch a reality, almost on a whim. By the way, it is always a good idea to mention any potential plans like this to your housemates. In this case, I really should have warned my wife Erin *before* she came downstairs to find me posing on top of my son Kellen's highchair…which was also on top of the table.

In any case, I soon won Erin over with a batch of coffee and enlisted her involvement with the shoot. By the end of the morning I had all the images I needed, and by the end of the day, I had a finished version of *Put Daddy Down, Please* (**FIGURE 12.1**). On the surface, this project was an exercise in selections and masking, but it also demonstrates the power of good planning and a thoughtful setup. Although I didn't realize it at the time, without my sketches and preparation, the image really would have been impossible.

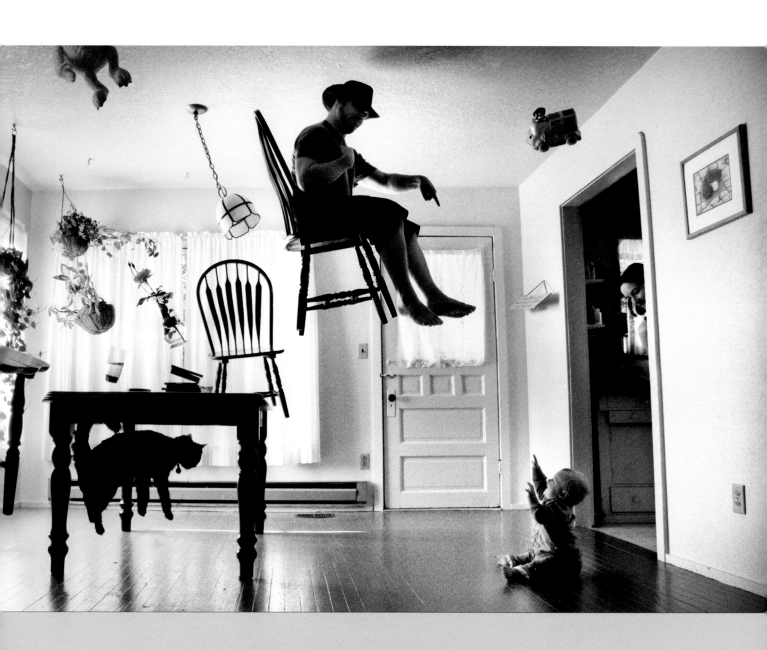

Preparing for a Composite

Each composite presents its own challenges; however, I have found a few things to be absolutely critical to achieving success with in-frame subject-object-background composites like *Put Daddy Down, Please*:

- Use a tripod.

- Shoot in raw format and use a large memory card.

- Shoot automatically with an on-camera app, an intervalometer (a remote trigger with a timer), or a mobile device you can use as an intervalometer. Intervalometers are available for most DSLR cameras, and even a simple, inexpensive one like mine will save you hours of time when shooting by yourself (**FIGURE 12.2**).

FIGURE 12.2 An intervalometer can save you time and frustration when doubling as cameraperson and subject.

- Set your lighting and exposure controls; then don't change them. The same goes for focus, although this is a good one to double-check from time to time, just in case!

- Get some clean shots of the scene empty of props.

- When you shoot the props, over-shoot a variety of positions and possibilities. You never know which ones will work and which won't until it's too late!

- When working with babies or toddlers, be prepared to make the shoot entertaining and fast. Keep toys or something fun handy to motivate some super interaction. A partner to help can be invaluable, as well.

- Be prepared to do it all over again. Things may not look the way you imagined after the first shoot, so study your shots and ask yourself how things can be improved. Try again if needed; you'll notice huge improvements by the end because you will be able to visualize the scene better after all that practice.

Step 1: Sketch the Scene

Never underestimate the power of planning. The rough sketch I jotted down the night before (**FIGURE 12.3**) enabled me to envision lighting conditions, composition, point of view (POV), props, and a slew of little details I might not have been able to think about while shooting.

FIGURE 12.3 Plan everything from angles to lighting. Making changes when it's time to shoot is fine, but go in with a plan so you at least have something to start with. Re-work it from there.

NOTE To watch a short video on the shoot and editing process, visit https://www.youtube.com/watch?v=AhUsqzoJAmk.

So, sketch out your idea. Whether it's rough like mine or detailed and meticulous, make sure your sketch includes

- Lighting position and direction

- POV and lens size (if not in millimeters, then an indication of wide or telephoto)

- General composition and mood

FIGURE 12.4 shows a rough sketch for *On the Edge*, another picture in the Raising a Super-Child series (**FIGURE 12.5**).

FIGURE 12.5 Some things definitely changed from the original concept, but the sketch gave me a solid idea of how to start shooting, where the lights should be, and where to place Kellen.

FIGURE 12.4 Compare this rough, initial sketch to the finished image in Figure 12.5.

Step 2: Set Up the Shot

It's always easier to place objects where you want them in Photoshop rather than to use Photoshop to remove them later, so start any shoot clutter free. You can use Content-Aware Fill and the Clone Stamp tool to fix up just about anything, but why spend an extra 10 minutes in post instead of a few seconds in properly setting up a good base shot? Save your photo-mojo for things that you really can't change without Photoshop, like an ill-placed light switch or ugly carpet. For the *Put Daddy Down, Please* base shot, I cleared away all furniture and props (except for the table) from the scene beforehand (**FIGURE 12.6**).

For this project I also took my time in finding just the right POV and wide angle (15mm lens on a APS-C size sensor, not full-frame) to frame the scene properly. I wanted the position to be subtly low to help viewers identify more with the baby as a subject and his perspective of looking up.

Exposure Controls

Finally, check your exposure controls and intervalometer before you begin, and adjust as necessary. Lock everything down (including white balance) in Manual mode so that there are no variations from shot to shot. I gave myself a challenge by shooting into the light, but I wanted the room's windows in the background with their bright and beautiful morning light as the dominant source for this shot. My idea was to play with contrast and a near silhouetting in parts of the scene. I mostly exposed for the brightness of the windows while still trying to keep some detail in the shadows. Shooting raw files gave me plenty of pixels to fine-tune in post-production. You'll notice that my original shot is severely under-exposed for most of the picture (**FIGURE 12.7**). In retrospect, I should have brought

FIGURE 12.6 Make sure you shoot a good blank image or two as a background for layering your other images onto.

FIGURE 12.7 Trying to find the balance of lights and darks in a high-contrast situation is never easy, but when in doubt, don't blow your highlights if they are important.

in additional lighting and saved myself work in post. Unfortunately, though, grabbing my lighting kit would have woken Erin, so I used what was at hand. You'll always encounter unanticipated limitations during a shoot, so be creative and work with them as best as you can.

Setting the intervalometer to take a picture every 5 seconds left me just enough time to run around like a madman and hold something in place for each shot. (Kellen thought this was hilarious. I found it less so.) When you're working with children, however, too much can happen in 5 seconds. For Kellen's shots, I shortened the interval to triggering every 2 seconds. Increasing the frequency of shots with the intervalometer increases your chances of getting that great performance moment from the little one.

Step 3: Place the Objects

Placing objects sounds easy: You just run around holding things in the air and freeze before the picture snaps. It's not. Not only must you hit the right mark, the object must be oriented to both look good and be of use for the final composite. Here are some tricks for getting it right:

- Stand out of the way of the background. Just because you *can* use Photoshop to remove yourself from behind the object does not mean you should.

Extricating yourself takes time, and the results may still look funny even after investing that precious time. In short, stand aside!

- Hold objects with your hands behind the prop or at the very edges whenever possible. You need to keep your visual involvement with the object to a minimum. Keep in mind that whatever is between the object and the camera will result in covering up the object (this seems obvious, but you'd be surprised how challenging this can be to remember when shooting). If you can grab a prop from its back or edge, do so. The results will be better looking, and removal will be easier. Multiple exposures of holding an object from different edges can also potentially help those tricky ones. Once in post-production, you can stitch the best sections together.

- Variety is an absolute must in prop placement. As you walk around the scene holding objects awkwardly in the air, you may think you are varying object placement greatly. In reality, you're probably not. When you're not behind the camera with each shot, it's pretty impossible to know how prop positions—especially *depth* and orientation—will look in the final selection and the overall composition. It's an easy fix, though: just over-shoot until you get the hang of it! I've reshot scenes more times than I can count, we all have—or will.

Step 4: Select Your Best Images

After you transfer your images to the computer, launch Adobe Bridge and start combing the shots for composite-worthy candidates. I used the Filmstrip work-space for this step (you can choose this from the options bar). Filmstrip allows for easy thumbing through the shots and good side-by-side comparisons when multiple image thumbnails are selected while holding down Ctrl/Cmd.

Rather than deleting anything at this stage, use the ratings feature of Adobe Bridge to rank them: Select an image and press Ctrl+[a number from 1 to 5]/Cmd+[a number from 1 to 5] to give it a one- through five-star rating (**FIGURE 12.8**). You can later sort by rating; to see all images with four or more stars, for example, press Ctrl+Alt+4/Cmd+Opt+4 or click the star filtering icon to the right of the workspace name (**FIGURE 12.9**).

TIP If you shoot in both raw and JPEG, filter by file type raw before rating your images. This way you'll be comparing only raw files and won't accidentally rate any JPEGs. You can always put your JPEGs in a separate subfolder if things get too confusing.

The general rules for my rating system are

- 5 stars: Perfect shots I just *know* will work

- 4 stars: Could be great in the final composite, but I need to see it to be sure

- 3 stars: Might be workable, but only if I can't find better

I never use shots below 3, so I simply just don't bother rating the bottom tiers (unless I am marking images to delete for sure). I start my final selection by displaying those 4 stars and above (Ctrl+Alt+4/Cmd+Opt+4), and I include 3-star shots only if I'm desperate for more variety.

FIGURE 12.8 Adobe Bridge is ideal for sorting through your shots and rating them.

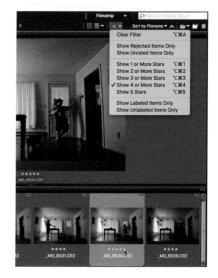

FIGURE 12.9 View only the best shots by filtering your images by the star rating.

Step 5: Edit in Raw

Once you're satisfied with your collection of filtered images, it's time to edit. I selected everything (Ctrl+A/Cmd+A) and then double-clicked one of the shots to open the images for editing in the Adobe Camera Raw plug-in (ACR) in Photoshop (**FIGURE 12.10**).

Once your images are in ACR, batch processing makes tedious work quicker. For example, these shots were mostly too dark. I selected them all (Ctrl+A/Cmd+A), and then lightened some of the shadows with what used to be called *Fill Light* in CS 5 and now in CC is simply called *Shadows* (**FIGURE 12.11**). I found the slider sweet spots for these images by looking at both the shadows and highlights to strike a more even balance for the scene. When balancing your own images, be sure to get as much detail as possible in both lights and darks while still maintaining a good contrast.

TIP If you shot in JPEG and still want to learn about raw editing (only without the raw file's bit depth), right-click one of the selected images and choose Open With Camera Raw from the context menu. Be aware, though, that because the JPEG file has already been compressed, the powers of the editing sliders are very limited compared to adjusting an actual raw image, especially in regard to highlights and white balance.

When I'm done editing the images in ACR, I click Done rather than Cancel or Open. Clicking Done saves your edits without permanently changing the file but does *not* open all the images all at once within Photoshop, instead letting you later choose which to open. Too many tabs opened in Photoshop can easily become overwhelming and confusing. Keep them controlled whenever possible.

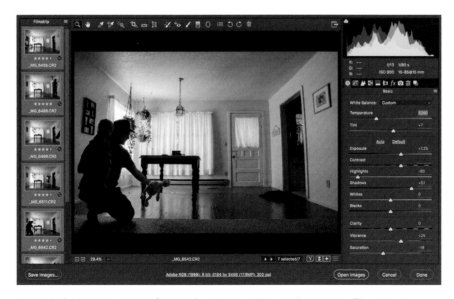

FIGURE 12.10 Using Adobe Camera Raw keeps edits nondestructive. Plus, you can batch process them.

FIGURE 12.11 Adjustments that you make in ACR affect all your images once they are selected in the Filmstrip on the left of the interface.

FIGURE 12.12 This is the main stage image empty of most props; the image had a good 5-star rating.

Step 6: Set the Stage with a Clear Base Image

The value of finding a good, clean, and evenly lit first background image cannot be overstated. This back-plate shot has to be clear of extraneous props, people, pets, potatoes, and so on for it to function well as a background stage image. For *Put Daddy Down, Please*, I settled on that 5-star shot of the empty background (**FIGURE 12.12**), opened it with a double-click to bring it into ACR, and then clicked Open Image Open Image to bring the image all the way into Photoshop for composite editing.

Step 7: Organize from the Beginning

When you move into a new home, you first put your boxes in their designated rooms; leaving the box of kitchen supplies in the master bedroom won't help when you start opening boxes to put things away. Think of your base image as your home. The next step is to bring in the other objects and layers, organized in folders that, like the moving boxes, relate to their designed locations. Although every move is different, there's no budging on this point: Label and organize from the get-go! For this project, I immediately made groups for each part of the composite (**FIGURE 12.13**). An organizational structure like this will help eliminate confusion and enable you to order elements based on depth (foreground, middle, and background). Remember, Photoshop determines visibility by reading the layers stack from top to bottom. If you want a layer, such as the background, to be behind others, stack that layer below the others (at the bottom for the background).

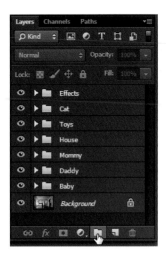

FIGURE 12.13 The groups for *Put Daddy Down, Please* helped me stay organized as the project's complexity grew.

Keep these organizational tips in mind as you group your images:

- If there are layers that need to be above others, plan this out in your groups. Keep in mind that we see top layers first. If some layers don't touch or conflict with one another, don't worry about which comes first in ordering.

- Your Effects group must be above all other groups and layers. This folder will house global adjustments, such as lighting, that affect everything.

- As mentioned in Chapter 2, label and color code layers as much as possible, or at the very least, label the groups. Sticking with a default name may

seem to save time at first, but it costs a lot more when you're trying to decipher just what's on Adjustment Layer 47.

- Save your Photoshop document in a place you can find and with a name you can search. Just like with groups and layers, if you can't find what you're looking for, it's no good.

Step 8: Select from the Chosen

For composites like this one, I prefer to view all the potential elements together before I begin picking and placing, like laying out all the pieces face up before working a jigsaw puzzle. This way, I can see what I have to work with and try fitting them in various positions. For this project, I used Adobe Bridge as my composite palette and bounced back and forth from Adobe Bridge to Photoshop ferrying pieces into the composite file (**FIGURE 12.14**).

Starting with Kellen and myself as subjects, I found the few potentially usable images of each of us before opening them all the way into Photoshop and proceeding to step 9. I didn't want to bring *all* composite images into Photoshop, because massive tab trains easily get confusing. Opening a relatively small number of sibling images (images in the same category) can be very beneficial for staying organized and efficient while finding the best fits. After copying and pasting a group of images into the composite file (step 9), I closed the individual tabs in Photoshop and went back into Adobe Bridge for the next family of images (such as the toys) to also bring them into Photoshop and their respective group.

> **TIP** You can always bring in more layers than you need and then turn off their visibility once in Photoshop. It's good to still keep them around until you're absolutely sure of their uselessness. Sometimes we change our minds for the better of a composite.

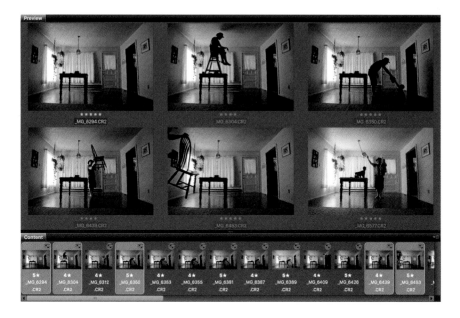

FIGURE 12.14 Choose all the usable shots for each category of image you need. Here I've picked all the best shots of the image's main subjects.

FIGURE 12.15 I like to use marquee selections with plenty of extra room for blending around subjects.

FIGURE 12.16 Use Paste in Place to add a selection, and it goes right where it needs to.

Step 9: Copy and Paste in Place

Shooting all of your images from a matching point of view makes compositing *much* easier. Instead of cutting, pasting, and painstakingly repositioning the image pieces you wish to use, you can use Paste in Place (Ctrl+Shift+V/ Cmd+Shift+V) to paste your copied selections into the composite in spots corresponding to where they were taken.

Take a look at how I added Kellen to the background image, for example. As you can see in **FIGURE 12.15**, I selected a big rectangle around him (and each subject) with the Marquee tool (M). Quick and dirty, this gives me a good chunk of the subject with a fair amount of the surroundings I can use later for seamless blending with masks. Think of it as collecting slack for tying two ropes together.

After copying the rough selection with Ctrl+C/Cmd+C, I returned to the composite image tab and pressed Ctrl+Shift+V/Cmd+Shift+V to paste Kellen into the background in the exact place he occupied in the image I cut him from (**FIGURE 12.16**).

NOTE Keep your workspace clutter free whenever possible: Close the tabs of the source images as you copy from them.

I repeated this sequence for the remaining elements (going back and forth between Adobe Bridge and Photoshop), using Paste in Place to add all the elements I wanted to bring into the composite, and then saved. Having everything loaded into one file is great for this kind of composite. Unlike other composites where you may be taking from vastly different imagery, kinds of selections, and objects, everything for this project was shot in the same space, same frame, and with the same lighting and camera position. Because of this uniformity, I could quickly bring everything that was potentially usable on the stage and begin choosing one object variation over another for a drastically stronger overall composition. Masking something out when it might not even get used can eat too much valuable time.

Step 10: Refine Selections

At this point in a composite project, you have a choice: You can continue to refine the edges on an element with the selection tools before applying a mask, or you can simply begin painting on a layer's mask with black and white. Good selection technique goes a long way when it's needed, but painting on a mask gives you absolute control. The drawback is that painting directly can take more time for an image with lots of nooks and crannies around the edges—*a lot* more time if you're not used to it.

How do you decide which technique to use? My general rule is to make a good selection *before* masking if:

- You intend to move the pasted image around a bit from its original location within the shot. For example, you need a rough idea for various compositions before choosing the best.

- There are other layers that need to overlap with the pasted image seamlessly, especially objects that need to go *behind* it.

- You find selecting the object easier and less time consuming than getting a mask just right by painting.

Otherwise, if the pasted image doesn't meet these guidelines, then go straight to step 11.

For images that need a selection first I use a variety of tools depending on the job. For the floating objects here, I used the Quick Selection tool (**FIGURE 12.17**). This tool is phenomenal at finding edges, and objects especially—although if this tool fails to grab the selection and some appendages of the image, the Magnetic Lasso tool usually enables me to be a little more specific with my selection, as you can see in **FIGURE 12.18**.

> **TIP** Sometimes it is easier to select an object by first selecting its background. Select the background, right-click the selection, and then choose Select Inverse from the context menu.

FIGURE 12.17 The Quick Selection tool is great for speed.

FIGURE 12.18 The Magnetic Lasso tool allows for better definition in a selection.

To hone in your selections even more (and save a little more time and effort in masking), use the edge refining features. For example, I selected the bus and then clicked the Select And Mask button (center of the options bar) to open the Select And Mask workspace (**FIGURE 12.19**).

When refining edges, keep three things in mind:

- Feather your selection. Matching the focus and blur of the image is critical for avoiding the typical collage look. If the image has a little blur about 2 pixels wide, add this to your feathering. If it has a focus blur of 3 pixels, match it in feathering. Zoom in close to be sure it looks right.

- Shift the edge in the negative to bite just a little into the selection to avoid any greasy halo pixels. Halos stand

out immediately in bad composites; even if our eyes can't tell exactly what's wrong with an image, they still know that *something* is wrong. Usually that something is a slight pixel halo from not shifting this edge inward.

- It doesn't have to be perfect. My preferred way of making things look "right" is to paint on the mask itself, which you'll see in the next step.

TIP To avoid halos and digital grease, try changing your Select And Mask view background to better see what is part of the selection and what is not before you create a mask. Press the A key to change to a black background, T for white, and O for Onion Skin (to see the background layer(s) along with the selection).

FIGURE 12.19 Select And Mask does wonders for cleaning up selections and refining the edges of selections especially.

Step 11: Add the Mask

For any kind of composite, masking is the magic behind the scenes. To make the magic happen for the bus shot, I added a mask by clicking the small Add Layer Mask button in the Layers panel (**FIGURE 12.20**).

> **TIP** Alternatively, you can go straight to creating a mask from the Select And Mask workspace if you're satisfied with the selection. In the Output Settings section of the Properties panel, choose Output to > Layer Mask. Click OK, and the mask will instantly be created based on your selection.

In this case, my refined selection of the toy told Photoshop to keep that area visible and make everything else invisible. But this is only the beginning as it almost always takes some hand painting to get things looking just right.

FIGURE 12.20 Add a mask to a selected layer by clicking the Add Layer Mask button as I did for this bus.

Step 12: Paint the Mask

I have one rule for painting on a mask: I always keep my brushes sable soft. Well, it's more like a guideline really (as there are exceptions, but very few for my own workflow). When removing a background, such as with my floating self, for example, I used a small, soft brush (Hardness set to 0) and painted out the unwanted bits (**FIGURE 12.21**).

Using a hard brush while painting on a mask frequently produces an amateurish result, like a collage cut in a rush with dull scissors. Instead, soften up your brush and blend things seamlessly.

When you need more detail and a sharper edge to your brush (because you always will), try changing the brush *size* instead. This will allow you to be more nimble and articulate with the brush in ways that a big hard brush could never dream to be. The smaller the brush, the sharper the edge and the more painting dexterity.

SOFT AND SMALL BRUSH

FIGURE 12.21 Paint on a mask with a soft brush for better blending.

A few other tips to keep in mind are

- Press backslash (\) to see your mask highlighted in obnoxious red. Now you can avoid leaving any digital grease behind! You will be able to see exactly where those pesky remaining pixels are that add up over the long haul.

- Press the X key to switch between painting with black (the default) and painting with white while you mask. Remember, black erases nondestructively, and white brings it all back (black conceals, white reveals).

- Never use a brush radius softer or harder than the blurriness of the original shot; if you do, the result will look fake! Again, I keep a soft brush and simply change my brush size to work with an edge that is less fuzzy.

- Adjust your brush size to mask out larger sections. The Right (]) and Left ([) Bracket keys make your brush larger and smaller, respectively. Alternatively, you can hold down Ctrl+Alt/Control+Opt while dragging right (for a larger brush size) and left (for a smaller brush size).

I painted in the mask for both Kellen and myself (**FIGURES 12.22** and **12.23**) without first making a selection. For the image of Kellen it was more important to paint in the shadows gently with a brush. Besides, because everything else matched the background perfectly, making a tight selection was fairly pointless. Save time where you can! Plus, drawing on a Wacom tablet can make things like this go much easier (compared to drawing on a track pad or with a potato—er, mouse).

FIGURE 12.22 Masking myself required a small but soft brush with about the same softness radius as the blur of the photograph.

FIGURE 12.23 Kellen's mask needed gentler blending and a much larger (yet still soft) brush to accomplish it.

WHEN TO INCREASE BRUSH HARDNESS

As hard as it is for me to admit, sometimes it is helpful and necessary to increase the brush hardness for masking. Do this by pressing Ctrl+Alt/Control+Opt while dragging downward on the image itself or by right-clicking the image with a brush tool selected and changing the hardness slider from the context menu. For my own workflow, here are those few times that I make an exception and increase my brush hardness:

- When I need to make sure there is no digital grease remaining after painting on a layer's mask (a soft brush can leave hard-to-find remaining pieces).

- When the content I'm masking has fairly rounded and smooth edges (without lots of nooks and crannies) and is not the slightest bit blurry. Even so, I never increase the hardness beyond the width of the image blur that's visible when I zoom in (the number of pixels blurred across a defined edge).

- When I'm working on extremely fine details, such as hair or some other element that needs a sharply drawn line.

Step 13: Use Clipping Masks for Isolated Adjustments

Imagine you accidentally left a jigsaw puzzle piece in the sun on your window sill and it faded. When you fit it into place, it will still look wrong compared to the other pieces. In composite projects, too, sometimes you need to adjust one piece, one layer, *only*, not the layers below it. Clipping masks and clipping layers are designed to affect just that one troubled piece.

Most of the layers for this kind of composite (where you are working from one POV, one scene location, and the same light sources) should match up almost exactly to the original background shot, but natural lighting conditions change over time and depending where you stand (and more importantly, where your shadow falls) in relation to each object, will change even more so. To compensate for this reality we can make a clipping mask and a series of subtle adjustments that will get each layer puzzle-piece to really *sit* into the composite.

For example, I needed to change the lights and darks of the sitting baby layer. The light had shifted from that first establishing shot to something a little darker and slightly bluish (**FIGURE 12.24**) by the time Kellen was on stage. Curves were the first tool I needed for the job.

For adjustments like these, get the lights and darks looking right first; colors will change *after* you alter the contrast in Curves (unless you change the layer's blending mode to Luminosity). To add a Curves adjustment layer, I clicked the small Curves icon in the Adjustments panel (**FIGURE 12.25**).

Now here's the secret to fitting just that one puzzle piece: Add a clipping mask! This keeps the adjustment from affecting the layers below as well. By pressing Ctrl+Alt+G/Cmd+Opt+G I *clipped* the selected adjustment (the

Curves adjustment) to the layer below it (the baby). Unless I tell it otherwise, the Curves adjustment will now use the mask of the layer below it and affect the visible pixels of that layer only (**FIGURE 12.26**). Once you master this technique, you can apply it to just about any scenario of selective adjustments or effects. It's quite the subtle, yet incredible feature.

FIGURE 12.24 Notice the lighting differs from the baby layer to the background shot.

FIGURE 12.25 A slight Curves adjustment lightened the layer.

FIGURE 12.26 Clipping masks are a genius way of making selective adjustments.

As for the actual adjustment, unless you are going for something dramatic or radical, less is more in Curves (see Chapter 4 for a refresher on this). The super-child was only a little underexposed compared to the background, so the Curves could be very gentle. **FIGURE 12.27** shows the results.

Next come color adjustments. After adjusting the lights and darks with Curves, I clipped a Color Balance adjustment to the layer to take care of the bluish hue from the change in lighting (**FIGURE 12.28**). It wasn't a great deal off, but enough to throw it even with a blended mask applied. As you can see in the figures, I temporarily disabled my mask (Shift-click a mask to disable or enable it) for a larger sample area to make adjustments to and see their effects. Now I was able to see that my color adjustments of slightly more red and less blue again hit the mark for matching the background.

Just from a couple minor adjustments, the baby layer fits in nicely. This adjustment process is what I call sitting a layer into the composite.

As part of the demonstration I disabled the mask for this layer so now that I am finished with my adjustment I can once again enable my disabled mask—and we have ourselves a seamless edit (**FIGURE 12.29**)!

I made similar adjustments across the entire composite for those shots that needed it. Some images, though, also needed a little more adjustment triage before they could really sit. Typically, I made tweaks in Hue/Saturation or even did some clone stamping, such as to remove some of the remaining hands that could not be simply masked out.

FIGURE 12.27 Compare the shot after the Curves adjustment with Figure 12.24.

FIGURE 12.28 A second clipped layer to remove the bluish cast will not affect the other clipped layer below it in this case—and, fortunately, you can't clip to an already clipped layer.

FIGURE 12.29 The seams are now nearly invisible from these two adjustments.

Step 14: Use Clone Stamp to Remove Unwanted Fingerprints

No matter how carefully you hold your props, a few fingers or even a whole hand may end up visible even after careful selection and masking. The Clone Stamp tool (click the ![icon] icon or press S) will help you remove them.

The catchword for success with this tool is "small." Examples of bad cloning are all too easy to find, and many share the same flaw: The cloned sections are too large, and when repeated, they look just like another part of the image—and obviously so! The key is to construct something new by cloning multiple pieces together for a subtle and seamless result. To improve your results, remember to:

- Use a soft brush.

- Keep your sampling point and brush size relatively small.

- Vary the sampling point location to avoid telltale signs and obvious pixel repetition. Take samples from little bits of multiple areas for a good blend.

- Use small strokes, always small strokes! Again, this will help avoid things looking too cookie-cutter similar, as well as help avoid the clone sample point drifting astray into unwanted areas.

For *Put Daddy Down, Please,* I needed to remove a rogue hand from beneath my chair (**FIGURE 12.30**).

Chapter 2 offers lots more tips on cloning, but for this section I kept it fairly simple. I set my sample point to the small area beside the hand by Alt/Opt-clicking once. I began to piece the chair back together with very small and careful strokes. I kept moving my source target around, as well, to avoid the look of cloning and the obvious pixel repetition (**FIGURE 12.31**). The final results reveal a hands-free dining set (**FIGURE 12.32**).

UNWANTED HAND

FIGURE 12.30 The Clone Stamp tool can help you remove awkward, disembodied hands or fingers.

CLONE STAMP BRUSH SAMPLE POINT

FIGURE 12.31 The more source locations you target, the better the results, especially when blending two sides together. Here, two fingers are almost gone already.

FIGURE 12.32 Hands off my chair.

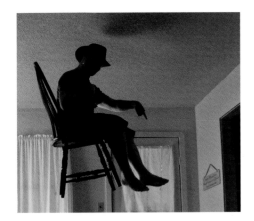

FIGURE 12.33 The shadow above my head needed extra manipulation that couldn't be accomplished just with the Clone Stamp tool alone.

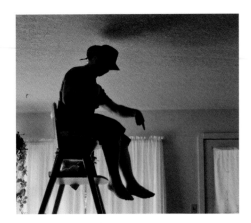

FIGURE 12.34 The original shadow overhead was from a different part of the ceiling with different perspective. This shadow needed to be altered to match the new floating location.

Step 15: Combine Techniques as Needed

Sometimes clone stamping or any one technique just isn't enough. Take the shadow above my head for example (**FIGURE 12.33**).

Originally, I was sitting over the *table* on a high chair and at a very different angle and elevation as well (**FIGURE 12.34**). Once I was relocated over to my floating position, the shadow also needed to be moved and rotated to match, and no amount of clone stamping was going to get me out of that one! I needed a bit of everything.

I made a copy of original me in the high chair by Alt/Opt-dragging that layer down one level in the Layers panel (you could also press Ctrl+J/Cmd+J while the original layer is selected) (**FIGURE 12.35**). Next, I painted a mask to remove myself and isolate my shadow, and then I rotated the shadow with the Move tool (V) to match the correct perspective (**FIGURE 12.36**). To finish it off, I used more clipped Curves and color adjustments.

FIGURE 12.35 Make a copy of a layer by holding down Alt/Opt and dragging to a new position in the Layers panel or by pressing Ctrl+J/Cmd+J. In this instance, I copied the layer to one position below the original.

ROTATE COPIED LAYER TO
MATCH CEILING PERSPECTIVE

FIGURE 12.36 Rotate the shadow with the Move tool.

Step 16: Adjust Lighting and Effects

After everything is more or less in place, it's time to begin perfecting the lighting. Here are some post-production lighting tips:

- Direct the viewer's attention. As mentioned, humans are a lot like moths: we go for the light (and faces too). Add subtle light to those places you want noticed first.

- Add a little more contrast or brightening to draw the viewer's attention to a subject. If there needs to be an emphasis conceptually, make one visually.

- Make changes that can work on a subtle level; use a soft and large brush for slight edge darkening (creating vignettes) or gentle brightening of the center of the composite to draw the eye where you want it. People won't really notice the large visual impact of these changes, but they will definitely experience it! See the video for a look at this final step.

- Work on light and color continuity, usually in the form of low-opacity overlay layers or general adjustments. Make sure they match the scene!

For *Put Daddy Down, Please*, I found the darks horribly distracting while editing, so I painted in my own perfect lighting. I usually do a roughed out job of this early on if lighting is as problematic as in this shoot, and then I fine-tune it at the end of the process.

The secret to master lighting adjustments is to create a brand new layer with the Create A New Layer button ▣. Always adding adjustments and effects on their own separate layers helps keep the entire process nondestructive, which is endlessly valuable when compositing. Once there is a new layer, I can change the blending mode to Overlay (**FIGURE 12.37**); I would consider this to be the big guns of lighting effects.

As mentioned in Chapter 4, the Overlay blending mode is particularly incredible and versatile. In Overlay mode, you can dodge and burn the image nondestructively just by painting with white (dodging) and black (burning)— or infuse new color in interesting ways when painting with other color choices. Because I didn't like how dark most of the images came out from this shoot, this Overlay layer truly saved the composite from becoming a well-composed dark mud puddle of pixels.

FIGURE 12.37 Choose Overlay as your blending mode to dodge and burn nondestructively with white and black paint.

FIGURE 12.38 The Effects folder contains my final lighting and other layer adjustments, such as Curves and dodging and burning with nondestructive Overlay layers.

TIP Bring your brush opacity way down (usually well below 10%) when first painting on an Overlay layer. You want to work subtly and avoid painting in accidental halos or severe and obvious lighting alterations. Low opacity will help you better control the force of the effect.

Other effects in this final stage include a Black & White adjustment layer ▮ at 46% opacity to control the color. A heavily masked Curves adjustment ▦ is fantastic for getting things to really pop with strong lighting and contrast. Finally, I painted on another blank Overlay layer with black and white for end-of-the-road lighting touchups on faces and detail shadows. As mentioned, this is equivalent to dodging and burning only nondestructively. Overall, I lightened the center of the image, my face, Erin's face, and Kellen, as well as emphasized the shadows and highlights around all of us. **FIGURE 12.38** shows the Effects folder containing the final four touchups that I used. Both the Small Adjustments and Overlay Dodge layers were set to Overlay blending mode. The masked Curves adjustment allowed isolated and subtle exposure controls that avoided looking too painted, as can be the case with too much dodging and burning.

TIP Keep your dodge and burn Overlay layers separate for more isolated adjustments with layer opacity to find that sweet spot you are truly satisfied with. If you lighten everything just a little too much, bring down that layer's opacity while maintaining the same painted locations.

Conclusion

Each composite is obviously very different from the next and will present its own challenges and successes, but with enough practice and creativity, you can accomplish any kind of magic in Photoshop. My son will forever be a super-child now. How cool is that (**FIGURE 12.39**)? *Put Daddy Down, Please* highlights a style of compositing that can easily be completed in a day or two and is so much fun to do. Sketch out a few ideas of your own, and make them happen! The power is truly yours!

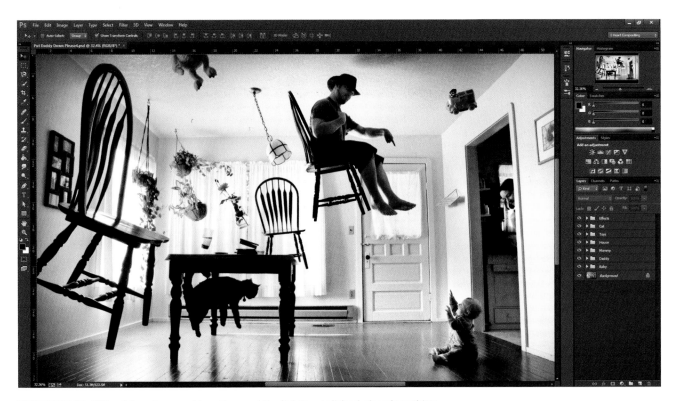

FIGURE 12.39 With all the pieces put together and the lighting polished, there's nothing left to say but, *"Put Daddy Down, Please!"*

JOSH ROSSI

www.joshrossi.com

From his childhood in Florence, Italy, Josh Rossi has been obsessed with art, but it wasn't until he attended Miami Ad School that he found his artistic voice. There he discovered that through photography and compositing he could actually create the images that were inside his head. "Whenever I create an image," Josh explains, "I try to think of a story behind it. I want my viewer to get into the picture and imagine a whole scenario." Dividing his time between Los Angeles and Puerto Rico, Josh now specializes in commercial and advertising photography. His diverse client list includes Acura, LG, Nickelodeon, Laura Pausini, Daymond John, Glenn Beck, Xerox, Wacom, Mountain Dew (DevinSuperTramp), Lindsey Stirling, Advanced Photoshop Magazine, The Color Run, and The Piano Guys.

When you visualize a composite, where does it go from there?
Once I visualize, I create somewhat of a sketch, and then I get reference images that have a similar mood. After that, I will think about the wardrobe, hair, and makeup, and then go shoot.

How much of your own material do you shoot for a composite versus using stock imagery?
Unless a client requires stock imagery, 99.9% is shot by me. It's important to get the right height and angles to easily match things up, and this is much easier when you are able to shoot your own material. You have to fake a lot more with stock. It's a lot of guessing and tweaking.

Any new technology or equipment you find exciting in regards compositing? What do you typically shoot with?
I'm always looking at the new cameras that come out—I would love to see a 100-megapixel, anti-shake, mirrorless, medium format that shoots 8K video. I shoot with the Sony A7R2.

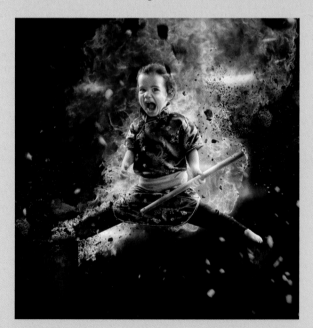

POWER UNLEASHED, 2014

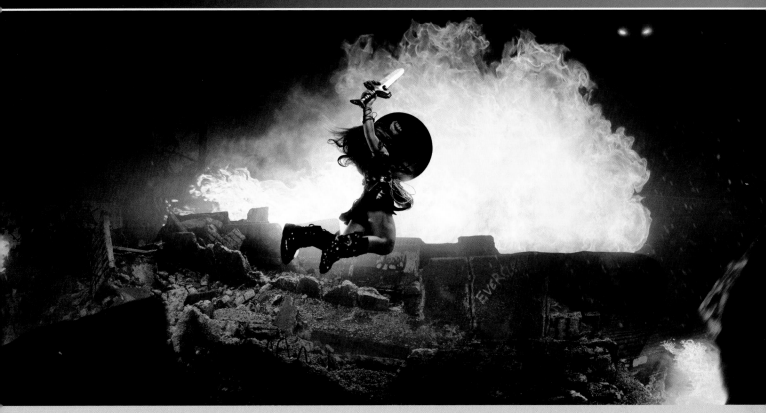

ATTACK! 2016

UNICYCLE, 2014

When you have an epic idea for a composite with your daughter, what is your general creative process from there? How involved is your family?

My wife is super involved and usually finds the talent and produces the shoots. Once I have an idea for my daughter or anyone else, I usually contact my costume lady and get that set up ASAP. Usually, there's a waiting period of about a month, and then it's off to the shoot.

▲ LG's Pogo Athletes, 2016

Are the images of your daughter more for your own fun, or hers?

I think we both love it equally. It's more work for me, and more fun for her.

Aside from your daughter and family, where do you get your inspiration and ideas?

I get my inspiration from illustrators, designers, movies, music, and other photographers, such as Erik Almås, Dave Hill, and whoever I can find on Behance.

How do you balance personal work with professional? Do they relate and influence one another?

They are one in the same. Clients usually give me free rein on the creative, so it's pretty fun. My personal work really fulfills me and also helps to get my name out there.

How do you decide on a final style or look for each composite? Is it pre-planned—or is it inspired from the process itself?

In general, it's always pre-planned in my mind; I always have to visualize it first. For the process itself, the initial placement of objects in an image is what I plan out next, but the coloring and effects come during the process most times. The work often starts as a sketch for a client, but I rarely think about the final coloring. The coloring is inspired from finalizing the image—over the course of days, in most cases. I tweak the color after each fresh look; it changes a lot by the end. In many cases, I get an idea while I'm editing a shot. I'm always asking myself what is going to take an image to the next level. If I keep doing the same things, same effects, it gets boring to me. I'm always trying to push myself. If there is emotion behind it, though, if I feel something after it's done, I know it's a good image.

◀ Provincial Village, 2017

ADOBE'S WHIMSICAL NEW YORK

What has been your favorite composite to work on to date—and why?

My favorite composite looking back (not during) was one I shot for Adobe. This image was done for the marketing cloud directed by Jeff Allen and was an epic undertaking. I went to New York for seven days, shot every street and building I could, and made a huge collage. I built my own city. Then I photographed over 100 people, employees of Adobe, and placed them into the scene. We had to figure out the logistics of capturing the unique angles and ended up getting a tripod and sticking it way high up in the air. I love that shot, because it pushed me to the edge of what I was capable. Adobe absolutely loved it as well. They have it in the offices and call it *The Rossi*. ∎

Big Store, Big Scenery

COVERED IN THIS CHAPTER

- Shooting and matching backgrounds
- Using the Smart Sharpen filter
- Noise reduction
- Painting vegetation
- Painting clouds and mist with advanced brush settings
- Texturing buildings

With a touch of customization, clouds become mist, plants become anthropomorphized, and you can transform even the most mundane, common space into an entirely new scene and narrative. As part of a series about reversing the relationship between humans and nature, *Forest Construction* visualizes what the landscape might look like if our positions of expansion and progress were reversed. In this project, the forest sprawls to swallow the urban big-box store, greenery erodes cars, and each element progresses like construction phases. The idea lent itself to some hugely fun compositing, as I brushed in the various elements from actual photographs. In the end, the project was as much a lesson on the relationship of correct depth, color, sharpness, noise, and lighting to seamless compositing as it was a commentary on human progress and nature (**FIGURE 13.1**).

▶ **FIGURE 13.1** For a hypothetical vision of development reversing the roles of nature and humans, *Forest Construction* enabled me to practice a variety of techniques to paint with photographs, using nature images as a palette.

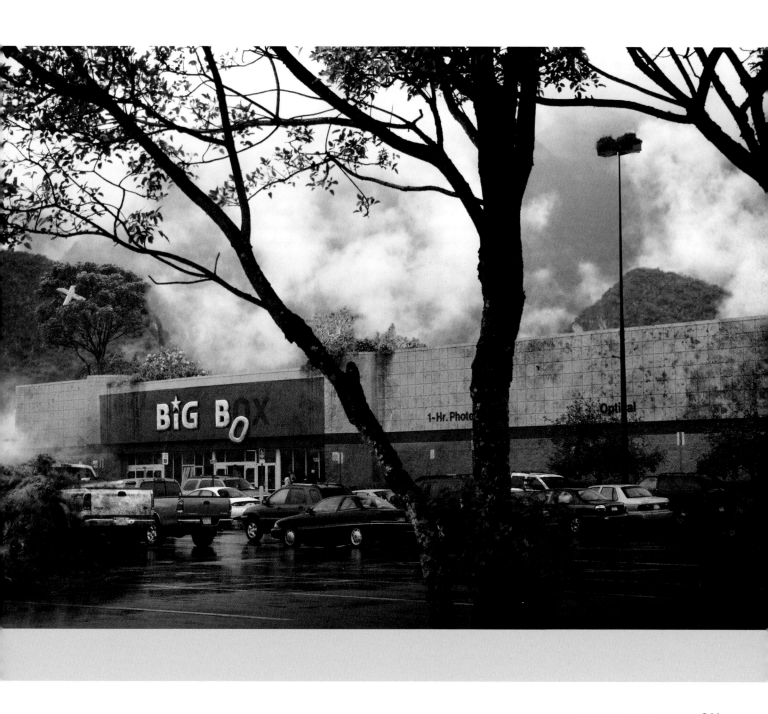

Step 1: Photograph

One of the main mechanisms of compositing is not the work done within Photoshop, but photographing the right shot that you can bring *into* Photoshop. Before you can composite, you need to find a base and inspiration to build on. For the *Forest Construction* concept to work, I needed to find the most typical department store around. Syracuse, New York, supplied a location that fit the bill perfectly (**FIGURE 13.2**). When I shoot a background image, I keep my plans for building on it in mind, along with a few other strategies:

- **Scout locations.** Find a perspective that gives you what you need to build on or alter at a later time. The parking lot view of the store, for example, grounded the perspective and enabled me to expand the composite into the overcast sky above and behind.

- **Shoot for variety.** There's nothing like having options. You may *think* you captured that perfect shot in camera, but seeing it larger on the computer screen may expose flaws and reasons why the shot won't work after all. Having several images and a variety of shots is the kicker for success. Each new angle or location can increase your chances for one of them working out.

- **Don't just think about the image content.** Instead, plan for an interesting point of view and frame the background shot with the potential to add more things to it. Even if you don't know exactly what you will do to the image, plan and allow for growth in an already workable shot. Figure 13.2 was angled upward purposely so that I could build on top of the store without the image feeling forced. Changing the position of objects in post-production can have a strange effect, like distorted mirrors in a carnival fun house.

FIGURE 13.2 This shot of a big-box store (which prefers to remain anonymous) makes a perfect background because of its clutter-free surroundings and iconic urban sprawl representation.

- **Always use a tripod whenever possible!** True, sometimes you can get away without one for bright daylight shots, but tripods offer more than a stable base. Setting up and using a tripod also slows the whole process down a little, forcing you to think about the composition a bit deeper compared to a quick walk and shoot.

To cite another example of keeping on the lookout for potential: You don't usually see waterfalls while walking in downtown Montreal, Quebec, but they came quickly to mind when I spotted the building in **FIGURE 13.3**. The building's very angular forms were perfect for contrasting against the organic bursts of water. Finding this background shot made it easy to composite in nature to start its beautiful demolition process.

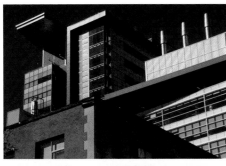

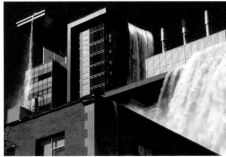

FIGURE 13.3 As in *Forest Construction*, the background image here formed a natural base on which to build and integrate into something new. The waterfalls highlight the rigid and immense forms of modern buildings.

FIGURE 13.4 The photo palette for this project was composed of images I shot while on a trip to beautiful locations around Peru.

Step 2: Build a Photo Palette and Scaffolding

As a compositor, I have found that traveling and photographing are invaluable to my work. The number and variety of images I have within my database is really the only thing that enables me to create my unique projects, rather than relying on stock images (although there is definitely a place for stock if you really don't have a way to shoot what you need). For *Forest Construction*, I again gathered potentially useful shots into a photo palette that I could draw from to piece together the final image. Some of the shots that worked best for this project were from a trip to Peru; from hiking in the clouds at 15,000 feet of elevation to venturing into the jungles at the headwaters of the Amazon, I got plenty of variety (**FIGURE 13.4**). Just about any green space or park, however, has potential as a source.

Never underestimate the value of generating your own image archive, so whether it's sunny, rainy, or snowing in your main background shot, you'll always be ready to hunt down just the right textures and appropriate image palette needed. Never stop gathering!

As usual, I next gathered the folder-like layer groups and organized them into the layer order of my composite document (**FIGURE 13.5**). Notice that effects are once again on top and that the parts that need to be painted and composited over are toward the bottom of the layers stack. Although you might be tempted to skip this step and create groups on the fly, I find it worth a few minutes of extra time to set up my groups like scaffolding, so I can more easily build from there. Later, you can always work on different levels and jump back and forth as needed—much simpler than finding yourself painted in a corner without the right ladder.

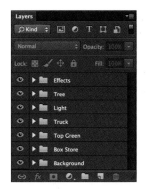

FIGURE 13.5 These groups set the framework of depth for the rest of the composite.

FIGURE 13.6 Convert the layer to a Smart Object to apply non-destructive Smart Filters.

Step 3: Sharpen and Reduce Noise

I needed to clean up my base image a little before I could match all the other layers to its look and feel. Like preparing the bed of a real garden to avoid veggie planting hell, I decided to apply the Smart Sharpen and Noise Reduction filters to the base image into which I planned to plant the scene elements. To keep the process nondestructive, I first converted the layer to a Smart Object by choosing Filter > Convert For Smart Filters so that I could apply the filters as Smart Filters (**FIGURE 13.6**). (Alternately, you can right-click the layer's name in the Layers panel and choose Convert To Smart Object from the context menu.) The power behind Smart Filters is that I can mask, edit, or remove them later or even just turn off their visibility temporarily.

NOTE Although it's possible to use the Convert To Smart Object command on a layer that's already been converted, don't do it without a good reason. Re-converting a Smart Object layer will more or less flatten the layer's previous smart edits. Likewise, unless you have a specific reason, don't do any masking work before converting to a Smart Object. During the conversion Photoshop applies the mask (really it embeds it into the Smart Object—and that's what would have to be edited every time you would want to make a change). It's much better to keep your Smart Objects simple and easy to adjust in your layers.

The Smart Sharpen filter (Filter > Sharpen > Smart Sharpen) not only sharpens the image with Amount and Radius control but also has a great Reduce Noise

adjustment. I tend to increase both the Radius and Amount levels right up to the point where I get a small hint of haloing creeping in—then I back off the adjustment just a bit. As you can see in **FIGURE 13.7**, setting Amount to 180%, Radius to 2 px, and Reduce Noise to 38% worked well for the background shot.

Noise Reduction

Noise—that visual static in an image, like bits of sand thrown onto the picture—has met its match in recent Photoshop releases. Not only does its Reduce Noise filter clear up this noise better than in earlier versions, it also works especially well on *color* noise, in which colors are randomized and exaggerated (**FIGURE 13.8**).

> **TIP** When you shoot in raw, try using the noise reduction features within the Camera Raw Editor before bringing the image into your composite. The raw noise reduction adjustments are quite powerful and refined with the various ways you can tackle noise in all its forms but do take some playing around with. Opening a base image as a Smart Object (pressing Shift in ACR will turn the Open Image button into Open Object) will allow repeated tweaking of parameters such as sharpening, even within your composite.

I typically use the Reduce Noise filter (concentrating mostly on color) after Smart Sharpen so that I have a better idea of how much to apply. When you enhance and sharpen, you also sharpen all the noise bits and pieces as well. If you apply Reduce Noise first, you may end up

BEFORE

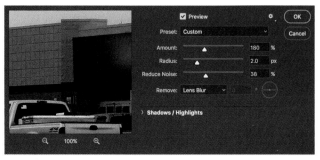

DURING SHARPENING

FIGURE 13.7 Smart Sharpen does as its name implies—and does it *very* well in the current release.

FIGURE 13.8 Noise, especially the color noise shown here, can detract from your digital images to sabotage your compositing efforts—like when combining noisy shots with already noise-free shots.

FIGURE 13.9 Reduce Noise filter is great at knocking out noise left over from sharpening.

FIGURE 13.10 This one shot serves as both an interesting foreground and background image for the composite.

making the image a little soft with small islands of high-contrast noise left over. Choosing Filter > Noise > Reduce Noise, I applied the Reduce Noise filter with Reduce Color Noise set to 100% (**FIGURE 13.9**). This helped obliterate any color noise issues that could have come up.

However much noise remains in the end, the various images must be matched up as close as possible when compositing (including any noise), so I try to get everything at a fairly low noise level when starting out (and always getting rid of color noise). On occasion, though, a layer being added must have a slight bit of noise *increased* for a better fit if the image it is being matched to cannot be fixed any further. This is rare in my own workflow, but it does come up. In these situations you can *add* noise by going to Filter > Noise > Add Noise, but make sure that Monochromatic is selected so no color noise is brought in, only contrasting noise!

> **TIP** Avoid noise altogether when shooting by using the lowest ISO possible combined with a proper exposure, or at least not one that was severely under-exposed! (See Chapter 5 for more advice on reducing in-camera noise.)

Step 4: Plant a Foreground, Grow Depth

Creating a sense of depth is vital for a more immersive feel, having a foreground and deep background will take you a long way. For this project, I was lucky to have one image in my archive that provided both: the tree with clouds behind shown in **FIGURE 13.10**.

Taken in Machu Picchu on a cloudy and wet day (just like my background shot), it provided not only a foreground and background in a single photograph, but also matched the project's mood and lighting while simultaneously creating more visual interest. When you find a gift like this, take it! Why labor to force your photographs together when you can let them work for you with their own continuity? Overlaying the two images worked easily; because of their framing, they both left room in all the right spots for the other to contribute to the narrative.

Slice an Image in Two

For the Machu Picchu image to work as both foreground and background, I needed to split it in two and then place the foreground portion (the tree) in the Tree group above the Box Store group (which held the base image) and the background portion (the mountains and clouds) in the Background folder below in the layer stack. Basically, I had to split the Machu Picchu shot into two slices of bread for a store sandwich.

After bringing the tree shot into the document, I duplicated it (Ctrl+J/Cmd+J) and placed a copy in each group. Jumping up to the Tree folder copy, I selected the tree trunk pieces with the Quick Selection tool, being sure to deselect (by Alt/Opt-clicking) some spots where the viewer would need to see through larger gaps in the leaves (**FIGURE 13.11**). Making the right de-selections is important, because the Select And Mask feature is good at adding to the selection, but not subtracting. So in your own projects, make sure to not only make the right selection, but also the right de-selections. You will see why in a moment.

FIGURE 13.11 Make selections using the Quick Selection tool, but be sure to subtract from the selection for such areas as large gaps between leaves and branches.

NOTE Using the Quick Selection tool may be the best choice in situations where there are edges to seek out, but it still has trouble when the selection area and background are extremely similar in value and color. Going over areas repeatedly and in detail does help improve your results.

Because the top part of this layer would be repeated as the background, I focused on the bottom trunk and leaves. I clicked the Select And Mask button in the options bar to open Select And Mask; I then selected the Refine Edge Brush tool to paint the selection edges. I changed my brush size so I could capture the edges without Photoshop biting too deep into the bark or leaves for its edge analysis. Because it will occasionally take away parts that need to stay, be safe and only paint areas that need it.

FIGURE 13.12 Paint around the leaves with the Refine Edge Brush tool inside Select And Mask.

FIGURE 13.13 To make the selections just a fraction more efficient, select the piece with the most uniformity, such as the sky, and then invert the selection with Ctrl+Shift+I/Cmd+Shift+I.

TIP If you go too far with your Refine Edge Brush painting, you can hold down Alt/Opt to subtract using the same brush. Paint along those areas you want to stay untouched.

When I was satisfied with my painting with the Refine Edge Brush and its slider adjustments, I clicked OK to return to the main image to see the new selections that took place (**FIGURE 13.12**). All was in order, so I clicked the Add Mask icon ⬤ in the Layers panel to create the mask.

Step 5: Mask the Big Box

To remove the boring blah-gray sky to make room for mist and mountains, I again started with the Quick Selection tool (W). I first selected the sky, because it was more uniform and easier for the tool to pick up, and then pressed Ctrl+Shift+I/Cmd+Shift+I to invert the selection (**FIGURE 13.13**).

To fine-tune the selection, I again turned to Select And Mask and its adjustments. Specifically, I used the Radius slider under Edge detection to find the edges of the building and pole (**FIGURE 13.14**), because the Quick Selection tool had trouble with the sloped straight edge on the first try. As for the other adjustments, I always like to add a slight .5 px feathering to soften those sharp collage-like borders, as well as use Shift Edge to bite into the selection to eliminate halos. In this case, I used a –25% Shift Edge setting to rid the image of halos left over from slight bits of sky.

Selections may look nice from far away, but in reality may need some fine-tuning—like looking more closely in your mirror in the morning to discover, yes, you do need to

comb that bed-head before facing the world. In the world of selections, visible halos and other unwanted pieces are the equivalent of bed-head. To better see the remaining bits that need fixing, I like to use Quick Mask mode (press Q or click the Quick Mask icon at the bottom of the toolbar), which displays everything that is not selected in a semi-transparent red.

> **TIP** Switching between multiple tools within Select And Mask may inadvertently apply an adjustment such as Edge Detection > Radius (as when painting with the Brush tool after using the Refine Edge Brush or Quick Selection). Because of this, use your tools first to grab whatever remaining bits of selection you need *and then* apply adjustments like Radius afterward.

Whenever you use the Smooth slider within Select And Mask, for example, it will inevitably iron out some details you want to keep. Besides helping with visibility, Quick Mask mode enables you to paint with black to subtract from a selection and paint with white to add to the selection, just like painting on a mask (**FIGURE 13.15**). To bring the lighting pole back into the main selection, I needed to draw in straight lines with white and then refine them with black lines to remove any halo.

FIGURE 13.14 The Radius slider under Edge Detection does a nice job finding the edge of rugged selections that were off by several pixels here and there (in this case 8 px). The other settings such as Feather and Shift Edge also help iron out any wrinkles and slight halos.

FIGURE 13.15 Quick Mask mode can be a great way to visualize a selection before committing into mask. Paint with black and white to subtract and add to the selection in spots that other adjustments may have missed.

Bringing the pole and light back into the selection, I painted straight lines by clicking once at the bottom-right edge of the pole using the small and soft brush set to 15 px, and then I Shift-clicked the top-right edge of the pole. Photoshop translated this into drawing a straight line from point A to B. I did this around the entire light post until everything was looking better. A few corners

and the security cameras also needed some custom brushing for the selection. When I was satisfied, I clicked the Add Mask icon 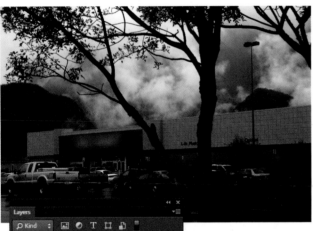. **FIGURE 13.16** shows how all that sandwich preparation paid off.

Step 6: Sink in the Scenery

With my foreground and background features planted, I turned to painting in greenery from my Peruvian photo palette. When painting your own vegetation, having options is always helpful—and I do mean painting. Unlike other elements that I *selected* with good edges and then masked, these organic bits were quickly cut and pasted in. Then I applied a mask and used brush strokes directly on the mask to refine the shape—no selections needed (**FIGURE 13.17**).

Swallowing a Truck

As you can see in **FIGURE 13.18**, the truck is being swallowed by six painted-in greenery layers that constitute the first bite of green development. Grabbing pieces of the photo palette using the Marquee tool, I copied (Ctrl+C/ Cmd+C) and pasted (Ctrl+V/Cmd+V) each one into the

FIGURE 13.16 With the mask on the tree and building applied, you can see how the building is sandwiched between the two separated foreground and background pieces.

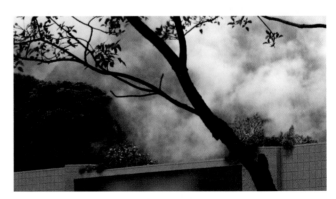

FIGURE 13.17 Apply a mask directly to pieces of greenery and simply paint in the desired shapes and forms.

composite, immediately clicking the Add Mask icon ⬛ in the Layers panel to give it a mask upon arrival. Painting on the masks, as with the previous example, helps constrain their unruly nature to just the areas intended to be covering the truck.

When choosing pieces from your palette, you're aiming for elements that might fit and not look too "off" once in place, or at least have potential to be blended seamlessly. My strategies for searching and collecting are:

- **Look at an object's form from all angles, and consider the form you need.** Starting with the big chunk taking over the truck, I had to turn my head sideways to see its potential, but it matched the angle and form I needed (**FIGURE 13.19**). If craning your neck is a pain, you can always use the Rotate View tool (R). Just make sure to double-click the tool in the Tools panel to return to the default orientation. Note that this tool does *not* rotate the image, just the orientation of your view of the image.

- **Match lighting as closely to perfect as possible.** For overcast days you are given a start with generally soft lighting, and you can then paint in the lighting you want afterward. With sunny direct light, you are more or less stuck with the high-contrast shadows from those sunbeams, so make sure the chosen pieces have continuity with the rest of the composite.

- **Find details that can provide a potential edge for the element you're painting in.** Working *with* the material as a guide whenever possible significantly assists in blending the piece in seamlessly. Try to match a path of natural variation; brushing in any shape just because you can may work against you, producing a forced, cutout look.

FIGURE 13.18 I used six pieces from the greenery photo palette and added new masks for each when I brought them into the composite.

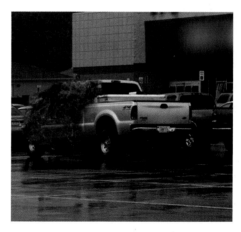

FIGURE 13.19 I choose the first major piece by looking at its shape and form and matching it with the scenario in the composite.

Vegetation Painting Lessons

With my pieces roughly positioned over the truck and masked out (hold down Alt/Opt while you click the Mask icon 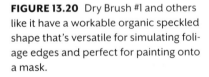 to conceal the layer at the start), I began painting back into view the portions of their shapes that I wanted (with white selected as the foreground color). Painting vegetation sounds, at worst, environmentally unfriendly, and at best messy, but it's actually quite simple. For each piece, I followed the same basic procedure:

1. Using the advice in the "Brush Tips" sidebar, I found an organic-looking speckled brush (Dry Brush #1), selected Transfer (and nothing else), then chose Pen Pressure from the Control menu `Control: Pen Pressure ⇕` for use with a graphics tablet (**FIGURE 13.20**).

> **TIP** Add variety to the edges of the form. Even if you find areas that work as straight edges, bring some variation whenever possible.

2. I Alt/Opt-clicked the Mask button when creating a mask for the vegetation to ensure that it started out as black and therefore concealed the layer content. Alternatively, I could have created a standard white mask, inverted it (Ctrl+I/Cmd+I), and temporarily erased the vegetation. This approach is helpful if you have already created a default mask and want to change it after the fact (such as with adjustment layers).

FIGURE 13.20 Dry Brush #1 and others like it have a workable organic speckled shape that's versatile for simulating foliage edges and perfect for painting onto a mask.

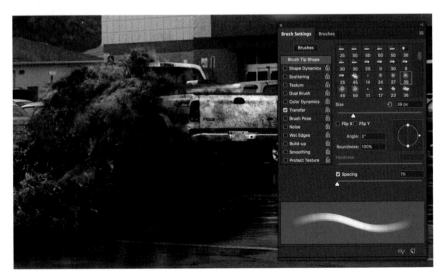

3. Painting with white, I started with the outline of the general shape I wanted and then worked toward the outer edges of the final shape. The best strategy is to follow the natural formations and direction of material, whether it is clumps of grass, leaves, a mound of dirt, or anything else that has an identifiable mass or good cohesion. To see what material you can incorporate into the form, try painting a little too far beyond the edges you want.

4. When necessary, I subtracted from the image by painting with black on the mask (press X to flip between black and white). If you paint too far beyond workable areas of vegetation (say you accidentally paint in a rock as well), pressing X to flip back to black lets you mask things back out of the picture. Not only are you tossing the rock aside, but also you can do so knowing exactly where to leave an edge or shape. In this case, I knew the point right before where the rock was hanging out.

In this way I painted in each layer, fitting it into place before using black and white on the mask. The couple exceptions included some bits that already had a defined edge I wanted to use, such as the trees on top of the store; for these layers it was more efficient to make a selection before masking and refining the edge. But for all other custom work that doesn't have easily found edges, any kind of selection is most likely going to be fairly pointless. As another example with a different setting, this technique is the same method I used to paint in both bushes and rock in the image *Floating Journey* (**FIGURE 13.21**).

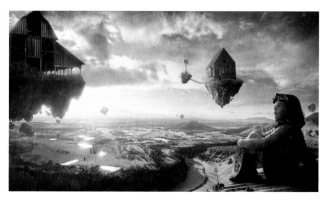

FIGURE 13.21 Painting in shrubs and rock from pieces of a photo palette greatly helps sell the overall look.

Step 7: Enter Grunge, Exit the X

In new development and construction zones, nature attempts to go about its business as usual for as long as it can, and in this role reversal project, so too does the intrepid big-box store (tired of being anonymous it petitioned for a new identity from Witness Protection), which is still determined to serve consumers despite some grunge and its X becoming a snack for an over-achiever of a tree.

To create the grungy discoloring texture, I used the same rusty metal source image with which I added texture to buildings in Chapter 9 (**FIGURE 13.22**). Once you find a good texture, you will find a million and one uses for it over time, so always be on the lookout. I added the texture layer directly above the

BRUSH TIPS

You need a good brush when painting in bits of organic material or any other masked element. To create some interesting brush combinations all within the Brush Settings panel, try these tips when painting on masks:

- **Use scattering.** This can help when you need those moments of randomized strokes that break up the obviousness of something being brushed in. It also can be good for adding in texture, because the connected smear-like stroke portion is replaced with more of a brush dabbing simulation.

- **Select Dual Brush to combine two tips for a more realistic or interesting brushstroke.** Depending on the shape you select for the second brush tip, the combined brushstroke will look irregular or eaten away, adding to a more organic feel. Disguising that things were painted is crucial for keeping a photorealistic effect.

- **Use the simply brilliant Transfer setting if you have a tablet.** With Transfer specified, choose Pen Pressure from the Control menu in the Brush Settings panel to give every stroke greater control over opacity and gain the ability to create even more variety in the look and feel. The more you can simulate real mediums of painting, the better the control and look generally.

- **Bring your brush's Flow setting (in the options bar) down to 50% or less (or press Shift+5).** This will help you to articulate greater control and subtle variation without a tablet.

- **Use the Flow setting when you want to soften the effects and edges of a brush while still keeping the desired shape of the brush.** Flow lets you paint in repetitive movements, building up opacity with each return gesture to an area—all with a single click (only movements are needed, not single-click strokes).

- **Don't over-complicate the brush.** You need not use a complex brush to achieve a good effect. Just be sure the brush has some kind of controlled variation to it.

building's layer and its mask and then Alt/Opt-clicked between the two layers to clip the texture layer to the visible parts of the building layer below. As in Chapter 9, I next changed the texture layer's blending mode to Overlay, which allowed for both discoloration and darkening in parts that had much darker patches of rust. A custom mask on this layer enabled me to paint exactly where and how much rust I wanted (**FIGURE 13.23**). Overlay also let me stay lighter and kept the texture from getting too harsh or dark as Multiply or Color Burn mode would have done in this situation. With a few variations of this layer (including scaling and rotation) and heavily controlled masking, the results came out quite grungy, yet refined.

Rebrand Techniques

While grafting a new identity on the store, I found the logo an especially fun challenge. I painted in the letters, gave them shading (both highlights and shadows) for a little added depth, and then rearranged a couple letters in compromised positions. In order for the name to still be understood as a stand in representing all big-box stores, I kept a copy of the letter shapes to darken where they supposedly were keeping the original paint rich.

The O felt like it needed to just hang out like an excavated boulder in the process of being moved, but I felt the X needed to bring in a hint of mystery, narrative, and humor at the same time, so I tossed it up into the tree (**FIGURE 13.24**). Once I got the X shape fleshed out and slightly shaded for depth, I added the mask and moved the layer to the top of the Top Green stack in the Layers panel.

FIGURE 13.22 With a couple layers of rusty metal set to Overlay mode, this building is grunged up quite nicely.

FIGURE 13.23 Overlay blending mode combined with a controlling mask lets you choose exactly where to add grunge and where to keep clean.

FIGURE 13.24 The O and the X were part of the demolition narrative and important to create a bit of humor as well as draw some attention to the subject.

FIGURE 13.25 Paint onto the mask where some leaves would be on top of the X and it sinks right in.

FIGURE 13.26 Find a cloud with some variety and dissipating edges that you can use for blending.

To make the letter look like it was being held by the tree, I moved and rotated the X. Specifically, I chose the Move tool (V), selected Show Transform Controls in the options bar, and rotated the X clockwise. Next, I flipped it horizontally by right-clicking the image and then choosing Flip Horizontal from the context menu. Painting a little black on the mask where some leaves would be over the X completed the look (**FIGURE 13.25**). If I needed to add a little more skew for perspective, I could have also held Ctrl/Cmd while dragging a corner control point. In this case, a rotation and flipping did just the trick that was needed.

Step 8: Turn On the Fog Machine

Clouds, mist, and fog are hard to create and control in Photoshop. *Any* water is for that matter. So the trick I used is a combination attack using real pictures of clouds and a specialized brush, just like when working with the greenery. The more you can co-opt the credibility of the actual photograph, the better the end result in most cases. It just needs the right touch and brush to complement it! Here are some tips for creating a mist-wrapped building:

- Find a cloud picture that matches the feel of the other clouds and mist. For *Forest Construction*, I used the atmosphere from another shot of a misty mountain in the background of Machu Picchu (**FIGURE 13.26**). The main thing to look for is variety of dissipating edges and a little definition in the body of the cloud as well.

- Completely paint out the edges with solid black before anything else once you have a mask on the layer. Again, because you're not selecting before masking, be careful to leave no digital grease in your wake. Brush out anything that could be seen as a hard edge; zoom in close for this do be sure!

- Paint the water vapors using some advanced brush parameters; the next section discusses these in detail.

Create a Cloud Brush

You may be thinking about turning a cloud into a brush, which is easy enough, but that gives you only a single stamp-like use out of the cloud brush—pretty limiting! Because I wanted full flexibility and customization for my brush, I used an existing cloud image (much like the vegetation) and designed a brush that

simulated floating water vapors that I applied to the cloud's mask. Combining the actual cloud image's characteristics with a specially designed brush, I could paint on the mask going back and forth with black and white (by pressing the X key) until just the right pieces and shapes were remaining of the initial cloud—the perfect balance of real and simulated water vapors! Here are the parameters that I used for a pretty killer brush to simulate cloud and mist:

- The Spatter 39 brush set up a nice base with decent variety.

- I selected Shape Dynamics and adjusted Size Jitter to 100%, Minimum Diameter to 60%, and Angle Jitter to 100% (making sure that Off was chosen from the Control menu). This randomized variations in the spattering to avoid making unwanted patterns as I painted (**FIGURE 13.27**).

- I selected Scattering and increased Scatter to 210%. I made sure to select Both Axes to produce a thicker concentration of mist toward the center of the scatter.

(A)

(B)

(C)

FIGURES 13.27A, B, and **C** Adjust the Brush Settings panel's parameters for the best effect; here I made adjustments to Shape Dynamics (A), Scattering (B), and Transfer (C).

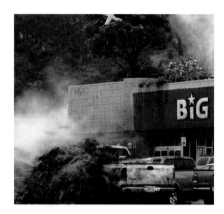

FIGURE 13.28 With a combination of custom brushing and use of an existing cloud photograph, the mist nicely wraps around the store.

- I selected Transfer, set my Flow Jitter to 53%, set Opacity Jitter to 100%, and chose Pen Pressure from the Control menu (for tablet users this is a must); this is but one more parameter of control you can add to the painting and is incredibly helpful for more natural-gestured strokes and repeated movements with a light touch. When working on something like mist and clouds, changing the density in just the right way (adding an organic randomized effect) is the only thing that makes the technique effective. For those who do not have access to a tablet, lower both the Flow and Opacity (in the options bar) even more so (50% Opacity and 5% Flow is a good place to start), and vary these settings after a few strokes to simulate the same kind of variations you might get with a tablet and Pen Pressure.

- I lowered the Flow setting in the Options Bar to 10% so that the back-and-forth gesturing over an area would thicken and simultaneously soften the brush's spatter. At 100% Flow, the spatter shape is too pronounced and strong to be an authentic water vapor (even when I lowered opacity). Flow forces the brush to have many more spatters before it adds up to something with density, very much like the small water vapors accumulating themselves (**FIGURE 13.28**).

Step 9: Adjust the Final Touches

Finally, I added a bit more atmospheric perspective to soften the darks of the greenery above the store to blend them within the composite more convincingly, and then I made some global lighting adjustments to balance the entire scene.

To create a little more atmosphere, I added a new layer within the Top Green group folder, enabling me to paint on top of both the store *and* greenery, while staying underneath the foreground tree and truck that's being swallowed up. Using an extremely low opacity (6%) white and a soft, large, round brush (no texturing this time), I gently brushed in greater atmosphere and set the feeling of depth back a bit more, matching the mist that's wrapping around the side of the building (**FIGURE 13.29**). One last Curves adjustment layer brought up the brightness on just about everything except the bottom of the composite where I still wanted it to look a bit dark and not draw attention (**FIGURE 13.30**).

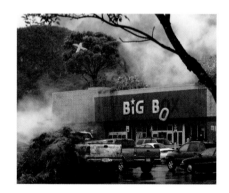

FIGURE 13.29 Brush white with a soft, low-opacity, round brush very gently for creating greater depth with added atmosphere.

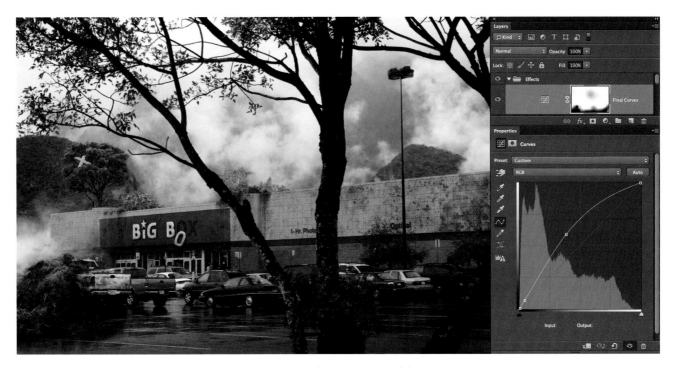

FIGURE 13.30 Add one last Curves adjustment layer to make the image pop and draw attention to the parts of the scene you intend.

Conclusion

Much of a project such as this comes down to control. It is about figuring out ways to control each layer, its mask, noise, sharpness, shape, color, and overall lighting. This is all part of the craft of working in Photoshop, and a project like *Forest Construction* allows for a balanced practice with a variety of small challenges. Much like levels to a game, each step has its own lessons and victories! The other component to creating scenes like *Forest Construction* is generating an idea that you can work with and implement your techniques on, an idea that's fun and has meaning all in one. When you have an idea and try to visualize it, it becomes a matter of applying craft to concept—and in my case, releasing hungry vegetation on symbols of consumerism.

ERIK JOHANSSON

erikjohanssonphoto.com

Erik Johansson is a full-time photographer and retoucher from Sweden, who is based in Berlin, Germany. He works on both personal and commissioned projects, as well as sometimes creates street illusions. Erik describes his work by saying, "I don't capture moments, I capture ideas. To me, photography is just a way to collect material to realize the ideas in my mind. I get inspired by things around me in my daily life and all kinds of things I see. Although one photo can consist of hundreds of layers, I always want it to look like it could have been captured. Every new project is a new challenge and my goal is to realize it as realistically as possible."

How would you describe your use and control of lighting in a shoot and editing?

Light and perspective are super important in creating a realistic montage, which is why I always shoot everything myself and avoid stock photography. I want to be in full control. I often shoot in natural light but keep the direction of light in mind. If I use lighting, I just use it to make it look like the sun or cloudy sky. I don't want the studio look.

Do you have any suggestions for getting colors to look right for the final composite? Do you begin with a specific color palette in mind?

I usually give all my images some final adjustment in terms of color and tone, but I begin with a quite natural look. It's a lot easier to change that afterwards instead of in the beginning. I do like a quite high-contrast look with desaturated colors, but I try to experiment.

Any good tips for staying organized from start to finish?

Try to keep everything layered and work in a nondestructive way. Try to put names on the layers as well and use folders for the layers. Sometimes it's a mess, but I try to stick with these rules.

What is your favorite aspect or tool in Photoshop?

I love the simplicity of the Smudge tool; I use it all the time. I always start by masking out the parts I don't want to be visible in a photo with a rough mask. I then use the Smudge tool to push and pull the borders of the mask to make it perfect and blend it together with the rest of the picture.

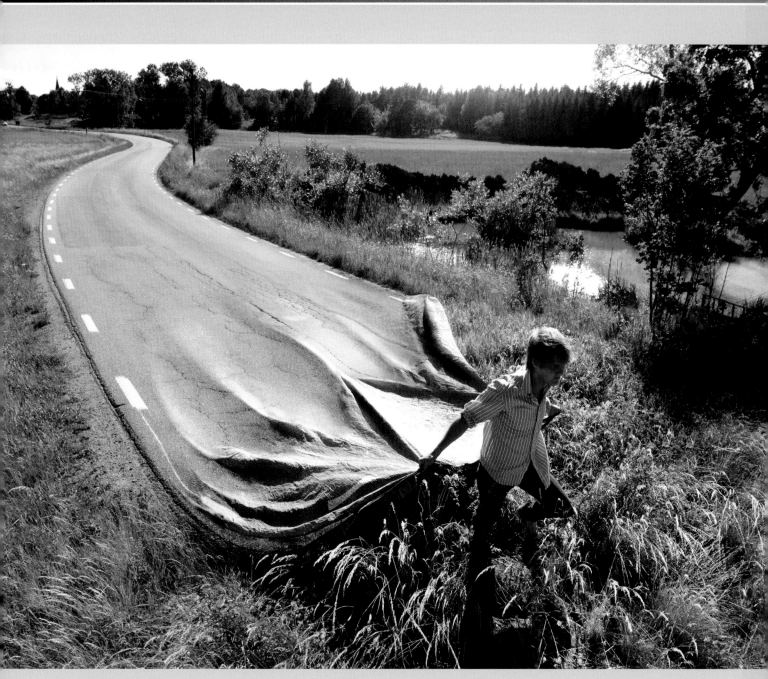

Go Your Own Road, 2008

How do you go about shooting your photographs for an idea you are realizing?
It always starts with planning, trying to figure out where to find the location. When it comes to the photos, it's super important that all photos combined should have the same light and perspective. That is something I keep in mind for looking at locations as well.

Do you have ideas that just never quite work out as planned? If so, how do you overcome this obstacle?
Yes, it's not so often, but it does happen that I work with something for a long time, almost finish it, and then think that it isn't good enough or that I don't like the composition. I just move on to the next idea, no reason to cry over that. Just move on, move forward.

Any general advice for people wanting to go into the industry?
Learning by trying is just great! It takes time, but it's the best way to figure out how the tools work! It's also a lot about quantity, at least in the beginning; you have to do mistakes and learn by them. Just do as many photos as you can, and you will learn something from every time you do something. Don't just sit and wait for inspiration; go out there, and inspiration will come to you!

What has been your most favorite work to date? Why?
It's always the next one I'm about to create. Always moving forward! ∎

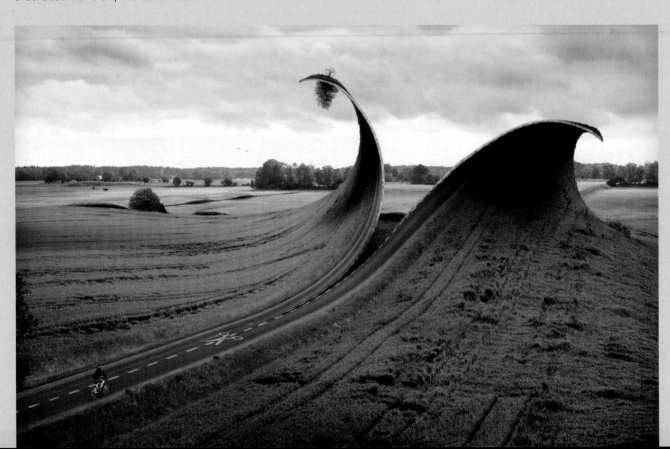

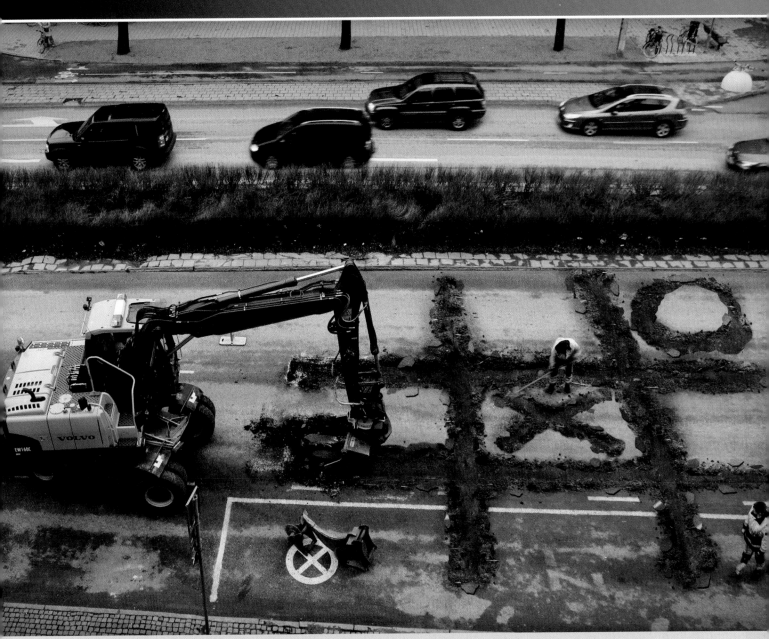

Roadworkers Coffee Break, 2009

◀ Cut & Fold, 2012

CHAPTER 14

The Hunt

The Hunt has an interesting and yet highly embarrassing story behind it. The interesting part is the mammoth; it's actually a metal statue textured in Photoshop with patches of kitten fur. The embarrassing part is that the hunter, who's not covered in much of anything, is me in my underwear with flowing, digital-hair extensions. While my wife and I were attending graduate school, I took a summer off from classes and used whatever means I could scrape up to make some fun digital art. For *The Hunt*, I used our bedroom lamp to light a nearly naked me doing very stupid and yet epic poses on our bedroom floor. Combine one of these with a mammoth, some kittens, and an image from a trip to Canyonlands National Park, and you get *The Hunt* (**FIGURE 14.1**).

This project proves that whether you have a fancy-pantsy photo studio or just a lamp in a tiny apartment, you can create killer results. Just match the lighting angle to your background inspirational shot, and much can be forgiven.

▶ **FIGURE 14.1** *The Hunt* has four main elements to it: the hunting caveman falling to his peril, the background shot of Canyonlands, the mammoth, and the background clouds.

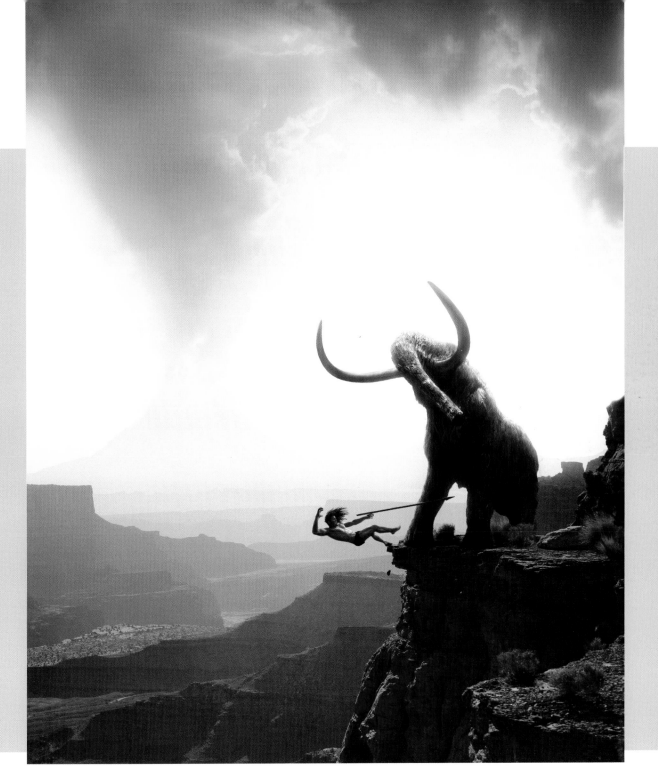

Step 1: Use Photography as Inspiration

Take pictures like crazy! *The Hunt* was possible only because I had so many pictures of Canyonlands National Park from a long-ago road trip (**FIGURE 14.2**). Location scouting and shooting is a huge part of compositing. The more pictures you take, the more possibilities you have that combinations can fit together and be made to look "right." And if nothing else, you have solid location scouting imagery for potential future shoots.

The Hunt is made from four or five main images (the Canyonlands, some clouds, the mammoth statue, and me in my underwear), as well as a plethora of smaller shots, including kittens to supply hair for the beast and my wife to supply hair for me.

In browsing for images, I typically look at the point of view and setting while trying to imagine what scene or narrative could potentially unfold within a composite.

FIGURE 14.2 National parks, such as Canyonlands National Park, are a perfect way of getting background images as well as inspiration for future composites.

Step 2: Sketch Alternatives

Really enjoying that epic shot of the cliff to begin with, I wanted to put in a narrative that also accentuated the potentially dangerous landscape. I was mainly interested in having the *wild* kick some humankind butt as my graduate work was about environmentalism and consequences of human impact. So regardless of the historic inaccuracies and using Canyonlands as the backdrop, I sketched a quick commentary on aggressive humankind being dramatically humbled by the wild and it stuck.

When exploring potential narratives, try variations on any idea you think could work well—your first idea may not always be the best. **FIGURE 14.3A** shows one of my first sketches, but after further consideration I chose **FIGURE 14.3B** instead.

When inspired by your own photographs, keep a few things in mind while sketching:

- The depth, scale, and placement of key elements are important to get right. For example, I had to figure out how large the mammoth and caveman were going to be in relation to each other and to the cliff as well. Clouds and atmosphere also would balance and bring the larger narrative into focus with the rest of the image.

- Pinpointing and roughing out the lighting direction helps tremendously. When you have to shoot extra elements after the fact, you need a solid blueprint to build on.

- Allow for movement and capture the right timing to have the greatest impact emotionally and visually. For this image, the right timing was after the caveman was committed to the fall and possibly throwing the spear (but before its impact). This leaves viewers to imagine what is going to happen next and to carry forth the narrative that's just a mere snapshot in time. The *time design* factor, or "when" of an image, enhances and changes its meaning and scope.

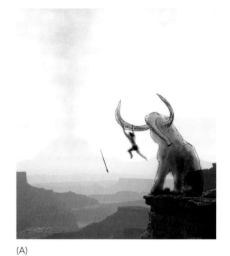

(A)

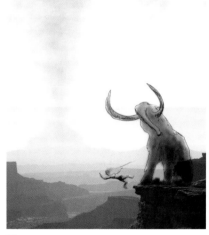

(B)

FIGURES 14.3A and **B** The top sketch (A) was the first possibility, but I decided on the bottom sketch (B) so that there would be less hope for survival.

Step 3: Shoot the Subjects

Not having my own time machine to get an authentic picture of a caveman (not to mention one willing to leap off a cliff backward), I played the part myself while my wife snapped the pictures. Armed only with a crummy house lamp, I set up the shot in the darkness of our small bedroom, paying attention to the direction and harshness of the scene's lighting (**FIGURE 14.4**). I had to make sure that I was fairly evenly lit and fully in the shot and the pose looked like I *could* be falling—if only I wasn't sitting awkwardly on the floor amongst our things.

When posing and photographing a model for a composite, consider these tips:

- Plan ahead by drawing a separate sketch of the lighting scenario you will be matching. A quickly diagramed bird's-eye view will often take care of this part as you figure out the camera position, subject position, and lighting angle. Take a close look at the inspiration shot, take note of the angle of shadows, and plan from there.

- Make sure that whatever your subject is resting on does not overlap your subject, necessitating cloning or other fixes later on.

- Model a believable pose! Simply sitting on the floor without mimicking a believable action won't look any more dynamic in your composite. You'll still look like you are sitting on the floor, simply in new surroundings.

- Plan to use support props to help your subject balance and hold still for the shot. Motion blur in the source elements needs to match the level of blur appropriate for the scene you're creating. *The Hunt*, for example, is simulating an action shot with no blur whatsoever.

FIGURE 14.4 Even a small college room lamp can work to your advantage to create an effective source image.

FIGURE 14.5 Sometimes you still need to re-shoot various parts (especially when you find the caveman has a twenty-first century watch on)—here the hand and arm were reshot to be combined later.

- Photograph plenty of poses and a variety of shots. A range of options will be a great help when compositing—and can save you from mistakes. Halfway through the shoot for *The Hunt*, for example, I remembered that my watch was still on. Talk about an awkward moment! I took some new shots of my hand, and the end result was much better for it (**FIGURE 14.5**).

- Previsualize where your subject is looking in relation to the shot and other picture elements. Consult the original sketch frequently! Sometimes even very small changes in head tilt or body angle will throw off the direction and orientation, so make sure to plan it out ahead of time.

- If you're acting as the model, as I was, use an intervalometer or recruit someone to photograph you. If no other option is available, the camera timer will work for this, but it makes positioning difficult and may require many takes to get the right look.

- Shoot the poses and images you think you need; then just about double that number of shots—just in case! At the very least, overshoot more than what you think you need. While it may feel like you have captured a load of usable imagery, chances are there are not as many composite options as you think. Overshooting is much easier than re-shooting.

Step 4: Piece It Together

Before the detail work, it is important to first get the keystone pieces in place for structural integrity of a composition. To lay *The Hunt*'s foundation, I planned to set the mammoth and caveman in place in relation to the background image. Because the clouds would need a bit more piecing together, I decided to bring them into the composition at a later time, but I needed to make some room for them to balance the composition. To organize this project in Photoshop, I created the basic scaffold of layer groups for building up the composite: Effects, Hunter, Mammoth, and Background. The latter included two subgroups: Sky and Canyon, containing the image of Canyonlands (**FIGURE 14.6**).

Make Room for Clouds

Because the Canyonlands image was oriented as a landscape picture, I needed to create some more headroom for the clouds and billowing volcano ash. Starting with the background image, I expanded the canvas height by another 90% (Image > Canvas Size or Ctrl+Alt+C/Cmd+Opt+C). You can change your canvas size by various measurement units, but I prefer percentages because they make the change easier to visualize (**FIGURE 14.7**). I set Height to 190% and then set the expansion direction as indicated by the

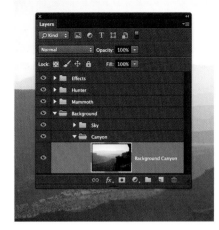

FIGURE 14.6 To help with layering and overall effects, I set up my layer groups by depth. Always stack the folders in the order they would be seen in the composite with the closest object on top.

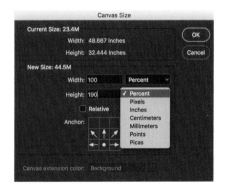

FIGURE 14.7 I prefer to change the canvas size by a percentage rather than a fixed measurement unit (which can be harder to visualize).

arrows and anchor point to add the extra canvas space to the top of the composition. Be sure to expand your own canvases in the direction you intend (not equally in all directions). With the three-by-three grid in the Canvas Size dialog box, you can customize the point of canvas expansion by clicking within one of the boxes.

Caution, Mammoth Territory

Opening the mammoth picture into its own tabbed window within Photoshop, I selected the bulk of the mammoth with the rectangular Marquee tool (M), copied (Ctrl+C/Cmd+C) and pasted (Ctrl+V/Cmd+V) him into the composite, and then moved the layer into the Mammoth folder so that the depth ordering would be correct with the rest of the images (**FIGURE 14.8**).

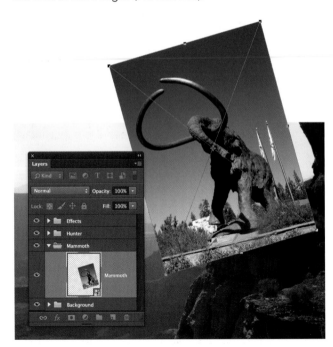

FIGURE 14.8 Bringing in the mammoth helped establish a key element and sense of scale before bringing in the hunter.

Transforming the mammoth to the proper size was my first priority; I right-clicked the layer in the Layers panel and turned it into a Smart Object for nondestructive transforming. Using the Move tool (V) with Show Transform controls selected in the options bar, I scaled the mammoth to mostly match the original sketch. (By pressing the Shift key while scaling from a corner I was able to constrain the height and width proportions.)

In addition to scaling the mammoth, I added a bit of rotation, as well, to make that foot on the left sit flat on the ground instead of hanging in the air after scaling. When your source images are fairly different (like the mammoth image's lighting and perspective versus the canyon's more telephoto look), the more ways you can ground them and make the images sit better together, the more convincing the final payoff. Here, I rotated the mammoth's front left foot until it was level with the cliff top so he was standing *on* rather than above it.

> **TIP** To find the sweet spot while scaling and rotating, change the opacity of the layer being transformed to 50%. Not only will Photoshop let you do this mid-transform, but also you won't have a big mammoth blindfold on you as you do.

Using the same method of copying and pasting, I brought the hunter into the composite and, as **FIGURE 14.9** shows, I scaled the image to roughly match the original sketch that I tucked away within my Effects group. Keeping the sketch handy at the very top of your layers stack (such as in my Effects folder) can help keep you on track with the original idea and look. Knowing where the sketch is, I can turn its visibility on and off at any time without having to go hunt it down.

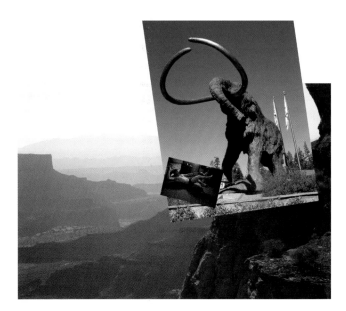

FIGURE 14.9 The caveman was brought in and, like the mammoth, was matched to the original sketch.

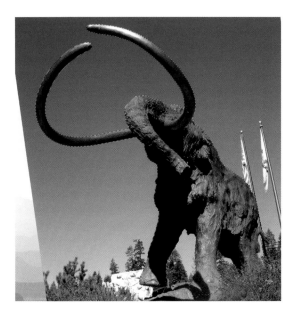

FIGURE 14.10 Select the mammoth with the Quick Selection tool and include some area around the feet to work with later.

Step 5: Mask a Group

Using masks on groups is a bit of a workflow shift from relying solely on clipping, but using group masks has several advantages. For example, by using a mask on an entire group you can clip adjustments to portions within the group while still controlling the group with one overall mask, something not yet possible using clipping groups even with the latest CC releases. In addition, sometimes clipping various layers to a single layer's mask can be more limiting than it is helpful. *The Hunt* centered more on masks created for entire groups and pushing the different and controlled elements that could come of it. This allowed for better controlling of embedded groups and more complicated layer stacking.

Mammoth Mask

Although clipping masks are simple and you can add multiple ones quickly, they do not have the lateral mobility to enable you to work on areas in different ways, such as with multiple subgroups and between clipping layers. For the mammoth and all its parts (from fur to lighting), I instead decided to place all the elements into a group and apply one master mask to the folder and everything within it.

To start with, though, a good selection saves mask painting time, so I first selected the mammoth with the Quick Selection tool (W). I made sure to include a little of the surrounding area the feet were standing on as well (**FIGURE 14.10**) to allow for whittling down the extra pixels while creating the mask. Before jumping into Select And Mask, though, I pressed Q for Quick Mask mode and truncated the tusks by painting them off with a hard black Brush (B). Once the tusks had a good trim, the beast was good to go for Select And Mask. It's often harder to add to a masked part you cannot see versus simply refining

the mask down to its needed shape. As usual, I used the Refine Edge Brush tool in Select And Mask to soften the edges with a small (1 px) Feather setting and shifted the selection edge inward by setting Shift Edge to about −40%. Biting into the selection edge with Shift Edge helps with some of the blue sky halo, but it can linger from especially saturated skies like the one behind the mammoth (**FIGURE 14.11**).

With the selections adjusted for a better overall look, I selected the Mammoth group within the Layers panel. I then clicked the Add Layer Mask icon 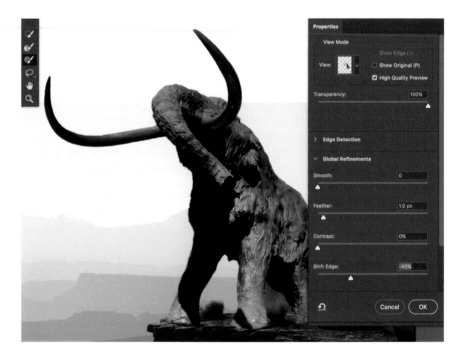 to add a mask to the entire group, meaning Photoshop would apply the mask to everything inside the group. This has a similar effect as clipping a lot of layers to the Mammoth layer and then applying an individual mask. The difference is applying a mask to a group offers more freedom of structuring subgroups and clipping to various layers within the entire group. For an element as complex as the mammoth, having the entire folder carry the mask worked brilliantly. Unfortunately, though, the masking job still needed quite a lot of work all around. Literally.

FIGURE 14.11 Always soften the edges and shift them inward for more seamless results and less overall work on the mask itself later.

Paint Around the Edges

Just when you think you've got a good selection happening, the mask comes into play and immediately brings attention to all the spots that need further detail work. I favor using a soft brush with full opacity and a radius matching the softness of the edge focus. For the mammoth group mask, this translated to a 10-pixel radius (**FIGURE 14.12**). Paint around the edge for a more precise and customized mask. With practice, you can be nearly as quick with painting a mask as with the Quick Selection tool, especially when using a photo palette.

> **TIP** If you put a mask on an actual layer rather than the group you intended, simply drag the mask onto the folder thumbnail in the Layers panel and—POW!—the mask moves without a hitch. Somewhat related, this can also be a good way to duplicate masks: Hold the Alt/Opt key while doing the same procedure and—KAPOW!—duplicated mask.

FIGURE 14.12 Paint around the mammoth mask with a small and soft brush to get a smoother and more exact mask area.

The Hunter's Mask

The caveman's mask was even trickier for the Quick Selection tool and is a good example of how painting can be more efficient and better at improvising than most selection attempts. Here's a quick list for when I suggest opting for painting an accurate mask versus trying to create one with the selection tools:

- When the edges are dark (or extremely similar to the background) and blend in with the scene to the point that Photoshop cannot discern where they are. But your knowledge of shape and form can help you infer where the edges are, just as in figure painting. In this way it's similar to painting, only you have the added benefit of painting in an actual picture.

- When you will need to make subtle changes by painting even after a selection. Sometimes it is just faster to skip the refining and jump straight to the painting portion.

- If you know you are clever with the paintbrush and selection tools just tend to annoy you. Digital frustration is a real thing and can turn even the best project into a freeway pile up. By all means, take the back road!

FIGURE 14.13 While tedious and requiring some skill and patience, painting the mask manually is sometimes needed for best results.

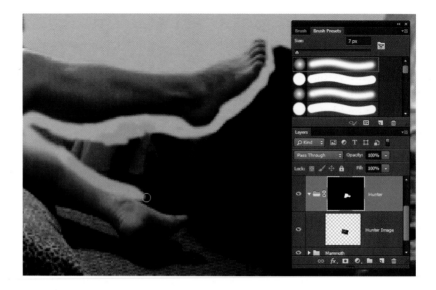

In **FIGURE 14.13** you can see the method of going around the edges and meticulously getting the mask precise; I'm using a paintbrush set to the default round at 7 pixels. Notice also that I am painting on the Hunter folder that contains the hunter and not on the hunter layer mask itself. In cases where you have no studio in which to shoot against a background that's easy to select and remove, painting will be (for most occasions) your optimal approach. You can, however, make selection and removal easier by using a solid-color sheet as a background under or behind your model.

TIP If you are used to Adobe Illustrator and its Pen tool, the Pen tool in Photoshop (P) can be another good option for selecting both objects and subjects. After you use the Pen tool to create a path, you can create a vector mask by clicking the Add Layer Mask button ■ twice. The first click creates a standard pixel mask, and the second creates an editable vector mask based on your vector shape. One benefit to this method of masking is that your soft edge is added with the mask properties' Feather adjustment and is quick to adjust. The second benefit is that you can edit the path shape with the Path tool (A). (For more tips on using the Pen tool take a look here: helpx.adobe.com/photoshop/using/drawing-pen-tools.html.)

Step 6: Put Hair on That Mammoth

In general, the mammoth had two obvious problems with fitting into the composite. The original mammoth picture's bright midday lighting was all wrong for the final scene, and the hair looked metallic—because it was! For a convincing composite, both of these needed to be fixed, and the hair was the best place to start. I planned to stack lighting changes above the hair additions in the layer stack to alter the mammoth's overall look.

Because this monumental rebuild has several phases, I broke these down into groups within the main Mammoth group. This arrangement works well for complex projects: All of the subgroups are still contained by the mask paired with the topmost folder (Mammoth, in this case), so you can essentially work on a composite within a composite. **FIGURE 14.14** shows my layer stack and folder arrangement for the mammoth rebuild.

Fur Palette from Fuzzy Kittens

When looking for how to add hair to the very metallic mammoth, I decided a photo palette of kittens was just the trick for proper browsing, picking, and pasting into place. (Chapter 6 details the process of building a photo palette.) I filled the palette with photos of rescued kittens I photographed at a local shelter to make sure I had enough variety to work from (**FIGURE 14.15**). Because the photo palette was a Photoshop document, I was able to stay within Photoshop while trying out various sections of hair, which dramatically improved my workflow—no bouncing back and forth from program to program or multiple tabs just to see if a tiny section would or would not snap into place and have hair flow in the right direction and shape.

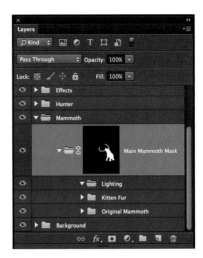

FIGURE 14.14 Within the mask on the main Mammoth group, the sections of the beast are broken down into subgroups for better organization and editing customization.

FIGURE 14.15 Although a bit of a cuteness overload, this photo palette of kitten pictures was useful for piecing together hair on the mammoth.

Smart Sharpen the Fur

Taken during a photo shoot intended for finding homes for rescued kittens some years back, the pictures had a fairly large variety in lighting and fur coloring, not to mention their soft, dreamy focus. While useful for over-the-top accentuating of cuteness, soft focus is not preferred for texture sources. I decided to apply the Smart Sharpen filter to the layers within the photo palette.

The Smart Sharpen filter has had some dramatic quality upgrades in Photoshop CC, and the kittens provide good demonstration material. (Be sure to solo the layer in your photo palette you want to work on before you begin.) As before, choose Filter > Sharpen > Smart Sharpen (**FIGURE 14.16**) to open the Smart Sharpen dialog box.

For optimal sharpening of the kitten fur I used a radius of 2.5 px to stretch that depth a little deeper artificially. The radius needs to be pushed right up to the point before creating noticeable halos (especially if small and close-up sections of fur are going to be used as texture). If you are a veteran Smart Sharpener, you may recall that anything over a 100% on the Amount slider would potentially cause some issues, but this latest version can be pushed a bit further with fairly solid results. Again, when you begin to notice halos or other distortion, ease the Amount adjustment back down slightly to avoid this effect (**FIGURE 14.17**).

Once this filter is finessed, you can apply it to the remainder of the layers in your photo palette by selecting and soloing each layer and then pressing Alt+Ctrl+F/Cmd+Control+F. This will apply the last-used filter to the selected layer. You still have to apply the filter individually, but with the shortcut, this goes fairly quickly. Be prepared for sometimes long processing times once the filter is applied.

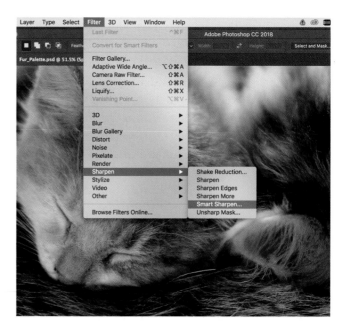

FIGURE 14.16 The Smart Sharpen features are accessible through the Filter menu and can help clean up those softer shots.

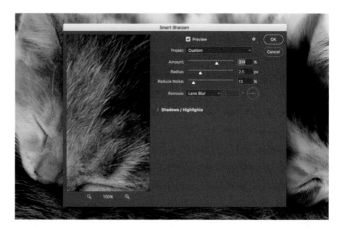

FIGURE 14.17 Push the Smart Sharpen adjustments to the point just before causing halos or other undesirable effects.

Texturing Tips

Finding pieces that fit in the mammoth fur patchwork was ultimately less about the lighting, shadows, and highlights (I planned to add those later) and more about getting the right direction and form to the fur. Using the statue base as a guide, I found the metal provided much of the form and hair-flow, and it then became a game of seeking and matching. There's no quick way of working around this meticulous process short of painting in your own hair strands (no thanks, that can be even more difficult to get looking right), but there is some strategy involved in sewing it all together (**FIGURE 14.18**):

- Find small pieces that have a little shape and direction to them.

- Change the blending mode in some areas; try Screen and Overlay to lighten and darken while retaining the form of your subject beneath. For example, not all of the fur layers needed to be full opacity and Normal mode over the original mammoth. The statue already provided a nice three-dimensional form, which I used as a good under-painting. Changing a small patch of fur to Screen, for instance, can add the lighter parts of the fur while keeping the dark shadows of the statue. Overlay will likewise allow for a place that has existing 3D form while still texturing the metal as hairy and organic feeling. This is where a lot of experiment-as-you-go comes into play, because there often is not a direct way of planning it, so have digital courage and try some variations.

- Rotate and scale the parts that need it. If there is a section that is supposed to be rounded and disappearing around the backside of your subject, having smaller textures near these edges can help enhance this illusion of disappearing around a curve.

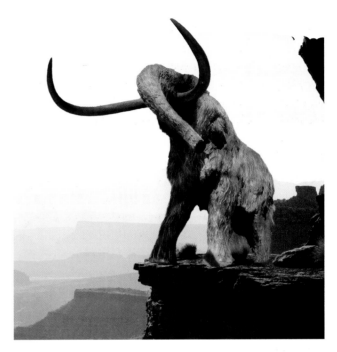

FIGURE 14.18 Add the fur and don't worry about the lighting, just texture only.

- Duplicate hair that works. I must have duplicated about half of the 24 fur layers from two or three good sections of hair. Ctrl+J/Cmd+J is definitely your friend for this procedure. Change the orientation, scale, blending mode, and the rest for additional variety. (See the hands-on tutorials in Chapter 8 for more manipulation techniques.)

- Just focus on hiding the metallic qualities (or whatever material you are covering up) first and foremost, because that is the largest tell-tale sign when dealing with organic material textures.

With the fur more or less in place, the next stage was to control lighting and color to mimic a scene nearly backlit by the sun.

Step 7: Adjust Mammoth Lighting and Color

An important aspect of seamlessly compositing elements is to match their lighting to the scene as closely as possible. To match the scene and stop looking like a weird, wet kitten-mammoth, the mammoth needed some highlights for the backlit sun and deeper shadows to match the rock formation's shadows.

I started with some basic blocking of shadows with a new layer inside the Mammoth Lighting group and set its blending mode to Soft Light (**FIGURE 14.19**). This blending mode has the ability to take strong black coloring and apply it more gently than Overlay or Color Burn would. On this layer, I painted the first semblance of a shadowed area, mainly on the haunches and body.

Next came a new highlights layer with its blending mode set to Color Dodge to create a dodging (lightening) effect. Soft Light and Color Dodge are a little more sophisticated and particular than Overlay; paint with these when you need specific lighting and color control (**FIGURE 14.20**). I chose a hair-like textured brush from the Brush Properties panel and selectively stroked in highlighted fur.

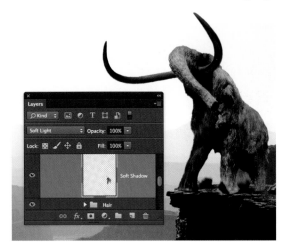

FIGURE 14.19 Work in lighting stages; this first addition was about a subtle and even darkening of the main shadow areas.

FIGURE 14.20 To add highlights, I used a Color Dodge blending mode and painted white with a textured hair-like brush in selective areas.

Next, I added the dramatic shadows, which are the kicker to syncing the mammoth into the scene: I created another new layer, leaving the blending mode as Normal, and painted with plain old black at low opacity (between 5% to 15%). Sometimes you *don't* need to change the blending mode for something you just want darker in all areas like a shadow. You simply need to paint (with low opacity) over the other content on a new layer to darken the entire thing down rather nicely in conjuncture with the other layers (**FIGURE 14.21**). Painting in this fashion also tends to obscure some of the detail of the texture as it is being painted over. This is a bonus for the mammoth, because the hair is not quite right in some areas. Paint to hide away the obvious faults with no one the wiser!

Mammoth-ish Color

Although its lighting was better, the mammoth still had a fairly metallic color overall and needed more of the reddishness already featured in the landscape palette. To control the color, I added a new layer with its blending mode set to Soft Light and then painted on a nice burgundy for the proper effect. This blending mode is able to combine some of the effects from Overlay mode (such as darkening the darks) with Color mode (replacing color and adding saturation) while still being very gentle in its application of both (**FIGURE 14.22**).

FIGURE 14.21 Painting shadows on a new layer in Normal blending mode can tone down the darks to look much more appropriate as well as add a 3D look (as the layer name implies).

FIGURE 14.22 Painting a burgundy red on a new layer with a blending mode of Soft Light gently added a more reddish hue while simultaneously deepening the darks similar to Overlay.

Step 8: Make Additional Alterations

Although the scene was shaping up nicely, there were still two problem spots that were a bit distracting to me, namely, the extra wide tusk shape and the back leg area (**FIGURE 14.23**). To better balance the composition and fit the mammoth into the scene as a whole, I truncated the left side tusk (even more than my first mask trimming from earlier). I did this using a pasted copy of left half of the long tusk (Ctrl+Shift+C/Cmd+Shift+C to copy a rectangular section of all the composite content in that section). In **FIGURE 14.24**, you can see the pasted (Ctrl+V/Cmd+V) tusk layer at 70% opacity (to better show how it covers up the longer section behind this little patch). Once this piece was moved over enough and covering the long section, I made sure the layer opacity was back at 100% before adding a mask and painting out the obvious edges (with a black soft and round brush). A mask blending from one to the other was easy enough to get looking right as long as the tusk edges lined up together.

The other remaining issue that needed covering was the back leg, so a shrub taken from the original canyon scene did the trick for that part in much the same way as the tusk: I copied a useful a section and then pasted it over the spot that needed to be hidden. **FIGURE 14.25** shows the final result after masking out the edges.

Finally, the last pieces that put the cherry on the trunk were some glare from the sun and proper shadows on the rocks beneath the mammoth. I added a clipped layer to the Mammoth folder; that way, I did not have to worry about getting paint on anything not part of the currently visible mammoth.

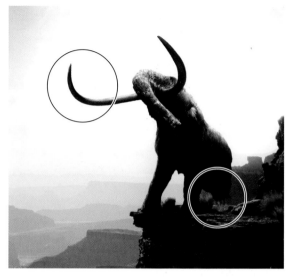

FIGURE 14.23 Two problem spots were distracting at this stage. It was time to make a couple quick fixes: one to shorten the long tusk, the other to cover up the back leg.

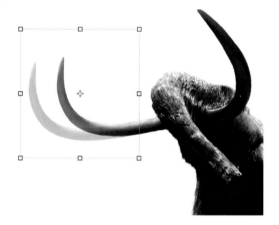

FIGURE 14.24 The left tusk was too exaggerated to fit with the canyon image (shot with a telephoto lens)—plus the shape was just simply bothering me. Copying a section and moving it horizontally over the top of the long section essentially gave it a tusk trim.

FIGURE 14.25 Copying then pasting a desert shrub to cover the back leg was the perfect solution to hide the missing piece. Masking out the remaining unwanted pieces surrounding the shrub left a perfect and believable patch.

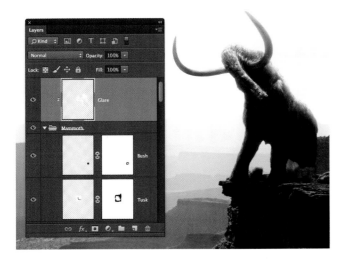

FIGURE 14.26 I created glare by gently painting around the edges on a clipped layer directly above the master Mammoth folder containing all of the various pieces.

To give this clipped glare layer a try, first group the content you want to affect (by selecting all the mammoth layers, for instance, and pressing Ctrl+G/Cmd+G) then create a new layer directly above the main group (Mammoth in the example). With the new layer selected, press Ctrl+Alt+G/Cmd+Opt+G to clip it to the entire group. From then on, wherever you paint, it will apply to everything visible within the group including new alterations and additions—but nothing else in the composite!

Using a fairly large (150 px), soft, white brush set to 10% opacity, I painted around the edges and created a nice glare effect that would match the rest of the scene (**FIGURE 14.26**). I painted the shadows the same way, but on a layer beneath the mammoth and its mask so that it could be seen outside of the hairy border.

Step 9: Accessorize the Caveman

With the hunted in good shape, I turned my attention back to the unfortunate hunter. For the epic eye-candy effects and overall narrative, he needs a few accessories: more muscles, a tan, hair extensions (or perhaps grafting is more apt a description), and a spear.

I started with the muscles. Adding them was exactly like creating the highlights for the mammoth: I created a new layer and placed it in a subgroup (named Hunter Effects) in the Hunter folder above the main image. I then changed the blending mode of this new layer to Color Dodge and once again painted with white in all the places that needed either muscle enhancement injections or highlights from the sunlight (**FIGURE 14.27**). Painting with white on a layer set to Color Dodge mode lightens things with enough subtlety and control to pull off a convincing look (for something that's just cosmetic).

FIGURE 14.27 Any kind of muscles can be more or less enhanced or airbrushed on in post-production, but the sunlight is also important to mimic; setting the layer's blending mode to Color Dodge lets you do just that.

To give these new muscles an equally new suntan, I created a new Hue/Saturation adjustment layer and cranked the Hue to the left to –12, creating a nicely baked red that matched the warmth of some of the rocks and grass (**FIGURE 14.28**).

If you ever need to change the hair length of a subject, simply shoot a hair model with matching lighting. For *The Hunt*, I caught my wife drying her hair on the edge of the bed with the same lamp and backdrop I used for the hunter source images. In Photoshop, I moved the hair into place and masked out the pieces I didn't want or need while also trying to create a more uneven dread-lock look (**FIGURE 14.29**). For this one it was all masking by hand painting.

Oh Spear Me

To create a spear from scratch, I needed a perfectly straight line. Rather than draw it freehand (which can be a huge pain in the butt), I let Photoshop help. To draw your own perfectly straight line using the paintbrush, click at one end of your line (say, one end of the spear), press and hold Shift, and then click at the other end of your line (or spear); Photoshop will draw a straight line from A to B for you. I was able to do this for the entire spear length including making a spearhead with smaller sections of straight lines. From there it was a

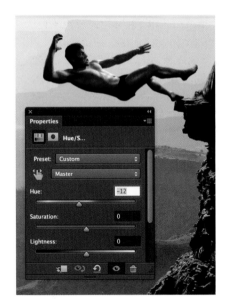

FIGURE 14.28 Adjust the skin hue with a Hue/Saturation adjustment layer.

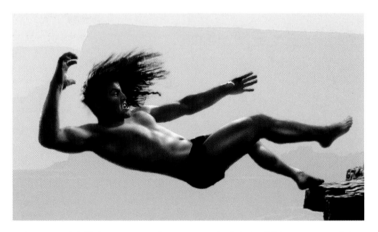

FIGURE 14.29 Take pictures of someone else's hair. With some careful masking and light matching, it will flow just right!

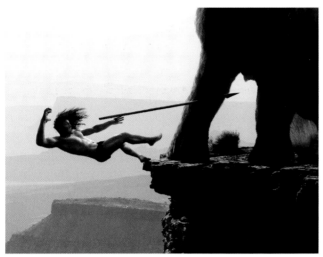

(A)

(B)

FIGURES 14.30A and **B** Draw straight lines for things like the spear by holding down Shift between two single clicks, one at each end of the line. Here I painted in the spear shaft first and then used straight brushstrokes to add highlights. All the while, I was mindful of the areas where shadows might be—and made those areas a bit darker.

matter of matching the spear's lighting and color to the rest of the scene, so I chose an orange-gold in the Color Picker and painted the highlights with a textured brush on a layer with the blending mode set to Color Dodge. After painting in a straight line just at the upper edge of the spear, I varied the highlights a bit more making sure to keep them darker where there should have been some shadow from the mammoth bulk (**FIGURE 14.30**).

> **TIP** Zooming way in (Alt/Opt-scroll up with the mouse wheel) to the pixel level can help you paint things with believable detail and precision—even things that don't exist. Get in close, take your time, and then zoom back out for quick referencing (Ctrl/Cmd-scroll down).

On the Other Hand

The mammoth got a tusk job, but the hunter needed some limb replacement (as you may have already noticed). Specifically, I swapped out an arm for one with open fingers as if he'd just thrown the spear—and without a watch attached to the wrist. I matched the same initial position and faded from one to the other by painting on a mask overlaying the arm socket positions. In many ways, this is similar to adding in various objects and subjects in *Put Daddy Down, Please* (Chapter 12).

Step 10: Cue the Volcano

The setting really completes a narrative. While the rest of the scene needed to be subtle and non-distracting, *The Hunt*'s background needed more impact in the form of a volcano and a composition-enhancing cloud of ash. Both of these reside in the Background group down at the bottom of the layer stack. When working on backgrounds, it's important to follow the timeline of cause and effect for circumstances like this. *The Hunt* has a distant volcano and needs a hazy plume related to it. So as a line of attack, the volcano itself must be the first thing to get right as the rest depends on its placement and size.

Painting a volcano is actually easier than you might think in this scenario, because of the flattening effect that atmospheric perspective has on those background mountains. Notice that there's just about no detail at all. To provide a volcano silhouette, I sampled a piece of the far pale-blue canyon with the Eyedropper. On a separate layer, I began painting with a very fine detail brush with a radius matching the sharp edge of the background. In a very short time, I drew a rough triangular peak that resembled volcanic mountain without adding any variation or detail work (**FIGURE 14.31**).

FIGURE 14.31 Painting with a matching flat blue can fool the eye just enough to see a volcano peak.

FIGURE 14.32 Adding a cloud goes even further toward completing the illusion of an active volcano in the background.

> **TIP** For elements that are painted in using a sampled color (such as a distant mountain), it's often a good idea to play with adding in some noise so that the new element blends well with the rest of the imagery. If it looks too smooth, it will look off, and noise can provide just the right bit of variation that resonates with the pieces around it. To add noise to a layer, first turn the layer into a Smart Object (always keep things nondestructive when possible) and then choose Filter > Noise > Add Noise. For the Amount setting, try between 1% and 5%, and be sure to keep both the Gaussian and Monochromatic options selected. Although I suggest these settings, always try to match the surrounding scene's imagery first and foremost.

A dormant volcano wouldn't provide the dramatic effect this scene needs. The volcano needed to be active, so I brought in some "lava," which was just the simple cloud picture shown in **FIGURE 14.32**. Well, really, it's an upside-down piece from a sunset, so it naturally had some nice vibrant edges that could be interpreted as spewing lava without close inspection.

Because the whole thing was going to be faded far in the back, the cloud would work. The sunset provided just a hint of warmth that, when faded with the rest of the mountains using a white layer, it appeared to be a burst of lava.

I pieced the rest of the clouds together much like the kitten fur patchwork and the fire from Chapter 8. Here are some tools and tips that I use when blending and crafting new cloud creations (**FIGURE 14.33**):

- Immediately mask out all edges; if you don't, you'll leave digital grease. Hunting this stuff down is never a fun test of patience and willpower.

- Create basic adjustment layers clipped to each cloud to get it to match others.

- Always look at lighting direction. It doesn't need to be perfect, but nearly so as our eyes recognize that something looks wrong when the cloud lighting isn't consistent.

- Go small, work piece by piece, and don't worry about finding that perfect cloud that does exactly what you want; those are pretty rare—especially when you may not know what you want until you land on it.

- Add additional atmosphere to cover parts that may not be working the way you want.

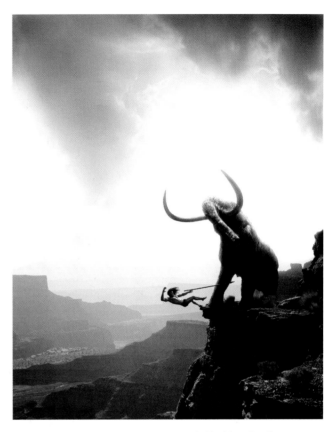

FIGURE 14.33 Blending clouds is much like blending fur or even fire: Always be sure to get very soft layer edges.

Step 11: Turn Up the Temperature

The entire image was far too cool, commonplace, and recent looking. It didn't feel ancient or perilous. For some reason, when I think of prehistoric times and volcanoes, I think of the ash creating a warm filtered light, much like how forest fire smoke creates stunning and brilliant sunrises and sunsets. To create this warm effect, I added three final layers to the Effects group (**FIGURE 14.34**):

- A bucket-spilt (G) yellow-orange layer with the Soft Light blending mode and 33% opacity. Soft Light has a similar effect to Overlay and Color combined but, in this case, retains just a hint of the blues in the shadows as it doesn't apply the color so heavily.

- A copied version of the spilt yellow-orange at 33% but with a Color blending mode instead. You can see the masking done to this layer so that it affects only the background canyon and clouds, reining in those last cool temps and creating a more solid uniformity.

- A red layer with 40% opacity and Soft Light mode. The entire scene felt far too yellow and green (because of the blending of blue and yellow-orange), so red was a good choice in canceling out these variations. This layer completed the final color range, especially where blue was mixing too much with the previous layers.

Conclusion

Sometimes it's good to get outside of your comfort zone, to push yourself—whether that means trying new blending mode strategies for controlling color and tone or seeing what you can do with that growing collection of cat pictures on your hard drive. Going all-out in effort and experimentation can definitely pay off and be a lot of fun. Pay close attention to details such as lighting and color, and you'll discover that most things can be put together in some fashion. After surviving this project, I learned to always retain a do-it-yourself attitude as you really can make just about anything happen in Photoshop, even if you don't have much more than a lamp, some textures, and your idea. Make your own imaginative narrative a reality!

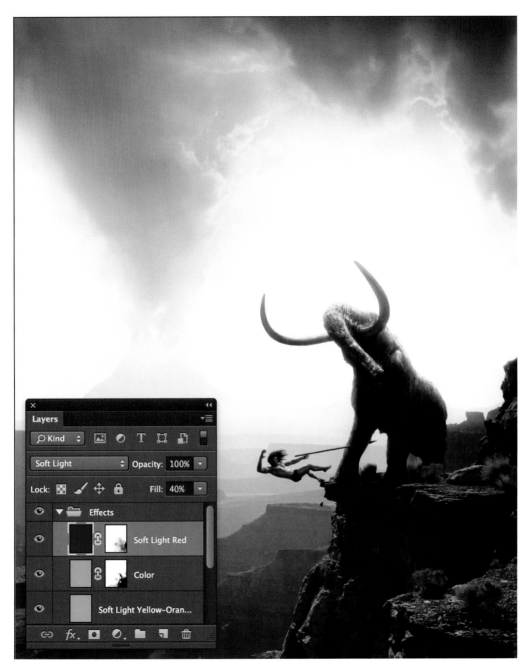

FIGURE 14.34 These last three layers control the warm palette of the piece in three different but collaborative ways.

CHRISTIAN HECKER

www.tigaer-design.com

A resident of Nuremberg, Germany, Christian Hecker combines his Photoshop skills with 3D landscape rendering software to explore his love for interesting landscapes. Concentrating on sci-fi and fantasy scenes as well as digital matte-painting techniques, he creates concept art for small game studios, DVDs, CD covers, and more. Christian has been featured in Advanced Photoshop, Imagine FX, and 3D Artist, as well as Exposé and the D'artiste Matte Painting series. His clients include Galileo Press, Hachette Book, Group/Orbit Books, Panini, and Imagine Publishing.

How do you decide your point of view and perspective for a composite?
I create my pictures with help of Vue. It's a great tool for environment and landscape creation and especially helpful for digital matte painting. Because you're working in 3D in Vue, you have a lot of freedom in choosing perspectives and angles for your camera. You can plan very precisely how to approach your idea—always keeping the general rules, like the golden ratio or the rule of thirds, for picture composition in mind.

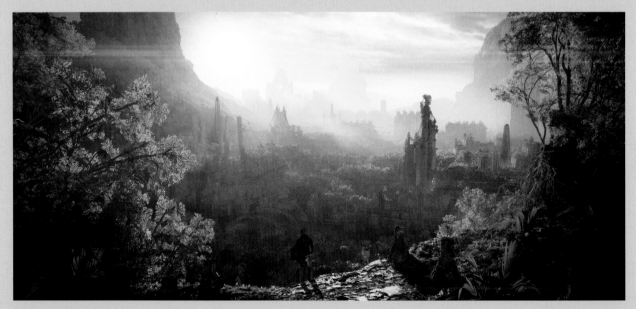

ANCIENT MEMORIES, 2012

SKYHIGH, 2011

THE UNDISCOVERED COUNTRY, 2011

How do you first come up with a concept, and where you go from there?

Generally it's the famous creative spark that gives me the ideas, at least when it's a personal project. A commissioned work is different, because normally the client has a certain image in mind and gives you some clues on what direction to go. Either way I usually go into my 3D software, play around, and throw some things together to come up with a concept. That concept usually consists of some basic 3D models with a nice lighting and atmosphere. I then use Photoshop to quickly refine, overpaint, and enhance the concept. If that concept works out right, I go back into the 3D software and detail the scene out. After a big render, I move into Photoshop to do a lot detail work where a lot of things can still change.

How do you incorporate other applications into your workflow? What are some of the other programs you work with in collaboration with Photoshop?

As mentioned before, I'm heavily using 3D to get my pictures done. In all honesty I do that to compensate for my lack of painting skills. The 3D gives me a fantastic plate to work from. Because the 3D software I use offers multipass rendering option, it can render the image as an individually layered PSD file, so I can refine highlights or shadows, for example. It also contains masks of pretty much every single object in the 3D scene, so I can easily add or remove elements from a scene via Photoshop. The whole mood of a picture can still change when I'm in the Photoshop stage of creating a picture. That's the freedom and flexibility I love.

What's your total favorite go-to tool in Photoshop?

Adjustment layers.

How can you tell when something is just not looking right? Do you move on or keep working at it?

It's a gut feeling to be honest. Usually when I'm stuck I tend to ask friends or fellow artists for opinions. Often enough that helps to get some pointers on where to go. Sometimes it's a simple taste thing, especially when doing commissioned work. Your taste may completely collide with what the client has in mind. That's when it can get difficult. Sometimes it's good to just leave the project for a while. Especially when it's a personal one. Lay it aside, and try not to think about it for a couple of days. Then come back and have a fresh look at it. That helped me a couple of times as well.

How do you help tell a story with an image?

The hope I have for all my works is that they tell some sort of story. It starts with the creative spark, and out of nowhere a door opens to a world in your mind. Then you start to flesh out this world by adding detail. That's when you begin to explore that world yourself and try to find things that make it look really cool and special. Hopefully in the end you created a window to a world no one has ever seen before—something that inspires and encourages others to maybe be creative or interpret the picture for themselves.

Do you have any final professional advice for others pursuing this field?

Be patient, especially if you are learning by yourself in an autodidactic way. By no means expect mind-blowing results on day one. If you already have some experience, don't hesitate to try new things and push yourself. Ask for opinions from friends and family, and listen to what they say. Also, have a look at the work of already established artists to find inspiration and motivation. ■

Strange News from Another Planet, 2011

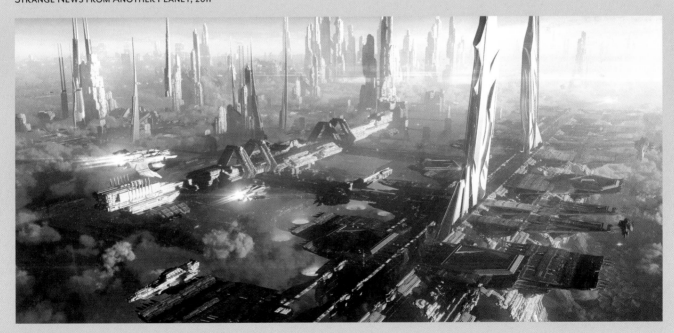

From Here I Can Almost See the Stars, 2012

CHAPTER 15

Family Portrait Magic

COVERED IN THIS CHAPTER

- Shooting multiple subjects and floating objects
- Pet photography and piecing parts together
- Remote and mobile shooting using camera Wi-Fi paired with a smartphone
- Rating, sorting, and batch optimizing using Bridge and ACR
- Painting custom masks
- Utilizing the Clone Stamp tool and Clone Panel properties
- Special lighting effects
- Path Blur for perspective motion blurring

Bringing the family together for portraits is always a special and magical time. Well, it can be more like a special kind of hell—but in this case, it at least looks magical! And that's all that matters when you send the photo to family and friends, right? Truth be told, this shoot with the Winder family *was* actually a blast for all of us. Their enjoyment shows in the final composite, which is key for best results in these situations! In *Family Magic*, each subject's narrative vignette was brainstormed and then shot separately within the living room scene—all the while keeping in mind how these pieces would interact and be brought together seamlessly as a composite. Being both careful and technologically clever during the shoot, I ensured that the Photoshop aspect would be fairly straightforward and easygoing. Overall, the magic in this was truly all from the family; it was my role to visually manifest their awesomeness with various lighting effects.

▶ **FIGURE 15.1** In *Family Magic*, the Winder family came up with the ideas and I helped make it a reality for them.

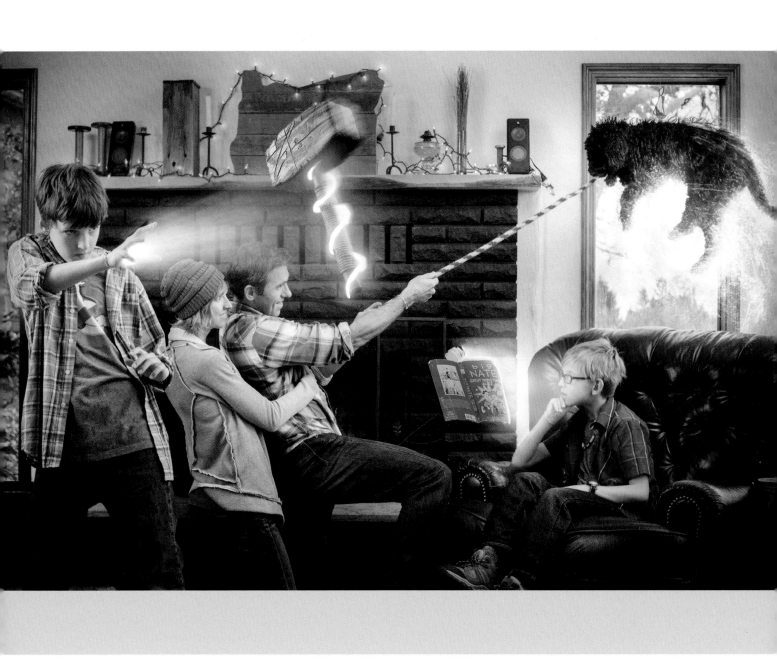

Step 1: Brainstorm

Walking into an unplanned space (not to mention some-one else's imagination) for a spontaneous shoot is an especially fun challenge to give yourself. On the flip side, it also has a higher than average potential of flopping, so stay on task and plan only as much as time and space allow. The best way that I have found to tackle one of these shoots is to begin by brainstorming. Nail down what you will be working with as far as subject mate-rial, props, and space. Will there be levitation? Other powers? Are there pets involved? In this case, the family had recently adopted a new canine family member and wanted her to be a featured part of their little fantasy world. Floating dog playing tug-of-war with the parents? No problem, let's just figure out some good framing and positions for all this!

While letting creativity run, keep it on a leash: Know the scope of what you can do with what you have available for the shoot. When a particularly imaginative family member

starts mentioning volcanoes and asteroids, know when to bring things back to reality (at least a little) for the shoot at hand. After I outlined what was possible to do for their family portrait, the Winders ran wild with ideas. More specifically, the two boys had a nearly endless barrage of scenarios they wanted to try. In this case, it was my job to help facilitate and hone in on ones that could work in their space and around each other.

For your own shoots, here are some things to keep in mind when working with someone else's narrative and space:

- Know your own limits and that of a scene and space. Yes, just about anything *can* be done in Photoshop, but not always as a successful image for the family's needs, so set those parameters early in the conversa-tion while still letting imagination fly.

- What does the available space provide? Are there windows that can be used for framing? What other features would be good to use—couches, chairs, a fireplace, and so on. Make note of what is available, and think of the setting as your stage for a live perfor-mance (**FIGURE 15.2**).

- Provide some starter examples to get the family going on what they can do, and then just help facilitate and harness their excitement and imagination into visual positions and examples.

- Get the subjects thinking about their own personal-ity in magical terms! It's the perfectly nerdy com-bination of their favorite things in the world plus a favorite superpower—how can you go wrong? (Don't answer that.)

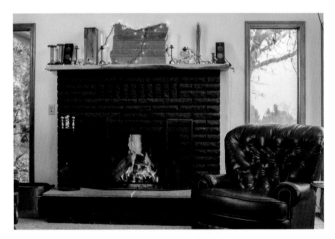

FIGURE 15.2 Look at your available space for ideas of framing, furniture use, props, and posing locations.

Step 2: Set Up Lighting and Gear

While the family was working on their individual and group ideas that best suited their personalities and imagination, I took the opportunity to set up the lighting and get my gear working. Knowing that the subjects would be spread throughout their living room, I needed to set up a lighting scenario to capture all of them as much as possible. I went with three continuous lights: one for a backlight that was placed just out of frame in the upper-right corner facing toward the subjects and camera, then the main light (key) off to camera right (adding to natural light from a windows along that wall), and a fill light directly to the left of the family (**FIGURE 15.3**). Once the general lighting was more or less good to go, I then framed my scene and locked down the tripod.

FIGURE 15.3 Arranging the lights with a backlight, key light, and fill, I was able to get the most out of the scene, regardless of the family's position in the room.

FILL LIGHT

BACKLIGHT

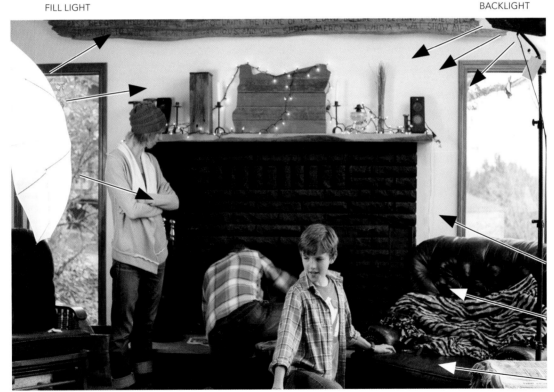

KEY LIGHT

Step 3: Previsualize and Position

Once the concept for each subject was figured out, it was up to me to decide how to piece it all in together. For many of my composites there's enough time to sketch and make my preparation well in advance—or at least not right on the spot! In this case, I developed my previsualization through a series of test shots, exploring the scene visually to get an idea for space, balance, lighting, and composition. Because the background was fairly flat, posing and prop placement needed to help create more dynamic angles and depth (**FIGURE 15.4**).

When running through each vignette in your own photo shoot, here are some things to keep in mind and practice:

- Talk to the subjects about your visual plans and the strategy going forward. Help them see your concept and positioning of how things can fit together. When everyone is on the same page, everything goes much smoother and requires less direction for the final shots.

- Rehearse a couple quick concepts with you behind the camera viewfinder checking for composition and potential variations you might try. With a run through and basic blocking out of each action, get the balance of how things can come together.

- At this stage, look for potential conflicts, distractions, and overlaps of subjects or props. Once you begin shooting for "real," it's super easy to lose sight of these things.

- If subjects are going to be helping by holding props (or animals), have them practice keeping their own visibility minimal. Remind them to hold the object by its edges or from the backside as much as possible.

FIGURE 15.4 Visually playing out ideas quickly to get the right balance is much like a dress rehearsal of an acting sketch. Don't rely on improv to create the entire scene!

Wireless, Remote, and Live

This shoot packed quite a lot of activity into a relatively small space, and I needed a few superpowers of my own—to see from the camera's perspective while in the midst of the scene, for instance. But, I had the technology! Specifically, I connected my phone to my camera using the Wi-Fi setting on my camera and the camera manufacturer's proprietary app running on my phone. With this pairing, I was able to move around the scene while watching a live preview of what my camera was seeing—which was so helpful in getting all the pieces to fit closely and precisely together! This definitely made up for not having made a sketch beforehand.

No longer was I limited to giving the subjects verbal direction only. If something needed a specific adjustment, I could come into the scene and help make it—such as moving the angle of a hand or object—while looking at my phone's live view. If needed, I could also take a picture (if a moment was truly perfect) with the app's remote shutter release. Keep these things in mind as you work with a similar setup:

- **Although you can remotely control the shutter and exposure settings, frequently check the focus from the camera itself.** Things look *amazingly* sharp on our little preview screens, which does not mean that they actually are sharp once blown up. Use manual focus and remember to re-focus for each part you are shooting. It's really the worst when you get done with an awesome shoot—just to find out those critical shots were blurry!

- **Be sure to stay out of the lighting.** This may sound rather obvious and common sense, but when you are totally nerding-out on technology and looking down at your phone or Wi-Fi device, you can literally lose sight of where you are. (Let's be honest, a lot of dumb stuff happens when we are looking down at our little

glowing screens!) With the capability to venture into the scene yourself, be aware of your effect on it. To truly get out of the way, avoid overlapping with subjects and objects—and blocking the lighting.

- **Use the technology for the right reasons, not just because you can.** If it helps you keep the pieces separate, assist in guiding subjects, compose the scene, add more dimension to the image, shoot without bumping the camera, or lend a hand to make something possible (such as lifting something heavy or awkward)—these are all potentially excellent reasons to use a Wi-Fi connection. Beyond these, I highly recommend getting behind the viewfinder more as you will be able to catch and fix an array of other potential mistakes, such as focus, lighting, and exposure adjustment problems.

Step 4: Shoot Each Vignette

While only one composite, *Family Magic* really needed several small photo shoots packed into on, because the subjects each had their own storyline. Thankfully, I also had built-in assistants who were already comfortable working together. As I shot each vignette, the other family members were all happy to lend a hand (or paw) to get things looking just right.

After everyone had done some basic rehearsing, we went through and shot each subject and the props. This is one place where you want to capture as much variety as possible and shoot more than you think you will need. In **FIGURE 15.5** you can see some of the 21 shots I took of this one segment in which one of the boys (to be to be masked out later) held the rope at an angle while his parents pretended to pull.

FIGURE 15.5 For every piece of the composite, shoot plenty of options, both with subtle and experimental variety.

A NOTE ABOUT EXPOSURE RECIPROCITY DURING THE SHOOT

If you harken back to Chapter 5, you may recall a few lessons in the use of manual exposure control as a strategy for better results—specifically the trifecta of exposure and the idea of reciprocity. This shoot was a good example of the trade-offs to consider.

To keep my ISO (and therefore noise) down even in low-light settings, I compensated by slowing my shutter speed at little (because I had a tripod) and opening the aperture up to F5—remember, the lower the f-stop number, the shallower the depth of field. This meant that each subject and object had to be in razor-sharp focus, without regard for the sharpness of the other items in the scene. While this could lead to problems with unwanted blur if you are not careful and double-checking, at least it was in my control and not going to introduce dreaded noise. In fact, this shallower depth eventually helped my selections in the end as the Quick Selection tool's algorithm found edges quite nicely for the foreground subject and prop.

If I had used strobe lights instead here (high-powered lights that flash an intense burst of light; more light overall, but as one single flash with each shutter release), my live preview would not have been as accurate, even with modeling lights—so I would lose the advantage of using the phone for Wi-Fi live preview.

For each shoot, it's always a give and take of features and results, which is why it's called reciprocity. The key lesson here is to have a reason for your exposure choices! Think of benefits and drawbacks for each scenario and decide which are manageable for you and your setup.

TIP Make sure to grab a clean and perfectly focused base image background shot (such as Figure 15.2)! It's easy to focus on the other elements so much that you completely overlook this step. Don't. Every composite needs a strong foundation shot to build from, so clear the stage and snap a few, just to make sure you got one. Take a couple of these throughout the shoot (beginning, middle, and end), just in case something changed by accident (it happens). If you only have one opportunity, grab what you need while you can—memory is cheap, so keep capturing.

Play as You Shoot for Variety

For a composite as playful as this one, it is imperative for the subjects to have fun and get into the fantasy of it. When everyone buys into what is being imagined, the self-conscious smiles of "wow, this feels really dumb" fade away and are replaced with half-decent and exciting performances! Except for pets—the poor things just have to hang in there while the humans act even more bizarre. To be fair, sometimes the animals can get into the play as well, but for them, there is no pretending. It has to be real, so set up situations you might be able to work this in. Here are some good tips to keep in mind for these kinds of shoots:

- To help give subjects direction, try coming up with narratives that they can react to. This can help keep them in the play mindset. If you need to give more direct feedback about say a hand position, definitely do that! One thankfully does not negate the other.

- If you need the subject to face a different direction or look a different way, try finding an object in the room or environment you can direct their attention to.

- Sometimes stand-in props and people can be useful for the subject to interact with.

- If a position or pose is exceptionally difficult to capture in one shot, don't feel like you need to. You can instead prioritize, shooting section by section, and bring it all together in Photoshop afterward. I had to do this for a CreativeLive shoot (that was live, of course), where the dog that volunteered itself for the scene was having second thoughts during the shoot. I was able to piece together all the parts from four different shots—and a lot of masking (**FIGURE 15.6**).

FIGURE 15.6 During a photo shoot with CreativeLive, I had to use four different shots to combine into the optimal dog position for the composite. No single shot in this case worked well enough on its own—but altogether they worked like magic. The Frankenstein kind, but still!

Step 5: Rate and Sort Images in Bridge

Once the subjects and props were all shot with some good variety in mind, things then shifted into the realm of Adobe Bridge and Photoshop. Starting in Bridge, I downloaded the files and rated and sorted out my options using the star rating system (**FIGURE 15.7**). Take another look at the "Rating and Sorting" section in Chapter 6 if you find you may need a more in-depth review on this process.

In short, I narrowed my shoot down to the five primary images shown in **FIGURE 15.8** with the exception of the base background shot and taking a few pieces here and there from some others as needed. Anything that was rated as five stars either was entirely usable or had a key element that could be perfect if I needed an alternative option (such as the poor doggy with stage fright that I pieced together for the CreativeLive shoot).

FIGURE 15.7 Using Bridge to rate and sort my available imagery let me cut right to the cream of the crop.

FIGURE 15.8 With the five primary images rated and gathered (by filtering for five stars), things were ready for launching into Photoshop and the composite.

Step 6: Gather, Process, and Compose the Family

Here's the stage where things really started feeling like a composite as I brought the family together at last. First things first: although I did a basic Camera Raw pass earlier, I still needed to fine-tune the selected images to make them more uniform. In Bridge, I used a Batch edit to open them again in Camera Raw. My goals were to optimize how the pieces look, as well as make them more uniform. Filtering to just the four– and five-star images in Bridge (**FIGURE 15.9**), I then selected all the remaining thumbnails (Ctrl+A/Cmd+A) and pressed Enter/Return to open the ACR workspace.

Once in Camera Raw, I again selected all the images (Ctrl+A/Cmd+A) so that I could edit them all at once. I warmed the image up (with Temperature at 6000 and Tint at +14 Magenta), increased the Exposure (+1.95), and decreased the Highlights (–70) so as to not blow out the window highlight and background details (**FIGURE 15.10**). When increasing settings like Exposure, it's often a good idea to take down the Highlights so that they do not get too over-powering. After adjusting all four- and five-star images I clicked Done (not Open); sometimes it's best to make batch changes, but not clutter the Photoshop workspace until you need a particular image. In this case, I wanted to start with just the key images and build from there.

Back in Bridge, I continued with the star rating filter and found the core images I would be using and selected each one by Ctrl/Cmd-clicking. Double-clicking

FIGURE 15.9 Weed out the unusable images by using the star filtering feature in Bridge. Once just the four– and five-star images are visible, it is much easier to then batch process them all at once.

FIGURE 15.10
The various settings that warm and brighten the images can be seen in this before and after split view in Camera Raw.

one of the selected thumbnails again opened it in the Camera Raw plug-in; this time I clicked Open Image Open Image .

Starting with the clean background shot (**FIGURE 15.11**), I began adding my various composite groups (one for Tug of War, Reader, Thor, and FX). This gave me an easy starting place to unite the family in one file based on the depth order they were captured at. Next, working from the back and progressing toward the camera, I selected the group for Tug of War, and then found the parents image in a tabbed window. From there I selected a large portion of the scene, giving myself some masking room surrounding the main action and poses before copying (Ctrl+C/Cmd+C) and pasting in place (Ctrl+Shift+V/Cmd+Shift+V) into the main composite and Tug of War group (**FIGURE 15.12**).

For the remaining pieces, I followed a similar method of copying and pasting in place, just taking the specific areas of each shot needed with enough room for future seamless blending. For these kinds of composites, here are some strategies I keep in mind while deciding what to take and leave:

- Use the rectangular Marquee tool (M) for both ease and speed. Not much is quicker than dragging across diagonally for general selections.

- File size builds up quickly, so keeping the selections from being too large is important.

- Find what the action is and select just a bit beyond that; allow for enough room that you can use a large, soft brush to make the transition. In **FIGURE 15.13** you can see size of the copied pieces I used for *Family Magic*.

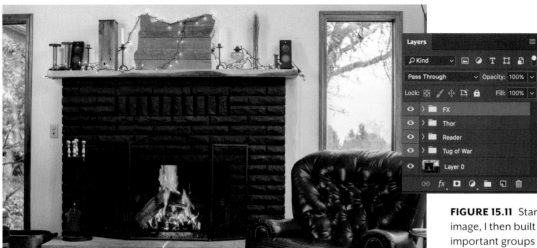

FIGURE 15.11 Starting with the base image, I then built the framework of important groups for both organization and depth.

FIGURE 15.12 I made a selection using the Marque tool (M) that gave me room for future masking around the subjects and rope.

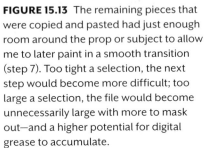
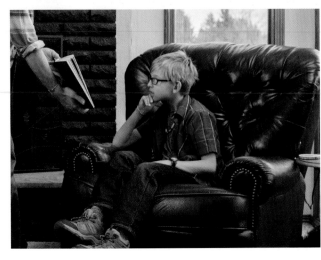

FIGURE 15.13 The remaining pieces that were copied and pasted had just enough room around the prop or subject to allow me to later paint in a smooth transition (step 7). Too tight a selection, the next step would become more difficult; too large a selection, the file would become unnecessarily large with more to mask out—and a higher potential for digital grease to accumulate.

Step 7: Mask and Paint

For composites that are all taken from one frame and point of view like this, masking can be more about painting than selecting in many cases. With the exception of the Thor-like foreground subject, the main pieces were painted in—or more specifically, the edges and unwanted parts were painted *out* using a soft, full-opacity, black Brush.

Starting with the parents, I created a mask by selecting their layer and clicking the Add Layer Mask icon ▣. I used the Soft Round Brush (B) ranging in size between 200 px and 400 px, sometimes making a smoother gradient, other times keeping it a little tighter for areas directly around the subject and details. In **FIGURE 15.14**, you can see where I quickly painted out the edges and how this blended with the background image.

From there I quickly created new masks for the remaining subjects and props and painted the masks using the same method as for the parents' layer mask (**FIGURE 15.15**). This kind of paint-masking is super quick and dirty—or perhaps, more accurately, potentially greasy! Although it is easy to quickly stroke a brush around like an abstract master painter, as with any use of low opacity (the soft, transparent edges of the brush), there can be small, unwanted bits of the image left behind. I carefully kept each shot uniform to intentionally avoid this problem, but the unwanted elements, in this case, were the pieces with noticeable blurriness due to the shallow depth of field I used. This is especially evident on the foreground Thor subject and his hammer, Mjölnir (yes, nerd alert). While the other image pieces grabbed elements within a similar depth, the closer subject and prop simply could not do the same at aperture f5. The solution? Do away with painting. Instead, go straight to the Quick Selection tool (Q) and use Select And Mask when the contrast in focus (sharp versus blurry) is too great.

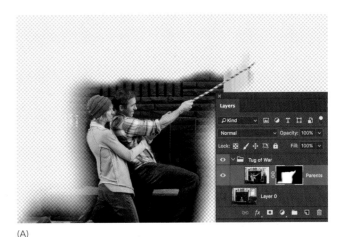

(A)

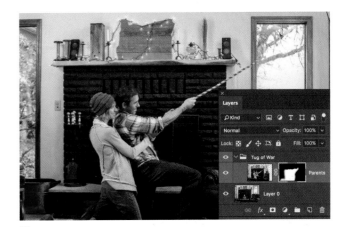

(B)

FIGURES 15.14A and **B** Looking at just the parent image (A), the smooth but quick painting of the mask helped create a transition that blended nicely with the background (B).

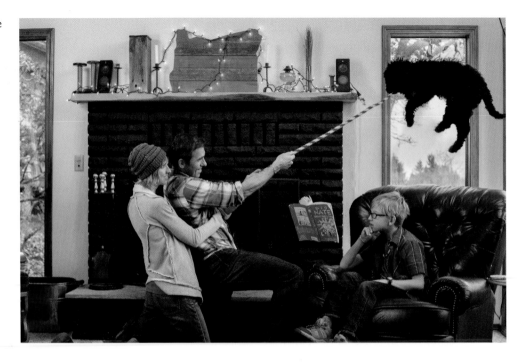

FIGURE 15.15 Using the same method as with the parents, I masked out all edges from each layer.

When Masking Gets Hairy

In the case of the dog's mask and a couple other detail spots where I needed to mask out a hand or body that was touching an object (such as around the floating book), my method for masking was still that of painting. In these areas, however, I used a much smaller brush size, sometimes changing the brush tip shape to better match the content as well. For the dog's layer, I had to switch to a spatter brush and paint from the outside of the dog, stroking inward with a low Flow (10%) to simulate some of the hair. In **FIGURE 15.16**, you can see the results and the level of detail I ended up painting; everything in bright red is what has been masked out. This worked as at least an initial clean base of this layer (mostly free of the holding hands), allowing me to do further healing and cloning magic later on for those spots that still didn't quite look right.

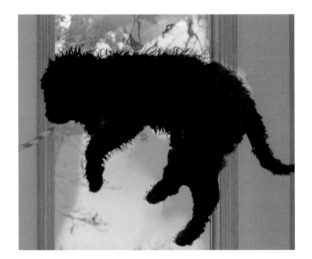

FIGURE 15.16 The mask (shown in bright red) was created by painting with a combination of a soft and round brush for the simple transitions and a textured brush, such as a spatter, for those hairy areas.

Thor and Hammer, Select And Mask

For the older Winder brother in the foreground and his flying magical hammer, painting in a mask like the others would have left a halo of blur around both as these shots had a noticeably shallow depth of field and blurry background. Although the others were also photographed using an aperture setting providing a shallow depth of field, there was actually very little variation in depth between the subjects and their backgrounds. The subject and the hammer were much closer to the camera by comparison, making for a more dramatic contrast between their sharpness and the fuzziness of their backgrounds. This provided an excellent opportunity to use the Quick Selection tool and Select And mask!

By first selecting the Thor subject's layer and then picking up the Quick Selection tool (W), I painted using a brush that was roughly the size of the fingers I would be selecting (**FIGURE 15.17**). It's helpful to start off with a larger size for the bulky parts and then make sure by the time you

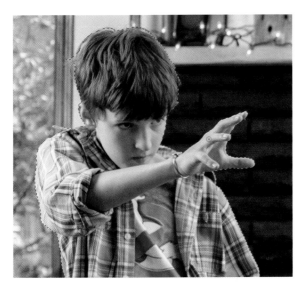

FIGURE 15.17 I used the Quick Selection tool to make a tightly controlled selection of the foreground subject.

get to some of the details that the Quick Selection brush size does not exceed the details you want to select.

Once the subject was selected, I then clicked Select And Mask in the options bar and made my various adjustments. Specifically, I increased the Edge Detection Radius setting to 5 px; this took care of most the edges that were previously a little rough (**FIGURE 15.18**). Because the subject was not going to be moved to another location, I did not need to worry about halos in this case; just removing the blurry background would be plenty sufficient. After clicking OK to close the Select And Mask workspace (with Selection still chosen from the Output To menu), I gave the selection one last close inspection. Once satisfied, I added the mask with the Add Layer Mask icon ⬛. From there, I applied the same process to the floating hammer and the scene was all set to go (**FIGURE 15.19**)! Well, nearly so—at least the base pieces were set—like the corners and edges in a jigsaw puzzle.

> **TIP** When refining a selection using Select And Mask, try starting with Edge Detection for smoothing out some bumpy selection edges. This often works better than the Smooth setting. Smooth is optimized for creating soft and gentle curves, and sometimes you still need those important nooks and crannies (like between fingers)! Radius, instead, does a search along the edge of the selection to include (or exclude) pieces, as if you brushed with the Refine Edge Brush. If you also notice some halos that you need to take out, first click OK to exit Select And Mask. Then, go back into Select And Mask a second time to change other settings, such as Feather and Shift Edge. Clicking OK the first time (with Selection still active in Output Settings) before going back into Select And Mask allows you to apply adjustments, such as Radius, and paint with the Refine Edge Brush.

FIGURE 15.18 I used Select And Mask to refine the edge created from the Quick Selection and moved the Radius slider (under Edge Detection) to 5 px for a simple and clean selection adjustment.

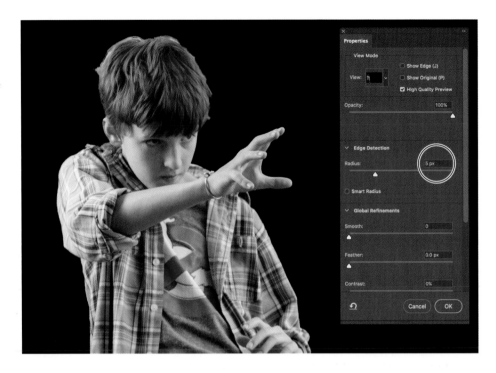

FIGURE 15.19 With all the selections complete, the scene was ready to go for the added touch-ups and effects.

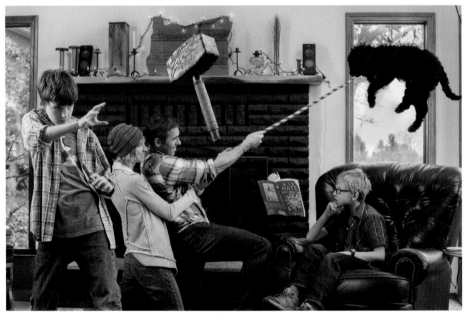

Step 8: Cloning and Hair Repairs

With the masking in place for each main layer, usually for these kinds of composites that is just the starting platform for some added touchups to each section. Things like hands overlapping parts of objects need to be touched up nondestructively, with either the Spot Healing Brush or the Clone Stamp tools on new layers. Remember those areas where I masked using a spatter brush on the dog to get things looking okay-ish but not fantastic? Those pieces needed another pass of nips and tucks. Or doggy hair-plugs. Both of those sound far too intrusive for just some Clone Stamp use, but in this case, I pulled out some fancy features for this specific operation—check it out.

WHEN TO PAINT AND WHEN TO SELECT, THEN MASK

There is no golden rule for a certain method of masking (unfortunately); however, there are some good guidelines you can keep in mind as you begin compositing your scene. Sometimes it is best to simply and quickly paint directly on a new mask without a selection being made beforehand, other times it's important to use the various selection tools and create a mask once the selection is refined and edited to perfection—here's how I draw the line between these two general methods. Use the fast and simple painting method when:

- You are sure that the composited layer matches the area surrounding the subjects and objects uniformly.

- You feel confident in quickly being able to paint out harsh edges at full-opacity black with a soft and round brush. This method can save a good amount of time—just make sure that if you are using a drawing tablet that you deselect Transfer in the Brush Settings panel during this process. Otherwise, if you have Transfer selected along with Pen Pressure for Control, there will very likely be faint pieces of edges left over (unless you press down with Hulk-like strength on your poor tablet).

On the flip side, here are two cases where you might want to make a selection first and then go into Select And Mask before finally creating the mask:

- If your soon-to-be-masked image layer's background is different than the background layer in any noticeable way—such as it being blurry or having different objects visible. Slight lighting and color changes can be dealt with (by fixing with clipped adjustment layers); it's the more dramatic differences to watch out for—like a new or missing object in the background.

- You are planning to move the soon-to-be-masked subject or object into a different position or location within the scene. This simply does not work well without a tightly refined selection that is turned into a mask.

For touching up the underside of the dog (**FIGURE 15.20**) I first made a new layer and placed it directly above the content I was planning to touch up with cloning. Next, I switched over to the Clone Stamp tool (S) and opened the Clone Source panel (Window > Clone Source). Here's where some nifty things like to lie in wait for just the right time—like rotating the clone source reference if the angle does not match up! For example, I was able to use the dog's hair from its back (the edge at a fairly horizontal angle) and clone it to the rough parts of the leg by setting Rotate Clone Source to 120 degrees within the Clone Source panel (**FIGURE 15.21**). I set my source point (Alt/Opt-clicking the location from the back fur), and I then painted the spot of interest below. In fact, one quick click did the trick!

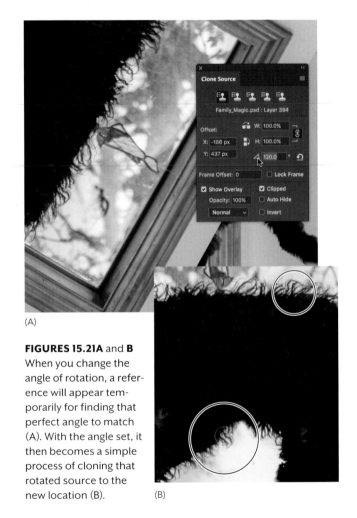

(A)

FIGURE 15.20 The underside of the dog had an area from the mask painting that was still not looking quite right, but the hair on the back had some potential for cloning as a source.

FIGURES 15.21A and **B** When you change the angle of rotation, a reference will appear temporarily for finding that perfect angle to match (A). With the angle set, it then becomes a simple process of cloning that rotated source to the new location (B).

(B)

Spot Healing

So aside from a few spots of clone stamp usage taking full advantage of the Clone Source panel, there were still a few remaining hands and fingers, which mostly were taken care of by using the Spot Healing Brush tool (J). For places such as the hands holding the dog underneath, I simply made my brush size larger with the left and right bracket keys until the brush size perfectly covered the offending fingers and hand. One click and they disappeared (FIGURE 15.22); now compare this to the Figure 15.20 for a better before-and-after visual of what has been altered. This same simple trick worked across the entire composite on all the remaining bits—and for those that were still too stubborn, I went back and used some ninja Clone Stamp moves until the scene was cleaned out of enemy oddities.

FIGURE 15.22 Remaining places where hands were still present were easy to take out with the Spot Healing tool, designed exactly for this kind of removal.

Step 9: Add the Special Effects

Finally, we are at the special effects section! These may seem neat to look at, but hopefully these effects look more than a little familiar as well. After all, there is the sunray effect from Chapter 9 (glowing out from the hand), the Outer Glow layer effect from sketching a fire demon in Chapter 8 (the snaking power tendril wrapped around the hammer handle), and some simple sparkle painting and blending mode changes from Chapter 11 (doggy sparkle dust and thrusters) (FIGURE 15.23). This section will give a brief reminder on these effects but will focus mostly on the hammer and its slight Path Blur to add an effect of motion. Path Blur is a somewhat newer blur to Photoshop and has not been described all that much within the covered projects as yet.

FIGURES 15.23 Most of the effects are variations on methods from previous chapters and projects and should be somewhat familiar already—even if used in a different way.

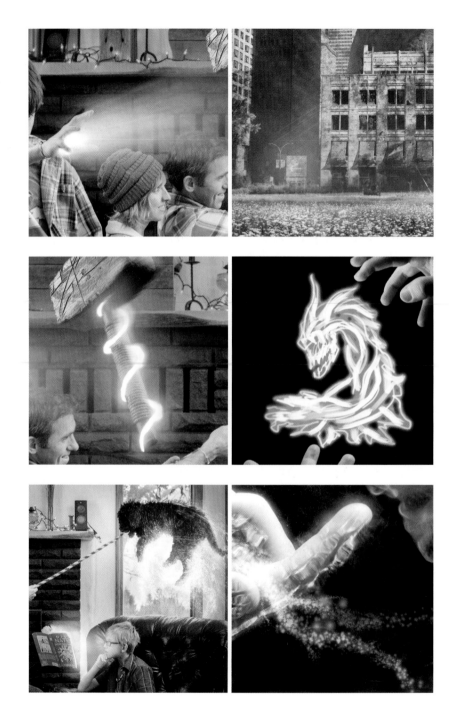

Glowing Light Rays

As a quick refresher of making light rays (again, see Chapter 9 for the expanded version of this), I started with a large spatter brush (300 px) and clicked once with white at full opacity on a blank layer just above the foreground boy and his outstretched hand. This is where adding in a simple motion blur (Filter > Blur > Motion Blur) starts that distinct light ray look with a Distance setting of 500 pixels—although it's not terribly visible at the moment on top of the fireplace and its horizontal lines (**FIGURE 15.24**). I kept the angle at 0 degrees before clicking OK to accept the blur. We'll soon change the angle manually through transforming.

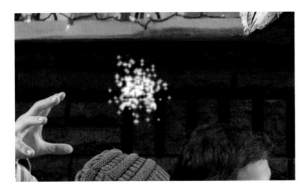

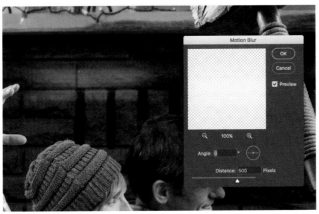

FIGURE 15.24 The Motion Blur is great for smearing some textured spatter brush into streaks of light you can later transform and move into position.

LIGHT, BUT NOT FAINT

Applying a Motion Blur will fade the layer no matter what, because it is mixing pixels with the transparency around them. However, if your own motion-blurred spatter brush image ends up too faded to really see over your imagery, try these three things:

1. First, start over with this effect again. On a blank layer, paint with a spatter brush, but this time with double– or even triple-clicking one spot. This will add more opacity to those pixels (even though the brush Opacity and Flow settings should have been at 100%).

2. If you notice that once you are adjusting the Distance slider, the blurred live preview in the composite is far too faded to see, try pulling back on the setting's blur pixel amount. There's a threshold of where you see a motion streak, and where it gets blurred beyond visibility.

3. Duplicate the layer (Ctrl+J/Cmd+J) for more density of the same effect. Just make sure to group them or link them so that they stay together when moved around. It's the precise doubling that adds to visibility. If two is too much, take down the opacity of one until you find the sweet spot.

From there, it was a matter of using some of those Swiss Army knife features of the Move tool (V) (rotating and transforming individual corners) before playing with Layer effects for the blue-ish glow. To shape the light rays and make them shoot outward at differing angles, I rotated the rays before holding down Ctrl/Cmd while dragging a corner anchor point with the Move tool (**FIGURE 15.25**). This allowed me to independently move these corners and spread them out and away toward the hammer, as if they were glowing outward from the hand.

And now for the glow! This is the coolest part in my opinion—I added this same glow effect to various parts of the image where there were lighting effects; the only difference was changing the color of the glow gradient here and there. Also, more detailed instructions about creating an Outer Glow layer effect can be found in Chapter 8, but here's another brief refresher that shows some of the settings for this specific glow.

With the same light rays layer selected, I then clicked Add A Layer Style *fx* and chose Outer Glow from the menu. In the Layer Style dialog box, with Outer Glow selected and highlighted, I changed the settings so that the glow effect would definitely be visible, but not too dramatically intense or over bold. I wanted it be more of a colorcast than anything (**FIGURE 15.26**). For the color gradient, I selected colors starting in a light blue (at full opacity), and a darker blue for the transparent end. This gave off a nice transition that faded well with this lighting effect.

FIGURE 15.25 Using the Move tool, hold down Ctrl/Cmd to drag the corner control points individually in any direction—in this case, out and away from the hand.

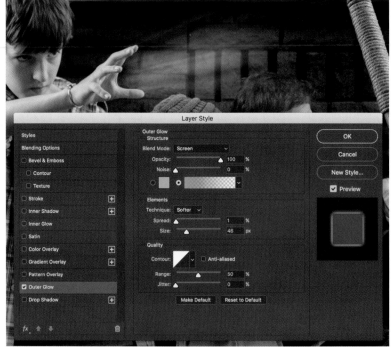

FIGURE 15.26 Layer Styles are great for adding elements such as a glow. Here I'm using these settings for the blue-ish gradient applied to the light rays.

Paint with Light

Once I had this glow dialed in and rockin' those rays, I started creating other layers with copied versions of the layer effect (Alt/Opt-drag the layer effect to another layer in the Layers panel) for painting and adding to the overall effect, bit by bit. Still focusing on the hand area, I came in painting white with a soft and low-opacity brush (5% Opacity and 50% Flow), sometimes changing my brush size to match the level of detail I wanted to paint with. For the glowing palm, I simply increased the brush opacity and flow to make sure it appeared to be a bright light source, rather than a slight glow like the rest of the effect.

This same glow effect can be seen throughout the composite; sometimes I've changed the gradient's coloring to warmer hues (such as with the reading brother), but still using the same idea. For the snaking glow power around the handle of the hammer I painted white with a spatter brush and then added in the Outer Glow layer effect—and *voilà!* Thor's power is unleashed (**FIGURE 15.27**)!

Blast Off with Blend Modes and Fractals

Shifting back to the dog once again, this time to shed some light on the magic, I painted with a scatter brush (**FIGURE 15.28**) (see Chapter 11 for more information on similar brush settings for this effect) and copied yet another version of the Outer Glow layer effect to this layer. I modified the Outer Glow's gradient to be more of the warm variety explored in Chapter 8 while sketching out a fire dragon. Once the base layer of sparkly magic was brushed in, it was still missing some power—for that I went to fractals!

FIGURE 15.27 Applying the same layer effect to some painted power tendrils around the hammer handle created more of the blue glow, just as it did the with the light rays.

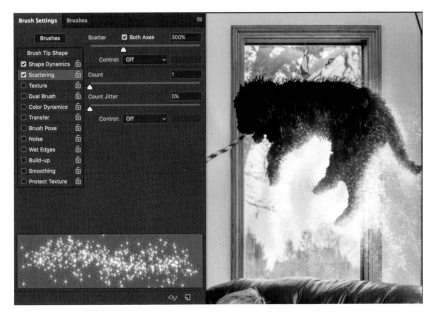

FIGURE 15.28 I used a Star 55 brush with Scattering selected to paint in some of the magic being used by the dog.

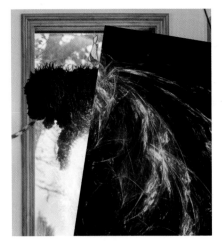

(A)

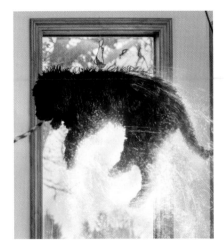

(B)

FIGURES 15.29 Using fractally generated elements with their blending modes set to Screen allowed me to have their black backgrounds disappear, allowing just the light bits to shine through. Combine with this some masking and you have yourself a floating magical doggy.

Using an arcane PC application called Apophysis, I generated some fractals (glowing designs based on math, triangulation, and infinity as far as I can tell). These look great when used with Screen blending mode as they have nice black backgrounds. Once I had the fractal images, I copied and pasted these pieces directly above the dog layer. Just as I made the fire's background disappear in Chapter 8, I switched the blending mode to Screen and masked out the unwanted bits (**FIGURE 15.29**).

Path Blur

Shifting focus back to Thor's hammer (and the final effect), this is where I used just a pinch of Path Blur to help add some motion to the object. The Blur Gallery options available are simply awesome—this one especially. The first thing I did at this stage was to duplicate both the hammer layer and the magic light encircling it, placing these copies into a single group I named Blur. Once there, I selected both layers and right-clicked to the right of their thumbnails; I chose Convert to Smart Object from the context menu—and bam! Just like that, the two layers had been combined into a nondestructive Smart Object, perfect for playing with some blur effects nondestructively. Once the two layers become one, I rotated the layer clockwise just a smidge to give it just a little offset from the original hammer (**FIGURE 15.30**).

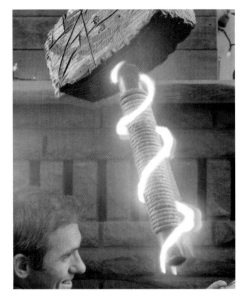

FIGURE 15.30 Offsetting the two hammers allowed a slight bit of separation, almost as if the hammer is leaving a trail behind as it flies.

NOTE The one major drawback to combining two layers into a single Smart Object is that the blending mode of the layer style does not work outside of the internal blending mode layers. Once you see the Smart Object in your Layers panel within the main composite, that's it. All the pixels and blending modes it contained are now being processed as Normal blending mode. If you decide that you don't like this and try changing the blending mode back to Screen for the Smart Object, it will take all of the Smart Object's content with it, meaning the rest of the Hammer, not just the glowing lights. Ye be warned!

With the Smart Object still selected, next came applying the Path Blur (Filter > Blur Gallery > Path Blur). This opens the Blur Gallery workspace where Path Blur is active. **FIGURE 15.31** shows the settings I used for creating a slight motion blur (in this case increasing the Speed slider position to 50%), but most importantly it shows where I placed and shaped my two paths (one was already there by default). Creating these paths is as easy as single-clicking places in the workspace image to add control points that define the path. For the top curved path, I clicked three points before I pressed Enter/Return to finish up the line. The image smears in the direction of that path (which is so awesome), in this case giving a slight

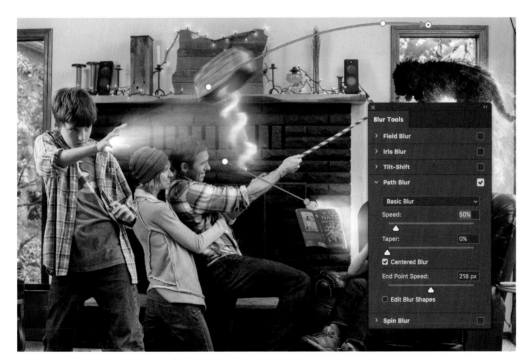

FIGURE 15.31 Path Blur allowed for a perspective motion blur by creating two paths that converge toward a vanishing point like perspective lines; Path Blur also enables you to create a curved path—which is perfect for adding in a slight amount of rotation blur in addition to perspective.

curve to the motion. To add dimension and perspective to the blur, it requires another path, more or less setting up perspective lines. With two lines pointing outward from one another, the blurred content also gets smeared in those directions—thus giving the image a slight z-axis motion blur! After calming down a bit from my total nerd-excitement about this blur feature, I clicked OK.

Once back in the main composite, I created a new mask for the blurred Smart Object by holding down Alt/Opt while clicking the Add Layer Mask icon ; this created a black mask concealing all of this layer, allowing me to paint in with white (with the Brush tool, shortcut B) *just* the parts I wanted blurred. **FIGURE 15.32** shows the final results of my masking of this Smart Object. A lot of work for a small effect, true—but it has a big visual impact. If a moving object feels too static, it can feel "off" to our eye; adding in even a hint of motion can often be enough to sell the idea and feeling of the action.

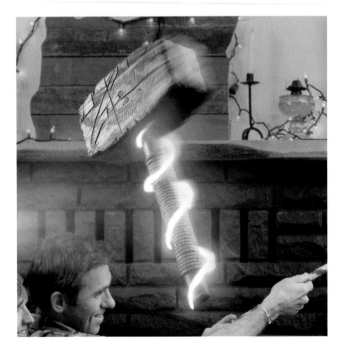

Step 10: Emphasis and Composition

The final touches in this image were fairly minimal and consisted of two layers that played a bit with creating emphasis and eye-flow with lightening and darkening various parts of the image to better highlight the subjects and actions. The first layer I added was for nondestructive dodge and burning; I did this by creating a new layer within the FX group and changed its blending mode to Overlay. Painting with a low-opacity (under 10%) black or white brush let me push and pull the tones until I was satisfied with the overall balance. Specifically, I darkened the bottom edge (painting with black), legs, and image corners—all the while gently lightening the faces (painting with white) and various parts of the subjects, as well as adding to the various glow effects (**FIGURE 15.33**). For these kinds of edits, less is usually more. A good rule of thumb I go by is that if after I've made my edits and I can't really see what I edited exactly (unless I turn off their visibility of the layer), then I know it's just right; if on the other hand something now stands out too much, I've overdone it! This process is, of course, highly subjective and is always changing with your improving eye (such as when you can't stand looking at your older work)!

FIGURE 15.32 Even just the slightest blur can add to the overall feeling and communicate the motion; here is the effect once the mask has scaled back the intensity, leaving only bits of the perspective blur—but enough to sell the idea.

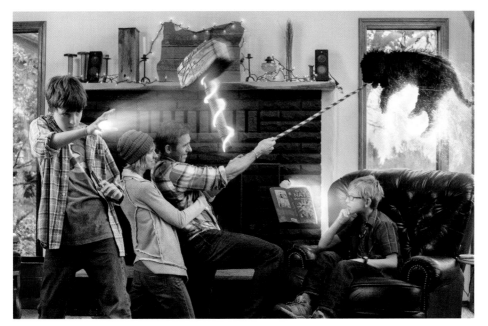

(A)

FIGURES 15.33A and **B** Painting black and white with a soft brush set to low opacity (under 10%) on a new layer set to Overlay blending mode, I nondestructively dodged and burned around the image; this helped with the hierarchy and eye-flow I was going for. Compare the composite before (A) and with the global dodge and burn effect (B).

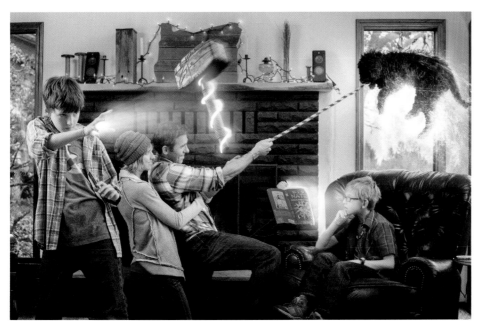

(B)

FIGURE 15.34 The final vignette added the last touch to help contain and direct some of the eye-flow within the image and not get too drawn outward, especially by those bright windows.

The final layer was a simple vignette to darken down those corners even more so. Using a large (massive 2000 px) brush, I painted black at 6% opacity just along the corners and edges. **FIGURE 15.34** includes the last touch of darkening down the sides helping your eye stay circulating within the frame not being too drawn outward even with those windows (always a potential issue as our eyes act like moths drawn to the light). And with that, it was done! Well, there may have been a couple little touchups here and there I caught after inspecting (such as a lighting cord still hanging out somewhere), but for the most part, the magic took its own course!

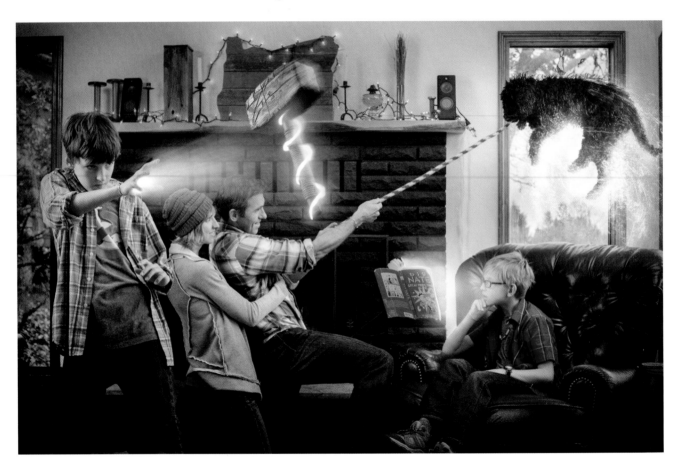

Conclusion

The importance of shooting strategically and editing in a way that collaborates with your imagery (rather than fixes or forces it) cannot be understated. Although this was perhaps long-winded in the explanation and rundown of what I did to make *Family Magic*, the entire process in real-time from shoot to final vignette took no longer than three hours tops—all because of thinking about the end structure given the material at hand. Especially when you may not have the opportunity for sketching or thorough planning, use the tools at hand to get a previsualization of the final image and composition. From there the pieces seem to fall (or float) into place—and if you are lucky, can be incredibly fun for everyone involved! (Though probably not for the dog! Let's face it, humans are just plain weird, right?)

HOLLY ANDRES

www.hollyandres.com

Holly Andres uses photography to examine the complexities of childhood, the fleeting nature of memory, and female introspection. She has had solo exhibitions in New York, Los Angeles, San Francisco, Atlanta, Seattle, Istanbul, and Portland, Oregon, where she lives and works. Her work has been featured in The New York Times Magazine, Time, Art in America, Artforum, Exit Magazine, Art News, Modern Painters, Oprah Magazine, Elle Magazine, W, The LA Times, Glamour, Blink, and Art

Ltd., which profiled her as one of 15 emerging West Coast artists under the age of 35. Andres's first major museum exhibition, The Homecoming, premiered at the Hallie Ford Museum in Salem, Oregon.

What do you look for when you set out to compose a new image? What's your process?

To borrow a distinction coined by Jeff Wall, I'm more of a farmer rather than a hunter. Although I have a really perceptive "internal camera," I'm not a photographer that shoots on a daily basis. I usually embark on a photo project with a prevailing theme in mind for the entire series and then, rather systematically, craft each individual photograph. Typically an idea evolves from a life experience, memory, or conversation that elicits a powerful image (or filmstrip) in my mind. Depending on the shoot, I may even create a storyboard for it.

The way that I work requires a lot of pre-production, much like preparing for a film shoot, as well as an extensive post-production phase. Often my work involves the tension between an apparently approachable subject matter and a darker, sometimes disturbing subtext. I'm interested in the cognitive dissonance that can result from employing formal elements such as bright colors, decorative patterns, theatrical lighting, and characters that reflect stereotypes of innocence, girlish femininity, and motherhood to address unsettling themes.

BEHIND THE OLD PAINTING, SPARROW LANE SERIES, 2008

CAT WHISPERER, 2011

How does Photoshop fit into your workflow?

Photoshop is an integral part of my workflow and allows me to use photography to materialize images that would otherwise stay trapped in my mind. My educational background is in painting and drawing, which significantly impacts the way I approach photography. I am fascinated by photography's legacy to be perceived as an agent of "truth," and recognize that Photoshop provides me with a powerful tool, not inherent in the more traditional art forms, to exploit this.

I've welcomed the spontaneity and experimentation that has resulted from transitioning from a large-format film camera to a digital camera. Shooting exclusively with my digital camera provides me with so many more files to consider when I'm creating my final image. I use Adobe Lightroom to peruse all my source files and flag any files that I think may possess some potential. From there, I start to create really rough composites in Photoshop. I experiment with a variety of options, and it's a very creative period in the overall process for me. This is when I set the tone and can get a sense of the most ideal character interaction, formal unity, and the potential to the effectively guide the viewer's eye around the frame.

How do you use lighting to enhance the meaning and narrative potential of each idea?

At the most rudimentary level, of course, photography is about capturing light. Not only do I employ light as a formal device to emphasize my characters, but also as a content carrier. The illumination of light in and of itself often suggests a revelation.

What do you find to be the most challenging part of compositing after a shoot? What's the most rewarding?

Without a doubt the most challenging part is combining all of the assets in such a way that the image actually appears convincing. The most rewarding part is when I start to see the potential of bringing a mental vision to life. It takes a lot of finessing, and in the end, none of my images are flawless. As I continue to grow and learn, I'm also working to embrace the artifice of my process and my limitations with the medium.

THE GLOWING DRAWER, SPARROW LANE SERIES, 2008

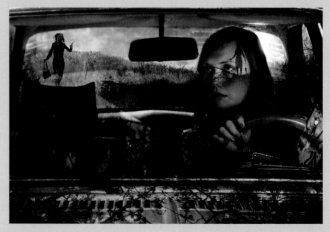

GUNFIGHT, 2012

How do you direct the subjects in one of your shoots for getting the results you are looking for?

For the Sparrow Lane series I revisited many of the covers of Nancy Drew books that I read as a child for inspiration. Because they are illustrations they have a vastly different, a more hyper-mannered quality, than we typically see in photographs. I love the melodramatic body language, the way their figures frame the scene, the separation of their fingers, and their startled, but lovely, expressions. While directing I emulated this aesthetic.

Currently I try to embark on my shoots with a consciously prepared vision, still consisting of a constructed environment, theatrical lighting, deliberate costuming, and implied narrative, but with an attempt to capture natural uncertainty. I am finding that the counterbalance of a choreographed structure and the unpredictable response of the subjects' "performance" can create the most compelling results. Shooting digitally certainly allows me to capture more of these "off moments," than I was ever able to when I previously shot exclusively in film.

Do things generally go as planned on a project? How flexible do you have to be with your style of work?

Despite my best efforts, of course things never go as planned! But, I feel like I've been shooting long enough to have faith that if I free myself up to stay flexible and open, precious moments of serendipity can and will occur. There's a degree of grief that always seems to result from what I've captured and how it departs from the vision that was in my mind. There's an adjustment period, and while it can sometimes be frustrating, surprisingly after a few days, I may realize that what I captured is actually more compelling than what I initially sought out to create.

What is your most favorite composited image or series to date?

The Sparrow Lane series is of course a personal favorite and is probably my most celebrated body of work to date. It was shot on a large-format camera, and because the film is so expensive to shoot and digitize, the compositing work is relatively subtle. I embarked on the project with the intention of concocting a set of identical "twins" out of just one girl. Like most people, I find identical twins mysterious and compelling, and I wanted to explore the idea of them as counterparts, equivalents, or accomplices embarking on these discoveries together.

Additionally, *The Cat Whisperer*, which is far more elaborate in its compositing, is also a personal favorite. It's so tempting to use Photoshop in a rather gratuitous way to multiply entities, but I think this image is a good example of employing this technique to build and reinforce a narrative.

Do you have any advice for future artists combining the worlds of photography and Photoshop?

I think having some sort of foundation in drawing, as well as understanding linear perspective and the logic of light and shadows, can go a long way when you're shooting photos and manipulating them in Photoshop. Otherwise, I think recognizing that you must make an investment. It takes a long time to develop a discerning eye, and even longer to master the techniques of Photoshop so that you can "fix" the problems that you create for yourself. Stay perceptive, continue looking at other artists work, ask questions, and keep practicing. ■

Epic Fantasy Landscapes

COVERED IN THIS CHAPTER

- Matching scale and perspective for subjects and landscapes
- Matching flow and physics of water
- Using masks as mortar for stone work
- Custom thatching from a single texture
- Construction with texture, duplication, and painted shading
- Adding wildlife and sun-rays for detail

Creating fantasy landscapes is one part imagination, two parts persistence, and, as usual, *completely* fun—or at least that's about how it goes for me. In the midst of a study on over-fantasized nature and its use in graphics for advertising (such as greenwash), I decided to try my hand at some seductive and fun eye candy while I was at it. The result was *Rainbow's End* (**FIGURE 16.1**), which represents a collision of most techniques and lessons presented in this book's earlier projects.

As usual, the project began with a typical previsualization and being inspired by the natural beauty I found hiking, adventuring, and constantly photographing. Memory is cheap, so there's really no excuse to not grab something that might have potential, and this project ended up containing hundreds of images from years of digital hording. It also contains some fresh lessons on blending waterfalls and various natural elements—both liquid and green—into a landscape, as well as how to construct a cottage texture-on-texture from multiple selections and assemble an entire waterwheel from two planks of wood.

Step 1: Lay the Groundwork

After much summer hiking in lush upstate New York and taking pictures of just about every waterfall within a 100-mile radius of Syracuse, I came up with some ideas and just enough reference material to create an epic nature scene. Keeping these shots, as well as those in my photo archive, in mind, I made a preliminary sketch—the first step on the road

▶ **FIGURE 16.1** Made of more than 200 layers, *Rainbow's End* contains bits of Yosemite National Park, upstate New York, Peru, Spain, and elsewhere.

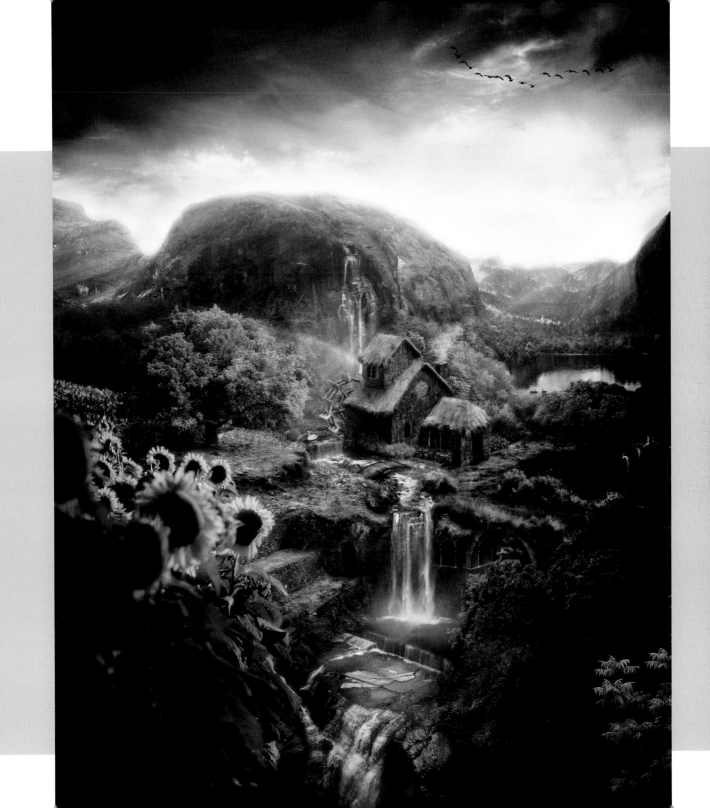

FIGURE 16.2 A sketch is always a good way to initiate the creative process; this one provided a good starting point to dive into the greenery.

TIP Always shoot a huge variety of different points of view so you have options when you sit down to piece them all together. A work like *Rainbow's End* was possible only because I gave myself the flexibility of many perspectives.

to *Rainbow's End* (**FIGURE 16.2**). Then, with the sketch in mind, I began assembling my photo palette of raw material for the composite.

Here are some strategies I learned from this project for fleshing out an idea before getting too deep into the groove of one track:

- **Start on paper.** For my process I find it useful to begin sketching on a pad while looking though my image archive and source material on the screen.

- **Block out the key features you want the composite to have.** For me, it was a waterwheel of some kind, a waterfall or two, a cottage, a lake, garden, and mountains in the background. Including the key features in some form can get you looking for the right pieces; just know that depending on the images you have, placement may deviate from your sketch dramatically—this is totally okay!

- **Scan or photograph your sketch and then make some digital revisions and additions.** This revision process will also be informed by the source material you can or cannot find. For example, I couldn't find a workable spiral stairwell, so out of the sketch it went.

Chapter 6 and others previously covered the mechanics of creating and managing a photo palette, but a project the size of *Rainbow's End* presents additional challenges. Some strategies I use when gathering potential source images for a complex project are

- **Look at the sketch and start searching for images that match both the perspective and visual elements required, such as point of view (POV).** For a cliff, look for one at the right angle and consistency. (Is it straight on, angled, higher or lower than the viewer?) For trees, try to match the proposed vantage, foliage, and size. Lakes and water need to be spot-on matches with the intended perspective and have good obedience to gravity; any angles where water isn't flowing as it should for the composite's POV will look so very wrong.

- **Gather by category: waterfalls, cliffs, trees, mountains, thatch.** Grouping potential images by category makes searching easier when you begin compositing. You can use Adobe Bridge if creating a photo palette is not your workflow or if your computer doesn't have the memory to handle multiple, heavily layered documents open at once. At least bring the pieces within reach, so that after you take a break you easily can reopen all the elements you need.

- **Find images that you like, and see if they can play a role in the project.** For me this was **FIGURE 16.3**: a photo of sunflowers from a nearby ranch. The lighting was right, it seemed to fit with the idea, and the flowers added a new dimension to my original concept.

TIP You can use Adobe Bridge not just to browse regular folders, but also to browse collections. The Collections feature enables you to add similarly themed pictures (such as waterfalls) and place them into a virtual folder—and it doesn't actually move the file to a new location. This virtual folder can be composed of files from many locations including multiple hard drives. Add selected files to a new collection by clicking the Add Collection button [⊞] in the Collections panel in Adobe Bridge, then you can drag more files into this folder at any time.

FIGURE 16.3 Find an image or concept that you like (for me it was these sunflowers), and see if you can work it into the project.

Step 2: Work on Scale and Perspective

After looking at the photo options and generating a photo palette, the next stage is to develop a more solid plan in regard to perspective and scale, which will evolve as you go. For me, once I get the project plan fleshed out, I start throwing images into the composite to see where key pieces may need to change to better fit with the new contents of my photo palette. When I found the great waterfall shown in **FIGURE 16.4**, I altered my overall plan a bit to accommodate its wonderfully long cascading shape. A lot of working on a composite of this nature is a give and take: Try to conform the images you find to your idea, but also let them guide where the composite needs to go so things stay looking right. Shifting plans to help make an image more believable can make quite the difference in the end.

Part of getting the perspective right is planning the sense of depth within the image. Finding matching imagery early on helps dramatically. With it, try to rough out the three major components to the landscape: the foreground, middle ground, and background. Doing this really does help establish everything else in between, so pay close attention to getting it right. **FIGURE 16.5** shows a first draft of my depth planning: sunflowers in the foreground, some mountains behind the cottage, and even more mountains beyond. Seeing the elements in relation to each other literally helped me lay the groundwork for all the other pieces and details to come.

I wanted the sunflowers large and close to help generate an immersive feeling, as if the viewer is peering through them, looking at the scene from a bridge or ledge. The flower image worked as a perfect foreground base to root the point of view. The back mountains I added mostly in one layer. Setting these two extremes (foreground

FIGURE 16.4 If you find an especially interesting image that has potential, it's a good idea to alter your original plans to make it work.

and background) laid the foundation for all other blocks to build on and scale to match. Sketching on top of them helped me envision the rest, such as the cottage placement.

Step 3: Fill in the Scene

Having fleshed out my sketch with the main depth components and a clearer POV, I was ready to tackle the epic jigsaw puzzle that is the essence of a large composite. Although not as simple as it sounds, all I needed to do was find the right source elements and position them where they belonged in the scene. **FIGURE 16.6** illustrates the elements beginning to take shape—stage by stage, piece by piece.

Looking for elements that fit your composite is very much like assembling a gigantic jigsaw puzzle, only the box

FIGURE 16.5 Rough in, scale, and mask some key images to help establish the depth and perspective for the project.

FIGURE 16.6 The process of filling in the pieces takes time, patience, and many lucky breaks, but with a continued critical eye you definitely can make progress.

reference image is in your head and the pieces you're choosing belong to their own puzzles. In general, you look to see if the shape matches first and then compare the lights and darks, the size and scaling, and so on. As for any puzzle, some strategy helps, so here's a bit of my own:

- **Use your imagination like a layer mask.** For me, finding a piece means I have to look objectively at one small section of a larger image and use my mind's eye to "imagination mask" out everything but that one area that has potential (**FIGURE 16.7**).

- **In Photoshop, turn those imagination masks into real ones by painting black with extreme detail and care on each layer's mask.** Get in close and get it done right; fudging and roughing it will add up layer by layer, and every promise in the fantastical world won't help you hunt down that digital grease left over in the end. You'll end up with less of a rainbow look and more of a mud-and-fuzz look.

- **Combine multiple pieces to assemble a section for which you have no single image that works well.** Your palette won't always contain an image that fleshes out an area as you may want. Combine two or more that have similar features, however, and you can get away with the perspective not exactly matching perfectly on any of them. For our brains to register something as "wrong," they require an unbroken area that doesn't fit entirely. Break your layer into multiple pieces, and it can blend in much better. In **FIGURE 16.8**, for example, I needed three pieces for the sunflowers to fit well.

- **As usual, look for matching lighting.** Harsh direct sunlight is a pain to match, as it's not very flexible. If you happen to have a match, great! Otherwise, look for those soft lighting shots and edit in your own lighting afterward.

THIS PART MIGHT JUST FIT ALONG THE RIVER'S EDGE.

FIGURE 16.7 During the process of searching out those workable pieces, just look in one area and not the whole picture; I call this imagination masking.

ONE

TWO

THREE

FIGURE 16.8 To get the right look for the sunflowers, three pieces worked much more effectively than a single, larger section of the source image.

- **Make clipped adjustments as you go.** Each shot will have different issues with colors, lights and darks, noise, sharpness or blur, and so on, so your best practice is to create and clip adjustment layers to your image layer and then apply Smart Filters as needed.

- **Don't get discouraged!** Most of the parts that you'll put together will match only somewhat in a physical sense and not at all aesthetically. For my own projects, I know that I can later add custom lighting with dodging and burning (nondestructively on an Overlay blending mode layer), bring in atmospheric perspective, and make a slew of adjustments that get refined as I work. So piece together with the confidence that mostly everything is workable to some extent; at this stage, you just want to match up shapes, perspective, and point of view.

Step 4: Go with the Flow: Convincing Water

Compositing water images adds a few new ripples of difficulty: working with gravity, flow, and reflections— all things our eyes can immediately pick up if they feel wrong. A waterfall, after all, should *fall*. So just make sure water flows and splashes in the right way, and you're good to go, right? Almost.

Waterfalls

Shaping and combining waterfalls is a challenge. A failure to obey the laws of gravity and flow is a telltale sign that can give the composite's illusion away. Here's a breakdown of some watery advice that helped me when matching the pieces for the waterfall section of *Rainbow's End* (**FIGURE 16.9**):

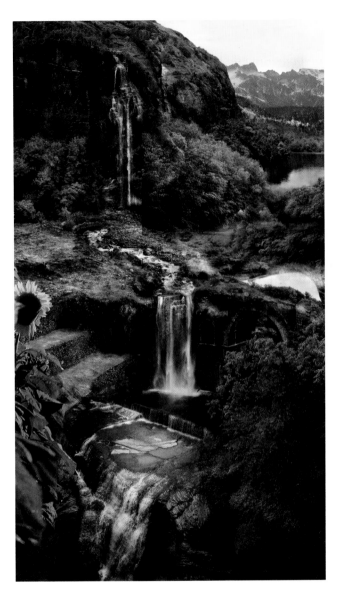

FIGURE 16.9 Waterfalls must obey gravity, so make sure all pieces are flowing in the same downward direction.

FIGURE 16.10 Establish what the waterfalls will be placed over to ensure the forms match up.

FIGURE 16.11 Brush in the water that you want to flow, painting black directly on the layer's mask.

- **Have an idea of the surface and form that will be underneath the waterfall:** Would the water you plan to add actually flow over it naturally? From there you can begin to find the appropriate pieces to match the background. I mostly filled out the outer areas around the waterfalls in **FIGURE 16.10**, for example, before I added the water.

- **Mask with a textured brush rather than selections.** Painting with black on the mask gives you the control to break the technical conformity of selection tools, which, in turn, helps create a more believable look overall in massive jigsaw composites. When you make a selection before masking, it often includes areas that are similar or have easy-to-follow edges. When you need a more organic look that takes only small pieces from each waterfall layer in a very customized fashion, selections cause more interference and steps compared to manually finessing a brush directly on the mask. In the case of **FIGURE 16.11**, I used a textured, speckle brush at a radius of 15 px and painted along the edges of where I wanted water or pieces of rock.

- **Use clipped adjustment layers as you go, always staying nondestructive and keeping the pieces matching as you work.** Sometimes this is a Curves adjustment layer pushing the highlights for the whitewater, other times it's shifting a color to match those around it.

- **Paint out all edges with black and be sure not to leave any digital grease, especially on hard edges of the copied pieces.** I immediately paint with 100% opacity black with Mr. Round-and-Soft just to be sure I don't miss anything as I customize.

> **TIP** Visually check for digital grease by turning off layer visibility and mask visibility. Clicking the layer's Visibility icon 👁 while looking at areas that are supposed to be masked will show a faint change if there is a little leftover grease. Similarly, disabling and enabling (Shift-clicking the mask thumbnail) will give a before-and-after view of the mask. For more helpful and clean as-a-whistle-techniques, review Chapter 3's "Digital Grease and Masking" sidebar.

- **Paste in only the pieces that you can see fitting well with the rest of the waterfall.** This would seem to go without saying, but it's easy to get this wrong. Grabbing the entire waterfall picture (such as with the Place feature

in Adobe Bridge), in most cases, doesn't help as much as you might think; it leaves you with less flexibility, and it's more difficult to get looking right with other layers. Rock formations alter the way the water moves and falls, so taking smaller, more controlled pieces helps with creating a more seamless blend. Additionally, when you work with more than 200 layers as for *Rainbow's End*, using full images rather than pieces of images is way too cumbersome, even for super-machines and the 64-bit versions of Photoshop.

Rivers Run

Creating a river is much like the waterfall process but has some added complexities, such as the water's color, depth, and flow direction, as well as rocks and, most importantly, POV. If these things don't line up with where the viewer is supposed to be looking from, the illusion is lost sooner than you can say running-river-rapids (**FIGURE 16.12**). Masking at the places of change, such as whitewater or a rock ledge, can help with the seamlessness. You can see in Figure 16.12 the green of the top water beneath the waterfall changed to the streaks of white as it turned into the bottom river and waterfall. This ledge drop going across the river is actually a seam between two river images.

Lazy Lakes

At least lakes stay put. These placid entities are easier in some ways compared to rivers and waterfalls, but they do have one added element to keep you from relaxing too much: reflections. If you have the right shot and everything lines up perfectly, lucky you. Otherwise, it comes back to that give-and-take idea. You may have something else planned in that spot beyond the lake, but unless you have a shot that somewhat reflects what needs to be reflected, it can be difficult to get it in and still look okay.

FIGURE 16.12 To blend together pieces of water like flowing rivers, make sure they match in nearly every way, including flow direction and POV.

One compromise is to alter your original idea to better match the reflection. Alternately, you can paint in the reflections you need (which may have to happen a little in any case). For *Rainbow's End*, the bottom section of the lake began to give away the fact that the lake was not an exact match. I found a nice bushy tree to simply cover it up—another good option to keep in mind (**FIGURE 16.13**). Coloring the water with a layer set to Color blending mode can help a great deal for matching the rest of the scene and reflections. The original water reflection in this case was a nice sky blue.

FIGURE 16.13 You can see the added lake at least somewhat matched the reflections of the mountains and the gap between the ridges, but the close shore didn't match as well, so it got covered with greenery.

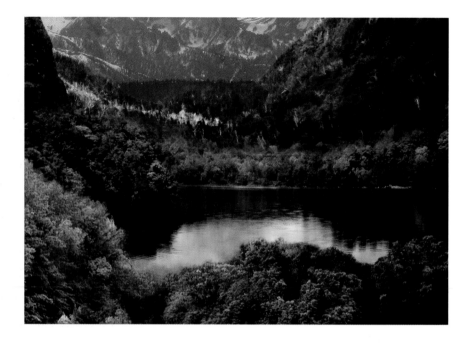

TIP Try to get the physics as close to real as possible, but when it's just not working, go with what works on an emotional and aesthetic level. Reflections may not be perfect; just keep them close enough to work with the composition and overall feel.

Rainbows

Technically, rainbows aren't water, but they do require water vapor. They also need direct sunlight, but this is a *fantasy* landscape, so science can take a raft down the river at times. You can always stretch the impossible, as long as it is visually believable.

The key to the rainbow was finding one with a similar enough background; **FIGURE 16.14** was photographed in Yosemite National Park and already had a darker scene behind it. One more trick to getting rainbows to shine: Although they're water based, they work on the same principle as flames. Just as you did for the flames in the fiery creation in Chapter 8, change the rainbow's blending mode to Screen. This allows just the lighter elements to peak through—perfect for a rainbow situation! Beyond that, careful and softly brushed masking is always in order.

Step 5: Plant the Tree

Finding the right tree, bush, or stone sometimes can be quite a pain in the quaking aspen—and finding the right perspective and angle can be even harder. So getting out and doing some location scouting and searching for those pieces that fit just the right way can be substantially more fruitful than *forcing* something to fit out of pure stubbornness (and this goes for any of the puzzle pieces mentioned so far).

Besides, there's more than one benefit to getting outside! Your eyes actually become accustomed to an image you've been working on for hours on hours without a break, and they simply stop being objective evaluators. Ever notice when you work on something all night and you feel like you're just nailing it to perfection and then you come back the next day and wonder what blindfolded baboon made the mess you're looking at? So do yourself, your eyes, and your project a favor: Get out and shoot some matching material rather than forcing an existing image too much.

For me, this meant finding a particular tree, a perfect tree with the perfectly matching POV. I found it in a park where I was able to shoot from a higher vantage using a gentle hill (**FIGURE 16.15**). The lighting also matched wonderfully once I flipped the image horizontally with the Move tool.

FIGURE 16.14 For rainbows with a darker background you can change the blending mode to Screen to give the colors prominence while most of the background drops out.

FIGURE 16.15 Go outside and shoot the right tree with the usable angle and perspective. You'll save yourself quite a lot of frustration in the end.

FIGURE 16.16 Hue blending mode clipped to a layer can help shift green leaves to pink flower-ish colors in a snap.

Alter Color with the Hue Blending Mode

Where did I find a pink tree? I didn't; I cheated! While working in the composition, I realized that although my tree *was* perfect in its shape, POV, and lighting, it still wasn't the right color. I needed it to stand out and bring further attention to the center of the image; green blended just a little too much. The remedy? A quick color shift using a new clipped layer and changing the blending mode to Hue (**FIGURE 16.16**). Like salting the stew, from there it was just a matter of painting in the desired color to taste.

Step 6: Build a Cottage, Rock by Rock

Okay, I'm not going to lie to you, the cottage (**FIGURE 16.17**) took a considerable amount of patience, masking muscle, and close-up detail work—but at least my back doesn't hurt from lifting all those stones in person (though that might have been faster). The process began with a fleshed-out sketch and a search through my source photos for the right stones to build with—a digital quarry, if you will. Having shot many different angles of various terrace stonewalls while in Peru, I had plenty of material (**FIGURE 16.18**).

▶ **FIGURE 16.17** Building the cottage was a long process in itself, but was quite rewarding in the end.

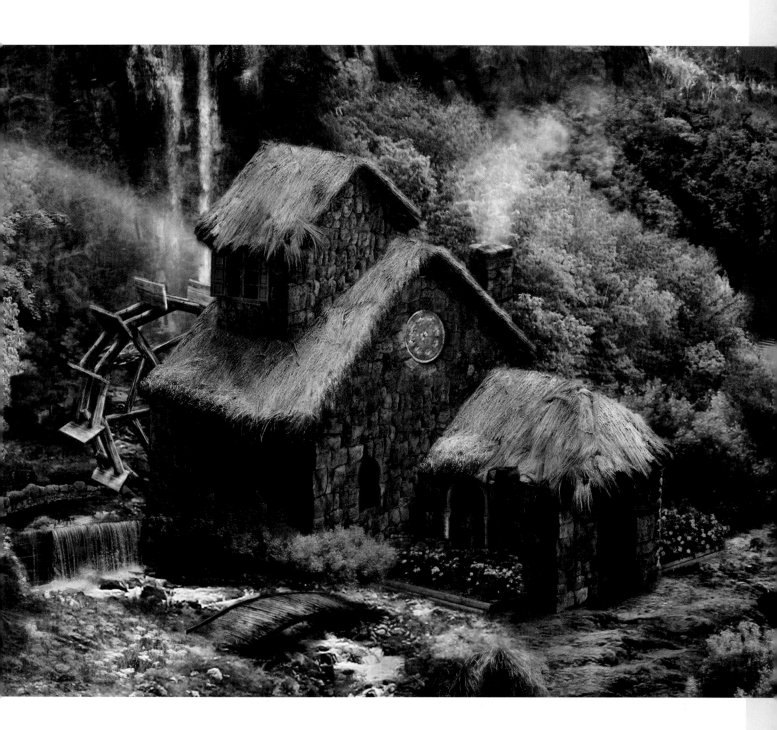

Unfortunately, the lighting was not quite what I needed in the shots that would form the main pieces of the cottage. The Peruvian stone walls that were in the shade (optimal) had the most potential and flexibility; however, they also had intense under lighting from the sunny dry grass at the base. That meant if I wanted the lighting to be from above, the original walls needed to be turned upside down. So that's what I did (**FIGURE 16.19**).

With the main walls in place, I finished the rest much like its real-life counterpart: I found and placed stone upon stone that matched. Careful masking along rock edges allowed for easy lines to follow, and duplicating an especially fruitful wall worked well for adding bits of variety with just one or two stones showing from the original wall (and the rest masked out).

The corners, in particular, needed to feel like edges and took some extra care to get them masked and arranged just the right way (**FIGURE 16.20**). Honestly, though, this is no different than any time you may have spent working with Legos: Find the right pieces, plug them in, and just have fun! Here are a few takeaway tips for stonework that I gleaned from this experience:

- **Angle is everything.** Finding the correct angle (or being able to rotate to match the correct angle) is the key to having the building not look flat or too much like a cheap Hollywood set.

- **Use masking like mortar.** Having the right space and shadows between stones makes it feel like a believable and cohesive wall, even if it was pieced together from five walls. Finish masking around one stone, keeping the shadow and any highlights before adding in a different piece around the first.

FIGURE 16.18 Incan ruins provided the perfect stone walls to build with as they offered variety and many angles to choose from.

FIGURE 16.19 If lighting needs to be brighter from above but the source is under lit, you can flip the orientation to match what you need, not what you see.

FIGURE 16.20 Finding more Incan ruin pictures with edges of stonework was perfect for the corners of the sketched cottage.

- **Take it slow.** Like any good masonry, a thorough job yields the best results, and quick and sloppy work looks—well, quick and sloppy! If this kind of work drags too much, go play in another part of the scene and come back with renewed patience.

I filled in other details around the house piece by custom piece, such as the various windows (imported from Spain), the entrance (more Incan stonework), and even gardens (thanks to the Syracuse rose garden). Some of the images matched well, but others had to be fudged and masked dramatically for the best fit. Even so, while not perfect up close, the pieces added up to a fairly adequate and convincing cottage.

Step 7: Brush in Thatch from Scratch

Sometimes you just don't have the shots you need nor can you really go out to shoot them either. Creating the thatch was a challenge for me: I didn't have much source material to work from or any thatch nearby to photograph. In these cases, you need to be a little more creative. For *Rainbow's End*, I made the most of my few usable shots and then created a custom brush for the rest of the thatching (**FIGURE 16.21**). To create your own custom brush—thatch or otherwise—from scratch, try these steps:

1. Select a fairly generic area from your thatch (or other) source image that doesn't contain too many unique features. If something repeats an obvious mark, it will give it a cookie-cutter look when you paint with the brush. I was fortunate to have at least one clean shot of thatch to use as a brush-able section.

FIGURE 16.21 Thatch is iconic for a nature-oriented cottage. With only a little in my archive, I improvised by creating a custom brush to paint in the rest.

2. Copy the selection (Ctrl+C/Cmd+C) and then make a new document matching that size (the default after copying in most cases). Paste the copied content into a new document (Ctrl+V/Cmd+V). Note that this can be done within the main document on a layer, but I prefer separating it out in case I want to do additional adjustments or cleanup with the healing tools.

3. Create a mask using the Add Mask icon and mask out all hard edges, leaving only the thatch inside (**FIGURE 16.22**).

FIGURE 16.22 When defining a new brush preset, be sure to mask out all hard edges.

4. From the Edit menu, choose Define Brush Preset. This will turn your active layer selection into a usable brush for repeated uses as a grayscale image. Be sure to name it something meaningful when prompted. Like other brushes, areas with content will paint the color you have selected, so grab a thatch-like yellow.

> **TIP** I typically paint with black and white once I make a brush in order to get the right lights and darks. I then add color through a new Color blending mode layer. On this layer I can paint the appropriate color that I've directly chosen with the Eyedropper tool from some other dark part of dry grass or thatch.

For the remainder of the thatch, I both painted with the custom brush and duplicated some sections, much like for the stonework. I used the brush only with quick clicks, as strokes blur the texture too much, but it worked quite well as a foundation to then add variety to afterward.

Step 8: Build a Two-Board Waterwheel

When photos are limited, there's always the option of complete fabrication, even for complex objects like a waterwheel. That's right, I created the wheel in **FIGURE 16.23** entirely from a couple wood textures that were then arranged and painted over to create a believable dimension. The process I followed was surprisingly simple:

1. I started with a basic wood texture. This is equivalent to finding that first board in a construction project—and it was that first board in this construction process (**FIGURE 16.24**).

2. From there I copied (holding down Alt/Opt and dragging using the Move tool) and arranged the wood texture to follow a sketched-out shape of the structural rings (**FIGURE 16.25**). As this part of the project would be fairly small, I wasn't too worried about it looking too similar and cookie-cutter. Plus, I knew that painting in the shadows would add enough variation to compensate for any similarity.

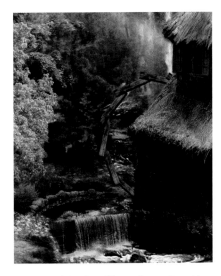

FIGURE 16.23 The waterwheel was constructed from a couple wood textures and shading over the entire thing.

FIGURE 16.24 Start with a wood texture that is fairly flat and without three-dimensional shading.

FIGURE 16.25 Just like real woodworking projects, get the structural parts lined up and working before anything else.

3. After getting the first circle in place, I made an exact copy so that the wheel would have a second ring and more dimension. With the first wheel placed within a group, I selected the group and Alt/Opt-dragged it downward in the Layers panel to place a duplicate directly below the original group. This made a duplicate of all the layers within while also placing them behind the first wheel.

4. Using the Move tool and with the new group still selected, I moved the second wheel group to an offset position to create a 3D effect by dragging the layers to the left and upward (**FIGURE 16.26**).

5. To create the paddles and spokes for the waterwheel, I again took a wood texture and angled it in a new orientation each time as needed (**FIGURE 16.27**). The best strategy for paddles, which are different in each case, is keeping an eye on the perspective lines and also using the Move tool to free transform one corner at a time (Ctrl/Cmd-drag).

6. Shadows and highlights transform mere textures and shapes into three-dimensional forms, so I added a couple layers that brought out the highlights around the wheel and added some shadows consistent with the scene's general lighting (**FIGURE 16.28**). I used two layers for this. On one I controlled the highlights, as well as most of the shadows and edge definition, by adding a layer set to Overlay blending mode. Painting with black on this layer darkened the natural attributes of the wood, while painting with white brightened them (imagine painting with the beam of a flashlight). On the second layer, I finished the effect by adding deeper shadows with less definition; this involved a new Normal blending mode layer placed above the Overlay layer. Just the underside of the paddles and some other underside areas needed a little bit more darkening.

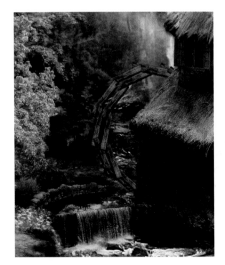

FIGURE 16.26 Rather than repeating a lot of time-consuming work matching individual plank for plank, duplicate the layers.

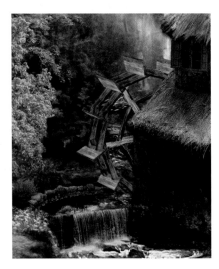

FIGURE 16.27 It wouldn't be a very functional waterwheel without some paddle action; these were customized using the Move tool's Transform commands.

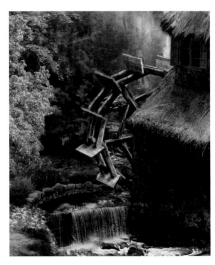

FIGURE 16.28 Shadows and highlights transform a textured shape into a believable object.

Step 9: Cue the Birds

The landscape projects that I find most enjoyable always contain interplay between a vast expanse and the small details hidden within the scene. Something that takes us aback, yet draws us further in. Adding detail work is equally, if not *more*, important to a scene as the landscape itself. In *Rainbow's End* those hidden details came to life when I added birds—a variety of birds. Birds are the face and voice of a forest, and placing some variety in a scene indicates a specific tone and vitality. Advertisers and greenwashers have mastered the use of wildlife, so as a part of my study, this scene definitely needed a bird or two, including the following:

FIGURE 16.29 Create a quick reflection simulation by duplicating the layer, flipping it vertically, and lowering its opacity.

- **Ducks.** These fellows hanging out in the lake were brought in obviously but didn't have workable reflections. To create some, I quickly made a duplicate of the ducks, flipped them upside down with the Move tool's transform controls, and lowered the layer's opacity to 44% (**FIGURE 16.29**). With such a small detail, it didn't need to be perfect, simply suggestive of true reflections.

- **Flying geese.** These noisy buggers were quite easy to bring in as they were photographed on top of a blown-out sky (all white with no detail). This meant that I could use Darken blending mode. Made just for these white-background situations, Darken lets only the darks show while the lights fall away. (Yes, it's the counterpart to Lighten mode used on the hands in Chapter 8.) Switching the blending mode to Darken knocked out the sky and left me with a flying V that I could place anywhere without a single mask (**FIGURE 16.30**).

FIGURE 16.30 For objects on a white background, often changing the blending mode to Darken will do a solid job of knocking out the background to leave just the dark bits visible, as the geese are here.

- **Swan.** This image of the swan was a lucky find, dating all the way back to darkroom photos I took in high school. And honestly, what super-green, fantasy cottage would be complete without its resident swan? As far as technical, swan-crafting techniques, the process was fairly straightforward. It already had a low-profile reflection and needed only some masking and a layer for a slight bit of color. I created this using a new layer sitting above the swan with the blending mode switched to Color and a touch of yellow-orange painted on the bill (**FIGURE 16.31**).

Step 10: Polish the Effects

In addition to darkening and lightening subtly by painting with a large brush on an Overlay blending mode layer (as I do in each composite), I also used the sun-ray effects covered at the end of Chapter 9 along with some general atmospheric perspective for added depth and softening (covered in Chapter 9 and others as well). While earlier chapters contain more detail, here's a quick recap.

Sun-rays

Create sun-rays by first painting white on a new layer with a large Spatter brush (setting Size to about 300 px does the trick). With a single click, you get one instance of the brush pattern. Apply a fairly dramatic motion blur on the layer and then use the Move tool (V) to stretch the layer until it gets a nice effect of sun-rays through a faint mist. Rotate and transform to taste (**FIGURE 16.32**).

> **TIP** Ctrl/Cmd-drag one of the corner control points to customize the perspective. Sometimes rays flange outward as you look toward the source of light, so dragging the two bottom corners wider apart works well for this.

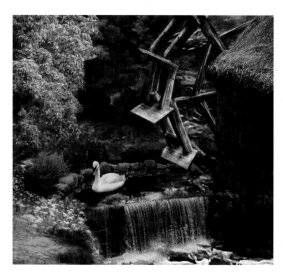

FIGURE 16.31 As the swan was a black-and-white image originally, the bill needed a little color added by a new layer set to a Color blending mode.

FIGURE 16.32 Sun-rays through mist (seen here in front of the dark gray stone cliff face) are a nice fantasy touch and are easy enough to make with some motion blurring.

Atmospheric Perspective

In addition to the rays, adding some general condensation in the air helps make an outdoor scene more believable. As shown in Chapter 9 and others, the technique is pretty straightforward: The more distant the object, the more atmosphere you pile on top of it. I do this by simply painting a pale yellow with a soft, round, low-opacity brush (or feel free to try out the cloud brush shown in Chapter 13 for a moment like this). Painting faintly (under 10% opacity) reduces the contrast and clarity of distant objects, which is what actually happens in the real world when we look at distant peaks and far-away cities. If your world was looking pretty fake and flat up to this point, go wild with atmospherics and prepare to be amazed (**FIGURE 16.33**)!

Conclusion

As a compilation of nearly all the techniques covered in some form or another in this book, *Rainbow's End* illustrates the ways you can get inspired and apply a photographic archive in tandem with craft and technique. Creating fantasy landscapes forces us to pull out all the stops and reach for things that should be impossible—yet are still derived from the real. For me, these scenes are a journey of sorts as well as a satisfying destination. Along the way of this particular journey I discovered that the best Photoshop projects are the ones that don't just leave you stuck in a room with a computer; they take you to another place, sometimes literally. I'm glad to say that *Rainbow's End* was just the beginning, one view along an adventurous path.

FIGURE 16.33 Adding atmosphere to distant objects creates a full sense of depth, continuity, and a more life-like look to the scene.

ANDRÉE WALLIN

andreewallin.com

Andrée Wallin is a concept artist and producer who works mainly with commercials and films (such as the concept work for the latest Star Wars films). His projects range from concept and pre-visualization art to high-end promotional art, such as movie posters, magazine covers, and billboards. His clients include Lucasfilm, Universal, Warner Brothers, Disney, Digital Domain, MPC, Blur, and Legendary Pictures.

RAIN, 2012

How would you describe your own work and process?
That's a tough question. To be honest, I never really feel like an artist. I still get the feeling that I have no idea what I'm doing when I start out with a blank canvas. The same feeling I got the first time I opened the program, and it's a good thing. It forces your brain to be creative. Once you start going through the motions as an artist I think you're screwed. My process is usually just blocking out a very, very rough composition, and then try to build up momentum by throwing some photos or textures in there to build off of. You don't want it to look like a sloppy photo bash, but I love it when I'm able to keep a gritty, textured feel and still make it look like a painting.

When were you first drawn into using Photoshop?
It was back in 2001. I was 18 and stumbled across a tutorial made by Dhabih Eng, an artist who works at Valve. He made some Photoshop tutorial, and it just looked like so much fun I had to try it myself. It was love at first sight. I painted using a mouse for the first four or five years before finally getting a Wacom tablet.

What is your favorite capability of the application?
It's certainly not exclusive to Photoshop, but the way you can experiment with colors and brightness and contrast levels. When I was a kid I always liked to draw and scribble, but I rarely used colors. I was too lazy; I just

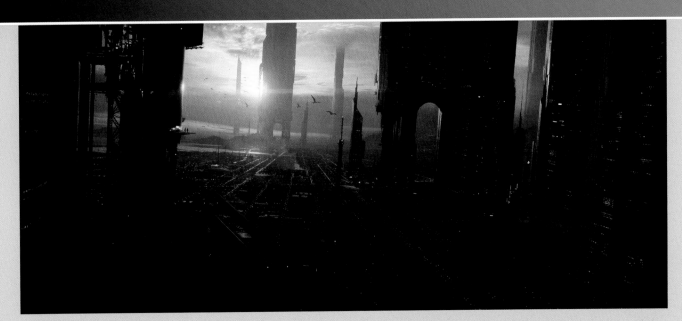

LA 2146, 2012

POSTAPOCALYPTIC CITY, 2009

wanted to get an idea out as fast as I could before I lost interest. It's the same way now, but thanks to programs like Photoshop I have the ability to quickly try different color schemes and more.

What suggestions do you have for getting a composite looking "right?"
If you go to art school, someone would most likely teach you what makes a good composition and how it all works from a theoretical point of view. I never studied art; I only learned the very basics of the rule of thirds, and that's about it. I honestly only go by what looks good in my eyes. I'll paint a rough composition, flip the image after a while, work on it some more, flip it back, and keep doing that for an hour or so. Then I usually save and close the program, do something else for a while to refresh my eyes, and then open it up after a couple of hours. If it still looks good, I'll start to flesh it out with details. If it doesn't feel right, I'll go back and try to figure out what's throwing me off.

DRAGON VS. SOLDIERS, 2009

How do you plan and prepare for one of your creations?

I don't like to plan or prepare. For my personal art, there's nothing I love more than just coming up with an idea on the spot and then painting it in a day. If I can finish a painting within a few hours, I'm then able to go back the next day and look at it almost as if it was someone else's. I really like that, because it makes me look at my art much more objectively and I can enjoy it way more than if I'd spent a week on it.

Of course, if we're talking about client work, then it's a whole different story. You have to collect reference material and study up on the subject matter—a process I'm not a big fan of.

Any general advice on going into the industry and living off of your artwork?

If you're going to work as a freelancer, prepare for a life of ups and downs. You've got to love what you do, and you better be prepared to do it *a lot*. You're never going to succeed as a freelancing artist unless you're willing to make some sacrifices and really give it your best. This won't be a problem if art is your passion, then this will all come naturally. It's always easier said than done, but if you tough it out during the first few years and build up a network with clients and other artists; you'll have an awesome life; there's no doubt about that.

What has been your most favorite piece of work to date? Why?

That's another tough one. If I had to pick one, I think it's a piece called *Dragons vs. Soldiers*, just because I feel like that was the piece where I really found my cinematic tone and style. It was also one of those paintings where the process went smoothly. It wasn't a big struggle to make it work, and that's always fun. ■

Mountain Serenity, 2010

Index

Dodge layer, global effect, 253
dodging and burning. *See also* burning areas
 nondestructive edits, 149, 162, 389
 Overlay layers, 180–181, 303–304
dog
 blend modes and fractals, 385–386
 masking hair, 376
dragging control points, 384
Dragon vs. Soldiers by Andrée Wallin, 420
Dry Brushes, 322
DSLR (digital single lens reflex) cameras, 87–88
Dual Brush, 324
ducks, creating, 415–416
duplicating. *See also* copying
 images, 317
 layers, 21, 42, 163, 179
Dust layer, creating, 210–211
A Dying Wish by Mario Sánchez Nevado, 280

E

Edge Detection, Radius slider, 319
edges
 adding variety, 322
 bending, 230
 feathering, 200
 painting around, 343
 refining, 296, 317–318
 straightening and aligning, 186, 189, 194
Edit menu
 explained, 7
 keyboard shortcuts, 9
editing and shoot process, 287
editing in ACR, 98–103, 291. *See also* localized edits
effects
 adding, 381–388
 applying to pixels, 59–61
 and lighting, 148–151
 limiting, 22
 polishing, 416–417
 using, 8
emphasis and composition, 388–391
Exit keyboard shortcut, 9
exposure control
 aperture, 92–93
 ISO, 93–94
 overview, 90
 shutter speed, 91–92
 using, 288–289
exposure reciprocity, 368

exposure trinity, 94–95
Eyedropper tool
 icon, 18
 matching color palettes, 177
 switching from Brush, 37
 switching to, 178
 using, 32

F

F (function) keys, 9
Family Magic
 brainstorming, 364
 cloning and hair repairs, 379–381
 emphasis and composition, 388–390
 lighting and gear, 365
 masking and painting, 375–378
 overview, 362–363
 positioning, 366–367
 previsualization, 366–367
 rating images, 370
 shooting vignettes, 368–369
 sorting images, 370
 special effects, 381–388
 working with subjects, 371–374
fantasy scenes. *See Blue Vista; Rainbow's End*
fast lenses, 90
feathering, 29, 200
feet, keeping on ground, 201–202
Field Blur effect, 77
file formats, 10–13
File menu
 explained, 6
 keyboard shortcuts, 9
file size, controlling, 240
Fill keyboard shortcut, 9
fill light, 365
Filter menu, 8–9
filtering layers, 44
filters. *See also* warm effect
 ACR (Adobe Camera Raw), 80
 Adaptive Wide Angle, 184–187
 and adjustment layers, 64
 Blurs, 76–79
 choosing, 96
 keyboard shortcut, 9
 Lens Blur, 174
 Liquify, 168–169, 271–273
 Motion Blur, 214, 383
 Reduce Noise, 75–76, 315